Civic Dialogue, Arts & Culture

Civic Dialogue, Arts & Culture

::: **FINDINGS FROM ANIMATING DEMOCRACY**

Pam Korza,
Barbara Schaffer Bacon,
and Andrea Assaf

AMERICANS
for the ARTS

WASHINGTON, DC

"It's The Art, Stupid!" by Michael Marsicano was previously published
in *Grantmakers in the Arts Reader,* winter 2003. Reprinted with the
permission of the author and Grantmakers in the Arts.

Cover images: illustrations from Animating Democracy-supported
projects and convenings.

Book design by studio e$_2$.

Library of Congress Cataloging-in-Publication Data
Korza, Pam.
 Civic dialogue, arts & culture : findings from Animating Democracy /
Pam Korza, Barbara Schaffer Bacon, and Andrea Assaf.
 p. cm.
 Includes index.
 ISBN-13: 978-1-879903-33-3 (alk. paper)
 1. Arts—United States—Citizen participation. 2. Community arts
projects—United States. 3. Artists and community—United States. 4.
Animating Democracy (Initiative) I. Bacon, Barbara Schaffer. II. Assaf,
Andrea. III. Americans for the Arts (Organization) IV. Animating
Democracy (Initiative) V. Title.
 NX230.K67 2005
 306.4'7'0973--dc22

 2005021979

ISBN-13: 978-1-879903-33-3
ISBN-10: 1-879903-33-4

The paper used in this publication meets the minimum requirements of
the American National Standard for Information Sciences—Permanence
of Paper for Printed Library Materials, ANSI Z39.48-1992

Additional copies available at www.AmericansForTheArts.org/bookstore

Civic Dialogue, Arts & Culture is a publication of Animating Democracy.

Animating Democracy, supported by the Ford Foundation,
is a program of Americans for the Arts

Table of Contents

Foreword

WITH A VISION OF ACCESS TO THE ARTS FOR ALL, Americans for the Arts works to foster an environment in which the arts can thrive and contribute to the creation of more livable communities, generate more public- and private-sector resources for the arts and arts education, and build individual appreciation of the value of the arts. Animating Democracy's emphasis on the vital role of the arts and humanities in a democratic society connects Americans for the Arts to all three of these core goals.

Americans for the Arts aims to increase the national clout of the arts through research and information, policy and advocacy, leadership development, visibility and recognition, and strategic alliances and partnerships. But equally important is our work to provide local tools to advance the arts in communities and to increase the involvement of individual citizens in arts and culture. Animating Democracy, with its support of on-the-ground projects (thanks to generous resources from the Ford Foundation) and its dissemination of best practices through convenings and publications like this one, is helping to build capacity for creative, effective, and responsible civic engagement through the arts at the local level. And because participation in civic engagement efforts typically extends beyond traditional arts audiences, Animating Democracy's efforts are helping to broaden public participation in the arts.

As many Animating Democracy projects have demonstrated, the arts can help citizens better understand and deal with issues that affect their communities and their own lives. When people connect the power of the arts to enhanced civic life, they are motivated to become advocates for the arts.

Americans for the Arts has felt privileged to work at this exciting intersection of art and civic engagement, contributing to a tradition of community-based cultural activity, bolstering a widening array of cultural organizations and community partners in the process, and offering valuable research and documentation that can advance scholarship and artistic investigation. We hope Animating Democracy's work, to date and into the future, stimulates new as well as continued endeavors that make a civic and an artistic impact in all corners of the country.

Robert L. Lynch
President & CEO, Americans for the Arts

Preface

CIVIC DIALOGUE, ARTS & CULTURE captures the discoveries of three dozen cultural organizations across the United States that experimented with stimulating civic dialogue through the arts. From 2000 to 2004, with support from the Ford Foundation, Animating Democracy—an ambitious initiative of Americans for the Arts—provided these organizations with funding, opportunities for peer exchange, and other technical support. This book, *Civic Dialogue, Arts & Culture*, synthesizes and highlights the best practices in arts- and humanities-based civic dialogue born out of their endeavors. Animating Democracy set out to demonstrate that civic dialogue and art can be mutually enhanced when the two are thoughtfully brought together. With focus and intention, artists and cultural organization leaders can use the inherent power of art to stimulate civic dialogue and engagement. Valuable artistic investigation and innovative aesthetic work can result.

These culturally based projects addressed pressing and persistent civic and social issues. They were ambitious, impactful in their artistry and civic connections, but also challenging. Because Animating Democracy was designed as a collective learning effort, it hosted many gatherings of artists, cultural organization leaders, community partners, dialogue practitioners, and others involved in the projects to share their experiences and to benefit from mutual inquiry about challenges and successes. Participants were encouraged to reflect openly and critically about their efforts. In the spirit of experimentation and learning, what *didn't* work was welcomed as much as what did, and this approach is reflected in these findings.

These findings are grounded in practical applications of emerging principles in arts-based civic dialogue, and in practitioners' documentation of their efforts and outcomes. This information evolved over four years of conversation among Animating Democracy participants, including "project liaisons" who shadowed each project, asking questions and helping to draw out what artists, cultural organizers, and partners were experiencing. The authority of this book resides, therefore, not in any one point of view, or in an empirical study of a wide body of research, but rather in a deep look at the work through the many diverse voices that comprised the Animating Democracy cohort. What we believe has resulted is a deep and holistic look at the work of arts-based civic dialogue from many perspectives—new as well as affirmed knowledge drawn from rich practical experience.

We hope that artists, cultural organization leaders, scholars, and students who read *Civic Dialogue, Arts & Culture* will take away a deeper understanding of the philosophical, practical, and aesthetic dimensions of arts- and humanities-based civic dialogue work and the principles and best practices that underpin effective work. For civic and community development practitioners, in particular, the book offers a spectrum of examples of how arts and humanities can be tools for civic engagement. It illustrates how arts, cultural, and history organizations can be strong partners in fostering productive dialogue and engagement, and it provides insights into how to work with artists and cultural organizations toward common civic goals.

Part I, "The Intersection of Arts and Civic Dialogue," describes the context for Animating Democracy—the impetus behind it, the tradition of artistic practices that link art and civic issues, and Animating Democracy's evolving definition of "arts-based civic dialogue." The projects supported by Animating Democracy and referenced throughout the book are summarized in this section. Patricia Romney's essay, "The Art of Dialogue," concludes this section. She reviews the ideas of selected historic and contemporary philosophers and dialogue theorists and considers the implications of their ideas for arts-based civic dialogue practice.

In Parts 2 through 4, findings illuminate the civic, artistic, and institutional dimensions of this work. In "Seeking an American Identity (Working Inward from the Margins)," an essay that follows the section on "Artistic Practice," artist Suzanne Lacy offers a "democratic rumination" on questions raised by artists and other participants in Animating Democracy, providing historical context for, and pursuing a host of questions about, "civic discourse art." Michael Marsicano's essay, "It's the Art, Stupid!" which follows the "Institutional Practice" section, conveys the story of one community whose cultural institutions responded to intolerance of homosexuality and galvanized a community to think and talk in new ways about its core values. Part 5 provides insights into two arenas of activity that factored prominently in projects supported by Animating Democracy—youth-centered arts-based civic dialogue work and history as a catalyst for civic dialogue.

This book comes at a time when artists and cultural organizations are bringing their creative energies to bear in encouraging and facilitating greater civic participation in issues that affect communities, the nation, and the world. In this moment, too, there is growing interest among civic leaders, community developers, and the dialogue field in the arts as civic agents. They are seeing the potency of arts and humanities to engage people in new ways in civic dialogue. We hope *Civic Dialogue, Arts & Culture* will prove to be a timely resource, as well as an enduring one that informs continued vital work in civically engaged art in communities across the United States.

Acknowledgments

IT HAS BEEN A PRIVILEGE to support and learn from the many projects that have been part of Animating Democracy. We thank all Animating Democracy participants whose work is the basis for these findings. With intelligence and candor, they shared insights and learning in deep and generous ways, including doubts and stumbles, as well as sure steps and strides forward. We appreciate their commitment to the educational value of the work as well as its impact in their own communities. This report draws substantially on reports, case studies, and other materials written by project leaders. We're grateful for this wealth of documentation from which to develop these findings. In addition, the artistic work that has been at the center of their efforts has been immensely rewarding to experience, as well as a contribution to the field.

Animating Democracy was guided by a core team of field leaders. Their national perspectives, experience across artistic disciplines and in art and civic dialogue, and their collegiality were profoundly important to the success of the initiative. We warmly thank our project and dialogue liaisons, many of whose writings are incorporated into these findings: Caron Atlas, Kim Chan, Kathie deNobriga, Abel Lopez, Jeanne Pearlman, Patricia Romney, Wayne Winborne, Sue Wood, and Cheryl Yuen. We recognize especially the above-and-beyond ways that Caron, Sue, Wayne, and Abel contributed to the program's development and special activities. In addition, we thank many national advisors for their support, knowledge, and lively contributions to the program and explorations along the way: Jennifer Dowley, Sondra Farganis, Amalia Mesa-Bains, Martha McCoy, Maggie Herzig, Jan Cohen-Cruz, and Ann Daly.

Essays by Suzanne Lacy and Patricia Romney included in this volume have been anchoring reference points for us throughout the initiative. Our special thanks to both authors for these pieces, which are both grounding and advancing in their ideas about the intersection of art and civic dialogue. And thank you to Michael Marsicano and Grantmakers in the Arts for permission to include Michael's inspirational essay about a whole cultural community's engagement in civic concerns in Charlotte, NC.

Many have contributed to the content and form of this book. We thank our manuscript readers whose investment and thoughtful feedback enormously improved and clarified the text: Sandy Agustin, Andrea Assaf, Brent Hasty, Caron Atlas, Tom Borrup, Maggie Herzig,

Leslie Ito, Julie Numbers-Smith, Liz Sevcenko, Lynn Stern, and Monica Williams. Gayle Stamler's skillful and intelligent hand at editing truly transformed an unwieldy body of material into a coherent and engaging read and made the process enjoyable. We are grateful to Kirsten Hilgeford and Susan Gillespie, editors with Americans for the Arts, for their expert proofreading, additional editorial work, and for overseeing the production process. Our special thanks are extended to studio e$_2$ for book design that captures so beautifully and functionally the intent and spirit of the publication. The many hours and hard work of all of these individuals has paid off in a resource for the field that we are very proud of.

Thanks to all our colleagues at Americans for the Arts who have offered their ideas and support to Animating Democracy's efforts and to this book in particular. We thank Bob Lynch, president and CEO, for his consistent support and guidance, whose leadership and vision were key to conceiving and forging this joint program with the Ford Foundation. We also thank Nina Ozlu for her early efforts with Bob and the Ford Foundation to establish Animating Democracy; Pat Williams and Mara Walker for their valued guidance and support; Brent Stanley, Kim Hedges, Randy Cohen, and Marc Tobias for their own and their departments' many contributions; project associates Melissa Palarea and Carrie Gloudemans; and to all who helped within the Meetings and Events, Web and Technology, Research and Information, Field Services and Planning, External Relations, Operations, Finance, and Government and Public Affairs departments. Finally, our heartfelt thanks go to Animating Democracy staff members. Andrea Assaf's artistic and intellectual foundations have lent deep understanding and integrity to Animating Democracy's work; we thank her for her writing and the ideas contributed to this book. And we thank Michael del Vecchio for his insights at every point and level of inquiry and analysis of content, superb organization, and critical contributions to all phases of this book's development. They have been integral to these findings and to Animating Democracy's work as a whole.

The Ford Foundation demonstrated great vision and vital support in its investment in Animating Democracy. We would like to thank all those at Ford who have guided and supported our efforts at every point over the span of the initiative, especially Christine Vincent, Animating Democracy's co-conceiver, Lynn Stern who during her time at Ford and afterwards has advised in many important ways, current Arts and Culture Program Officer Roberta Uno, and Dave Mazzoli for his continued assistance and support throughout. We also thank Margaret Wilkerson, Alison Bernstein, and Susan Berresford for their commitment to support the intersection of art and civic interests through Animating Democracy. Without the Ford Foundation's vision and support, Animating Democracy would not have been possible.

Barbara Schaffer Bacon and Pam Korza
Co-directors, Animating Democracy

1

The Intersection of
Arts and Civic Dialogue

The Power of
Arts-based Civic Dialogue

*Begin with art, because art tries to take us outside ourselves. It is a matter of trying
to create an atmosphere and context so conversation can flow back and forth and we
can be influenced by each other.*

—*W.E.B. DuBois*

Open and meaningful public dialogue is a critical means to any and all democratic ends. In
the myriad and interrelated dimensions of civic life—social, cultural, political—the flow of
conversation back and forth is essential to understanding, decision-making, and account-
ability. Historically, the arts have called up a sense of humanity to deepen understanding
of persistently problematic social issues of race, economic inequity, and identity. Many
individual works of art, past and present, as well as broader cultural movements, have
contributed to or engendered significant public discourse on issues of consequence, such
as race, war, class, the environment, AIDS, globalization, and more. Nonetheless, Martha
McCoy, who heads the Study Circles Resource Center, a national organization devoted to
communitywide dialogue on a range of contemporary issues, observed that "the arts world
is rarely mentioned in the world of civic engagement. That can and should change."

[1] Animating Democracy was launched in 1996, following the completion of a study conducted by Americans for the Arts and funded by the Ford Foundation. The study profiled a representative selection of artists and arts and cultural organizations whose work, through its aesthetics and processes, engages the public in dialogue on key issues. This resulting report, *Animating Democracy: The Artistic Imagination as a Force in Civic Dialogue* (1999), maps activity during the last couple decades, identifies issues and trends, and suggests opportunities for leaders in the arts field, policymakers, and funders to work together to strengthen activity in this lively arena. The study reveals pivotal and innovative roles that the arts can play in the renewal of civic dialogue, as well as challenges faced by arts and cultural organizations as they engage in this work.

Americans for the Arts created Animating Democracy with support from the Ford Foundation.[1] It was grounded in three connected ideas: Art is vital to society; civic dialogue is vital to democracy; and both create unique opportunities for understanding and exchange. Beyond what is commonly known as the potential of art to stimulate spontaneous and incidental conversation, Animating Democracy set out to nurture artistic work that was intentional in its civic goals, deliberate in planning civic dialogue activity, and conscious of the role that the art could play in generating dialogue.

Animating Democracy recognized that, beyond the basic role of producer, presenter, or exhibitor, arts and cultural institutions are making significant civic contributions as catalysts, conveners, or forums for civic dialogue. In exercising this civic role, they are expanding opportunities for both democratic participation and aesthetic experience, and engaging a broader, more diverse public in giving voice to critical issues of our time.

The arena of practice that Animating Democracy has termed "arts-based civic dialogue" is not new, nor is it in itself a movement. Rather, arts-based civic dialogue is part of a continuum of community-based practice and civically engaged cultural work. Dialogue or dialogic processes have been integral to the creative work of pioneering community-based artists such as Liz Lerman, Judy Baca, John O'Neal, Cornerstone Theater Company, Marty Pottenger, and Urban Bush Women (all participants in Animating Democracy), to name only a few.

For example, Judy Baca's work with communities in Los Angeles to create murals reflective of the city's untold histories is grounded in a process that combines dialogue among local residents with historical research. Baca creates pedagogical structures within her artworks that merge education, civic dialogue, and activism through mural-making.

Art expresses difficult ideas through metaphor, beyond the limits of language. *Art is a powerful f* difficult ideas through metaphor. *Art creates in* limits of language. *Art is a powerful force for illumi* Art expresses difficult ideas through metaphor, beyond the limits of language. *Art is a pou*

Concerned with persistent issues of civil rights and racial inequality in America since his involvement in the civil rights movement, John O'Neal uses story and theater to inspire and motivate social action. He believes that, "In telling our stories, we identify what is important to us. By listening to the stories of others, we find out what is important to them; and by listening and telling together, we have the possibility of creating a clearer sense of what our community is and what our collective priorities are…we can take those stories and help craft our way to the future."

These artists and others involve community members in defining and executing, to varying degrees, the content and form of their work. Many, including Suzanne Lacy and other "new genre public artists," view the public process inherent in their work, which includes dialogue, as an aesthetic dimension of making art.[2]

[2] In her seminal book *Mapping the Terrain: New Genre Public Art,* Lacy defines new genre public art. New genre public art—visual art that uses both traditional and non-traditional media to communicate and interact with a broad and diversified audience about issues directly relevant to their lives—is based on engagement.

Learning from the innovative work of such artists, cultural institutions have increasingly explored their civic roles through initiatives such as the Museums and Communities program of the American Association of Museums, or through funding programs like the Rockefeller Foundation's PACT (Partnerships Affirming Community Transformation) and the Association of Performing Arts Presenters' Arts Partners Program, supported by the Lila Wallace Readers Digest Fund and the Doris Duke Charitable Foundation.

[3] The 35 projects supported by Animating Democracy are summarized in this section. Full case studies can be found on projects on the Animating Democracy website and in the companion publications, listed in the back of this book.

Whether dialogue is embedded in art or cultural practice, or planned in conjunction with arts events, or both, Animating Democracy projects have demonstrated the potency of the arts and humanities to illuminate civic issues in their communities.[3] Albeit in different ways, these projects show the value of:

*rt creates indelible images. Art communicates
e for illuminating civic experience. Art expresses
elible images. Art communicates beyond the
ting civic experience. Art creates indelible images.
rt creates indelible images. Art communicates
rful force for illuminating civic experience.*

Art as a **SPARK** for civic dialogue

Art can be the focal point that explores dimensions of a civic issue, the questions surrounding it, and multiple or alternative perspectives on it.

Art as an **INVITATION** to participate

Art can bring forward the voices of those often silenced or left out of public discourse. It can bring together groups of people with divergent viewpoints who might not readily agree to talk or work together in other settings.

Art as **SPACE** for civic dialogue

In addition to offering a physical setting, the arts and humanities can offer psychological, experiential, and intellectual space conducive to reflection and discussion. Art taps and validates emotions in civic dialogue, giving permission for emotion to exist in public space. It can create empathy among participants, helping people suspend judgment and hear each other in new ways.

Art as a **FORM** of dialogue

Art provides an alternative form of dialogue. Dance, poetry, theater, performance art, and other forms, when they embody dialogue in their structure or processes, may carry meaning and communicate beyond the limits of conventional language.

At an Animating Democracy gathering, Grace Lee Boggs—a Detroit-based activist, cultural worker, and octogenarian—observed the dire need to reinvigorate the human connection, the sense of caring, and the willingness to participate in civic life that underpins a healthy democracy. She observed, "Americans have become increasingly self-centered and material-

istic, more concerned with our possessions and individual careers than with the state of our neighborhoods, cities, country, and planet, closing our eyes and hearts to the many forms of violence that have been exploding in our inner cities and in powder kegs all over the rest of the world— both because the problems have seemed so insurmountable and because just struggling for our own survival has consumed so much of our time and energy…Politics as usual, debate and argument, even voting, are no longer sufficient." And she implored, "Can we create a new paradigm of our selfhood and our nationhood?"[4]

4 Grace Lee Boggs, "These are the times that grow our souls," Keynote presentation at Animating Democracy's National Exchange on Art and Civic Dialogue, October 2003, Flint MI. www.AmericansForTheArts.org/ AnimatingDemocracy

Artists, cultural organizations, and their community partners are helping to shape a new paradigm of civic participation by tapping the power of the arts and humanities. In a society compelled to act quickly and "solve the problem," dialogue is an increasingly critical dimension of public process. Animating Democracy projects demonstrated that arts-based civic dialogue efforts can act as a counterbalance, allowing time to reflect on the issue and understand it fully first, before moving to solutions. The arts and humanities can broaden citizens' voices and participation, offering a welcoming entry point to those who have not felt access to the civic realm before. Arts-based civic dialogue can create an environment and a new context for civic leaders to connect with citizens about issues in their communities, informing leaders at new levels about the issues. The arts can enhance the quality and capacity for dialogue—offering new ways of looking at issues that move people to deeper exploration, and shifting contentious public debate to a more open and receptive space for listening, expressing, and truly hearing alternative views. With greater awareness and understanding of issues, arts-based civic dialogue may bring about shifts in thinking and attitude. With a greater sense of self and collective efficacy, people may even be moved to action. Evident in all of these possibilities is the power of the arts and humanities to animate democracy.

Art creates indelible images. Art communicates
rful force for illuminating civic experience.
rt creates indelible images. Art communicates
e for illuminating civic experience. Art expresses
e images. Art is a powerful force for illuminating
ommunicates beyond the limits of language.

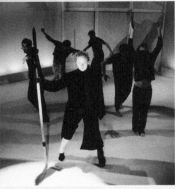

Projects in Animating Democracy

A nimating Democracy sought *to foster artistic activity that encourages civic dialogue on important contemporary issues.* With the Ford Foundation's investment, it aimed to achieve five goals:

- To advance aesthetic and programmatic experimentation and innovation;
- To strengthen the role and organizational capacity of arts and cultural institutions;
- To build the body of knowledge about this work and increase access to information and resources for arts and civic dialogue fields;
- To increase understanding and exchange across artistic disciplines and with civic dialogue leaders about the philosophical, aesthetic, and practical aspects of arts-based civic dialogue; and
- To increase public understanding of the role of artists and arts and cultural institutions in civic life.

Animating Democracy employed an integrated set of activities, including an informational website, publications, field convenings, and—at the center of the initiative—the Animating Democracy Lab. The Lab provided grants and advisory support to 35 cultural organizations across the country for projects that experimented with or deepened existing approaches to arts- and humanities-based civic dialogue. From Anchorage, AK, to Miami; New York to Los Angeles; Portland, ME, to Kapa'au, HI, the projects encompassed a range of urban and rural communities, artistic and civic interests, and approaches to arts-based civic dialogue work. All types and sizes of cultural organizations were involved, including local arts agencies, community cultural centers, artist-driven organizations in the

visual and performing arts, presenters, contemporary art centers, statewide humanities commissions, a statewide arts education alliance, museums, orchestras, a church, and a folk arts organization. Projects were supported in visual arts, dance, music, theater, literature, media arts, public art, and the humanities, as well as interdisciplinary fields.

Lab projects focused on the creation, presentation, and/or exhibition of new work or enduring work of the past. They varied in emphasis: advancing artistic and humanistic practice in relation to civic dialogue; creating innovative approaches to dialogue; and/or employing strategies for building institutional capacity to successfully support art-based civic dialogue work.

Projects addressed longstanding and pervasive issues facing communities and the country, such as race relations, class, cultural identity, and growth and development, but also dealt with issues that commanded public attention in the late 90s and early years of the new millennium—human genomics; religious intolerance; school violence; the rights of same-sex couples; and the influx of immigrants, exiles, and refugees to every part of the country.

Most projects focused locally. Several of them grappled with land development concerns, including gentrification, waterfront enhancements, casinos, and urban-to-rural sprawl and their effects on populations, the environment, and quality of life. Two communities addressed issues of trust in elected officials and the effectiveness of their leadership, bringing to the surface much larger and long-standing divisions between neighboring communities.

Issues of race were at the center of eight local and national projects (a quarter of the projects). The legacy of slavery in America framed issues of white privilege, reparations, marginalization, and intergroup relations. Civil rights motivated several projects that dealt with racial profiling and ongoing struggles for equality and justice. Demographic shifts and the implications of the resulting hybridization of cultures were the focus of other projects.

In some projects, cultural concerns emerged as civic concerns. Communities explored cultural democracy (the rights of all cultures and peoples to define, sustain, and perpetuate their own cultures); cultural preservation (identity, traditions, and heritage sites); cultural representation (authentic and self-determined representation in such public arenas as tourism); and cultural equity (access to funding and other resources that can help cultures thrive).

These projects are the basis for this volume. The participants' deep reflection about linking civic dialogue and the arts and humanities formed a true "laboratory" for better understanding the principles and practices of the work, the underlying philosophy and theory, and just what difference art can make in engaging people in more meaningful civic dialogue. We hope that this book will advance field knowledge about the philosophical, practical, and social dimensions of this work.

American Composers Orchestra—New York

COMING TO AMERICA: IMMIGRANT SOUNDS/IMMIGRANT VOICES

In *Coming to America: Immigrant Sounds/ Immigrant Voices,* the American Composers Orchestra (ACO) sought to link the music of four immigrant and refugee composers to questions central to immigration and cultural adaptation in American society. Spanning ACO's 2000–2001 season, the project brought immigrant and refugee composers and their music into nontraditional settings such as the New York Historical Society, the Japan Society, Hostos Community College, and The Henry Street Settlement. It also brought immigrant and refugee community members into concert settings such as Carnegie Hall. School-based programs were held at the High School for Environmental Studies in Manhattan and the Newcomers High School in Queens. Because the concept of civic dialogue was a practice new to

the orchestra, ACO engaged a dialogue specialist to help execute the project, with particular emphasis on introducing dialogue techniques for adapting pre- and post-concert talks, "informances" (informal performance/discussions), in-school activities, and presentations within partner institutions. The project helped ACO to examine its mission and role within the civic sphere; open up its notions of what constitutes civic dialogue, including the personal dimensions of civic issues; and understand how civic dialogue goals require a different sort of partnership. *Coming to America* investigated opportunities to apply arts-based civic dialogue principles to orchestra education and outreach programs and contributed to the knowledge and practice of arts-based civic dialogue in the concert music field.

Boise City Arts Commission—Boise, ID

CIVIC DIALOGUE IN THE ARTS: DIVERSITY AND ACCESS

The Boise City Arts Commission (BCAC) presented a three-day Urban Bush Women (UBW) residency, drawing upon UBW's *Hair Parties Project,* to explore diversity issues through dialogue and dance. A Hair Party is a hybrid art-dialogue experience that combines excerpts from the dance-theater performance work *HairStories* with dialogue to explore the politics of hair and to re-examine closely held beliefs about race, class, and gender. The event was co-sponsored by Boise State University as part of its 2002 Human Rights Celebration.

The genesis for the project was the growing realization that the constituents of the Boise City Arts Commission—artists and art organizations—had a limited understanding of issues of access and diversity. This was reflected in their responses to the City Arts Fund subgrant program about access and community involvement. The program works to help arts constituents develop a better understanding of access and diversity when planning their projects and seasons and when applying for funding. On another level, the BCAC also came to understand that music, theater, and dance compa-

nies were experiencing disheartening challenges when attempting to recruit and retain artists of color. The commission hoped that civic dialogue about access and diversity would stimulate a more proactive and involved arts community.

Residency activities included two Hair Parties and diversity training sessions. An all-day session for staff and board members of the BCAC and Boise arts organizations featured diversity trainer Sam Byrd in the morning and the UBW Hair Party in the afternoon, with a wrap-up panel and discussion on the issues and possible action steps. After the residency was complete, the BCAC created a civic dialogue committee to change how the arts community manages issues of access and diversity. With support from the Idaho Commission on the Arts, the BCAC collaborated with the McCall Arts & Humanities Council to develop a new project called *Building Community Bridges.* In May 2003, the BCAC developed *Portals/Portales,* an arts-based civic dialogue project exploring the experience of being a Latino or Hispanic person in the Boise community.

Brooklyn Philharmonic Orchestra— Brooklyn, NY

KLINGHOFFER DIALOGUE PROJECT

In 2003, the Brooklyn Philharmonic Orchestra (BPO) partnered with The Dialogue Project, which had been facilitating Arab-Jewish dialogues for some time in Brooklyn, to organize the *Klinghoffer Dialogue Project*. Partners felt that the addition of relevant artistic experience would enhance the ongoing dialogue. Through a series of dialogues set around a reprise performance of *The Death of Klinghoffer,* BPO engaged Brooklyn residents in dialogue on the effects of Israeli-Palestinian tensions on their community. *The Death of Klinghoffer,* an opera by John Adams and Alice Goodman, is about the 1985 commandeering of the Italian cruise liner the *Achille Lauro* by Palestinian hijackers, and the murder of a wheelchair-bound American Jew. The *Klinghoffer Dialogue Project* used the opera as a platform for dialogue on issues of identity, nationalism, and the roots of violence. The philharmonic also intended to build capacity and experience for incorporating dialogue into future projects.

Three dialogues held in advance of the production were designed to provide a safe facilitated opportunity for 30 participants to constructively explore the issues. Each dialogue focused on one aspect of the production—libretto, music, and staging—in order to inform the dialogue with understanding of the opera. Three days after seeing the performance, a final dialogue focused on reactions to the production itself. In general, participants felt that dialogues provided an education about the opera and an opportunity to express basic concerns. There was minimal participation by the Arab or Palestinian people. For the future, organizers recognized the importance of both creating an advisory committee to link directly with these communities and presenting a theatrical work that reflects the interests of the Arab community. To incorporate arts-based civic dialogue into future activities, BPO is evaluating programmatic possibilities, such as exploring a constant theme over multiple years or focusing on themes of interest to different communities.

CEC International Partners/
Artslink—New York

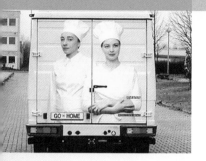

go_HOME was a collaborative, international artist residency involving two artists of different ethnic and religious backgrounds: Danica Dakic from Bosnia and Hersegovina and Sandra Sterle from Croatia. Based on conceptual art, the project explored issues of physical, psychological, and cultural dislocation for immigrants and exiles and the changing meaning of "home." Through CEC's Artslink cultural exchange program, the artists set up a temporary home in New York City where they created artwork intended to stimulate dialogue— local and global, real and virtual. Dialogue occurred at four monthly dinners hosted by the artists and focused on topics such as the "Architecture of Migration," dealing with the physicality of the how displacement and exile are expressed, and "Women Who Move Too Much," which explored the impact of gender-based roles in the conceptual framework of displacement. Dinner guests included artists, academics, and representatives of immigrant service organizations, some of whom were themselves immigrants and exiles.

The dinners were broadcast to other sites and gatherings throughout Europe using live-streaming technology to achieve an encounter that could be both intimate and global. The artists' photographic artwork and "virtual diary," along with images and transcripts of the dinners, became the foundation for a website that chronicled and disseminated the ideas and aimed to stimulate virtual discourse on the project and issues.

Dakic and Sterle established a living work of art, experienced by its participants rather than observed by passive, disengaged viewers. In the tradition of Joseph Beuys's "social sculpture," the artists enacted a seamless art/life continuum that by its very nature functions as dialogue. The September 11 attack on the World Trade Center, which occurred just blocks from the artists' shared apartment and only days after their arrival from Europe, had a significant impact on the *go_HOME* project, altering the context in which the work took place and causing one of the artists to relocate to Brooklyn.

Center for Cultural Exchange—Portland, ME

AFRICAN IN MAINE

A continuation of the Center for Cultural Exchange's ongoing work, *African in Maine* assisted three African communities new to the city of Portland—Sudanese, Congolese, and Somali—in developing cultural programming that would represent their respective cultures and people. Each of the three African communities took a different, self-determined path to plan and implement their events, with the Center helping to facilitate dialogue. Dialogue occurred first within each group, as community members decided on and planned their cultural events. These often-difficult dialogues helped bridge fractious divisions within each African community group and enabled them to negotiate what and how each would represent its culture to itself and to others outside the group. The Congolese produced three events featuring Congolese music, fashion, arts, and food; the Somalis held a Muslim celebration of Eid el Fitr with a performance by the contemporary Shego Band; and the Sudanese developed a festival featuring dancers, singers, wrestlers, poets, lecturers, and speakers, plus a huge feast.

The project aimed to address how cultural representation (or misrepresentation) can affect public perception of refugee communities. It also aimed to build broader awareness of the diversity of these newcomer African communities, and the conflicts that they face. The cultural events did indeed bring members of each African community together and drew audiences from the community of "traditional Mainers," who left the productions more informed about the history, culture, and politics of their new neighbors.

African in Maine challenged the concept and illuminated the realities of "dialogue" within and between cultures, including divided immigrant and refugee communities. It deepened understanding of the significant internal differences that exist within each African national group—tribal, generational, religious, immigrant/refugee, and gender—and how these differences need to be taken into account. It illuminated language and cultural differences between the Center's predominantly white U.S. staff members and the immigrant groups and examined the role of an "outsider" cultural organization in fostering cultural democracy.

Children's Theatre Company—Minneapolis

LAND BRIDGE PROJECT

The Minnesota farming community is deeply divided between farmers struggling to maintain family farms with sustainable agriculture and farmers who contract with agribusinesses to make a living. Related tensions exist between farmers and banks, legislators and rural activists, and among neighbors. The *Land Bridge Project,* which Children's Theatre Company (CTC) developed and implemented in collaboration with the Perpich Center for Arts Education, was anchored in rural Montevideo and urban Minneapolis. It sought to engage rural and urban residents in theater activity to discuss and understand the various dimensions of the modern-day farm crisis. Perpich Center theater educators Tory Peterson and Diane Aldis and CTC company members conducted theater workshops in Montevideo with farmers, their families, teachers, and students to gather stories and explore the issue. A new work, *Stories from Montevideo,* was developed through interviews and a dialogue process conducted by guest artist Rebecca Brown and CTC apprentices. Performed five times in both Montevideo and Minneapolis, *Stories from Montevideo* brought together urban and rural adults and young people to see the play

and to engage in facilitated dialogues. People on both sides of the issues, who formerly didn't speak with one another, found a way to do so through the shared experience of seeing a performance that addressed their day-to-day concerns. Beyond the farm crisis, dialogue broadened to encompass persistent questions about the future of the small town. Will the young people growing up in rural communities stay? Or will people in the cities choose to live a small-town life? Project organizers noted long after the play that informal dialogues continued in coffee shops, libraries, and homes as a result of this experience—evidence of a hunger for coming together for meaningful discussion.

The *Land Bridge Project* enabled Children's Theatre Company to experiment with new approaches to community-based work, work with civic intent, and move post-performance discussions from conventional Q & A sessions to issue-based dialogue. The project underscored for CTC the challenges within large institutions of authentically shifting to community-based work, including how to work in partnership and how to commit the staff resources and energy needed to do the work effectively.

City Lore—New York

THE POETRY DIALOGUES

The Poetry Dialogues was a series of intergenerational workshops, presentations, and community dialogues centered around contemporary and traditional poetry forms—including rap, slam poetry, spoken word, African *jali* (or *griot*) praise poetry, Muslim prayer-calling, and Filipino *balagtasan*—in which poets debated issues and challenged one another's positions. The project sought to help younger and older generations discover links between their poetry forms, to reenergize the artistry of these forms, and to encourage both generations to employ the power of their art in expanded ways toward engaging others in public dialogue.

City Lore created three intergenerational poetry teams, defined by identity and comprising elder master poets or "mentor poets" (Ishmaili Raishida, Amir Vahab, Frances Dominguez, and Kewulay Kamara), poet-facilitators (Suheir Hammad, Regie Cabico, and Toni Blackman), and young poets. Each of the teams explored the interrelationship of poetry forms, issues, and music through exercises and improvisations led by the poet-facilitators. Issues such as profiling in the Muslim community, perspectives within the black community about the ghetto, and differing values placed on college education within the Filipino community were deter-

mined by each cultural group. *The Poetry Dialogues* project explored dialogic poetry, the concept of poetry as dialogue, and the potential for poetry to contribute to broader civic dialogue. "Dialogue" occurred through the encounter of the elder and youth poets, and within the performance of the forms, especially *balagtasan* and hip-hop freestyling. Facilitated audience dialogues followed community presentations by the youth and elder poets.

The Poetry Dialogues demonstrated the potential of poetry to create indelible images, to extend the reach of language, and to express complex ideas and feelings through metaphor, making it a powerful force for illuminating community issues and concerns. Workshops created a safe space in which young poets could explore their identities, cultures, personal life experiences, and histories, as well as contemporary political situations. *The Poetry Dialogues* yielded many lessons for the continuation of the program about effective partnership, decision-making and power-sharing; intracommunity dialogue; and youth pedagogy models useful for dialogue. These led to further development of the model toward a next phase, with particular attention to establishing more explicit connections to civic concerns and policies.

Cornerstone Theater Company—Los Angeles
FAITH-BASED THEATER CYCLE

In its *Faith-Based Theater Cycle,* Cornerstone Theater Company created original, community-based plays in collaboration with specific faith-based institutions, as well as interfaith communities, to explore how faith both unites and divides American society. For a company whose work is based on tolerance and inclusion, this project sparked a difficult, internal company dialogue about faith and homosexuality and the challenging question it raised: "When does tolerance lead to a betrayal of one's beliefs?" This "epic" project provided an opportunity for Cornerstone, in partnership with the National Conference for Community and Justice (NCCJ), Los Angeles region, to engage multiple communities around this powerful and often challenging theme, as well as to work in depth, over time, and toward cumulative impact.

The five-year cycle began in 2001 with the Festival of Faith—21 short plays at five religious venues—at which Cornerstone and NCCJ experimented with different dialogue activities to encourage reflection on issues in the plays. A series of multiweek dialogues called Weekly Wednesdays followed the festival, exploring themes of ritual, belief, and social justice. Cornerstone created *Zones*—part play, part community conversation—in which characters confronted the challenges of living in a religiously pluralistic city and audience members were encouraged to do the same with each other as part of the play. The *Faith-Based Theater Cycle*

included additional community collaborations in which dialogue, in the form of community story circles, contributed to the development of plays exploring issues of Catholic immigrants; the relationship of African American clergy with African American people infected with or affected by HIV/AIDS; and faith and sexuality. A bridge show held in 2005 was informed by each of the community collaborations and brought together participants from each of the faith-based residencies.

The public embraced the theme of faith, as evidenced by sold-out shows and participation in dialogue. For Cornerstone, the collaboration with NCCJ resulted in new approaches to dialogue at performances, in addition to furthering its community collaboration methodology; for NCCJ, the collaboration expanded its capacity to use theater and creative activity in dialogue work. The *Faith-Based Theater Cycle* revealed the tensions between the trust needed for good dialogue and the risk-taking needed for good art, and also raised key questions about arts-based civic dialogue such as: What is the relationship between risk-taking and art in a project where participants have such a deep stake? How does abstract and evocative art sometimes evoke deeper insights than a literal message? Is depth only about inquiry and questioning—what is it for people who are firmly rooted in their beliefs? What is the role of humor?

Council for the Arts of Greater Lima—Lima, OH

ALLEN COUNTY COMMON THREADS THEATER PROJECT

In Ohio's Allen County, issues of race, leadership, and water resources have divided city and county officials and residents. Lima, the county's largest city, suffered from loss of industrial jobs, a declining tax base, shrinking population, and downtown and neighborhood decay. In the suburbs and rural farmlands, county residents mistrust city officials who control needed water resources and who have made moves toward annexing the county in order to revitalize the city. Issues of race have persisted over many years between the largely white rural and suburban population in the county and the significant African American population in the city itself.

The *Allen County Common Threads Theater Project* sought to address these issues. Building upon a successful 2000 event called *Common Threads* (which itself was based on a European community arts model), the Arts Council of Greater Lima, Bluffton College, and a steering committee of interested citizens set out to develop a second *Common Threads* endeavor. The goal was to engage a large cross section of both city and county residents and leaders in dialogue about issues of "trust among leaders" and "respecting differences." Over 14 months, company members

from Sojourn Theatre met and interviewed 400 residents. Their words and perspectives fueled Artistic Director Michael Rohd's script for the "poetic documentary" play, *Passing Glances: Mirrors and Windows in Allen County*. The company's dialogic research and creative development approach afforded an opportunity for diverse voices to be heard, and built a foundation of trust and honesty for the project.

Dialogue consultant Patricia Romney trained 40 local residents to design and facilitate community dialogues in relation to script readings and later after public performances. They designed a culminating *Common Threads* conference where more than 200 citizens saw the play, discussed the issues, and formed action teams to address them. *Common Threads* action teams have made strides to improve relationships among city and county elected officials and have linked with the Chamber of Commerce to propose a citizen's long-range community plan. The *Common Threads* dialogue process continues to be used in school and community settings supported by a cadre of trained dialogue facilitators. The arts are perceived by more people in the community as a way to address community issues.

Dell'Arte International—Blue Lake, CA
THE DENTALIUM PROJECT

Dell'Arte conceived *The Dentalium Project* in 2001 when the Blue Lake Rancheria, a sovereign nation that abuts the small northern California city of Blue Lake, built a casino to secure its financial future. Although the Rancheria pledged significant support to the surrounding community, many Blue Lake residents took a dim view of the casino, fearing an increase in traffic, crime, and noise—and, most critically, a loss of power and control over their own destiny. Dell'Arte believed that, by employing its distinct aesthetic of commedia dell'arte, and by giving people from both communities a chance to talk with one another about their fears and visions for the future of their place, *The Dentalium Project* could begin to build bridges toward a healthier whole community.

The project began with 40 interviews with a wide variety of residents and five community dialogues facilitated by the local Cascadia Foundation that brought together residents of the city of Blue Lake and the Rancheria. The dialogues were a chance for people to sit and talk about the present and future of their community without a pressured agenda. For many, it was the first time they had sat down together to talk, to listen, and to learn from each other. Inspired by the issues that emerged from the interviews and dialogues— namely a history of bad blood between the city and Rancheria governments and city leadership's lack of proactive steps to make positive change— Dell'Arte created *Wild Card,* a live radio play with music set in a future following a decade of changes sparked by the casino's opening. In addition, a documentary video capturing public perspectives interspersed with excerpts of the play was shown in the community, stimulating further dialogue.

According to the Rancheria chairwoman, Arla Ramsey, the "dialogues had given the Rancheria the opportunity to present its case…in a spirit of goodwill and cooperation." Directly motivated by the play, two people ran for Blue Lake City Council. One was elected and created a formal liaison role to increase regular communication between the governments of the Rancheria and Blue Lake. Through the project, the company built on its commitment to creating "theater of place": work for, about, and with its own community.

The Esperanza
Peace and Justice Center—San Antonio
ARTE ES VIDA

Arte es Vida is an ongoing program of The Esperanza Peace and Justice Center in San Antonio. Supported by Animating Democracy from 2001 to 2003, *Arte es Vida* addresses issues of cultural equity and democracy and examines "the role of artistic and cultural expression in a society that inherits the deep wounds, economic and political disparities, and continuing practices of injustice that are the legacy of cultural domination in the United States." The program explores the concept of *cultural grounding*—the idea that a strong sense of selfhood and identity, rooted in creative expression and cultural practice, is necessary to empower marginalized communities and individuals to participate actively in public dialogue and civic life. In addition to recovering histories and cultural traditions, the Esperanza uses art to help communities envision alternatives and futures.

Four areas were the focus during Animating Democracy: (1) community visions of labor leader Emma Tenayuca; (2) the effort to preserve the La Gloria Building and other cultural landmarks in Chicano and Mexicano neighborhoods; (3) conflict of values within San Antonio's Westside community; and (4) historical conflicts between Chicanos and Mexicanos in San Antonio. In relation to these civic concerns, the Esperanza orchestrated a wide range of cultural events, art presentations, and artmaking opportunities set in community spaces, parks, outside City Hall, and in its own facility. In conjunction with these, the Esperanza hosted *pláticas* (informal conversations) facilitated by *animadoras* (trained Esperanza staff, artists, and community members). Formats used by the Esperanza Center range from large-scale public dialogues, to interpersonal dialogue on civic issues in public space, to ongoing small group community dialogues, to consensus-building among coalition partners, to widespread community engagement in civic discourse. Many of these formats are art-based or incorporate various art and cultural activities to empower community voice or stimulate discussion.

The Esperanza's efforts illuminate the role of arts-based civic dialogue work in a cultural organization oriented toward civic action and activism. *Arte es Vida* examines ways to reduce barriers that discourage civic participation by marginalized people, including the value of intragroup dialogue within Chicano/a and Mexicano/a communities, the involvement of community people as facilitators, and sensitivity to cultural values and norms that contribute to successful dialogue.

Flint Youth Theatre—Flint, MI

...MY SOUL TO TAKE

When Flint Youth Theatre began planning for a new play addressing the local and national problem of school violence, it had no idea that in the process of developing the project its own community would experience a devastating elementary school shooting. A year after the tragedy, the play...*My Soul to Take,* written by artistic director and playwright William Ward, became a focal point for fresh attention on this persistent and painful issue. The play, stylistically atypical of most youth theater in its nonlinear, collage style and its treatment of the subject, captured a swirl of opinions surrounding the shooting. The play's central metaphor, the Pied Piper, and the question "Can't somebody do something?" (implored by children throughout the play), became a call to reinvigorate community dialogue and move toward action on this pressing issue.

Over several months, ...*My Soul to Take* served as the backdrop for a diverse set of dialogue opportunities organized by Flint Youth Theatre and collaborating organizations concerned with education, neighborhood crime prevention, and community issues. These dialogue opportunities aimed to

coalesce fragmented efforts to address school violence. More than 100 community members met in small study circle groups over several weeks to consider causes and effects of school violence, and options for action. Young people explored dimensions of the issue through participation in process drama workshops, facilitated by artist Gillian Eaton, and through curriculum-based efforts related to their experience of the play. Dialogue was also integral to the process of creating the play; the script was inspired by the words and views of actual participants in the process drama workshops. With local partners and educators, dialogue was planned and facilitated in conjunction with the play.

Participants in Flint Youth Theatre's study circles dialogues came to a new understanding of the causes and effects of youth violence and defined actions they could take individually and collectively to stem school violence. The project also coalesced the previously fragmented efforts of community organizations that worked in partnership with the theater.

Hawai'i Alliance for Arts Education—North Kohala, HI

THE KING KAMEHAMEHA I STATUE CONSERVATION PROJECT

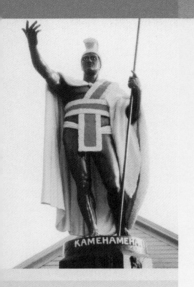

On the island of Hawai'i, residents of the rural region of Kohala deliberated how best to restore a statue of King Kamehameha I, a hero revered as the indigenous unifier of the Hawai'ian islands and native son to Kohala. Should the statue be restored to the mainland artist's original intent of a gold and bronze finish, or should it be repainted in life-like colors, thereby continuing a longstanding community tradition? Through the respectful collaboration of conservator Glenn Wharton, the Hawai'i Alliance for Arts Education, and Kohala community leaders and cultural practitioners such as Raylene Lancaster, a multiplicity of gatherings and activities were designed to engage local residents in the decision-making process. Drawing from both indigenous Hawai'ian and Euro-American traditions of community engagement and public discourse, activities included *hula ki'i* (image dance puppetry), "talk story," consultation with *kupuna* (elders), a high school debate with public forum, and an opinion ballot. Through these activities, people eventually reached the consensus to continue the community's practice of painting the statue.

Exploring the question of whether to paint or gild the statue deepened understanding of Hawai'ian history and connection to cultural identity and traditions. The links between cultural identity, heritage preservation, and current issues of land and economic development became even clearer. The project fostered a heightened sense of responsibility toward the statue, which has, in turn, helped people to see their role in larger issues of cultural preservation facing Kohala. Native and long-term residents who previously would not have come forward felt welcomed into the public process because the statue and traditional cultural programs provided a comfortable and respectful forum. Many of these Kohalans were empowered to engage in discussions for the new general plan for the county.

Henry Art Gallery—Seattle
GENE(SIS): CONTEMPORARY ART EXPLORES HUMAN GENOMICS

In April 2002, on the heels of the Human Genome Project's historic announcement about the completion of a human genome "rough draft," Seattle's Henry Art Gallery opened *Gene(sis): Contemporary Art Explores Human Genomics.* The exhibition brought together more than 50 recent and new artworks representing artists' imaginings of the social, ethical, and economic ramifications of genetic and genome research, including three new commissioned works by artists Shawn Brixey, Jill Reynolds, and Paul Vanouse to be developed in collaboration with experts from various scientific fields.

To spur dialogue about the provocative and potentially polarizing issues, the Henry engaged a wide range of cultural, humanities, and scientific partner organizations, resulting in a cross-disciplinary array of public programs in conjunction with its exhibition. Through its network of more than 150 book groups, the Seattle Public Library's Washington Center for the Book organized reading groups around relevant books such as *Frankenstein* by Mary Shelley and *Mendel's Dwarf* by Simon Mawer. The University of Washington's Center for the Humanities mounted a two-day symposium

with *Gene(sis)* artists, scientists, scholars, and the public for presentations and discussions that explored the potential social and ethical impact of genetic research. Participants in a Genetics Task Force public meeting, including representatives from the biotech industry, toured the exhibition as part of the day's agenda—a rare example of injecting contemporary art into a public policy dialogue. The Henry itself developed special programs including a dialogic performance art presentation by the Critical Art Ensemble; an experiential, in-gallery, movement-based dialogue with Liz Lerman Dance Exchange; and extensive arts-based civic dialogue resources for teachers bringing school groups to the exhibition.

The project tapped the power of contemporary visual art to elucidate and provoke dialogue about new developments in the science of human genomics. Offering multiple entry points to the topic, *Gene(sis)* effectively engaged a large portion of the Seattle community in considering the significance of human genome research as an important topic of public conversation.

Intermedia Arts—Minneapolis

PEOPLE PLACES CONNECTIONS

As Minneapolis' Midtown Greenway development project threatened to displace new immigrants, artists, and other low-income residents, it generated fear and distrust of well-intentioned community development efforts, signaling the need for an innovative approach to bringing together the haves and have-nots. Intermedia Arts, a longstanding cultural center in this community, commissioned five Minnesota artists working in various disciplines (Marilyn Lindstrom, Victor Yepez, Wendy Morris, Ta-coumba Aiken, and Douglas Ewart) to collaborate with community-based organizations that regularly work with populations affected by the Greenway development. Artists were paired with particular groups—for example low-income youth and families, homeless youth, and recently acclimated Hmong women—to create art together and to talk about "the meaning of safety" within and across communities.

Intermedia Arts aimed to broaden civic participation in urban planning discussions and to promote equitable and culturally appropriate community development patterns in targeted neighborhoods. Within this artmaking-dialogue process, they invited people who typically felt disenfranchised from public processes to participate in a safe environment; these participants gained confidence in discussing issues of fear, displacement, and community design. Practices that proved most effective in generating meaningful conversation combined artmaking, written reflection, and one-on-one interviews. Certain partner organizations, such as Hope Community, developed a deeper commitment to incorporating art into their own community dialogue processes and forged a strong relationship with Intermedia Arts. *People Places Connections* also looked to institutionalize the role of artists and the creative process in city planning and community development. Evidence of success included an invitation by one Greenway planning entity for artists to present their creative work at a board meeting. Artists helped to shed light on possible uses for a building slated for demolition. Although the building was not saved, one artist was invited to be a member of the community advisory committee.

The Jewish Museum—New York

MIRRORING EVIL: NAZI IMAGERY/RECENT ART

In 2002, The Jewish Museum in New York City mounted the exhibition *Mirroring Evil: Nazi Imagery/Recent Art*. The exhibition featured artworks by 13 young artists who are two and three generations removed from the events of WWII. These artists eschewed the deeply entrenched Holocaust imagery focusing on the victim and instead use images of Nazi perpetrators to provoke viewers to explore the culture of victimhood and as a means to identify the distinguishing characteristics of evil. Through the artworks and a program of facilitated dialogues, The Jewish Museum offered a springboard for discussion about complicity in, and complacency toward, evil in today's society. The design of the exhibition and interpretive elements facilitated dialogue. An opening video provided historical and cultural context through images of Nazis from television, film, and popular culture, and offered questions for dialogue that visitors could consider as they viewed the artworks. A second video at the end of the exhibition captured opinions and points of view from artists and diverse members of different communities reacting to the exhibition. The museum partnered with the National Jewish Center for Learning and Leadership, the organization Facing History and Ourselves, and other organizations to design dialogue opportunities both in and outside the museum that connected deeply within the Jewish community, as well as to a broad public of all faiths and cultural backgrounds.

The museum ventured into the exhibition with the knowledge it was addressing "taboo" subject matter and using provocative artwork in order to reframe the subject of the Holocaust. In doing so, curators and administrators extensively engaged staff across departments, as well as its board and scores of external advisors to build ownership and understanding for the exhibition and its dialogue goals. The public's reception of the work and the intense controversy prompted by the media before the exhibition even opened demonstrated the effects of the media on public discourse.

Junebug Productions—New Orleans

COLOR LINE PROJECT

As an ongoing effort, the *Color Line Project* is a performance and community story-collecting endeavor that encourages and trains local scholars, activists, and artists to draw upon civil rights movement stories to further public dialogue on current issues of race. Using Story Circle methodology as a dialogue form, artist John O'Neal and a national organizing team, including Amistad Research Center, worked for several months with local scholars, activists, and partner organizations in Glassboro, NJ, and Lake Worth, FL. They collected stories from local people about their involvement in, and understanding of, the movement. Local artists transformed these community stories into public presentations. These performances, along with Junebug Productions' Jabbo Jones plays and scholar panels, provided varied opportunities for public dialogues.

Each pilot community experienced the power of the story circle as an effective method for fostering dialogue and informing artmaking. They also experienced greater diversity in audiences and saw the rewarding nature of community collaboration when such collaborations are effectively carried out. Through the Glassboro and Lake Worth projects, Junebug was able to test its assumptions about how best to support organized, sustained activity at the local level. Junebug realized that to establish a foundation for accomplishing the project's goals, it needed to shift ownership of the project, as well as the creative focus, away from itself and toward the local community. The project raised valuable questions about who best at the local level—cultural organizations or other civic or activist organizations— should lead short-term and sustained efforts in order to establish a long-term infrastructure for continuing arts-based organizing efforts after the project's conclusion.

The Kitchen—New York

THE THREE WILLIES

The Kitchen presented *The Three Willies,* a multi-media jazz opera with music by Leroy Jenkins, libretto by Homer Jackson, and direction by Talvin Wilks. The opera addressed the image of the black male as perpetual suspect, the media's role in perpetuating stereotypes, and the ways that such stereotyping has affected different generations, all conveyed through a day in the life of an extended African-American family during the 1988 presidential campaign. *The Three Willies* used the "Willie Horton commercial," employed by George Bush in the 1988 presidential campaign to defame candidate Michael Dukakis, as a reference point and paradigm for the issues under exploration. In the commercial, Horton, a convicted murderer who escaped during a prison furlough program that Dukakis instituted while governor in Massachusetts, is seen with unkempt hair and glazed eyes leering out of a menacing mug shot. The family begins to identify with the image, and to accuse each other of being the "black bogey-man" on the television screen. Meanwhile, the black newscaster reporting on campaign news begins to question how he is identified in light of the repeated imagery.

Facilitated discussions were held after selected performances. In collaboration with the Vera List Center for Art and Politics at the New School University, The Kitchen held two panel presentations, "Racial Profiling: The Black Man as

Perpetual Suspect," and "Outlaw and Saint: Media Manipulation of the Black Man." Targeted youth attending schools in the Kitchen's West Chelsea neighborhood—itself experiencing the effects of racial profiling as the neighborhood becomes gentrified—engaged in dialogue activities through preproduction workshops in movement, music, and creative writing led by the artists.

The remounting of *The Three Willies* enabled artists to renew a work based on demonstrated potential as a catalyst for dialogue at an earlier Philadelphia presentation. However, the artists' roles in relation to dialogue intent was a source of tension in the project due to miscommunications and limited resources. The project was a significant and challenging organizational shift for The Kitchen. One of the goals was to build the organization's civic identity and local relevance, and, in light of this goal, to work more holistically within the organization to achieve civic as well as artistic impact. This was best met with the in-school programs, and the schools that participated have subsequently requested more such programming. The Kitchen's organizers saw, in retrospect, how they would approach future public programs to frame the issues in relation to current discourse, to involve partners more deeply in concept and design, to allocate greater staff resource, and to work with a longer planning time frame.

Liz Lerman Dance Exchange—
Takoma Park, MD

Liz Lerman Dance Exchange undertook a retrospective analysis of the company's ongoing practice using dialogue in its community-based work. Dance Exchange analyzed the kinds of dialogue in which the company engages as they develop work in a community setting, offering a deep insight into art itself as a form of dialogue. Dance Exchange's intention was "to make the integral overt, the organic concrete, and the intuitive intentional." This was accomplished through documentation, analysis, and development of concrete "tool boxes" that others might draw upon, as well as documentation that can strengthen the organization's capacity to do arts-based civic dialogue work into the future. Dance Exchange's "dialogue audit" sought to clarify and confirm Dance Exchange concepts as they relate to dialogue; to analyze practice in relation to identified qualities of effective dialogue; to excavate the smallest units, tools, principles, and "dialogue moments"; to analyze a typical Dance Exchange workshop to show how units of dialogue fit together; and to

examine the role of dialogue in a larger-scale community residency.

Dance Exchange took particular note of these practices as they played out during a two-year residency in Ann Arbor, MI, part of the company's multiyear, 15-site *Hallelujah* project. In that project, diverse groups in the Ann Arbor and Detroit communities worked with the company to develop a collaborative work that drew from the Biblical story of Adam and Eve, as well as from contemporary events in the Paradise Valley neighborhood of Detroit.

Dance Exchange's analysis offers compelling insight into strategies that support both "civic" dialogue and making dance, such as the value of nonverbal dialogue, the art of framing generative questions for dialogue and dancemaking, building trust and leveling the encounter, and "big story/ little story," i.e., finding the connections (often unexpected) between personal story and the stories of history, collective lore, or world events.

Los Angeles Poverty Department— Los Angeles

AGENTS & ASSETS

The theater work *Agents & Assets* is an investigation into the advent of the U.S. crack epidemic, conducted by the Los Angeles Poverty Department (LAPD) and led by founder and artistic director John Malpede. The show, originally developed and produced in Los Angeles in 2001, was recast for a Detroit audience to include local residents who had been heavily impacted by drugs and drug policy, as well as LAPD members. The text of *Agents & Assets* is a 1998 hearing transcript of the committee charged with oversight of government intelligence agencies. The allegations in question relate to CIA involvement in crack cocaine trafficking in the Los Angeles area.

The project was developed during a month-long residency and was timed to build public awareness of the issue of treatment vs. incarceration of non-violent drug offenders, an issue that was to be addressed in the November 2003 election. Organizers hoped that the company's efforts would directly enter into the public discourse as people considered how to vote on the issue. Dialogue took place in the organizing stage of the project as

LAPD worked closely with members of the arts community, drug policy activists, students, community residents, and others concerned with the issue. Four performances and dialogues attracted a diverse audience.

While no one actually got to vote on the issue (because it was knocked off the ballot), it remained in the forefront of the public eye. The governor of the state of Michigan signed legislation just before he left office in January that helped return sentencing discretion to the judiciary, but he left untouched stacked sentences, life sentences, and many other areas in need of reform. Despite the fact that no vote occurred, the project underscored that the issue of drug policy reform is a long, protracted struggle, and provided insight to the artists regarding how to build momentum in the public consciousness. Another outcome of the project was the beginning of a "recovery theater," a theater group comprising people in recovery in Detroit who work together to learn theater craft and develop and present theater within the inner-city Detroit area.

MACLA/Movimiento de Arte y Cultura Latino Americana—San José, CA

TIES THAT BIND

In September 2002, MACLA—a San José-based Latino contemporary arts space—opened *Ties That Bind: Exploring the Role of Intermarriage Between Latinos and Asians in Silicon Valley*. This was a photography-based installation of new work by artists Lissa Jones and Jennifer Ahn that reflected the history of Asian-Latino intermarriage and contemporary perceptions of ethnicity in the San José area. Capitalizing on public interest in ethnic and racial hybridization trends borne out by Census 2000, the *Ties That Bind* exhibition and dialogues sought to engage a broad cross section of San José residents in dialogue about how Asian-Latino intermarriages in Silicon Valley are challenging the prevailing myths of ethnic identity. To propel the artistic process and spur dialogue, MACLA devised a "humanities-based" model of community intervention that integrated the ethnographic methodologies of oral history, archival research, and social science scholarship with the artistic development process. As part of that effort, MACLA collected and documented 45 case studies of intermarriage and engaged 15 of those families to participate as oral history interviewees and subjects of the artist's photographic process. The installation, developed from this process, encompassed photo collages in a "documentary" mode, "interpretative" pieces that integrated photographs, fragments from the oral histories, and personal artifacts gathered during the course of the project, elements of food, and various physical metaphors for how porous cultural boundaries can be.

Approximately 2,600 visitors attended the exhibit during its two-month run in San José, making it one of the most successful in MACLA's history. *Ties That Bind* was especially well received by the participating families, many of whom visited the gallery several times to show friends and families the artist's interpretations of their stories. The project generated substantial dialogue among the ethnographers, artists, and participating families, but much of that discourse remained "interior" to the project, and ultimately did not enter the public sphere. The project raised a key question among organizers about the nature of civic dialogue: Given an unanticipated value of dialogue among participating families, does civic dialogue necessarily need to be "public"? How does the intent to foster civic dialogue affect aesthetic choices? Finally, *Ties That Bind* also shed light on MACLA's own quest to embrace a long-term commitment to civic dialogue and to embed those practices in the organization.

Massachusetts Foundation for the Humanities—Northampton, MA

IMAGING ROBERT

The Massachusetts Foundation for the Humanities organized local, statewide, and national showings of the video documentary, *Imagining Robert: My Brother, Madness, and Survival,* by Larry Hott and Florentine Films, along with dialogues to explore the personal, social, and policy dimensions of mental health as a civic issue. The documentary tells the story of two brothers, Robert Neugeboren, mentally ill for 38 years, and Jay Neugeboren, a prize-winning novelist who has been his brother's caretaker. Based on Jay's memoir, *Imagining Robert,* the film blends vérité-style footage of Jay's visits with his brother and documents Robert's road to recovery. Through Robert's poetry, drawings, experimental films, and diary readings, the video shows Robert as a whole human being who has previously been diminished by illness and the system.

Imagining Robert provided occasion to draw together people involved with mental health—family members, medical personnel, patients, police, laywers, and community partners—to explore the impact of chronic mental illness on families; the ways that police deal with mentally ill patients on the streets and in shelters and halfway houses; and how to challenge assumptions and perceptions about treatment, stigma, and delivery of services. More public screenings consistently drew an audience of people with mental illness, as well as families of the mentally ill. The video proved to be a powerful witnessing opportunity for people to declare their personal relationship to the issue, and to therefore make a stigmatized private issue public. Dialogues were facilitated at various times by professional facilitators, mental health workers, humanities scholars, and Larry Hott or Jay Neugeboren. (Jay and Robert were present at many of the events.) Although certain screenings and dialogues were geared toward lawyers, legislative policymakers, insurance professionals, and police with the intent to explore public policy related concerns, the intent to engage at a policy level was ambitious and also proved challenging in gaining the necessary attention of these types. The timing of the production and distribution of *Imagining Robert* effectively contributed to and strengthened a national dialogue about the needs of the mentally ill and their family members. *Imagining Robert* sought to increase dialogue about issues of mental health outside of a crisis situation and to provide insight into the most intimate personal and public dimensions of the issue.

New WORLD Theater—Amherst, MA

PROJECT 2050

New WORLD Theater's (NWT) youth initiative, *Project 2050*, is an ongoing exploration of the mid-twenty-first-century demographic shift, when it is projected that people of color will become the majority in the United States. The project promotes creative imaginings of a near future when it will become imperative not only to address issues such as race construction, ethnic balkanization, social inequity, and power imbalances, but to move beyond these traditionally disempowering institutional frame-works. *Project 2050* is anchored around an annual summer retreat, where artists, scholars, and youth mutually discuss issues raised by the coming demographic shift and create artistic responses to them. "Knowledge for Power" sessions with scholars afford young people a depth of understanding about the issues, promote discussion, and inform their creative work. Works in progress provide the impetus for issue-based discussions that, in turn, inform the artistic works. Performances by artists and youth culminate the summer program and are also honed for future presentation as part of NWT's main stage programs and in other contexts. During the

Animating Democracy time frame, new theater pieces created by Universes—the ensemble led by Stephen Sapp and Mildred Ruiz—and several guest playwrights played out a variety of future scenarios via popular culture aesthetics, in addition to youth-created pieces. A multicultural interactions specialist, NWT *Project 2050* staff, scholars, and youth themselves facilitated various dialogues and post-performance discussions.

Project 2050 blurs the lines between intergenerational art, activism, politics, and culture and has become a core program for New WORLD Theater, inspiring the creation of a youth action community coalition. The program challenges the position of artists and scholars as the established leaders and knowledge-holders in work with youth by creating an interactive environment where youth, artists, and scholars mutually inform, stimulate, and inspire each other. *Project 2050* illuminates particular approaches to youth-centered arts-based civic dialogue and the importance of rigorous aesthetic investigation in youth work.

Northern Lakes Center
for the Arts—Amery, WI
THE WATER PROJECT

Water is a critical life force for the small community of Amery, WI, and *The Water Project* was a multidisciplinary exploration into the issue of water— its use and abuse. Between November 2000 and December 2001, artists working in different art forms presented creative strategies for discussing perspectives on water, including a reading and publication of new writings inspired by water, an adaptation of Ibsen's *An Enemy of the People* to present-day Amery, a chamber orchestra concert featuring water-related classical repertoire juxtaposed with newly commissioned work, the creation of Amery's first three-dimensional piece of public art, and an exhibition of photography chronicling life along Amery's Apple River. Dialogue occurred around the presentation of the art, facilitated by intergenerational teams of local people.

As the region's primary coordinator of arts activity, the Northern Lakes Center for the Arts used its strength as an established community gathering place. The project also provided a multidisciplinary focus and an intergenerational approach to expand the Center's position in the community as a convener for civic dialogue. The artistic diversity of the project attracted different, as well as overlapping, audiences, reaching almost 65 percent of the community and involving nearly 100 artists. The project built awareness and new understandings of water-related issues through these diverse opportunities to engage. The project illuminated the vital role that a local arts agency can play in catalyzing and linking public discourse to a key civic issue in a small community. By training community members—including young people—as facilitators for dialogue, the project effectively developed a cadre of facilitators for future efforts. With the help of an outside dialogue practitioner for both training and dialogue design, the project considered how to tailor dialogue techniques to the particular artistic presentation, as well as its anticipated participants.

Out North Contemporary Art House—Anchorage, AK

UNDERSTANDING NEIGHBORS

In 2003, *Understanding Neighbors,* a collaborative project between Out North Contemporary Art House, the Interfaith Council of Anchorage, and Alaska Common Ground, brought together nearly 100 citizens in a month-long series of dialogue sessions to address the question: "What is the social, moral, and legal place of same-sex couples in our society?" Artists Peter Carpenter, Sara Felder, and Stephan Mazurek created eight performance and video works derived from interviews with nearly 70 community members to serve as the catalyst for small group dialogues. Using a customized dialogue approach based on the Public Conversations Project's "Power of Dialogue" model, the project trained 25 community volunteers to facilitate dialogue sessions. To engage a representative mix of Alaskans with socially conservative, moderate, and liberal viewpoints on this emotionally charged topic, the project implemented a broad-based recruitment plan and media strategy. The project also engaged a social research team to evaluate the impact of the arts-based dialogue experience on community members. *Understanding Neighbors* concluded with a multimedia work-in-progress performance reflecting the artists' experiences with the project.

Understanding Neighbors succeeded in fostering respectful dialogue and mutual understanding among community participants and effecting a shift in the tone of media reporting around issues of same sex couples from a contentious to a positive tenor. However, in spite of *Understanding Neighbors'* proactive media and dialogue recruitment strategies and its conscious efforts to establish a safe and neutral space for dialogue, the project was less successful in attracting holders of more conservative viewpoints. Other challenges occurred regarding employing art with a "point of view" in dialogues, but were productively dealt with. The project illuminates how efforts to establish neutrality and credibility in the eyes of the community fostered significant commitment and investment by partners and the coordinating committee. At the same time, however, such measures diminished Out North's role to an extent that was unsatisfactory for Out North. Given Out North's activist-oriented leadership and its previous work, *Understanding Neighbors* raised questions for Out North about the efficacy of civic dialogue as a means to achieve its vision for social change in its community.

Perseverance Theatre—Juneau, AK

MOBY DICK

Since it was founded in 1979, Perseverance Theatre has been committed to exploring classic plays and new works through a unique "Alaskan lens." Using an Alaskan adaptation of Herman Melville's classic work, *Moby Dick,* as the artistic catalyst, Perseverance mounted a statewide dialogue about some of Alaska's most divisive cultural, political, and social issues: How could theater effectively contribute to discourse about Alaskan issues of subsistence rights and the urban/rural divide in disparate places across the state? In conjunction with the play, the company tried several approaches, including Socratic dialogue in Fairbanks and Anchorage in the form of a "Socrates Café," and a culturally based potluck in Barrow. They sought media coverage to seed the play-based civic dialogues through features on radio and in print. In the process, organizers came to understand how the "gatekeepers" of civic discourse determine their priorities, and were reminded of their original goal to bolster a nonofficial level of public engagement. The company shifted its vision of civic dialogue from large public gatherings that address policy to more intimate gatherings in which personal story is a potent motivation and a stepping stone to civic deliberation.

The adaptation of *Moby Dick* within regional and contemporary contexts offered rich ground for a wide range of citizens to discuss issues framed by the project, underscoring the potential for classic works of art to stimulate civic dialogue. The project also gave the company new insights into its process for creating and presenting work; exploring the nuance and multiplicity of views around the issues—"the grey matter"—improved the art. Even after a successful conclusion, the Perseverance leaders questioned the theater's authority and responsibility to initiate and convene dialogue on civic issues. However, encouraged by Native Alaskans in Barrow, as well as legislators in Fairbanks and Anchorage, Perseverance has concluded that it has something unique to contribute as a civic player.

Rhode Island Council for the Humanities—Providence, RI

TRACES OF THE TRADE

The Rhode Island Council for the Humanities and producer-director Katrina Browne worked together on a documentary video and dialogue effort using *Traces of the Trade: A Story from the Deep North* as its artistic focal point. In *Traces,* filmmaker Katrina Browne tells the story of her Rhode Island ancestors, the largest slave-trading family in early America. Browne takes a journey with nine other DeWolf family descendents to retrace the notorious Triangle Trade from Bristol, RI to Ghana and then Cuba. Family members are filmed as they uncover the family's, the region's, and the nation's hidden past, and as they grapple with the contemporary legacy of slavery. Browne conceived the film as a means for white Americans to engage critically in dialogue about the issue of white privilege. By exploring this little-known history, the North's complicity in the slave-based economic system is revealed. The documentary explores the subsequent evolution of amnesia in white New England about its role in slavery and the ways in which this amnesia created fertile ground for a national blindness about contemporary racism, including the privilege afforded by white skin.

The project included a pilot dialogue program held in six Rhode Island communities, developed through a partnership between the Rhode Island Council for the Humanities and the National Conference on Community and Justice/Southern New England. The pilot program informed the design of a future statewide dialogue program in Rhode Island, as well as for the film's wider use. The pilot program revealed advantages and disadvantages of using film—personal documentary in particular—as a catalyst for civic dialogue; how the little-known history of New England's role in slavery may offer insights into contemporary racism and support meaningful dialogue; the role of empathy and emotion in dialogues on race; and obstacles and opportunities for using the film with white Americans to further dialogue about white privilege and collective responsibility for reparations in relation to the legacy of slavery.

San Diego REPertory Theatre—San Diego

NUEVO CALIFORNIA

In 2003, the world premiere of *Nuevo California* at the San Diego REPertory Theatre marked the culmination of an intensive three-year project that brought together citizens on each side of the U.S.–Mexico border to imagine their region's binational future. The International Border Fence, a 14-mile metal wall that divides San Diego and its neighboring city Tijuana, served as the project's springboard for cross-border dialogue on critical regional issues and the new play's theme. San Diego REPertory Theatre, together with project partners San Diego Dialogue, Centro Cultural Tijuana, and an ensemble of U.S. and Mexican artists, posed a provocative civic question to Mexican and U.S. residents of the border area: "Tear down the fence or fortify it?" Their deliberations and responses gave birth to *Nuevo California,* a multidisciplinary multilingual theater piece of multiple voices and viewpoints that imagines border life with the fence—and without it.

Project partners employed community-based dialogue for the new play's aesthetic development and grappled to create a theater piece that was both "multipartial" and "good art." Dialogue formats (open rehearsals, town hall forums, and public readings) were structured to include a work-in-progress presentation followed by a facilitated dialogue session. Community dramaturges, who were volunteer community members from both sides of the border, played a kind of check-and-balance role to preserve the authenticity and nuance of dialogue in the play. Thus, at all dialogue events the evolving script served as the springboard for public discourse about the project's civic question. The project's pairing of San Diego REPertory Theatre with San Diego Dialogue also shed light on the potential benefits and possible pitfalls in forging effective, mutually beneficial partnerships between arts groups and dialogue-focused organizations. Finally, as one of a handful of Animating Democracy-funded projects that featured a cross-cultural dimension, *Nuevo California* offered a window on the rewards and challenges of conducting community-based art projects in a transnational context.

SPARC/Social and Public Art Resource Center—Los Angeles

THE GREAT WALL OF LOS ANGELES

Social and Public Art Resource Center (SPARC) is using a community dialogue and design process, with the aid of internet technology to create designs depicting the last four decades of the twentieth century on *The Great Wall of Los Angeles* mural. This internationally recognized mural, begun 25 years ago, depicts previously neglected histories of minority American cultures and communities in Los Angeles through the 1950s. With the core belief that a variety of perspectives can deepen the content of the work, SPARC uses methodology developed by Co-founder and Artistic Director Judith Baca that brings together scholars, designers, poets, activists, historians, students, and local residents in forums to suggest and discuss incidents and ideas they consider important to be represented in the mural. These are articulated as imagery by a design team and Baca, and then taken back to the community and posted on SPARC's website for further feedback. Feedback is enabled through live and online dialogues with assistance from the UCLA/SPARC César E. Chávez Digital Mural Lab.

The process of deciding on and creating the images not only supports the creative development of the work, but also generates dialogue within and across racial and ethnic communities that furthers intercultural relations in the city.

In this phase of *The Great Wall's* artistic development, SPARC explores how to advance its process and accommodate the substantial changes within Los Angeles communities brought about by massive demographic shifts, migrations, riots, and earthquakes, as well as by increasingly divided communities. SPARC's "Prism of Place" approach, for example, examines the effect geographic location has on the perception of history and social realities. This phase also offers an opportunity to enhance understanding of how digital technology and the Internet can engage people in artistic process and civic dialogue, and to observe how civic dialogue can be sustained and rejuvenated through a single, ongoing art project.

Spoleto Festival USA—Charleston, SC
EVOKING HISTORY: LISTENING ACROSS CULTURES AND COMMUNITIES

Evoking History, a three-year program implemented in conjunction with the Spoleto Festival USA and developed by Curator Mary Jane Jacob, looked at contested sites of history in Charleston, SC and crucial contemporary issues challenging communities in the region. The program brought together artists, the Spoleto Festival, and the community to think deeply about the area's heritage by re-examining a range of sites, from high-profile plantations to a prime downtown real estate slated for development that was once a thriving African American community. Heritage tourism, an important piece of the city's economy, provided an impetus for reconsidering the meaning of historic sites and the possibility of finally acknowledging Charleston's slave history. Through dialogue stimulated by public art, performances, and other cultural projects, *Evoking History* sought to support a long-

term process of reconciling competing views of the past and changing long-held attitudes.

Dialogue was generated through a number of activities. Individuals from different walks of life who have a "stake" in "evoking history" (be it aesthetic, historical, civic, social, professional, or family heritage-based) came together for periodic, issue-based "Stakeholder Forums." At these forums, program organizers and artists listened while community members spoke with each other, in many cases for the first time, and identified shared questions and concerns. Artists made numerous site visits and held one-on-one meetings and small group sessions, focused around a series of questions related to Charleston's past and its current issues. Many local stakeholders were involved over multiple years in *Evoking History.*

St. Augustine's Church and The Lower East Side Tenement Museum—New York

THE SLAVE GALLERIES RESTORATION PROJECT

The ethnically diverse neighorhood of the Lower East Side of Manhattan has been created by the shifts and tensions of generations of immigrants living alongside American-born racial minorities. Oppression, domination of others, and efforts toward self-determination have alternated over time, as various groups have been used and exploited by other groups—some gaining a central role in the neighborhood while others have remained at the margins. Conflicts today on the Lower East Side continue over material resources like housing and schools, as well as how groups are represented in the neighborhood's history.

The Slave Galleries Project was a collaboration between St. Augustine's Episcopal Church and the Lower East Side Tenement Museum to restore and interpret the two slave galleries located in the church, cramped rooms where African American congregants were segregated during the 19th century. Over a year's time, and guided by two dialogue professionals experienced in intergroup relations, community preservationists—leaders representing African American, Asian, Latino, Jewish, and other ethnic and religious groups— came together with scholars and preservationists to help interpret the slave galleries as a catalyst

for dialogue within the community. They talked first among themselves about issues of marginalization in the Lower East Side. They explored the meaning and use of the slave galleries, a powerful artifact of the history of segregation, as a space for dialogue for the larger Lower East Side community. Finally, after receiving training in dialogue facilitation, they engaged people within their own communities in dialogue about the slave galleries and current issues they face.

The Slave Galleries Restoration Project points to the power of history—and particularly the historic site—as a catalyst for exploring contemporary issues. *The Slave Galleries Project* illuminated issues of ownership of history: How do we honor and retain the focus on the history of a particular group, while also drawing upon its relevance to other groups' experiences? *The Slave Galleries Project* is also an example of building and sustaining a community's capacity for civic dialogue through the creation of a cadre of community preservationists who are skilled in civic dialogue facilitation—community leaders who could imagine and apply their skill and understanding to other sites and issues on the Lower East Side.

Urban Bush Women—New York

HAIR PARTIES PROJECT

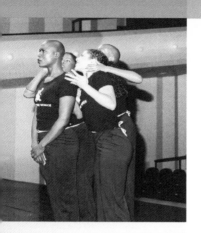

Hair Parties is a project of the Brooklyn-based Urban Bush Women (UBW) that uses a method of cultural sharing, alternating between dance performance and dialogue, to explore how ongoing debates about the politics of hair within the African American community might lead to deeper dialogue about issues of race, class, and social justice. Hair Parties have been held in homes, barber shops and beauty salons, YWCAs, corporations, and other community settings. Each Hair Party was unique, but all incorporated small and large group discussions, performance excerpts from UBW's *HairStories* piece to stimulate dialogue, and interactive games to prompt memories and associations from participants. UBW developed probing questions that were customized to specific groups to encourage critical thinking. UBW's multilayered approach allowed the dialogues to move back and forth from the personal to the civic, from the micro to the macro. The topic of hair provided a bridge to such challenging topics as race, social status, gender, sexuality, educational equity, the

impact of media and popular culture, economics, and the workplace.

As UBW has sought to establish a home in Brooklyn, *Hair Parties* have become a vehicle to bring community people together, build new relationships in Brooklyn, and begin to explore growing issues of development and gentrification. The powerful combination of art, dialogue, and social analysis in the *Hair Parties Project* has enabled UBW to explore such questions as: How does embodying dialogue within dance deepen the dialogue? Can a party format encourage candid, from-the-heart "kitchen talk?" What is the role of conflict, passion, and point of view in these exchanges? How does the seemingly personal topic of hair lead to critical thinking about challenging societal issues? UBW's work with dialogue trainers has helped them understand their own intuitive approach to dialogue, enhance their work through skill building, and codify their practices.

The Andy Warhol Museum—Pittsburgh

THE WITHOUT SANCTUARY PROJECT

The Andy Warhol Museum presented the traveling exhibition *Without Sanctuary: Lynching Photography in America*—100 photographic prints and post-cards from 1870 to 1960 that document the history of lynching in the United States. Recent racially motivated killings in the city had heightened exist-ing racial tensions, and the exhibition provided a potent context for refocusing dialogue about race in Pittsburgh. The Warhol worked with a community advisory group to determine how the exhibition should be presented and interpreted both within and outside the museum. A time line depicting African American achievement and resistance set against the history of lynching in America was developed in collaboration with community advi-sors and later reproduced for distribution to all high schools in Allegheny County. Artmaking dia-logues, led by artist-educators trained in dialogue, assured *Without Sanctuary* visitors a way to respond immediately to the highly charged images. A range of other dialogue opportunities included daily facilitated public dialogues, a video response booth, group tour discussions, use of the museum as a space for community groups to hold meetings and dialogues around race relations, and artist-educator outreach projects to extend the dialogue into the community. For training and to lead dialogues, artist-educators and museum staff partnered with the local YWCA Center for Race Relations, the National Conference for Community and Justice, and the organization Facing History and Ourselves.

The Without Sanctuary Project galvanized energies and focused collective attention on racial issues in a manner that was rare for Pittsburgh. More than 31,000 people saw the exhibition and approximately 1,000 engaged in dialogues. The activity surround-ing the exhibition drew substantial media attention, which, in turn, prompted further public discourse. The project revealed the tensions and challenges inherent in a largely white institution choosing to do this project, and the lessons learned while working with its advisory group to effectively involve the African-American community. The project experimented with how a museum can creatively operate in the cultural sphere as "civic engager," using its social space, as well as its traditional position as arbiter of taste, to focus attention on civic issues.

Wintergreen Performing Arts—
Wintergreen, VA

PRESERVING THE RURAL SOUNDSCAPE

Rural Nelson County, VA, although known for its scenic beauty, is threatened by decline of farmlands, wetlands, and open space by sprawl from nearby Charlottesville, by waste disposal and water quality issues, and by the fragmentation of its animal habitats. *Preserving the Rural Soundscape* was a year-long project spearheaded by Wintergreen Performing Arts, Inc. (WPAI), a music presenter located in a resort and retirement community and known for its summer classical music festival. For *Preserving the Rural Soundscape,* WPAI commissioned contemporary music to engage people in dialogue about issues of land use and sustainable economic development in the county. The project linked three separate elements. First was the commission and world premiere of *Singing the Blue Ridge,* a suite of songs by Dr. Judith Shatin, scored for electronic music, voice, and orchestra. The second was a community dialogue process using a study circle to explore issues of land use, planning, and development. The third element was a school residency project in which fifth graders created original songs and explored sound as a science and an art. All three elements were stitched together through "sound-walks," an opportunity for local people to listen deeply to the rich layers of human and nonhuman sounds in the rural landscape—or "soundscapes." Residents also recorded sounds that Shatin incorporated into her musical composition.

As a result of *Preserving the Rural Soundscape,* WPAI reached beyond its usual constituents to a broader public. WPAI came "down into the valley" and began to grapple with the concerns of the people who live and work in Nelson County, and board membership was expanded beyond Wintergreen residents. But the project also brought to light socio-economic tensions inherent in a retirement community and resort development located in a rural community, not only how WPAI perceives itself, but how it is perceived by the broader community. The project necessitated a shift in organizational culture as the board encountered new ways of working in the community and tried to adopt a more dialogic way of working internally. The project also experienced tensions between the orchestra leadership's view of artistic excellence and the composer's concern for the value of the artistic experience to community members.

The Working Theater—New York

ABUNDANCE

Conceived and led by artist Marty Pottenger, *Abundance* was a three-year, grassroots, theater-based dialogue about distribution and consumption of economic resources and the social impact of money on people's lives. The central focus of dialogue throughout was the concept of "enough." The project was designed to create opportunities for individuals across the economic spectrum to explore the intimate as well as societal impact of economic inequity in their lives. The potency of the effort was in exchanging these concerns in the presence of the artist, or with a group of people, all engaged in the same exploration.

Abundance had four components. Pottenger conducted interviews with millionaires and minimum wage workers across the country. She conducted an intensive workshop series in cooperation with financial, union, housing, and public service institutions in New York City. From these workshops, she engaged a group of individuals living at all points along the economic continuum to participate in a year-long dialogue group. In the workshops and dialogue group—through storytelling, photography,

poetry, and video—Pottenger elicited personal stories that stimulated dialogue on the emotional life of money, the interplay between resources and consumption, and new possibilities for ensuring that everyone has enough. In collaboration with The Working Theater, Pottenger then created and presented a multimedia performance project developed from the materials generated through all of these activities, which premiered in New York City and toured nationally with dialogue activity to accompany the performance. An interactive website, developed in consultation with the Center for Digital Storytelling, expanded participation possibilities through creative online dialogue opportunities.

Through Pottenger's reframing of issues of economic inequity, and a dialogue approach emphasizing artmaking and listening, *Abundance* broke the persistent societal taboo about discussing one's economic status. Arts-based civic dialogue often enabled participants to move between the personal and social effects of economic inequity on individuals and families to broader civic and political issues.

An Evolving Definition of Arts-based Civic Dialogue

I struggle with three different ways to look at this: What is really art-inspired in the dialogue? What is the issue-driven dialogue? What is community-come-to-know-each-other dialogue?…must it be one into the other?

—*Sandy Agustin, Intermedia Arts*

At the outset, Animating Democracy posited definitions of *dialogue*, *civic dialogue*, and *arts-based civic dialogue* that drew upon definitions and theory prevalent in the evolving civic dialogue field. These working definitions were intended to convey the qualities and characteristics of dialogue, civic dialogue, and arts-based civic dialogue that Animating Democracy valued, and to suggest that any number of approaches and models might embody these basics.

Dialogue—Animating Democracy's understanding of dialogue derived from the Study Circles Resource Center description: two or more parties with differing viewpoints work toward common understanding in an open-ended, face-to-face format. Dialogue is inclusive of multiple and possibly conflicting perspectives rather than promoting a single point of view. According to Daniel Yankelovich, author of *The Magic of Dialogue,* three qualities of dialogue distinguish it from debate or discussion:

- Dialogue allows **assumptions** to be brought out into the open and encourages participants to suspend judgment in order to foster understanding and break down obstacles.
- Dialogue seeks to create **equality** among participants. Certain conditions can be created to even the playing field for participants who have various levels of information about the issue, experience in public forums, or real or perceived positions of power or authority, as well as to help build the trust and climate of safety required for deep dialogue.
- Dialogue aims for a greater understanding of others' viewpoints through **empathy**. In dialogue, multiple perspectives are invited to the table and given encouragement.

Civic dialogue—Animating Democracy defined civic dialogue to specifically refer to dialogue about civic issues, policies, or decisions of consequence to people's lives, communities, and society as a whole. Meaningful civic dialogue is intentional and purposeful. Dialogue organizers have a sense of what difference they hope to make through civic dialogue, and participants are informed about why the dialogue is taking place and what may result. The focus of civic dialogue is not about the process of dialogue itself, nor is it intended to be solely therapeutic or to nurture personal growth.

Arts- or humanities-based civic dialogue—In arts- or humanities-based civic dialogue, the artistic process—or presentation—provides a key focus, catalyst, forum, or form for public dialogue on an issue. Opportunities for dialogue are embedded in or connected to the arts experience. Arts-based civic dialogue may draw upon any of the arts or humanities disciplines and the spectrum of community-based, experimental, mainstream, or popular approaches to making or presenting art. Individual artists or companies, community-based arts or cultural organizations, or large institutions may undertake arts-based civic dialogue by using a wide range of artistic practice and dialogic methods.

Cultural organizations that received support from the Animating Democracy Lab raised a number of important questions about the definition of arts-based civic dialogue. Some felt the definitions provided useful frames or boundaries that helped clarify vague notions of terms, distinguish a particular approach within broader civic or arts realms, and focus efforts. However, others felt the original working definition was too limiting. At regional and national convenings known as Learning Exchanges, some participants voiced frustrations about the disconnect between what they felt was already dialogic and of civic value in their work, and a looming sense that they were somehow falling short of the definition.

Some said that, in their view, the definition did not adequately describe the work they were doing, suggested practices that were foreign to their way of working, or elevated certain concepts or approaches to dialogue while ignoring others. Participants often critiqued what they perceived as the underlying assumptions of the original definition—e.g., that the "civic" aspect implied or required a certain level of "public-ness," or that "dialogue" had to be "civil" and polite. As groups reflected on each aspect of their work—the artistic basis, the civic nature, and the dialogue process—people repeatedly asked, "But does this *count* as arts-based civic dialogue? And if not, why not?"

Many valuable inquiries emerged: How does nonverbal communication (e.g., movement or visual artmaking) function as part of arts-based civic dialogue? Is cross-talk required for dialogue to occur? Are the dialogues that occur among organizational staff and partners when developing and implementing a project considered *civic* dialogue? What constitutes *difference* in trying to include "different perspectives"? At what point does arts-based civic dialogue achieve broad participation or impact public discourse? And, how might ways of communicating and making decisions based in indigenous and world cultures serve as alternatives to the predominantly Western or Euro-American canon of dialogue methods or enrich those methods?

Animating Democracy's collective understanding of the nature of arts-based civic dialogue evolved significantly over the course of the initiative. In an effort to document Animating Democracy's journey to clarify and, in some cases, rethink the definition and distinguishing characteristics of arts-based civic dialogue, this section deconstructs the original working definition by examining its individual elements—"arts-based," "civic," and "dialogue" (in reverse order). It also explores some underlying assumptions about these definitions, and considers the ways in which the concept of arts-based civic dialogue may be expanded to embrace the fullest range of contributions the arts can make to civic discourse.

DEFINING "DIALOGUE"

Participants examined Animating Democracy's definition of dialogue, with its emphasis on engaging multiple perspectives on an issue, its structured processes, and its bias toward verbal and Western orientation.

Neutrality

A common assertion of many dialogue approaches is that dialogue facilitators need to remain "neutral" or unbiased in relation to the issue and the participating groups. The origi-

nal working definition of Animating Democracy stated that civic dialogue "engages multiple perspectives on an issue, including potentially conflicting and unpopular ones, rather than promoting a single point of view." Many Lab participants, including those with more action- or activist-oriented goals, challenged the notion of neutrality, arguing that point of view is very important in art. In some cases, they contended, balancing all voices equally may not be the strongest choice aesthetically. Others believed that neutrality is impossible because everyone is subjective, and that transparency should be a greater value.

Patricia Romney, a dialogue practitioner, expressed her belief that, when facilitating dialogue, facilitators have to move out of an advocate's position. She introduced the notion of *multipartiality*—the ability of the facilitator to be on everyone's side simultaneously, to maintain a metaview of the situation, and to help participants seek the solution that will benefit all parties. This idea had resonance for artists in Animating Democracy because it allowed them to express points of view in their work while giving over the responsibility to a skilled facilitator to work appropriately with the point(s) of view in the artistic work.

Further discussion of neutrality is included in the section "Artistic Practice."

Listening and cross-talk

Listening is a practice emphasized in the dialogue field. Artist Marty Pottenger, who uses a form of dialogue that emphasizes empathetic listening, argues that too often people get stuck in simply swapping opinions, and that we need to move toward a process in which people learn to listen, and listen to learn. Drawing from her experience in co-counseling, she utilizes strictly structured listening exercises that allow one participant to speak at a time, uninterrupted and with little or no nonverbal response from his/her partner. Similarly, specialists in Jewish-Palestinian dialogue suggest that identity groups with deep historical conflicts between them should receive "equal air time," which may not be the same as equal time for all the individuals in the dialogue session. These examples suggest that some regulation of talking and listening can help create equality among members.

Artist Marty Pottenger, creator of Abundance, *a theater-based project exploring issues of economic inequity, done in collaboration with The Working Theater, 2001–2004.*

Some Animating Democracy participants, however, challenged formal dialogue methods that limit cross-talk or regulate spontaneous response. At an Animating Democracy Learning Exchange at which Pottenger facilitated an arts-based civic dialogue, some suggested that her listening exercises contained a cultural bias, explaining that in their community or family experience the lack of vocal or expressive response indicates that the listener hasn't heard, doesn't care, doesn't agree, or isn't enthusiastic about the discussion. Also, some participants from identity groups that have been historically suppressed or silenced, such as people of color and women, claimed that methods of controlling or regulating responses (especially when the dialogue is led by facilitators from groups who might traditionally be considered dominant) can recreate the sensation of silencing, thus causing resistance or discord in the dialogue group. They asserted that balancing all voices equally is not enough, because dominant identity groups have had the advantage of greater voice for centuries.

Based on artworks in Seattle's Henry Art Gallery exhibition, Gene(sis): Contemporary Art Explores Human Genomics, *Liz Lerman and visitors create movement during a dialogue about the human genome, 2002.*

Nonverbal dialogue

Liz Lerman Dance Exchange, among others, has developed innovative ways of using dance and movement to convey meaning. The Dance Exchange in particular raised, and included in their investigations, the question of whether dialogue is necessarily a verbal exchange. They believed that nonverbal signs and metaphors that are present in movement, for example, can communicate experience, exchange information, reveal assumptions, balance power, and more—all characteristics of dialogue.

Animating Democracy's understanding of dialogue came to include nonverbal elements present in movement and visual arts. As well as a meaningful mode of exchange in and of itself, "nonverbal dialogue" can be a very powerful way to lead up to, build on, or deepen verbal dialogue, especially on sensitive topics. In addition, the emphasis on verbal dialogue can give an advantage to people who are good at words and public speaking. Considering the diversity of multiple intelligences and modes of learning, nonverbal approaches did have the effect of making dialogue more inclusive.

Cultural bias

A recurring critique of Animating Democracy's initial definition of dialogue, and of prominent dialogue methods, was its predominantly Western or Euro-American orientation, which does not work in communities where different forms of inquiry and decision-making are an important part of everyday culture.

For example, Marilyn Cristofori of the Hawai'i Alliance for Arts Education explained that, in Kohala, bringing people together for a deliberative town hall meeting went against traditions and norms held by Native Hawai'ians and long-time residents. "[In Hawai'i,] talk story is a central process," she said. "Public meetings were imposed, in a way, by the Animating Democracy grant—by a kind of mainland, New England notion of civic dialogue

based on the town hall model…Talk story is a subtle, informal and hidden form of discussion that happens in grocery lines and on people's back porches."

Similarly, a participant at the Chicago Learning Exchange stated, "A lot of folks think they know what dialogue is…posing a Western perspective of dialogue. [But] a lot of groups are saying 'That's not how we "dialogue," or the way we handle issues in this community. The word "dialogue" is often used and seems to suggest something more contrived and formal than getting together and sharing personal stories over a meal [for example]. The publicness and formality of it, the idea of having a dialogue as a separate thing you do, doesn't work for a lot of communities."

In the end, rather than choosing to advocate a particular definition, Animating Democracy came to emphasize the significance of the *characteristics* of dialogue: revealing assumptions and suspending judgment, creating equality, fostering empathy, and encouraging multiple perspectives. Artists and cultural organizers likewise came to distinguish a range of approaches to dialogue, including their own creative dialogic approaches that, as with other methodologies, should be chosen to suit the goals of their project.

DEFINING "CIVIC"

While art can engage participants in dialogue, the dialogue is not always civic in nature. What makes dialogue civic? Is it intention, publicness, content, or deliberation? Animating Democracy's initial definition described civic dialogue as "dialogue in which people participate in public discussion about civic issues, policies, or decisions of consequence to their lives, communities, and society." Many projects focused on ongoing cultural or systemic issues not related to immediate policy decisions. The question of what makes dialogue civic prompted ongoing discussion about the following qualities.

*Bill Cleveland, Sue Wood,
and Michael Rohd of Sojourn
Theatre (left to right) at
an Animating Democracy
gathering, Minneapolis, 2002.*

Personal or public

Sharing personal experiences and stories was recognized as an important component of civic dialogue, particularly due to its potential to help people see the connections between their everyday lives and complex civic issues. However, some people asked whether this form of dialogue was, in itself, *civic* or whether it was a stepping-stone *toward* civic dialogue. Those who claimed that it was a stepping-stone argued that dialogue methods eliciting personal stories *without* moving on to explicit discussions about the related civic issue do not bring the dialogue to a civic level. They argued that the value of the arts in bringing personal stories to the foreground is a true contribution, but "civicness" has to do with intentions, and the focus on issues.

Questions about the point at which arts-based dialogue projects achieve broad civic participation in public discourse resonated for many participants. As mentioned previously, some participants challenged the notion of what "public" discussion looks like. Some felt that large-scale "public" dialogue processes looked more "democratic" by mainstream standards, but that true democratic structure and equal participation was really only possible in smaller groups. Many believed that the ripple or cumulative effects of sustained small-scale—or *personal*—dialogues on issues of civic import, if kept alive in public consciousness over time, can cause profound shifts.

For further discussion, see "The Relationship of the Personal to the Public" within the section "Civic Implications."

Civility

Animating Democracy participants raised the question of whether "civic dialogue" had to be "civil." Some dialogue proponents unequivocally answered yes, saying that an atmosphere of mutual respect, thoughtful exchange, and safety is necessary for successful dialogue, especially on sensitive issues. Some felt that, as a result of discussions becoming heated or emotional, "rational" thought is impaired or the sense of safety is violated, while others saw value in making room for emotion, passion, and spontaneity.

The challenge is how to create "safe space" that feels safe for everyone. Efforts to reduce tension may silence marginalized voices in order to make others feel comfortable. Tempering emotional responses may feel safe to some participants and stifling or controlling to others. This can be cultural or personal, and sometimes has racial implications, pointing to who feels in control of the space and who does not. Acknowledging and dealing with power dynamics is an important issue in both dialogue and artmaking.

Some Animating Democracy participants were responding to a long history of racist discourse about rationality and "civilized" behavior in public space, which gives primacy to European and white American notions of appropriateness. Cultural groups that didn't conform to the norms established by the dominant culture were often deemed incapable of "civil" behavior, and therefore excluded from the public arena. Unfortunately, traces of this history can often be recognized in underlying assumptions about what constitutes appropriate participation. In addition, long histories of inequity, oppression, and exclu-

Efforts to reduce tension may silence marginalized voices in order to make others feel comfortable. Tempering emotional responses may feel safe to some participants and stifling or controlling to others.

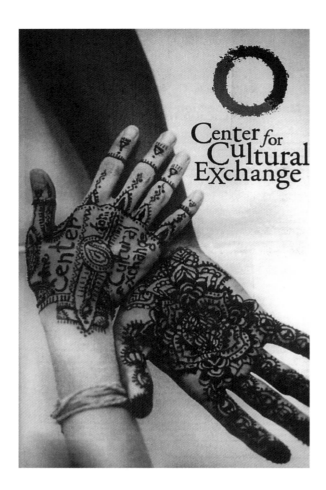

Image courtesy of the Center for Cultural Exchange, Portland, ME.

sion can make certain topics more emotionally heated, especially for participants who have been subject to those oppressions.

Some Animating Democracy participants suggested that a certain amount of conflict is to be expected, and that the facilitator's job is to provide productive mechanisms for emotional expression and response. In this area, art and arts-based process can be extremely valuable. Others suggested that emotional experience and affective learning is important to the process of shifting assumptions, achieving deeper understanding, and working toward change.

Cultural orientation

Some wondered how to consider issues of cultural identity, preservation, and hybridity in terms of their "civicness." In the context of multiple cultures in which certain ones are considered "minority," the majority tends to see its own culture as "normal." Hence, issues related to the "minority" culture are often perceived as "minority" issues, or "personal" issues, and consequently easily dismissed as not necessarily civic. In a monolithic cultural environment, cultural issues are generally experienced as "social issues," and more easily identified as having civic dimensions or implications. As the work of the Esperanza Center, the Center for Cultural Exchange, and the *King Kamehameha I Statue Conservation Project* in Hawai'i demonstrated, however, culture itself may be a civic issue.

For further discussion, see the section "Many Voices, Many Perspectives."

Differences

Animating Democracy participants responded to the idea that arts-based civic dialogue should bring multiple (i.e., different) perspectives to the table. But they asked what constitutes *difference*, and suggested that planners remain aware of their own assumptions. Among people who share some common ground, a certain like-mindedness is often assumed when, in fact, nuanced—or even more dramatic—differences may exist. Differences within a certain group often warranted intragroup dialogue and frequently proved an important precursor to intergroup dialogue. Participants also claimed that efforts to include community members based on common categories or assumptions of difference can institutionalize existing power-laden labels. This can limit the extent to which individuals feel they can talk from different aspects (e.g., race, gender, class, religion) of their own identity.

There are two ways of coming at this work, it seems: (1) artists in community create something and dialogue is integral; or (2) other organizations begin from the product. There is a really big distinction.

—*Margery King, The Andy Warhol Museum*

Animating Democracy began with the idea that "in *arts-based* civic dialogue, the artistic process and/or the art or humanities presentation provides a key focus or catalyst for public dialogue on an issue." From the outset, the concept was intended to embrace a broad range of approaches.

Particularly in the early phase of the initiative, tensions arose between artists and dialogue specialists regarding goals, approaches, and definitions. What did "arts-based" mean? Some felt concerned that the art itself would be undervalued, or valued only as a tool for dialogue. Long-time community arts practitioners felt that purists in the dialogue field would not recognize their knowledge and skills in facilitation. Some dialogue specialists were skeptical of the artist's role in framing issues, using abstraction or humor, facilitating dialogues on difficult issues, or putting forward art with a point of view on the issue.

What comes first, the art or the dialogue? Some participants adopted "Start with art!" as a kind of arts-based civic dialogue motto, while others emphasized the importance of intent in focusing issues and planning dialogue. Norman Kleeblatt, curator of The Jewish Museum's *Mirroring Evil* exhibition, offered the metaphor of art as the "nucleus" of a project. Henry Art Gallery and The Warhol Museum were equally emphatic about the primacy of art in their arts-based civic dialogue work. Keeping the dialogue rooted in the shared experience of art, whether responding to a finished work or engaging in the process of creation, can open new ways of perceiving and communicating about the multiple dimensions of difficult issues.

Some participants adopted "Start with art!" as a kind of arts-based civic dialogue motto, while others emphasized the importance of intent in focusing issues and planning dialogue.

In contrast, filmmaker Katrina Browne proclaimed her allegiance to the civic goals. Her film, *Traces of the Trade,* retraces her ancestors' roles in the North's slave trade for the purpose of white dialogue on white privilege. She said, "I feel that the artist in me is in service to the public servant."

Several artists within Animating Democracy specialize in artistic processes that contain dialogic elements, both in form and content. John O'Neal believes that the Story Circles process and format is not only dialogic, but also innately democratic. Equal time for everyone to speak and share stories equalizes power dynamics and allows all voices to be heard. For Michael Rohd of Sojourn Theatre, dialogue is implied and recreated by the multiple perspectives represented in the text that emerges from interviews with community members, a form he calls "poetic documentary."

These are discussed in depth in "Dialogue as an Integral Part of Artistic Practice" in the section on "Artistic Practice."

The "dialogue" that took place over time among Animating Democracy's many participants provided valuable analysis of the very definitions at the center of experimentation. Some artists and programmers continued to question whether the *civic dialogue* expectation obscured the natural contributions of artmaking to civic engagement. For others, dialogue practice was usefully distinguished from conversation, discussion, deliberation, debate, activism, and discourse. Maribel Alvarez, the former director of MACLA/Movimiento de Arte y Cultura Latino Americana, said, "Many organizations entered [Animating Democracy] reaffirming loudly that this is the kind of artistic work/practice that they 'have already been doing' for many years. My sense, however, is that sometimes we think we are doing more 'dialogic practice' than we actually are. The fact that MACLA has been and continues to be a 'community-based arts organization' certainly told part of the story of our engagement with community, but it left a whole lot out about 'dialogue' that needed a closer examination." Similarly, Urban Bush Women was able to look at intuitive dialogic practice in their community work with a new and viable theoretical framework that deepened understanding of current practices and pushed them to a new level. Thus, some participants found rigor, and opportunity, in the examination of a particular kind of public exchange.

Animating Democracy and its participants moved enthusiastically within a broadened definition of "arts-based civic dialogue" to affirm and embrace culturally diverse forms of public exchange, the nonverbal as well as verbal; to reach a deeper understanding of multiple perspectives in both dialogue and art; and to understand the value of the personal and the emotional in arts-based civic dialogue. We came to believe that an expanded definition of civically engaged arts and humanities practice can lead the way to more creative solutions, emergent possibilities, and animated approaches to democratic life.

The Art of Dialogue

AN ESSAY BY PATRICIA ROMNEY

I have to answer with my life for what I have experienced and understood in art, so that everything I have experienced and understood would not remain ineffectual in my life.

— Mikhail Bakhtin, Art and Answerability

There is a powerful movement afoot. Over the last 20 years, the focus of numerous scholars and practitioners has turned to the topic of dialogue. Dialogue has become the rallying cry of our day, and we see it taking place around the world: in the community dialogues sponsored by the Study Circles Resource Center, in the development of theory and practice at MIT's Dialogue Project, in the Seeds of Peace activities between Arab and Israeli youth, and in the open dialogues of family therapists in Finland.

While debate and controversy have been the norms, an increasingly diverse and conflicted world calls us to collaborate with one another in order to survive and share the planet as one humanity. Many forward-thinking citizens of the world now realize that in order to create just and humane societies, all kinds of individuals and groups need to come together to talk about the important and controversial matters that affect their survival and progress. They are also aware that how we talk is important—dialogue must address issues of equity before it can be successful.

Dialogue, which has a long history among artists and cultural institutions, has also become an increasingly important concept in the arts community. In 1996, the Ford Foundation funded Americans for the Arts to study current activity and best practices among artists and cultural organizations whose work engages the public in dialogue on key civic issues. Animating Democracy was the outgrowth of that study.

The purpose of this essay is to describe some key ideas about dialogue. The hope is that artists and arts and cultural organizations will find this information useful as they endeavor to use art as a catalyst to encourage audiences and community participants to talk about issues that matter.[1] I will use several arts examples to illustrate the power and potential of art when it is combined with civic dialogue. The essay is organized around questions that arise when considering how to initiate art and civic dialogue work.

I begin with an example of an artistic production that did not take place. This example is one where art itself is the controversial element that sparked the need for a community dialogue.

[1] The issues that matter will vary by time and place, but may include issues such as water pollution, racism, gun violence, self-determination, etc.

A Tale of *West Side Story*

In the 1999–2000 school year, the music department of Amherst Regional High School in Amherst, MA, announced their choice for the annual high school musical. *West Side Story* was to be the first "nontraditional" musical performed at the school, where musicals such as *Kiss Me Kate* and *Damn Yankees* had dominated the reper-toire. Finally, the school would produce a musical in which people of color—Latinos specifically—would be center stage.

West Side Story had been suggested by several members of the community, and they were delighted with the choice. Other members of the community were not as happy. Unforeseen by those who had considered *West Side Story* a contribution to the multicultural efforts of the school was the vehement opposition which emerged from several Latino students and their families who viewed *West Side Story* as a racist play.

With the choice of *West Side Story* announced and the opposition becoming more and more vocal, the school community (and the wider Amherst community) disintegrated into bitter conflict that divided the community for many months, persisting long after the decision was made to call off the musical. Mirroring the warring behavior of *West Side Story*'s two rival gangs, the Sharks and the Jets, the community fell into destructive battle. There were many casualties, not the least of which was the play itself. *West Side Story* was seen alternately as an extraordinary artistic production with powerful messages about the impact of bigotry, racism, and interethnic conflict, and as a play written by Anglos characterizing Latinos as gang members as they have stereotypically been characterized in U.S. theater.

Had members of the community been able to come together in dialogue, they might have learned from one another's perspectives. They might even have created a process for community-wide dialogue and deliberation in which the complex and conflicting issues raised

by the play might have been considered. Throughout this essay I will explore these possibilities further in order to shed light on how art and dialogue can occur in a proactive, planned way.

WHAT IS DIALOGUE?

How Is It Different from Other Forms of Communication?

Dialogue is focused, intentional conversation. It has the goal of increasing understanding, addressing problems, and questioning thoughts or actions. It engages the heart as well as the mind. It is different from ordinary, everyday conversation in that dialogue has a focus and a purpose. Dialogue is different from debate, which offers two points of view with the goal of proving the legitimacy or correctness of one of the viewpoints over the other. Dialogue, unlike debate or even discussion, is as interested in the relationship(s) between the participants as it is in the topic or theme being explored. Ultimately, real dialogue presupposes an openness to modify deeply held convictions.

The citizens of Amherst *were* intentionally engaged. For most people, however, the goal was not to increase understanding or to open one's mind. Rather, the conversations among town residents and among the young people at the high school took the form of a polarized debate with two potential win/lose outcomes—to stage the musical or to halt its production. The suggestion to stage *West Side Story,* and to follow it with a postperformance dialogue about the issues of concern, was quickly defeated. Other possibilities were not envisioned or explored. For the most part, dialogue did not happen, although many town residents lamented its absence. The Amherst community fell into the trap of what Deborah Tannen calls "the argument culture":

> The argument culture, with its tendency to approach issues as a polarized debate, and the culture of critique, with its inclination to foreground criticism and attack as the best if not the only type of rigorous thinking, are deeply rooted in Western tradition, going back to the ancient Greeks.[2]

[2] D. Tannen, *The Argument Culture* (New York: Random House, 1998), 257.

The relationships between residents of the town of Amherst deteriorated during the conflict. Neighbors argued at their mailboxes while picking up the mail. Letters to the editor of the local newspaper were vitriolic and full of diatribes. The teachers who had proposed the musical came under attack and were charged with racism, though one of them was black. Students argued acrimoniously in the high school cafeteria. The focus on "for and against" positioning, and the lack of attention to respect and relationship, were endemic.

Could things have proceeded differently? Were there other options? Had the community had awareness of the process and the resources to invest in it, engagement in civic dialogue might have provided an opportunity to transcend "the argument culture."

WHAT IS CIVIC DIALOGUE?

Animating Democracy defines civic dialogue as "dialogue in which people explore the dimensions of a civic or social issue, policy, or decision of consequence to their lives,

communities, and society." Martha McCoy, executive director of Study Circles Resource Center, defines civic dialogue as "a face-to-face discussion among community members of matters of common concern and social/political importance".[3] In *arts-based* civic dialogue, Animating Democracy adds, the artistic process and/or the art or humanities presentation provides a key focus, catalyst, or forum for public dialogue on the issue. Opportunities for dialogue are embedded in or connected to the arts experience.

The term "civic" refers to citizens, city, or citizenship. This essay does not employ the term "citizen" in the formal or legal sense, but rather in the communal or societal sense of those who are members of a particular community. The civic dialogue described here *does* intentionally convey the necessity of respectful engagement with people and ideas, yet it rejects the notion of civility[4] that "suggests a superficial, pinky-in-the-air veneer of politeness spread thin over human relations like a layer of marmalade over toast".[5] True civic dialogue is inclusive of people with different communication styles and allows for the expression of emotion. Because art operates at both visceral and cognitive levels, it provides rich opportunities to engage people in the examination of issues of societal concern.

WHAT ARE THE KEY IDEAS OF DIALOGUE?

Truth and the Contributions of Socrates and Plato

Perhaps the most well-known writer on dialogue in the western world is Plato (427–347 BC). Plato's ideas are important because they are the origin or point of departure for almost all considerations of dialogue. Many people still consider Plato's ideas the absolute word on dialogue. The dialogues with which we are most familiar (actually sometimes dialogues, sometimes debates) are examples of the Socratic method of Plato's teacher, Socrates.

Often described as a form of educational dialogue in which a student's knowledge is brought forth by the teacher's expert questioning, the Socratic Method can also be viewed as an exercise in logic, and, arguably, an exercise in "being right." Socrates sometimes convinces those with whom he "dialogues" that there are only two choices before them. Despite Socrates's assertion that his wisdom consisted in knowing that he knew nothing, his rhetorical prowess and skill took the form of a kind of verbal jousting that aimed to lead the student to truth. The dialogues were strategic verbal encounters intended to outwit the "opponent" and establish the intellectual dominance of the teacher in relation to the student. In his book, *Fighting for Life,* Walter Ong has made this same observation. He "credits the ancient Greeks with a fascination with adversativeness in language and thought. He also connects the adversarial tradition of educational institutions to their all-male character."[6]

The commitment to inquiry, as well as to justice and democracy, are much of what is remembered and celebrated about Plato and Socrates. The Platonic philosophy maintains that truth is discoverable, and that, once discovered, it is eternal and unchangeable. The idea that "nothing evil can happen to someone who is good" was one "logical truth" spoken by Socrates to his accusers in Plato's *Apology*. It is a "truth" that we might contest

[3] Martha, L. McCoy, "Art for Democracy's Sake," *Public Art Review* 9, no. 1 (fall/winter 1997): 5–9.

[4] It is noteworthy that George Washington cites respect as the first rule of civility. "Every Action done in Company, ought to be with Some Sign of Respect to those that are Present." (Washington, circa 1744).

[5] Tannen, 3.

[6] Ibid., 257.

today. While the arts share Platonic philosophy's commitment to beauty and truth, our contemporary world presents new challenges to the ideas and the style of dialogue seen in the work of Plato. Today, there is a lack of agreement about what truth is, with post-modernists, feminist theoreticians, and multicultural thinkers asserting that there are multiple and conflicting realities and truths.

For the arts, there are other limitations to the usefulness of Platonic conceptions of dialogue. Socrates and Plato privileged logic in their conceptions of dialogue and saw intellectual logic as the superior way to accumulate knowledge and make decisions, and saw verbal rhetoric as a superior mode of articulation. Anything other than logic, they believed, involved too much emotion. Poetry, for example, was seen as negative because it tried to use emotion to sway people, while Socrates and Plato wanted people's judgments to avoid the intrusion of jealousy, anger, and even compassion. Yet, emotion is an important aspect of artistic work and audience response. Aside from its cathartic qualities, emotion can stimulate people's thinking as much as logic does.

The shortcomings of Platonic philosophy were evident in Amherst's controversy over *West Side Story*. There was no *one* truth. There were multiple truths and multiple realities represented in the thinking and experience of different community members. Some saw *West Side Story* as a great work of art; others perceived the music and dance as poor imitations of authentic Puerto Rican cultural expression. For some, the racial slurs in the piece—the term, "spic," for example—were offensive. One Puerto Rican student at the high school said he did not want his younger siblings to be exposed to this language when they came to see the play. Other residents championed the piece as an indictment of racial prejudice and interethnic rivalries. Some stressed the fact that U.S. musical theater typically portrays Puerto Ricans in the role of gang members and criminals, while others were not cognizant of or focused on that reality. Some members of the community foregrounded the rights of freedom of speech and freedom from censorship, while others foregrounded the pursuit of social justice and the right to self-determination over works of art which misrepresented and stereotyped their ethnicity. From a multipartial perspective, there was truth in all of these positions, and from this perspective one can assert that "truth" is impossible to ascertain with certainty in a multicultural society where differences in experiences, perspectives, power, and resources abound.

Four post-Platonic perspectives on dialogue—the "dialogism" of Bakhtin, intergroup theory, the ideas of the "new" science, and the extensive writing and research of William Isaacs—may help us consider *West Side Story* (and other arts-based civic dialogue possibilities) from the vantage point of the considerable thinking about dialogue that has emerged since the time of Plato.

Polyphony: The Contributions of Mikhail Bakhtin

The Russian philosopher Mikhail Bakhtin (1895–1975) is arguably the dialogue theorist most important to the arts because his work focuses on cultural production (the arts) and language (dialogue), and also makes use of musical terminology (polyphony, tact).

[7] Michael Holmquist, *Dialogism: Bakhtin and His World* (London: Routledge, 1990), 18.

[8] Robert Stam, "Mikhail Bakhtin and Critical Left Pedagogy," in *Postmodernism and Its Discontent*, ed. Ann Kaplan (New York: Verso, 1988), 132.

Bakhtin's work has been described as "a meditation on how we know."[7] Bakhtin's study of the arts and dialogue led him to the theory of dialogism, which he defined as the "open-ended possibilities generated by all discursive (conversational/theoretical) practices of a culture."[8] For Bakhtin, the discovery of truth was not a focus of dialogue, nor was a specific outcome certain. Rather, he saw the goal of dialogue as "responsive understanding."

Several of Bakhtin's ideas are essential to a contemporary understanding of dialogue. First, dialogism encourages us to recognize and examine the many and varied perspectives that exist in most situations. The multiple voices and perspectives revealed are not framed as either/or choices, but are all viewed as *potentially* correct. There is not just one idea or two opposing ideas to be debated, but many ideas to be heard and considered. Therefore, dialogue leads not to one certain outcome but rather to many possibilities.

Bakhtin's dialogism stands counter to Hegel's (1770–1831) philosophy of dialectics, which is based in dualism. An idea (the thesis) is challenged by an opposing idea (the antithesis), and the resulting struggle of opposite ideas is thought to lead to a new idea (a synthesis). In terms of two people, with his and her opposing ideas (thesis, antithesis), a verbal struggle reaches a consensus or compromise (synthesis).

The key distinctions between Hegelian dialectics and Bakhtin's dialogics can be understood in this way: First, while the starting point of dialectics is "either/or" thinking, dialogics sees dialogue as multivoiced (what Bakhtin calls polyphony) and does not assume, as does Hegelian dialectics, that there are only two (usually polar opposite) perspectives. Second, Bakhtin's dialogical thinking suggests no need to arrive at a synthesis or consensus, and therefore leaves open the possibility of multiple outcomes. This important distinction reflects a significant shift in thinking. Many arts and cultural organizations, already working deeply within communities comprising people of different classes, races, genders, and backgrounds, recognize that the issues are never as simple as polar opposites. Indeed, they are often well-positioned, through the eyes of artists and their creative work, to explore and imagine multiple outcomes.

Bakhtin was also clear about the role of change in dialogue, believing that dialogue always implies change. All understanding is active, and the goal of dialogue is "responsive understanding"—not understanding alone, but *responsive* understanding. In dialogue something must be said or done, not just understood. Most powerfully, Bakhtin asserts that we are to respond with our lives for what we understand through art.

Bakhtin's literary examples for distinguishing dialectic and dialogics were the works of Tolstoy and Dostoevsky, respectively. An example from contemporary art may help clarify the distinction: At a basic level, Anna Deavere Smith's work, *Fires in the Mirror,* can be seen as a dialectic or dyadic representation. Two groups are central to the story: the Lubavitcher Jews and the West Indian community of Crown Heights in Brooklyn, NY, who were in conflict about the death of a young black child who was run over and killed by a Hassidic rabbi, and about the subsequent retaliatory murder of a young rabbinical student. Other voices,

9 "One problem with polarized dualism is that areas of overlap or similarity are obscured as we look only for points of contrast. Aspects of an issue—or of a person—that do not fit easily into one or the other polarity are rendered invisible or unacceptable" Tannen, 219.

such as those of white Americans and other New Yorkers, are largely absent. The background of the U.S. power structure and the world politics that could provide the context for understanding how black West Indians and the Hassidim have come to live side-by-side in this small community in Brooklyn is also absent from the play. The framing of the issues by the two communities themselves leaves the viewer to consider which community was right in their understanding of the incident: the Lubavitchers who saw the death of the boy as a simple, albeit tragic, accident, or the West Indian community who saw this "accident" and the response to it as another example of the power and racism of the Hassidic community in Brooklyn.[9]

In contrast, Smith's work *Twilight: Los Angeles 1992*, which deals with the Los Angeles uprisings that occurred after the arrest of Rodney King and the freeing of the officers who beat him, is much more dialogic or multivoiced. In *Twilight,* we hear the voices of members of the diverse jury, the multiple voices of the black community, the elite of Los Angeles, the Korean grocery storeowners, the politicians, the victims. In *Twilight*, we have a polyphony of voices competing to be heard, and we have both the present and historical relationships among the speakers—relationships that are both complex and at times unmanageable.

Another of Bakhtin's essential ideas is that dialogue is systemic and relational. Bakhtin rejected the idea of a solitary self, believing that consciousness always evolves in the context of others. Thus, even in our own heads, there are a series of dialogues. These internal dialogues are not solely individual, rather they are the echoes of the personal and historical voices of the people and experiences that have shaped us. There is also the dialogue between oneself and a text, between oneself and artwork or artistic production. What is this production communicating to me? How do I respond to this communication? What dialogue occurs between these ideas and me? Finally, we also have the relationship between the parties who are in dialogue about the art. These parties can be engaged in a private conversation, or the conversation can become larger and engage a community, thus becoming more civic in nature. What is important, Bakhtin asserted, is that there is always a relationship between the participants that coexists with the subject or topic at hand.

Like contemporary systemic thinkers, Bakhtin recognized that everything is connected. The contexts out of which dialogue emerges include the work of art and the lives of the dialogue participants. The work of art (painting, music, composition, theater piece, dance) and the individuals participating in a dialogue are also permeated by the social context. Meaning, for Bakhtin, arose from the relationships between dialogue participants as well as from the "the whole complex *social situation* in which it [the dialogue] has occurred."[10]

10 Tzvetan Todorov, "Bahktin and the Dialogical Principle," in *Theory and History of Literature*, vol 13 (Minneapolis: University of Minnesota Press, 1984), 30.

Subsuming both Bakhtin's rejection of dualistic thinking and his assertion of the relational aspects of dialogue, Michael Holmquist, a Bakhtinian scholar, writes: "It will be helpful to remember that [Bakhtin's] dialogue is not, as is sometimes thought, a dyadic, much less a binary phenomenon. Dialogue is a manifold phenomenon...it can be reduced to a minimum of three elements...an utterance, a reply, and a relation between the two. And these three elements do not exist just in a moment of time, but can (and often do) repeat

and repeat. It is the relation that is most important of the three, for without it the other two would have no meaning."[11]

[11] Holmquist, 38.

Polarized dualism was clearly evident in the *West Side Story* controversy. Puerto Ricans were characterized, by the press and by much of the white community, as monolithically opposed to the musical, while in fact there were many internal differences of opinion. These differences were characterized by *generation* (older people who remembered the original production and how it had highlighted for them their own difficulties with racism and urban poverty; younger Puerto Ricans who did not share that history and had only a white Maria [Natalie Wood] and a Hollywood version of *West Side Story* to view); *place of birth* (Nuyoricans who lived a *West Side Story* experience; Puerto Ricans who were island born and did not have the New York urban experience); and *relationship to performance* (Puerto Rican students who were singers and dancers and really wanted the show to be produced, seeing for the first time a production that they could potentially star in; Puerto Rican students who opposed the musical and were, for the most part, students who were not performers and most likely would not have participated in the production of *West Side Story* or any musical at the high school).

Bakhtin's ideas about power are also pertinent to a full understanding of dialogue. Reminding us of the power relationships between dialogue participants, Bakhtin recognizes that the language(s) used in dialogue are tied to beliefs and ideology, and that the languages (and the *use* of the languages) differ depending on social class. To describe the power relations that are embodied in language, he used the term "heteroglossia," defining it "as competing languages and discourses: the dialogically-interrelated speech practices operative in a given society at a given moment, wherein the idioms of different classes, races, genders, generations, and locales compete for ascendancy."[12] In other words, not only do these different groups speak in different languages, but they also compete to define the terms of the dialogue.

[12] Stam, 121.

Bakhtin distinguishes the language of the dominant classes who want to have the sole right to define meaning, from the language of the oppressed who wish to appropriate language for the purpose of liberation. Dialogue, in his opinion, "becomes the space of confrontation of differently oriented social accents."[13]

[13] Ibid., 122.

To summarize, Bakhtin's work is critical to arts-based civic dialogue. First, his definition of dialogic process pushes us toward thinking of dialogue in a more complex way, as he contrasts dialectic with dialogic. For Bakhtin, dialogue is not just a one-to-one experience with one or two contrasting ideas or one possible outcome. Second, through Bakhtin we become aware of the grand dialogical principle—the idea that relationships and connections (dialogue) exist between all living beings. Third, Bakhtin recognizes the ways in which dialogue is imbued with the struggle for power. Fourth, his related study of the arts and dialogue theory offers a direct opportunity to explore their connections. Finally, with regard to the question as to whether dialogue is about understanding or about change, Bakhtin is unequivocal—true dialogue necessitates change! Although Bakhtin's work is

highly theoretical and complex, it is also intriguing. Thinking *with* Bakhtin will deepen understanding about the role of art in civic dialogue.

Exploring Group Differences: Freire's Pedagogy and Intergroup Dialogue Theorists

Another major contribution to dialogue practice comes from the intergroup dialogue educators. Intergroup dialogue,[14] an approach currently practiced on college campuses and in many other settings,[15] emerges from two tributaries. One is the intergroup relations and cross-cultural movements where the work of scholars such as Gordon Allport and W.B. Gudykunst focused on the reduction of prejudice and the improvement of relations between individuals and groups. The second crucial influence is the critical pedagogy of social justice educators such as the Brazilian Paulo Freire.

Freire's contributions are essential to intergroup educators.[16] Freire encouraged classroom dialogue, advising that when classes engage in dialogue, "the teacher is no longer merely the-one-who-teaches, but one who is himself taught in dialogue with the students, who in turn while being taught, also teach. They all become jointly responsible for a process in which all grow."[17] In addition, central to Freire's work was the examination of the role of oppression in the lives of subjugated, minority groups.

In this spirit, intergroup dialogue is a "face-to-face meeting between members of two (or more) different social identity groups who have a history of conflict or potential conflict."[18] Contemporary educators such as David Schoem, Nicholas Burbules, and Ximena Zúñiga teach courses on intergroup dialogue as a means of consciousness raising, bridging differences, and social change. Through a process of sustained facilitated communication, accompanied by a carefully crafted curriculum, over the course of a semester or two, students develop a sense of their own and others identities, explore controversial issues, and develop an understanding and commitment to social justice. According to Zúñiga, the curriculum should integrate multiple perspectives through the use of (a) diverse bodies of knowledge, conceptual organizers and metaphors that encourage participants to examine their beliefs from multiple perspectives; (b) biographies and testimonials from diverse social and cultural groups; (c) critical examination of hegemonic views and Western values and paradigms; and (d) the structuring and sequencing of course content to match participants learning needs.

Intergroup dialogue pays particular attention to the identity of facilitators, seeking always to have facilitators who mirror the social identities of the groups involved in the dialogue. Intergroup dialogue is also characterized by the building of relationships among dialogue participants. In intergroup dialogue, inquiry is a focus that is invigorated not only by good questions, but *also* by a variety of structured experiential exercises that stimulate questioning, sharing, and reflection.

Though the practitioners and theorists have focused more on the pedagogy of intergroup dialogue, their work has generated findings that are significant for arts-based civic

[14] President Bill Clinton's Initiative on Race (1998) named the intergroup dialogue model as a promising practice.

[15] Harold Saunders and Walter Stephans are two practitioners who have used intergroup education methodology in community and organizational settings.

[16] Freire's work is well-known to the artistic community because of his belief that art and cultural production are, unavoidably, regardless of intention, a reflection of social, political, and ideological conditions. The work of Augusto Boal stems directly from Freire's work.

[17] P. Freire, *Pedagogy of the Oppressed* (New York: Seabury Press, 1970), 61.

[18] Ximena Zúñiga, Nagda Biren, and Todd Sevig, "Intergroup Dialogues: An Educational Model for Cultivating Engagement Across Differences," *Equity and Excellence in Education*, 35 (1): 7–17.

dialogue. Their practice and research reveals that (1) people enter into dialogue both as individuals *and* as members of social identity groups; (2) power, privilege, and historical institutional oppression (recognized or unrecognized, acknowledged or unacknowledged) are threads weaving through all dialogue among diverse groups; (3) moving from polite or angry talk to meaningful engagement requires time and a carefully structured process which encourages questioning and reflection; (4) dialogue facilitators need not be neutral, but should act as catalysts whose questions and probes deepen the dialogue; and (5) effective dialogue involves thinking and feeling, listening and learning, as well as talking.

The intergroup perspective helps us to see that the boundaries between the private and the public, and between the personal and the civic, are quite permeable. One's private dialogues (as Bakhtin indicated) are suffused with group identity issues, intergroup experiences, and power dynamics.

In the *West Side Story* example, time for dialogue was lacking. There was one conversation with the students at the high school, but having only one meeting did not provide opportunity for sustained dialogue or deliberation; it only provided individual students with an opportunity to have their say. In serial monologue fashion, reminiscent of our talk-show culture, students heatedly and passionately expressed their opinions about whether the play should be produced. The school officials, needing to make a decision because they had either to stage the play or select a substitute, decided not to produce the show after this first meeting with students. If there had been time or if time had been allowed, a carefully structured process that encouraged questioning, reflection, and a deeper consideration might have occurred.

Power, presumed and actual, was a key part of the conflict. Members of the Puerto Rican community collectively asserted themselves visibly and vocally for what may have been the first time in the community. They saw power as traditionally being in the hands of the school system and the affluent white members of the community, and they determined to manifest their own power to stop the production. This they did, and there were many gains. A meeting was held with the local state senator who knew few of the Puerto Rican citizens in his constituency. Important connections were made at that meeting that would lead to increased advocacy and impact for the Latino community as a whole. The school convened a panel of experts to talk at an assembly about racism in the schools. Still, the outcome was experienced by many as a "win-lose" as opposed to a "win-win" situation.

Civic dialogue, if it had been achieved in Amherst, might have led to a different outcome. If intergroup dialogue methods had been used, there would have been an opportunity to explore the content of the play and attitudes about it, first within identity groups and afterward by dialogue within mixed groups.

Working first with identity groups might have interrupted the polarization, because the differences of opinions within each identity group could have been discussed. Puerto

Rican residents could have had the opportunity to explore common and differing social histories and perspectives, allowing this identity group to learn more about the diversity of opinions within its own community. The formation of identity-based dialogue groups among the white citizens of Amherst might have given them a clearer sense of how their own racial identity was shaping their opinions and would have provided the opportunity to recognize the diversity of opinion among white residents.

Bringing art more into the center of dialogue by viewing the film of *West Side Story* or acting out particular scenes from the production might have taken place at the identity group meetings. Particular scenes might have been explored first in identity groups and later in mixed groups to help elucidate the multiple perspectives and interpretations of the film. For example, viewing the scene on the rooftop where, in the piece called *America*, the Sharks and their girlfriends argue about their perspectives on the United States, might have crystallized assumptions and interpretations fueling the conflicts about the production. The scene in the candy store when Officer Krupke displays his racism leading to the Jets protecting the Sharks against it might have offered the opportunity to talk about the way racist police often pit people of color and whites against each other. As it happened, little or none of the conversation during the controversy really centered on the particulars of *West Side Story*. Rather, global assertions and assumptions characterized the debate. Some of the disputants, in fact, had seen neither the play nor the movie. Reading materials, such as Alberto Sandoval's (1999) article on *West Side Story* and readings about freedom of speech as it relates to artistic production, would have informed dialogue participants more deeply about the attitudes and positions taken by members of the opposing sides.

Wholeness: The Contributions of David Bohm and The "New Science"

David Bohm (1917–1992) is the most well-known scientist in the field of dialogue. Drawing on his work as a physicist, Bohm turned to the study of dialogue in the last years of his life. He defined dialogue as "a free flow of meaning among all the participants."[19] Bohm studied the flow of meaning in dialogues that were usually leaderless and without a specific agenda. He believed that dialogues worked best when people sat in circles, and he thought that groups that ranged from five to 40 people were of optimal size. He believed in change through dialogue, and that a dialogue should last until change occurred. The goal of dialogue, however, was not to discuss opinions, nor to move to action, but to aim for an opening of the mind, an expansion of consciousness.

Drawing from quantum physics and the theory of relativity, Bohm emphasized the development of "the whole" in dialogue. He hoped that humanity might transcend individual and even collective dimensions in order to reach the cosmic, which for Bohm included everything that is, all that exists in this world and beyond, both animate and inanimate. In dialogue, Bohm saw the flow of meaning moving in the direction of wholeness. As Bohm put it, each speaker in a true dialogue brings a part of the story. The inclusion of other participants, with their own part of the story, leads to a fuller, more complete story that ultimately serves all participants better.[20]

[19] David Bohm, *Unfolding Meaning* (New York: Routledge, 1996), 175.

[20] "The widespread and pervasive distinctions between people…which are now preventing mankind from working together for the common good, and indeed, even for survival, have one of the key factors of their origin in a kind of thought that treats things as inherently divided, disconnected…When man thinks of himself in this way, he will inevitably tend to defend the needs of his own 'Ego' against those of the others; or, if he identifies with a group of people of the same kind, he will defend this group in a similar way…What I am proposing here is that man's…general world view is crucial for overall order of the human mind itself…If he can include everything coherently and harmoniously in an overall whole that is undivided, unbroken, and without a border… then his mind will tend to move in a similar way, and from this will flow an orderly action within the whole" David Bohm, *Wholeness and the Implicate Order* (London: Routledge and Kegan Paul, 1980), xi.

To achieve true dialogue, according to Bohm, we need increased attention, deep inquiry, and collective intelligence. The focus on inquiry (curiosity and questioning) is crucial to Bohm's conception of dialogue. Bohm's emphasis is different from Socratic questioning in that no "truth" is assumed, and different from Freire in that Bohm's work is more in the realm of ideas than practice. In addition, Freire's crucial perspective on power is absent in Bohm. Through questioning and wondering together in Bohm's dialogue, those engaged in dialogue attempt to grasp the whole story, and by doing so they transform subject-object relations into relationships of partnership.

Knowledge from other proponents of what has been dubbed the "new science" (which is actually about 70 years old) also sheds light on the subject of dialogue. Another student of physics, Dana Zohar, writes of ideas similar to Bohm's in her book, *The Quantum Society*. Zohar reviews the early mechanistic thinking of classical, Newtonian physics:

> The basic building blocks of Newton's physical world were so many isolated and impenetrable atoms that bounce around in space and collide with one another like tiny billiard balls. The only actors in Newton's space–time drama were such particles and the attractive or repulsive forces acting between them.[21]

She links these images to one way of thinking about citizens today—as people bumping into each other in the pursuit of self-interest. Newer ideas emerging from quantum physics focus on waves, particles, and transformation:

> …wave fronts that come together tend to overlap and combine. The reality of each is taken up and woven into the other. Quantum systems, with their potential to be both particles and waves, have a capacity to relate on both terms. When two quantum systems meet, their particle aspects tend to stay somewhat separate and maintain shades of their original identities, while their wave aspects merge, giving rise to an entirely new system that enfolds the originals. The two systems relate internally, they get inside each other and evolve together.[22]

Zohar suggests that we need to develop a new way of looking at our social potential. Society currently needs "structures that preserve the identities of participating members while drawing them into a larger working whole."[23] She stresses that we must go beyond the individual/collective dichotomy.

Essentially, civic dialogue aims for going beyond this dichotomy to include the needs, desires, and interests of individuals, as well as of the diverse social groups of which society is comprised. This way of thinking about community was strikingly absent in the Amherst conflict. Some residents (more typically people of color) believed that a sense of community had never existed in the town. Other residents (more typically white people) believed that the sense of community had been destroyed by the Puerto Ricans' position on *West Side Story*. One white man remarked, "I never had a problem with the Puerto Ricans before. Now they have destroyed our community."

21 Dana Zohar and Ian Marshall, *The Quantum Society: Mind, Physics, and a New Social Vision* (New York: William Morrow and Company, Inc., 1994), 25.

22 Zohar, 54.

23 Ibid., 29.

Another noticeable quality of the Amherst conflict was the conviction and certainty many residents had about their ideas. At the end of the controversy, most people were in the same position as they were in the beginning; they remained certain that the perspective they had about producing (or not producing) *West Side Story* was correct. There was little questioning, very little real listening, and not much constructive learning or attitude change.

From a dialogue perspective, certainty is considered problematic and viewed as interfering with the possibility of dialogue. Humberto Maturana and Francisco Varela, two Chilean biologists and leaders in the new science, embrace the idea that reality is indeterminant and probabilistic, and they invite their readers to "refrain from the habit of falling into the temptation of certainty."[24] They caution that being certain of something does not constitute proof that it is true. In fact, they assert that an experience of certainty is a solitary and individual phenomenon and constitutes blindness to the thoughts of others. Maturana and Varela are neither artists nor dialogue practitioners, yet their admonishment regarding the "sin of certainty" speaks to what is vital to both art and dialogue. It is noteworthy that all dialogue theorists call for the suspending of certainty and a surfacing of assumptions during the process of dialogue.

[24] Humberto Maturana and Francisco Varela. *The Tree of Knowledge: The Biological Roots of Human Understanding* (Boston: Shambhala, 1992), 18.

The new science also challenges notions of objectivity and neutrality. We have learned from quantum physics that an entity, such as a photon, may be seen as a wave or a particle, depending on the methods scientists use to view it. The actions of the observer can change "reality." Given the recognition that our own actions can change what we see, we can no longer uphold the notion of a truth that is "out there" and separate from ourselves. We can no longer be certain that what we see is what "really" exists; rather, we must acknowledge that we are neither neutral nor objective observers but participant–observers who shape and define reality. As participant–observers we can choose to enter into dialogue, and we can choose to move toward change in a "reality" that is mutually discovered and responded to.[25]

[25] If the findings of quantum physics are accurate, we should reach for multipartiality—the ability to see all sides, all parts of the whole. Metaphorically speaking, we would strive to increase our capacity to see both the particles and the waves.

Dialogue's "Holding Environment": William Isaacs and the MIT Dialogue Project
Another recent and significant development in dialogue theory and practice has emerged from the Massachusetts Institute of Technology Dialogue Project. The psychologists; scientists; consultants; and healthcare, business, and community leaders who were members of the Dialogue Project, led by William N. Isaacs, developed theory, guidelines, tools, and practices for dialogue engagement in a variety of settings. Their methodology combined both clinical and action research perspectives designed to build "communities of inquiry."

They worked with a variety of groups, including a healthcare community in Colorado, a diverse group of urban leaders in Boston, a group of managers and union workers in a steel mill in Kansas City, the Parliament of World Religions, and a group of educators in Germany. The Dialogue Project also convened several conferences on dialogue.

Not given to overly simplistic or romantic ideas about dialogue, the Dialogue Project encountered in its research both the benefits and the challenges of dialogue. "Dialogue

brings people more closely together and enables them to learn to reason and think together; on the other hand, we have seen that the dissolution of boundaries and the reframing of old problems can be deeply threatening and destabilizing."[26]

[26] W. N. Isaacs, "The Dialogue Project Annual Report, 1993–1994," 2–3, www.sol-ne.org/res/wp/8004.html (accessed February 9, 2002).

Despite a sometimes destabilizing impact on systems in which dialogue work was done, the research done by the Dialogue Project still concluded that dialogue is "emerging as a cornerstone for organizational learning…a powerful way of harnessing collective intelligence and inquiry," a potential "breakthrough in the way human beings might govern themselves," and "an innovative alternative approach to producing coordinated action among collectives."[27]

[27] Ibid., 3.

Beginning their work with an understanding of many of the theories described above, Isaacs and his team came to define dialogue as "a unique form of conversation with potential to improve collective inquiry processes, to produce coordinated action among collectives, and to bring about genuine social change."[28]

[28] Ibid., 20.

Like Bohm, Isaacs and members of the Dialogue Project recognized movement toward wholeness as the aim of dialogue, and they helpfully detailed the misdeeds of thought and action that can derail true dialogue. Fragmentation of thought and fragmentation of face-to-face interaction are two frames that they developed to understand the impediments to dialogue. According to Isaacs, fragmentation of thought is a typical way that people think and is characterized by "mental mistakes"[29] that unconsciously reduce the world into parts. The characteristics of this fragmentation are:

[29] Similar ideas, described as "potholes of the mind," are presented in Yankelovich's readable book, *The Magic of Dialogue*.

- **objectification:** the tendency to see ideas as real objects instead of constructs. In Amherst, some may have seen *West Side Story* as a "real" representation of Puerto Ricans, as opposed to an artistic construction.
- **independence:** seeing interpretations of events as existing independently or outside of one's own thinking and participation. In this way of thinking, individuals fail to recognize that the way they think has an impact on what they see; we believe that the way we think does not have an impact on what we see (or think we see) going on in the world. Many Amherst residents, for example, could not see how their own history and experience (race, politics, relationship to the arts, etc.) influenced their interpretation of the play or their conviction about whether or not to produce it. Instead, they saw an independent truth (racism, free speech, community control of schools) outside of themselves to which they saw themselves responding.
- **literalness:** believing that what we think correlates exactly to what is out there. Closely related to independence, this mental habit makes the mistake of thinking that the map is the territory.
- **rigidity:** the inattention to the difference between memory and present experience. When we are engaged in rigid thinking, we believe, because of our past experiences, that we know for sure what is happening in the present. With *West Side Story*, past experiences of racism and deeply held commitment to freedom

of speech were a mental overlay that clouded discussion of the "here-and-now" issues of the possible production.

· **violence:** the effort to "correct or alter whatever we do not like." The Dialogue Project's concept of violence includes verbal transgression.

These fragmented, unexamined ways of thinking are seen as leading to fragmented ways of acting and talking. Three of these "fragmented face-to-face patterns" are described by Isaacs. One pattern is polarization. As Isaacs comments:

> To the extent that thought creates independent, objectified pictures that are of necessity partial reflections of the world, holds them as literal, and then finds them at odds with other pictures, polarization is sure to arise."[30]

"Hot inquiry" is another fragmented pattern. When dialogue participants engage in hot inquiry, they are paying too much attention to the differing and conflictual aspects of the topic at hand. They lose their focus on inquiry.[31]

The third face-to-face error that Isaacs describes is "immunity to changes in self-image." When this error occurs, dialogue participants are in the mode of resisting self-reflection and become blind to how their own mental models influence their thinking and participation in the dialogue.

Isaacs suggests that one practical response to polarization is to pay attention to the "container" or "holding environment" in which dialogue occurs. Focusing attention on the environment that "holds" dialogue allows participants to "see the water in which they have been swimming."[32]

Isaacs and his colleagues maintain that the "field" is the most important and fundamental level of dialogue. They define the field as "the environment of collective attention, identity images, and dynamic movement of tacit thought in which these are contained."[33] They assert that in order for true dialogue to occur, close attention must be paid to the psychological environment. Focusing on that psychological environment, Isaacs and his colleagues observed the four-stage developmental process described below:[34]

1. In the initial phase of dialogue, participants are focused on trust and safety in the context or environment. This phenomenon is called instability *of* the environment. In this stage, participants are focused on certain parameters to which the facilitators must attend.

2. Participants in the second phase struggle with *each other,* both getting caught in and trying to avoid the polarization and conflict that emerge when individual's different beliefs and different assumptions are revealed. Groups at this stage search for new rules to guide them and help them through. They reflect on meaning and the question of "whose meaning has more power here." Isaacs defines this as instability *in* the environment. This stage leads to the

[30] Isaacs, 24.

[31] I call this focus on inquiry maintaining a "spirit of wonder"—curiosity about others' ideas and respect for the people with whom we dialogue.

[32] Isaacs, "The Dialogue Project Annual Report, 1993–1994," "Action Dimensions of Dialogue," paragraph 7.

[33] Isaacs, 24.

[34] For clarity's sake, I have replaced Isaac's word "container" with the word "environment."

group's first efforts to suspend personal assumptions publicly and leads to the next stage.

3. In the third stage, participants begin to ask questions about the different ideas and polarizing beliefs and statements. Participants begin to wonder about their own position and those of others. Called the phase of *inquiry*, a deeper level of exchange begins to occur, leading to the fourth stage.

4. The fourth stage is characterized by *creativity* in the dialogue environment. In this phase "members begin to think generatively, and new understandings based on collective perception emerge."[35]

[35] Isaacs, 26.

Another observation of the Dialogue Project is the "chrysalis effect for social change." They discovered that after sustained, intensive inquiry leading to new collective insights, a "sea change" of new action often emerges in communities—dialogue practices are taught to others, system changes occur, collective governance emerges. The concept of a "sea change" is analogous to the concept of the "tipping point," a phrase coined by Malcolm Gladwell to describe how little things can make a big difference.

The findings of the Dialogue Project also help us to understand the lack of civic, community dialogue about *West Side Story* in Amherst from another perspective. The residents of the town were not able to get beyond the instability of the environment. There was no effective holding environment (no organization, no process, no structure) that was able to contain the fears around trust and safety. The lack of an effective holding environment led residents to vent their ideas in relative safety by writing to the newspapers or by talking to people of like minds. Occasional forays into dialogue with others who held differing points of view often led to blow-ups or quick retreats.

It is important to note that theory development in the Dialogue Project emerged not only from the study of dialogue theory but also from concrete work in many practical settings. Of particular interest is the work on educating dialogue facilitators, and the goal of producing competency among them. Isaacs defines dialogue as "an actionable skill," and reminds dialogue practitioners that a "parallel process" can occur in which the dynamics of the facilitation team reflect the dynamics of the dialogue participants.

[36] Appreciative inquiry, an approach used by many different practitioners, consists of a series of questions that help people describe their preferred future by focusing on the successes of the past and future.

Their approach to facilitation stresses modeling the behaviors one wishes to see in a dialogue. For example, the process of appreciative inquiry,[36] one of the experiential exercises they use to teach the qualities of dialogue, involves asking participants to reflect on "extraordinary experiences of communication in their lives."[37]

[37] Isaacs, "The Dialogue Project Annual Report, 1993–1994," "Sample Critical Events in the Project," paragraph 1.

We see in the ideas of the dialogue theorists discussed above the repetition of many ideas that are crucial for successful dialogues. These important ideas about dialogue are stimulating and profound; still, one may wonder about how they relate to the arts community.

The philosopher Martin Buber reminds us that the act of artmaking is in itself a dialogue:

> To all unprejudiced reflection it is clear that all art is from its origin essentially of the nature of dialogue. All music calls to an ear not the musician's own, all sculpture to an eye not the sculptor's, architecture in addition calls to the step as it walks in the building.[38]

[38] Martin Buber, *Between Man and Man.* (New York: The MacMillan Company, 1971), 25.

It goes without saying, therefore, that there is no imperative for artists or cultural organizations to engage intentionally in civic dialogue. From Buber's point of view, whether or not dialogue is intentionally created, art is a form of "utterance" to which the audience can and does respond.

However, some artists and arts and cultural organizations do choose to present their art deliberately as a basis for civic dialogue. They want to use the power of art to involve audiences at a visceral and cognitive level in the examination of issues that matter. For those artists, cultural organizations, as well as dialogue practitioners interested in employing the arts in their work, the theories of dialogue presented in this essay offer a basis for reflecting on the underpinnings of that work.

Upon launching her Institute for Art and Civic Dialogue, Anna Deavere Smith posed several reflective questions: How does the artist meet the challenge of mirroring society?

QUESTIONS FOR REFLECTION

As we look to understand principles and practices of arts-based civic dialogue, Patricia Romney's survey of dialogue theory brings forward useful concepts and frameworks. Her piece moves us to raise and think about a number of questions, such as:

How can these theories help to define the intents and parameters of an arts-based dialogue?

How do any of these dialogue theories help to understand the role of artistic provocation in engendering dialogue?

How do Bakhtin and the intergroup dialogue theorists shed light on relationships between the personal and the public in terms of the intent for art to promote civic dialogue?

How does a cultural organization assess whether it has the potential to be, as Isaacs suggests, an effective holding environment for an issue to be explored?

Does the artist have something to offer society in terms of civic leadership? Does civic space have something to offer the artist? What happens if an artist determines both to absorb and be absorbed by his or her society?

The ideas of Plato, Bakhtin, Isaacs, Bohm, the new scientists, and the intergroup theorists invite us to wonder and reflect. We see this invitation in Plato's commitment to inquiry, Bakhtin's reminders to search for possibility, the intergroup dialogues specialists' emphasis on the exploration of differences, Bohm's accentuation of deep inquiry, and Maturana and Varela's cautions against certainty. The raising of questions, what I have called elsewhere the spirit of wonder, is a *sine qua non* of dialogue. Living in the questions is a good place to begin.

In Lima, OH, for instance, the *Common Threads Project* invited Michael Rohd and Sojourn Theatre to develop a theatre piece using his creative method of poetic documentary, writing theater based on interviews. After interviewing scores of residents in Allen County, Michael composed a powerful theatre production entitled *Passing Glances: Mirrors and Windows in Allen County*. The residents had a lot to say; Michael and his company creatively transformed those words and feelings into theater. His staging created a dialogue. How could the dialogues help audiences to take another step?

For the dialogues that followed the productions there were different participants, and therefore different dialogue formats were employed. Despite the diversity of form and audience, all post-performance dialogues began with two questions: "What in *Passing Glances* most mirrored your life in Allen County?" and " What in *Passing Glances* opened a new window into someone else's experience?" These simple questions were directed toward the heart of what *Common Threads* was trying to do in Lima—to create respectful conversations about differences, a conversation that would take people both inward to self-reflection and outward to an exploration of the experiences and attitudes of their neighbors.

Sojourn Theatre's art and artmaking process included workshopping the script while it was in process. The barnstorming dialogues on excerpts of the play stirred interest in the wider community and fostered a social context in which dialogue could occur both inside and outside of the structured dialogue events. Art and the artistic process, as exemplified by Rohd's work, was well-suited to serve as a conceptual organizer or metaphor that encouraged participants to examine their beliefs and experiences from multiple perspectives. *Passing Glances*, as a work of art, enabled a new way of representing the dimensions of leadership, race, and class issues in Allen County. Perhaps most importantly, vignettes from the play, sometimes organized around questions and sometimes around metaphors such as water, got inside the issues differently than a town meeting or newspaper accounting might have done.

Marty Pottenger's work is another example of artistic production that brings key aspects of dialogue theory alive. In her multiyear project, *Abundance*, crucial questions about money and wealth were explored in artmaking–dialogue workshops and through one-on-one

dialogues between the artist and millionaires, minimum wage workers, and people in-between these economic extremes. Ultimately, Pottenger will weave these many conversations into a play. Whether millionaires, people on welfare, or average working folk, characters in the production address questions like: "What is the most money you ever made? What is a lie you tell yourself about money? What would be enough for you? What is one thing you'd need to know to make the decision to give it all away?" Through the characters, the audience is drawn in to the dialogue as well.

In workshops and on stage, individuals respond to Pottenger's powerful questions from varying classes, races, and genders. The responses are in word arias and refrigerator poetry (some of the workshop artmaking activities) and, ultimately, drama. In the responses resides the polyphony about which Bakhtin spoke. The multivoiced reflections of participants embody the coming into consciousness that Bakhtin envisioned as taking place in a collective context. The potency of *Abundance* dialogues is the collective artistic and workshop context in which power configurations (in this case connected to class) are both recognized and contained (reminiscent of the safe container about which Isaacs writes).

Power relations are central to Pottenger's work and yet they coexist with the reaching for wholeness about which Bohm, the physicist, spoke. The holding environment that Pottenger so successfully created in her workshops facilitates the birthing of creativity and dialogue, art and inquiry. All of this has resonance to participants, because the inclusiveness of voice is so palpable.

Art and dialogues take many creative forms. We may be tempted to think that dance companies should engage in dialogue only through movement, or that orchestras should engage people only through music. And yet artists' work helps us see that in the realm of spoken words, dialogue might employ movement. Dialogue theorists and practitioners help us see that understanding of movement performances can be deepened through verbal articulation.

More than anything, the theories described in this essay are intended as an encouragement to think about the philosophical grounding of dialogue, to wonder what the theories demand of artists and cultural institutions and what they suggest as cautions. My invitation, at the close of this paper, is to ask *you* to "wonder" about these ideas and their relationship to your work.

A PERSONAL NOTE

Reflecting and writing about *West Side Story* in the context of this essay on arts-based civic dialogue led me to engage in an inner dialogue. The participants in this dialogue were myself as a 16 year old who fell in love with *West Side Story* (seeing it four times on Broadway and 10 times at the movies), me as a dialogue facilitator deeply engaged in inquiry during the Amherst *West Side Story* controversy, and me as a 58-year-old woman reflecting back on both of those times.

I found myself tempted to consider what the fictional characters of *West Side Story* would have thought about dialogue. What might have changed if Maria and Tony, Riff and the Jets, and Bernardo and the Sharks had had the opportunity to engage in a dialogue facilitated by someone, like Doc, perhaps, who was not neutral, but multipartial— someone who would not choose sides, but, choosing peace, would bring the sides together.

Could there have been a dialogue? Could a dialogue have helped the Sharks and the Jets to accomplish a resolution different from murdering one another with knives and guns?

Certainly facilitated dialogue would not have erased the issues of poverty, racism, and intercultural misunderstanding. Yet, the work done by the Public Conversations Project with lead-ers of the pro-life and pro-choice organizations, while not eliminating the controversy or changing minds, is thought to have had an important role in the reduction and elimination of the violence that characterized the years prior to their dialogues. A dialogue between the Sharks and the Jets would have had to include the community beyond the gangs. It would have had to include the issues of equity, oppression, politics, and community. If there had been a dialogue, the facilitators would have needed to be a diverse team, reflecting the diversity between the Sharks and the Jets. One facilitator would have had to have been Latino and Spanish speaking.

My fanciful ruminations about the fictional characters in West Side Story gave way to questions about the real life people who were engaged in the Amherst controversy, a controversy in which town residents engaged in an unwitting parallel process in which they "stuck to their own kind" and engaged in verbal violence which led to the "killing off" of the production of this classic piece of American musical theater and the wounding of their own community.

When I was 16, New York City, where I was born, was burgeoning with the influx of Puerto Ricans. This immigration was the result of "Operation Bootstrap," a little known U.S. government initiative, which accomplished its goal of relocating thousands of Puerto Ricans from the island colony to the mainland of the United States in order to make room for the U.S. armed forces and the U.S. industrialists who would take up residence there. At 16, I understood *West Side Story*'s universal themes of love, interethnic conflict, and the perils of violence, but I was unaware of Operation Bootstrap. I believed, then, that understanding alone would help people to find together a "way of living, a way of forgiving."

When *West Side Story* moved from the theater to the movie screen, I rued the casting of the film, in which a "gringa" Maria, with an atrocious Spanish accent, was the star, while Rita Moreno, a gifted and beautiful Puerto Rican, was relegated to a supporting role. Joining "Maria" was a cast of Anglo Sharks with brown make-up on their skin, using a Spanish filled with Mexican expressions.

The residents of Amherst who opposed the play had only this unfortunate replica to view and consider. They were left, not with a classic of American theater, but with Hollywood's representation of it. Still, even the Broadway event was written, choreographed, and scored, not by Latinos, but by white artists who, however well-intentioned, mediated that period of New York through their own Euro-American lens. As Jews, these artists knew about oppression, but the racism that Puerto Ricans experienced

was not their lived experience. If art is about image-making, about meaning and metaphor, the consequences of those images were disastrous for the new potential audience of *West Side Story* in Amherst.

Through dialogue with my Puerto Rican sisters and brothers in Amherst, I re-viewed the production, and deepened my understanding of their opposition. I heard from a contemporary of mine, a Puerto Rican who grew up in New York City at the same time as I did, that his mother had refused to allow him to see this production because it was about gangs. I met with young Puerto Rican students who were adamant that this movie did not accurately reflect them or their history. It explored neither the colonial status of Puerto Rico, nor the U.S. policy that placed the Sharks in the hate-filled, poverty-stricken context into which they had been forced to move. As a mother of two adult black Puerto Rican children, I saw for the first time that none of the Sharks were black, belying the racial and ethnic heritage of a people whose heritage is composed of a visually handsome African, indigenous, and European heterogeneity.

The images and messages that reached me at 16—the devastating impact of hatred and interethnic conflict, two gangs who unfailingly stood together in opposition against racist police, the enduring

importance of love—were now joined by other images unveiled for me by younger Puerto Ricans who had lived other realities and who had arrived at other truths. In the piece "America," I had heard the words of the Puerto Rican men on the rooftop who gave voice to the perils of capitalism, racism, and oppression. Now, I understood that others heard the "ascendancy" of the women's voices celebrating the freedom and privilege of living in America. Through the controversy, I came to see multiple sides and to understand that artistic representation inevitably leads to multiple, and at times, conflicting responses.

It is a testimony to the creativity of fine artists like Jerome Robbins, Leonard Bernstein, and Stephen Sondheim that, after 40 years, *West Side Story* still has the power to evoke responses which caused people on all sides of the controversy to answer with their lives for what they had experienced and understood in that production. Decades after its crafting, the work still had the power to evoke passion, as well as to teach those who were willing to open their minds. In dance, song, and script, *West Side Story* was not an exact replica of New York Puerto Rican reality (nor did it mirror the reality of anyone else in that period), but inspired by that reality, artists gave birth to new and unique music, dance, and story. The work of the art was, in this way, well accomplished.

Still, the art of *West Side Story* is not solely responsible for the Amherst response. The long-standing colonial status of Puerto Rico, the ongoing oppression and marginalization of people of color, the struggle for jobs, educational equity, and economic justice, and the racism that still poisons the atmosphere were also essential components of the Amherst "argument." Art does not stand alone. It is created and viewed in a context. This context, too, shaped the Amherst controversy.

The future work is ours. We need to do the work of dialogue that will help our society explore, critique, celebrate, expose, even subvert, as we search for common meaning and solutions to our differences. We need to engage in the art of dialogue so that, as Judith Jordan says, we are able to "listen each other into fuller voice." We must do as Bohm advised and "get inside each other and evolve together."

It is time to provide opportunities for the collaborative voice of dialogue to emerge. It is time to create contexts in which we can think and feel and talk together in an ongoing effort to liberate ourselves and to continue to make art that will help to free and lift us all.

—*Patricia Romney*

Patricia Romney has worked with Animating Democracy as a project liaison, and dialogue consultant and facilitator on several arts-based civic dialogue projects. She is Visiting Associate Professor of psychology at Mt. Holyoke College and is a clinical/organizational psychologist and president of Romney Associates (www.romeyassociates.com). She has held academic appointments at Hampshire College and Smith College. She received a Ph.D. in clinical psychology from The City University of New York in 1980. Romney has consulted for The Saint Paul Foundation, First Steps and Healthy Families, the Donahue Institute, the Massachusetts Department of Mental Retardation, and numerous independent schools, colleges, and universities. Pat has authored over 20 articles on organizational consulting, family therapy, diversity, and education, and is a published poet and memoir writer.

References

Bakhtin, M. M. 1981. *The dialogic imagination: Four essays*. Austin: University of Texas Press.

_____. 1990. *Art and answerability: Early philosophical essays*. Austin: University of Texas Press.

Bacon, B.S., C. Yuen, and P. Korza. 1999. *Animating Democracy: The artistic imagination as a force in civic dialogue*. Washington, DC: Americans for the Arts.

Boal, A. 1990. *Theatre of the oppressed*. New York: Theatre Communications Group.

Bohm, D. 1996. *On dialogue*. London: Routledge.

_____. 1980. *Wholeness and the implicate order*. London: Routledge and Kegan Paul.

Buber, Martin. 1971. *Between man and man*. New York: The MacMillan Company.

Freire, P. 1970. *Pedagogy of the oppressed*. New York: Seabury Press.

Gladwell, Malcom. 2000. *The tipping point: How little things can make a big difference*. Boston: Little, Brown and Company.

Gudykunst, W. B. 1998. *Bridging differences: Effective intergroup communication*. Thousand Oaks, CA: Sage.

Holmquist, Michael. 1990. *Dialogism: Bakhtin and his world*. London: Routledge.

Isaacs, W. N. 1994. The Dialogue Project annual report, 1993–1994. www.sol-ne.org/res/wp/8004.html (accessed February 9, 2002).

_____. 2001. Toward an action theory of dialogue. web5.infotrac.galegroup.com/…&dyn=34!ar_fmt?sw?aep=mlin_w_remote (accessed January 24, 2002).

_____. 1999. *Dialogue and the art of thinking together*. New York: Currency/Random House.

_____. 2001. The world café: Living knowledge through conversations that matter. *The System Thinker* 12 (5).

Maturana, Humberto, and Francisco Varela. 1992. *The tree of knowledge: The biological roots of human understanding*. Boston: Shambhala.

McCoy, Martha L. Art for democracy's sake. *Public Art Review* 9, no.1 (fall/winter 1997): 5–9.

McCoy, Martha, and Michael McCormick. 2001. Engaging the whole community in dialogue and action: Study Circles Resource Center. In *Intergroup dialogue: Deliberative democracy in school, college community, and corkplace*, ed. David Schoem and Sylvia Hurtado. Ann Arbor: University of Michigan Press.

McCoy, Martha, and Patrick Scully. 2002. Deliberative dialogue to expand civic engagement: What kind of talk does democracy need? *National Civic Review: Making Citizen Democracy Work* 92, no. 2.

Plato. Euthyphro, apology, crito. *Theater of the Mind*. vol. 2, CD-ROM.

Romney, Patricia. 2001. Dialogue: The spirit of wonder. Animating Democracy website: www.AmericansForTheArts.org/AnimatingDemocracy.

Sandoval-Sanchez, Alberto. 1999. *Jose, can you see?; Latinos on and off Broadway*. Madison: University of Wisconsin Press.

Schoem, D., S. Hurtado, T. Sevig, M. Chesler, and S.H. Sumida. 2001. Intergroup dialogue: democracy at work in theory and practice. In *Intergroup dialogue: Deliberative democracy in school, college community, and corkplace*, ed. David Schoem and Sylvia Hurtado. Ann Arbor: University of Michigan Press.

Stains, Robert, R. Reflective training: Matching educational practice with transformative tntention. www.publicconversations.org/pcp/resources/resource_process.asp.

Stam, Robert. 1988. Mikhail Bakhtin and critical left pedagogy. In *Postmodernism and its discontents*, ed. Ann Kaplan. New York: Verso.

Tannen, D. 1998. *The argument culture*. New York: Random House.

Todorov, Tzvetan. 1984. Bahktin and the dialogical principle. In vol. 13, *Theory and History of Literature*. Minneapolis: University of Minnesota Press.

Washington, G. circa 1744. Rules of civility and decent behavior in company and conversation.

Yankelovich, Daniel. 1999. *The magic of dialogue: Transforming conflict into cooperation*. New York: Simon and Schuster.

Zohar, Dana, and Ian Marshall. 1994. *The quantum society: Mind, physics, and a new social vision*. New York: William Morrow and Company, Inc.

Zúñiga, Ximena, Nagda Biren, and Todd Sevig. 2002. Intergroup dialogues: An educational model for cultivating engagement across differences. *Equity and Excellence in Education* 35, no.1: 7–17.

2 Civic Implications

Making a Difference

ANIMATING DEMOCRACY PROJECTS succeeded in making a difference in their communities. Some even contributed to national public discourse. Through these projects, Animating Democracy demonstrated that civic dialogue is a meaningful and important civic outcome in and of itself. In some communities, it was significant enough that people typically at odds about an issue—people who had never been in the same room together—talked to each other for the first time. In other communities, arts-based civic dialogue projects acted as a counterbalance to the compulsion to act quickly and "solve the problem," giving people time to reflect on the issue and understand it fully before proposing or deliberating solutions. Many projects brought forward new voices, empowering disenfranchised groups and providing access to public dialogue and decision-making processes to people who had never before felt a welcoming entry point.

Animating Democracy projects provided evidence that arts-based civic dialogue can:

- Expand participation in civic dialogue, by increasing the numbers and/or diversity of people who typically would participate
- Enhance public awareness and understanding of civic issues
- Effect shifts in thinking and attitudes about an issue
- Increase participants' sense of self-efficacy and collective efficacy to take action.
- Enhance quality of, and capacity for, civic dialogue
- Engage civic leaders in a mutually responsive environment with citizens and stakeholders

Understanding
Civic Context

DEFINING CIVIC INTENT

Clear civic intent is the foundation for the most successful projects. While art can be potent in illuminating civic issues and prompting informal conversation, it can be even more powerful when efforts are planned with clear civic purpose in mind. With intention, it is more likely that arts-based civic dialogue efforts will make a meaningful difference.

Dialogue professionals and community partners are helpful in narrowing generalized notions of impact and urging cultural organizations to become clearer about their civic intent. Cultural organizations need to consider other community efforts to address an issue, as well as their own capacity, resources, and ability to sustain attention to the issue in the long run. In a close review of Animating Democracy projects, nine common goals or intents for arts-based civic dialogue work emerged, reflecting these more refined statements about civic intent:

Common Civic Dialogue Goals

- Increase visibility for, or awareness of, the issue
- Deepen understanding of the complex dimensions of the issue
- Increase tolerance and respect among people who hold different beliefs or values

[1] It is important to note that, while Animating Democracy acknowledged the full spectrum of civic impacts from social/civic commentary to action, it was most interested in projects that encouraged the exploration of the full range of perspectives on an issue, rather than projects that advocated a particular position on an issue. This explains the emphasis of goals.

- Increase participants' sense of individual and collective efficacy for action on the issue
- Help people recognize their own roles in, and responsibility for, community norms and values
- Engage civic leaders in a mutually responsive environment
- Broaden participation in dialogue about the issue, including people who are concerned about the issue but don't typically become engaged
- Frame or reframe an issue in a particular way
- Enable people to see the connections between personal experiences and civic issues

As these goals suggest, most projects sought to employ arts and culture to engage people in civic issues at a level where it is possible to broaden participation, deepen understanding of the issue, and connect civic issues to people's personal experiences. Only a few projects were action-oriented. Fewer still were intended to directly address policy change.[1]

The efforts of the Massachusetts Foundation for the Humanities (MFH) and the Esperanza Center illustrate this range of civic intent. The Foundation's dialogues centered on the film *Imagining Robert,* the personal story of two brothers—one mentally ill for 38 years and institutionalized much of that time, and the other his caretaker—and their struggles with the mental health system and the personal stresses of mental illness. With mental illness gaining ground as a national health issue, MFH organizers envisioned the film motivating new conversations about the impact of mental illness on families, about the way police deal with the mentally ill on the streets, and about how to challenge assumptions and perceptions regarding treatment, stigma, and delivery of services. While certain dialogues were geared to targeted audiences, the cumulative intent was to make these conversations public.

The Esperanza Peace and Justice Center, in contrast, is a community and cultural activist organization that is firmly committed to effecting social change. The Esperanza mobilizes action on various issues related to cultural equity and democracy, particularly as they relate to Mexicano/a and Chicano/a communities in San Antonio. Through its ongoing *Arte es Vida* program, the Esperanza fosters dialogue with cultural activities such as festivals, ritual, performance, film screenings, exhibitions, and artmaking—almost all aimed at motivating action that can lead to change. For example, the Esperanza has sought, through culturally based dialogues, to save a cultural landmark important to the Chicano/a community and to deter development of a golf course located over a major water source for the city. The Esperanza values dialogue, or *pláticas,* as an important process that is only one dimension of a larger activist strategy aimed toward civic and social change.

No matter where cultural leaders were situated on the continuum of intent, their views about the value of civic dialogue in their work expanded. Activists saw that dialogue—when effectively framed, planned, and facilitated—can have a potent effect. Similarly, those for whom dialogue was a viable goal realized that participation in dialogue activities often prompted people to want to take action.

Jay and Robert Neugeboren from the Imagining Robert *project, including the film by Larry Hott and dialogues on mental illness implemented by the Massachusetts Foundation for the Humanities, 2002.*

Arts and humanities are particularly effective in revealing the social or personal dimensions of civic issues and catalyzing dialogue around those aspects. Sharing personal experiences is an important component of many arts-based civic dialogue projects. Art embodies and/or draws out the personal, helping people see connections between their everyday lives and complex civic issues. In fact, many projects focus on the more social dimensions of civic concerns—for example, cultural identity, religious differences, and personal economic concerns in relation to larger economic inequities.

MACLA's *Ties That Bind* project explored collective memory about cultural history with the intent to contribute to the social history of place. Recognizing the civic implication of increasing demographic shifts in Silicon Valley, CA, MACLA wanted to bring to light the role of intermarriage between Asians and Latinos in shaping the history and culture of California, specifically Silicon Valley. Project leader Maribel Alvarez observed:

> The project set out to "mobilize the concept of 'social memory' as an active, productive, and relevant tool to spark conversation on contemporary civic issues of intra-ethnic [and inter-ethnic] perceptions and relationships and how identity gets defined and communicated by influence-makers and gatekeepers such as the media and civic leaders."

MACLA brought the ethnographic expertise of Alvarez and local scholars, as well as the dialogue expertise of a Latina facilitator, to draw out past and current experiences of intermarried couples and families by collecting oral histories, photographs, and objects reflecting their lives. Artists Lissa Jones and Jennifer Ahn participated in this process and then created an installation in MACLA's gallery space that became a focal point for reflection and dialogue. Renato Rosaldo—scholar, cultural anthropologist, and poet—was engaged in the *Ties That Bind* project, both interviewing families and writing about the project. He saw the *Ties That Bind* project and exhibition as a series of moments most fully realized in the public dialogue, which included multiple generations of the families, as well as media and the artists. He said, "To bring these relationships into a public space, having felt themselves invisible in the past, is civic…I felt this was the realization of the project."

Understanding context for, and current public discourse about, a civic issue is the key to defining appropriate and reasonable civic goals and to designing effective arts-based civic dialogue efforts. As cultural organizations try to articulate civic goals, they often struggle with the tension between wanting to make an impact that advances the community in a meaningful way and understanding that there are no quick fixes to complex concerns. To envision what they might expect to achieve through their creative endeavors, it's important to understand what the focus and discourse is already around the issue in a community. This relates to other community organizations' work around the issue, how it is appearing in the media, and what others are or are not doing to focus attention on the issue.

As cultural organizations try to articulate civic goals, they often struggle with the tension between wanting to make an impact that advances the community in a meaningful way and understanding that there are no quick fixes to complex concerns.

Artists and cultural organizations help to put—and keep—issues in the public spotlight. They frequently play a civic role in drawing attention to issues that are under the surface, nascent, avoided, or no longer in the public view. This is particularly true for issues of race and class. Cultural and civic dialogue organizations may see advantages in doing their work at times when there are no complications or pressures from a community crisis. At such "calm" times, however, they often find it more difficult to motivate public participation and to gain media attention.

An urgent issue can give arts-based civic dialogue efforts a sense of purpose and agency. The degree to which an issue is pressing may dictate the amount of energy needed for gaining public attention and recruiting participation in the art and dialogue. When a community is grappling with an issue, the need for public dialogue is often perceived as greater, and people feel compelled to act, especially if they have a personal stake in the issue. Because Flint, MI, experienced a devastating elementary school shooting while Flint Youth Theatre (FYT) was developing a new play that addressed the problem of school violence, FYT had to carefully assess whether, when, and how to move ahead, given both the urgency of the issue and the community's still-raw pain about its own tragedy. The theater and its partners were deeply committed to addressing the issue, but they knew the potential for harm in reopening the community's wounds and asked how to approach the local school shooting without exploiting the incident or its victims. They decided to allow a year between the incident and play. They also deliberately chose not to refer to the local shooting in any way in the play and made sure community members directly affected by the shooting were involved in planning, implementing, and monitoring the project.

Scene from ...My Soul to Take, *Flint Youth Theatre, 2001.*

Cultural organizations that hope to influence policy change may be challenged to effectively time their arts-based civic dialogue activities to legislative decision-making. Projects take time, and it is not easy to schedule events to coincide with political opportunity. Los Angeles Poverty Department (LAPD) remounted its play, *Agents & Assets*—an investigation into the advent of the U.S. crack epidemic—in Detroit specifically to take place immediately before the November 5, 2002, election, which included an initiative on treatment versus incarceration. However, the referendum was knocked off the ballot. Said LAPD founder and director, John Malpede:

> We timed the residency so that our efforts could directly enter into the public discourse as people thought about how to exercise their vote. As it turned out, no one got to vote on the issue…we learned, on the one hand, that what we thought to be strategic, ultimately was way beyond our control. On the other hand, and on the up side, it became clear that the issue of drug policy reform is a long protracted struggle…the issue is one that is building in momentum in the public consciousness. This ultimately gives us more flexibility in thinking…how we might formulate, locate and time future residencies while still making relevant contributions to the public reevaluation of these policy issues.

Organizers need to consider the community's attitudes about the issue and to define goals that connect to people at their current level of readiness. For the *Understanding Neighbors* project in Anchorage, AK, project partners carefully considered this community's recurring experiences of intense controversy and debate "in the courthouse, pulpits, streets, and the media" about issues of homosexuality and gay rights. Among these experiences was a 1996 lawsuit seeking equal legal rights for same-sex relationships, filed by Out North Contemporary Art House co-directors Jay Brause and Gene Dugan, a gay couple of 17 years. A public ballot measure prompted by the lawsuit later amended the state constitution to limit marriage to opposite sex couples only. Brause, Dugan, and a Lutheran pastor and friend considered how, in an environment of sharp polarization, they could create safe spaces to encourage respectful speaking and listening. Moved by the pastor's encouragement to focus on the personal dimensions of social intolerance, and by the opportunity to secure Animating Democracy funds, Out North directors framed a new question for public dialogue: "What is the legal, moral, and cultural place of same-sex couples in our society?" The intent was deliberately not to focus this time on policy or legislation, but rather to foster greater understanding and tolerance of difference.

Understanding Neighbors organizers reflected after the project concluded:

> It is clear that during the project the specific question of same-sex couples did not have the public prominence that it had during the constitutional amendment campaign. One coordinating committee member suggested that, "the civic question was settled by the constitutional amendment vote, but that the larger issue of acceptance and inclusivity lives on…perhaps during a time of more open contest, more people would have felt unsettled about the topic and thus been drawn to participate."…but other coordinating committee members said that the question must be asked, ready or not. Civic discussion of contentious issues is critical for the good of society.

Projects that focus on particular constituencies or dimensions of an issue have greater agency than those that define the issue too generally, or fail to bring forward contemporary manifestations of a long-standing community problem. For example, New WORLD Theater's *Project 2050* strategically engaged young people, who will be the adult leaders in the year 2050, in exploring the implications of demographic shifts in the United States. Recognizing that young people are already becoming sensitized to diversity and demographic hybridity, but that they lack civic space in which to express their opinions, NWT is not only engaging youth now, but aiming to influence future civic discourse.

The context of local, national, or world events may or may not be anticipated, but can sometimes heighten the civic value of arts-based civic dialogue efforts. For example, the opening of Henry Art Gallery's *Gene(sis): Contemporary Art Explores Human Genomics* exhibition fortuitously coincided with the completion of the human genome mapping project. This milestone scientific achievement, which was in progress when the exhibition was conceived, generated enormous media attention by raising issues in broader

public discourse that became a lively and auspicious backdrop to the exhibition. In other projects, artists and cultural leaders grappled directly with the implications of 9/11 in their work, making plans and choices in a new and charged political climate. In response to growing religious intolerance and the increasing use of ethnic/religious profiling after 9/11, City Lore (based not far from the World Trade Center site) replaced a core piece of its *Poetry Dialogues* project with a program that would give voice to the Muslim com-

Bob Holman of the Bowery Poetry Club and Ishmaili Raishidi, elder poet in City Lore's Poetry Dialogues, *2001–2003.*

munity and provide a constructive opportunity for dialogue. Cornerstone Theater Company artists wondered how they should address the tragedy through their *Faith-Based Theater Cycle.* Cornerstone reported, "After much discussion, we realized that the work itself [already] addressed the issues that faced the nation: religious tolerance, pluralism, and the power of faith to unite and divide. After September 11th, some of the artists changed their texts to acknowledge the event. Many artists, however, kept their text intact knowing that audience members would hear the lines differently." In fact, Cornerstone members observed that their interactive play, *Zones,* seemed to have greater potency immediately following 9/11 because it provided a venue to discuss and reflect on the events of 9/11. When the play was remounted a year later, and civic dialogue regarding religious tolerance had shifted to focus on the war in Afghanistan, it did not seem as potent.

Deep-rooted issues require sustained commitment over time. Organizations like the Esperanza Center, SPARC, the Center for Cultural Exchange, and LAPD are working with a long view of civic change and have the benefit of being based in a local community where continued work and many efforts over time can make a difference. The goal of action or policy change is most often defined by groups such as these, with a long-term commitment and/or activist leadership driving the effort. LAPD's work over decades has sought to influence public perception of certain issues such as homelessness, poverty, and drug policy, and to motivate action. This is not to say that organizations like museums, presenters, and orchestras, which are less driven by their mission to undertake civic change, can't or won't commit sustained attention to an issue. But they know that the limitations of their missions, the schedule-driven nature of their programs, and other institutional factors make this more challenging.

See the "Institutional Practice" section for more on this.

Reconciliation is a critical contextual concern when addressing current issues stemming from legacies of social injustice. Katrina Browne believed her film, *Traces of the Trade,* had the potential to engage white people in consideration of reparations, reconciliation, and white privilege, but for many other projects, reconciliation was not a primary goal. In projects like *The Slave Galleries Restoration Project, The Dentalium Project,* and *Arte es Vida,* the reconciliation of groups that have been historically very divided was a distant thought, beyond the scope of what organizers believed any single project could do.

Jack Tchen, public historian and writer for *The Slave Galleries Project*, proposed that civically engaged art projects take concrete steps toward the goal of reconciliation. "It's easy to say what was wrong in hindsight," he said. "You need to have a strategy of reconciliation *before*."

[2] Ferdinand Lewis, "The Arts and Development: An Essential Tension," in *Critical Perspectives: Writings on Art and Civic Dialogue* (Washington, DC: Americans for the Arts, 2005).

Writer Ferdinand Lewis reflected in his essay on *The Dentalium Project* that, "Although achieving a goal as large as reconciliation between native and non-native communities would require much more effort than any single civically engaged art project could possibly deliver, making a contribution to that goal would be a reasonable aim. At the very least, the arts could help imagine what such a reconciliation might *look like*."[2] While Dell'Arte's project did not set out to reconcile hundreds of years of injustices perpetrated on Native Americans, it did aim, through the satire of the play *Wild Card*, to shine light on contemporary issues of leadership in the city of Blue Lake, CA, and the critical need for the city's leaders to change their ways of doing business with their Native American neighbors. Michael Fields wrote, "…perhaps, most simply, an opening has been made in a wall that had been built up over a century of cultural and economic divide. As with any wall, this opening will take time and a constancy of effort to sustain…but it is our belief that this has to be addressed in an organic, comprehensive fashion, not a symbolic one. But it must be addressed, and, through the experience of this project, this has become a critical priority for us."[3]

[3] Michael Fields, "A Response to the Essays," in *Critical Perspectives: Writings on Art and Civic Dialogue* (Washington, DC: Americans for the Arts, 2005).

When civic impact is not achieved, it is frequently because civic intent is not clearly focused, because organizers frame too ambitious a goal, or because the project does not link in relevant ways to the issue, its stakeholders, or current public discourse. Some project leaders felt they fell short of their potential for civic impact. For American Composers Orchestra's (ACO) *Coming to America* project, organizers struggled to set clear and reasonable goals and expectations for civic dialogue. The project was not propelled by current issues within local immigrant communities or other targeted populations, nor was it linked strategically to other public discourse. More time was needed in working with partners to effectively develop a mutuality of purpose and then design dialogue to the needs of particular audiences—immigrants, refugees, or ACO's core audience. Similarly, The Kitchen's *Three Willies* project, while effective through its school-based activity in generating student dialogue on racial profiling, never found broader currency either in its own neighborhood (an original goal) or more broadly in New York City, despite the pervasiveness of racial profiling as an issue at the time. Urban Bush Women (UBW) concluded that the original goal of the *Hair Parties Project*—addressing development and gentrification issues in Brooklyn—was unrealistic for a project that was more catalytic than sustained in nature. Jawole Zollar concluded that, "going from individual empowerment to systemic change can't be done in a one-and-a-half hour dialogue. That needs to be done through sustained dialogue." She also noted that it would have required linking the *Hair Parties* dialogues to other ongoing efforts, something that they were not able to do during the project. She does anticipate that as UBW's relationships continue to grow and develop in Brooklyn, and as they develop ongoing and sustained programs there, the company will be able to increase its impact as a social justice organization.

"going from individual empowerment to systemic change can't be done in a one-and-a-half hour dialogue. That needs to be done through sustained dialogue."

NAMING AND FRAMING THE CIVIC ISSUE

Arts- and humanities-based civic dialogue frequently prompts new ways of framing issues for public consideration and dialogue. Because people view issues from various perspectives, the way an issue is framed can affect participation. With the ultimate goal of equitable and culturally appropriate community development, Intermedia Arts' *People Places Connections* project aimed to engage a broad cross section of Minneapolis residents who were feeling the impact of development plans in their neighborhood. Residents included a high percentage of recent immigrants, young people, artists, and lower income people who do not typically engage in civic forums and processes. Although the issue was clearly "gentrification," Intermedia Arts reframed it to speak more directly to residents' concerns. They posed the key question, "What makes you feel safe?" as an open and non-threatening invitation for community members to examine and voice concerns about the future of their neighborhood. Intermedia Arts engaged five artists to work with various community segments and to talk with each other about these issues through creative artmaking activities—movement, assembling sculptures out of found objects from the neighborhood, creating living murals, and making music.

Naming one issue sometimes obscures interconnected issues that participants might find more critical. In *The Common Threads Project*—sponsored by the Arts Council of Greater Lima in Lima, OH—community organizers initially named "respecting differences" and "trust among city and county leaders" as the issues to be addressed by the project, since they had been named as concerns in a previous community forum. However, after interviewing community members, artist Michael Rohd and dialogue advisor Patricia Romney observed that race was at the heart of these and other tensions felt by both rural and township residents, and should be more directly named. Lima organizers were concerned that rural county residents would be reluctant to engage in a project explicitly about race, but African Americans insisted it had to be addressed directly; not to do so, they said, would cause blacks to withdraw in frustration. Acknowledging that public participation hinged in part on a delicate dance of language, "respecting differences" and "trust among leaders" remained the public frame for the project. But the organizers vigorously sought representation from all sectors, and that the artistic process and dialogue activities should fully embrace—but with care—issues of race, racism, and power. On the whole, African American participation in the project was better than in previous efforts, and the project kept a focus on issues of race in Lima and Allen County.

Arts-based civic dialogue projects may raise questions about who "owns" the issue and can serve as touchstones for the examination of representation and authority. Recognizing different claims on the issue is one of the most challenging dimensions of implementing arts-based civic dialogue projects and raises fundamental questions about the role of the cultural organization or the artist: What is the impetus for the project? Who wants to talk about it and why? Who has the right to represent the issue? Whose stakes are higher?

Tensions related to ownership are persistent when dealing with issues of race, especially when a specific history is taken up to serve broader purposes. In developing cross-

Scene from Passing Glances: Mirrors and Windows in Allen County, *Sojourn Theatre, part of* The Common Threads Theater Project, *Lima, OH, 2001–2002.*

cultural dialogues stimulated by the experience of the slave galleries in St. Augustine's Church on the Lower East Side of Manhattan, the Reverend Deacon Edgar W. Hopper and other African Americans saw the slave galleries as a sacred site in African American history. At the same time, the church and its partner, the Lower East Side Tenement Museum, as well as several leaders representing other ethnic and religious segments of the community, knew that this historic space could be both an extremely potent setting and vehicle for confronting contemporary prejudice. Deacon Hopper asked how to frame the African American history of the slave galleries as part of a civic dialogue project that would inspire connections among divided segments of the Lower East Side community while maintaining ownership of both the history of slavery and current issues of marginalization of African Americans in the community. As others with a stake came forward, the complexity of ownership became even more apparent—the church's congregants harbored feelings about the congregation's complicity for generations in hiding or denying the slave galleries' existence, while higher church officials were concerned that connections between the church and slavery might prove embarrassing. The sensitivity of local partners more or less helped achieve balance between these dual goals, but maintaining that balance required constant attention, especially from Deacon Hopper and St. Augustine's.

Issues of partnerships are further discussed in the section "Institutional Practice."

Artists and cultural organizations may meet with public skepticism when they become involved in a civic issue. While some groups, such as Intermedia Arts, the Esperanza Center, and Junebug Productions, were accepted as civic players, having linked their work to civic and social concerns over many years, others had to navigate public assumptions about their commitment to, and knowledge of, the issue; their ability to be neutral; or their capacity to operate effectively in the civic realm.

Tensions may arise in relation to who is calling for dialogue on the issue, and who is framing the issue itself. Some African Americans in a pilot intragroup dialogue about the *Traces of the Trade* film were angered that resources were being directed to a white-driven project about race, despite the project's intention to get white people—who may be complacent, reticent, or fearful—to take greater ownership of the issue. Similarly, for The Andy Warhol Museum the question in mounting the *Without Sanctuary* exhibition was: Can a primarily white institution present this exhibition credibly in the eyes of the African American community? When a leader from the YWCA's Center for Race Relations was invited by The Warhol to sit on the Community Advisory Committee for the exhibition, YWCA staff facilitator-trainer Sherry Cottam reacted, "Who in the hell do they think they are, a white museum showing the history of lynching? I went down to the museum with a whole bunch of my own people." Cottam was impressed that the museum staff listened and that they became even more committed to her participation. Although the relationship got a rocky start, it developed into a close, honest, and mutually supportive one in which a cultural institution perceived as "outside" the issue took responsibility to listen and learn in order to collaborate and lead. The partnership between the museum

Recognizing different claims on the issue is one of the most challenging dimensions of implementing arts-based civic dialogue projects and raises fundamental questions about the role of the cultural organization or the artist.

and the YWCA's Center for Race Relations was crucial to the project's credibility for both African American and white community members.

Out North Contemporary Art House and Dell'Arte theater were perceived as non-neutral ground based on their past creative work and the known political beliefs of the organizations' leaders. Both organizations contended with how to address this perception in order to gain broad participation and create a safe space for a range of perspectives. In its controversial *Mirroring Evil* exhibition, The Jewish Museum, a revered cultural institution in its own community, gave the right to "speak for the Holocaust" to young artists who are one or two generations removed from the Holocaust, including some who aren't Jewish. In doing so, the exhibition overtly raised the question, "Who can speak for the Holocaust?" After hearing the museum's curators talk about their intents and experience, artist Suzanne Lacy reflected on the outrage that occurred during the exhibition among certain Jews regarding the choice of art and artists in her essay, "Seeking an American Identity":

> *Mirroring Evil* challenged traditional representations of that historical moment—how it operates in Jewish and U.S. cultural memories—but for some survivors it generated a rage around ownership of representation. Standing on the authenticity of lived experience, survivors of the Holocaust are victims, yes, but they are also empowered through the representation of their own stories, their claim to cultural voice. Curators anticipated controversy that might arise in challenging traditional perspectives of the Holocaust. It was, of course, not only tradition that was being challenged; the museum became a contest in power, the power to shape meaning through representation. Pitted against each other, it appeared as if a fundamental shift had taken place between generations of Jews, each desiring to explore and find meaning in a common heritage. The exhibition provoked heated ethical debate in the Jewish community, raising provocative questions. Did the museum ignore, in its attempt to raise current questions for a generation virtually untouched by the Holocaust, the nonnegotiable visceral experience of pain for those who endured it? Or is it possible that, as consumers of an overmediated Holocaust, we've become complacent and inured to the predictable accounts of the direct experience, needing ever more provocation? Who has "the right" to speak on the Holocaust, those with direct experience, or those whose experiences were mediated, in this case through popular culture, associative inferences, and, consequently, fantasy?[4]

4 Suzanne Lacy's essay, "Seeking an American Identity," can be found on page 191 of this book.

Lacy describes the "origination of experience and communication of it by another" as a "central conflict in community-engaged art." She asks, "If we do cross borders, work with experiences not our own, where do we locate voice and agency in our art?" She sees "community-engaged art [as] most often a process of collectively making meaning via subjectivity that is translated into an aesthetic frame made most often by someone who does not have the exact same experience. The discussion on insider and outsider is of necessity a conversation on risk, privilege, and resources that is echoed in all civic discourse."

CREATING CIVIC SPACE

How does the setting for civic dialogue activities encourage or discourage civic participation and dialogue? Beyond literal "physical" settings, public or civic space is understood as a psychological or sociological environment mediated by behavioral norms. Civic space is also characterized by its collectivity—it is a place where many people want to gather and where people feel a sense of public ownership, whether or not the space is in fact publicly or privately owned. In a civic space, people feel they can express themselves in their own ways and everyone can feel safe. The perceptions of a space based on these norms can make people feel welcome and comfortable—or not.

A Story Circle in progress at an Animating Democracy Learning Exchange, San Antonio, 2001.

Community arts and economic development specialist Tom Borrup, among others, has said, "Creating civic space is a fundamental goal that cultural activity can achieve." Cultural spaces where art is experienced sometimes offer alternatives that feel safer to some segments of the community who would not venture into more traditional civic spaces. But the opposite can also be true. Cultural organizations are not universally perceived as neutral or safe spaces, and they may be unaware of their own biases or others' perceptions of their power.

At an Animating Democracy Learning Exchange, Richard Harwood of the Harwood Institute described a continuum of the settings for public life—from private and informal to public and formal—where dialogue about civic matters occurs all the time. The first three layers—"private," "incidental," and "third places"—are rooted in daily life. In the most "private" space—people's homes—civic matters are discussed over dinner or during the nightly news, and often in the context of private concerns or beliefs. "Incidental" exchanges about civic affairs also occur informally when friends and acquaintances randomly encounter one another on sidewalks and in grocery stores. The next layer of civic life, which Harwood refers to as "third places,"[5] are the places people choose to spend their time together with others, including places of worship, community centers, clubs, and the gym. Robert Putnam, author of *Bowling Alone*, noted these spaces have become less and less central in people's lives. Although they are not expressly political in their focus, Harwood says, these "third places" are where people talk informally to get information, understand their concerns, and test ideas with others with whom they relate. These are also places that often have untapped potential for attracting people who have common civic concerns. Art centers, theaters, and museums would be considered "third places."

The fourth and fifth layers, quasi-official and official, are where input from citizens is more formalized, where leadership is professional, and where civic discourse is organized, visible, and intended to influence civic change. Harwood describes quasi-official discourse as occurring in citizen organizations, municipal leagues and committees, neighborhood crime prevention groups, and advocacy organizations and the like. The "official" layer comprises government and other entities that set policy, such as city councils, planning boards, town meetings, etc.[6]

[5] The term "third place" has been in the lexicon of planners and others. It probably originated with Ray Oldenburg in his book, *The Great Good Place* (1989). Oldenburg says: "For want of a suitable existing term, we introduce our own: the third place will hereafter be used to signify what we have called 'the core settings of informal public life.'"

[6] From a presentation at Animating Democracy's Chicago Learning Exchange, November 2001. See also the Harwood Institute website www.theharwoodinstitute.org.

Arts-based civic dialogue creates new civic spaces and enhances existing ones.
Harwood's layers of civic life offered a helpful framework for cultural organizations to see where art and cultural activity can interface, potentially catalyze, and enhance civic dialogue as it occurs within communities. Urban Bush Women (UBW) deliberately located Hair Parties in Brooklyn living rooms and beauty salons where the comfort and

familiarity of these *private* neighborhood spaces would support personally grounded dialogue and allow people to begin making connections to larger issues of race, class, and neighborhood gentrification. Performance of the *HairStories* stage piece in traditional concert hall settings (Harwood's "third place") and the connection of activities to local planning efforts (quasi-official) catalyzed dialogue in increasingly public and official settings. Through the *Hair Parties Project*, UBW's work, and the ensuing dialogue, constantly moved back and forth across these layers, building relationships and encouraging the transit of viewpoints across different levels of the community.

Poet Regie Cabico coaches a young poet at Berston Field House, Flint, MI, 2003. Photo by Tony Caldwell.

As a community and cultural activist organization, and as a matter of ongoing practice, the Esperanza Center has infused cultural activity into all layers of civic life. Through its long-term *Arte es Vida* project, the Esperanza fosters dialogue not only through door-to-door campaigns, on streets, in parks, and in more traditional performance and exhibition settings, but also directly into official-level convenings where decisions are made. Executive director Graciela Sánchez wrote:

> …part of the work of community empowerment involves our learning to see our struggle within larger contexts and to see how decisions made by government and corporate officers profoundly affect the conditions of daily life. We have presented testimony to city council, have met with individual city officials, have shown video in a state court lawsuit challenging the denial of historic preservation status to La Gloria. Because people think visually as well as verbally, because stories (like parables) enable people to ponder a complex truth in ways that linear speech does not, we often find it effective to use multi-media, multi-genre means to inform community and challenge oppressive and exploitative government and corporate actions.

> Among various actions designed to inspire public discussion on the Temple-Inland/PGA golf development, the Esperanza organized communities (targeting people of color) to speak at city council and at public hearings and gatherings throughout the city. Based on the work of cultural grounding, it was our goal to speak from our place of knowledge, history, culture, and truth. Presentations included performances by the Artescuela youth program, song, poetry, *dichos*, *cuentos*, and videos. In a "citizens to be heard" session of city council on October 24, 2002, three actors from the Esperanza performed a piece about corporate domination. The actors walked to the podium with cloth gags, which they struggled to remove as the performance progressed.

Through art, cultural organizations can transform other social and civic spaces, enhancing their conduciveness to public dialogue and their value to the community. Cornerstone Theater Company turned places of worship into performance spaces. Intermedia Arts worked through partner organizations such as schools, low-income housing communities, and youth hangouts to link arts to existing civic spaces. New WORLD Theater (NWT) witnessed a profound demonstration of the affect that public space can have on public dialogue at one of its *Project 2050* community dialogues in Holyoke, MA. That night, "the star of the evening" became the site itself when a scheduling conflict required New WORLD to move the event at the last minute into the venerable War Memorial building, formerly a forbidding symbol of the split between the city's "old" white majority and its "new," largely Puerto Rican, minority. Members of the *Project 2050* youth ensemble performed, and scholars and artists gave formal presentations on the theme of personal and community space. During the dialogue session, several audience members remarked on being in that building, which they had always felt was virtually "off-limits" to their community. Roberta Uno, who at that time was NWT's artistic director, observed, "As people experienced their own bodies coming into that space, they were inspired to speak deeply of their feelings about citizenship and civic participation, their sense of belonging and exclusion." Those feelings were expressed by a woman who said to the young people, "You honored me tonight with your performance. I'm a native of Holyoke, and it's ironic—I think this is the second time in my life I've walked into this building. For a long time I went through everything that you've talked about—being bicultural, being called illiterate. You guys are incredible, you're empowering." After experiencing the presentation, she said, "I felt like a whole person."

Placing art and cultural activity within civic spaces transforms people's experiences and expectations of what can, and perhaps should, take place there. In addition, artwork often takes on a sense of immediacy and new meaning when put in the context of civic interests. In effect, not only does art transform space, but the space also transforms the art.

Although the arts are not often integrated directly into official public forums, the effects of arts and cultural efforts may be felt at official levels. The *Common Threads* conference in Lima, OH, resulted in an "action group" of city and county officials committed to the goal of improving relations among government leaders and who established a weekly breakfast group and met consistently in the year following the conference. In addition, African Americans have stepped forward or have been invited to serve in community leadership roles. The Esperanza Center, through its efforts to save a historic San Antonio building of great meaning to the local Chicano community, gained the support of a white historical commission member who has pledged to support future efforts with new understanding of the importance of history and traditions to the Latino community and beyond. Dell'Arte's play, *Wild Card,* that drew upon small, private dialogues between Blue Lake townspeople and Native American Rancheria members, motivated two people to run for city council. One of them won and immediately created a liaison role with the Native American Rancheria to ensure ongoing dialogue between the two governments.

Placing art and cultural activity within civic spaces transforms people's experiences and expectations of what can, and perhaps should, take place there. In addition, artwork often takes on a sense of immediacy and new meaning when put in the context of civic interests.

Richard Harwood's continuum model assigns value to the full spectrum of locations where dialogue occurs, including the private level, where people naturally talk about art they have experienced and make connection to larger ideas. It suggests that gatherings, whether planning meetings of a parent-teacher organization or neighborhood watch group, need not be highly visible and "official" to be points of civic engagement and dialogue. It puts forward the idea that those desirable third places where people naturally congregate, including arts and humanities spaces, could be used more for civic purpose. It suggests that one value of art is its capacity to work in multiple levels of civic discourse, encouraging participation from one level to the next.

THE RELATIONSHIP BETWEEN THE PERSONAL AND THE PUBLIC

The arts are highly effective in bringing forward compelling and illuminating personal stories and experiences, but sometimes arts-based dialogues don't move beyond the exchange of testimonials and stories to focus on the broader civic dimensions of an issue. On the other hand, personal or emotional dimensions of an issue are typically discouraged in public discussions of civic issues because of the belief that people need hard information, surveys, and technical data in order to have informed, rational dialogue. Public historian Jack Tchen explained at an Animating Democracy gathering that, in the United States, the dominant society's notion of civil or rational behavior in public space is still influenced by the European idea of the public sphere, shaped by Enlightenment-era notions of rationality and freedom. Traces of this history of civil discourse underlie assumptions about what constitutes appropriate participation; certain modes of expression or emotion are often considered inappropriate, uncivil, or even "irrational." Yet personal and emotional stakes are high in most civic issues, such as safe schools for children; the economics of farming; and discrimination based on race, class, or gender. When people's personal experiences and identities are fundamental to their beliefs about issues, dialogue can become heated and the realms of the personal and the civic may be intimately intertwined. Further, this Western orientation to a rational public sphere is in contrast to many non-Western cultures, in which passion and emotion are expected, and respected, in public exchange. "In the Chicano community," anthropologist and writer Renato Rosaldo noted, "people don't trust anyone who's not speaking from the heart."

A recurring challenge for both arts and dialogue practitioners is how to view the relationship between the personal and the civic, the individual and the collective, the rational and the emotional. When art is linked to civic dialogue, practitioners ask: How do you facilitate a productive movement between "heart space"—the emotional experience or affective response that art evokes—and the "head space" of civic context, impact, and systemic thinking? And how do you move from the personal space of direct response to the collective space of civic dialogue? This dual challenge opens up an opportunity to consider the unique role of art at the intersection of the personal and the public.

What's the difference between personal dialogue and civic dialogue?
The *personal* dimensions of an issue may include feelings, moral perspectives or beliefs, and personal experiences and stories relating to the subject. Personal dialogue involves self-

A dialogue group within the Understanding Neighbors *project, Out North Contemporary Art House. Photo by Jay Brause.*

reflection and reflection on others' experiences, and often results in empathetic understanding. *Civic* dimensions of an issue include historical context and contemporary realities. The civic also includes social structures, laws or policies, implications of personal or collective action (or inaction), systemic thinking, and social or systemic transformation.

A discussion of what constitutes dialogue, civic dialogue, and arts-based civic dialogue is found in the earlier section "An Evolving Definition of Arts-Based Civic Dialogue."

Some contend that dialogues focusing primarily on the "personal" or even "cultural" dimensions of an issue are not *civic* dialogues. They would say, for example, a public dialogue on the experience, nature, or morality of homosexuality is not really civic; instead it should be considered public dialogue about a personal issue. However, if the public dialogue focused on systemic or policy concerns—such as gay rights, hate crime legislation, or same-sex marriage—that would be more clearly *civic* dialogue on civic issues. From this perspective, civic dialogue, by nature, aspires to move beyond a personal frame of reference to a collective consciousness and the broader public good.

But others assert that personal life cannot be separated from civic life. Since the 1970s, artists and cultural workers in the United States have made the claim that "the personal is political, and the political is personal." (This phrase was particularly associated with feminism and other movements in identity politics.) "The personal is political" first meant that personal experiences and possibilities are limited and defined by broader political and social settings and systems. It later came to mean that the choices individuals make, even those that seem totally apolitical and personal, have political implications. More recently, the meaning has turned on end to convey that the "political is personal"—that is, the political, the social, the economic, and the cultural all derive from the accumulated personal choices of individuals. Some people involved in Animating Democracy believe that it is not possible to challenge the systemic dimensions of an issue without coming to deeper understanding of the personal, human implications, and that, consequently, emotional experience and affective learning are important to the process of shifting assumptions, achieving deeper understanding, and potentially leading the way to change.

Facilitators in the arts and civic dialogue alike have learned that it is almost impossible to talk about the civic implications of certain issues without talking about personal experience. Most people move fluidly between the two modes of thought, without necessarily distinguishing from which they are speaking. The arts play a valuable role in drawing out the personal dimensions of civic issues. The challenge is to help bring the civic elements and implications forward in a process of sharing personal experience, and to help participants connect social, civic, or political issues to human meaning.

Conscious strategies are needed to connect the personal and the public. The artistic experience is often a private, emotional journey. It can be difficult to switch from the memory of a private experience or the intense emotions evoked by a work of art, to the

"rational," intellectual response expected in civic discourse. It can be equally difficult for some people to bring private or closely held stories into the public realm. Conversely, it can also be challenging to shift dialogue from an intellectual to a more personal plane.

Dialogue practitioner Maggie Herzig sees several phases in arts-based civic dialogue: (1) internal, emotional response in relation to experience of the art; (2) a connection with others in sharing your response and listening to other people's responses; (3) shaping what has been stirred by that sharing, into thoughts about how issues are dealt with in the public realm; and (4) considering what the experience of the art or dialogue implies for action.

Story can be a pivot between the personal and the public. Personal story is useful in making the transition from emotional response to civic meaning. Through personal story, participants can speak freely about feelings; connect with civic issues on a very intimate, visceral level; gain respect; and form lasting bonds with others. The structure of story circles, in particular, is innately democratic, giving each participant equal time to convey a personal story in response to a question related to the civic issue. At first, the focus is on the uninterrupted individual stories and participants are asked not to respond or converse. As the process moves along, cross-talk allows participants to ask questions and respond to those specific stories. Eventually, the structure encourages opening the conversation to broader social and civic implications.

John O'Neal (center) and Theresa Holden (right) of Junebug Productions, with Tony Tassa of Palm Beach Community College, host of the Lake Worth, FL, Color Line Project.

Director Tony Tassa, working with Junebug Productions, which employs story circle as its primary strategy, said that he was impressed with the way story circles allowed participants to speak freely on both personal and civic levels. "They discussed highly sensitive issues of racial inequality and were extremely open," he said. Urban Bush Women's Hair Parties were carefully structured to move from performance excerpts, to personal story or testimony, to civic context and implications. In a *Hair Parties Project* dialogue, for example, participants would see the dance scene of sibling rivalry, in which the sister with long, straight "good hair" lords over the sister with nappy and wild "bad hair." Dancer-facilitators would typically first ask dialogue participants to describe their own memories of good hair and bad hair. Eventually, either in the natural course of dialogue or in response to specific prompts, the conversation would lead to issues of inequity, privilege, and media representation of African-American hair. Additional performance excerpts were also used to make the transition between topic areas—or when discussion became heated or tense, as a way to keep the dialogue fresh and moving fluidly between "heart" and "head."

When stories were potentially problematic, it was a challenge to honor participants' privacy and facilitate dialogue constructively. Maribel Alvarez observed that, in MACLA's *Ties That Bind* project, "Questions of intimacy, that is, when civic issues touch the arena of the personal, are not easy dialogic enterprises, in spite of the common rhetoric about much

of dialogue being about 'sharing one's feelings.'" While some families of intermarriage shared personal stories with ethnographers and artists in the privacy of their homes, they requested that the stories about discord or other challenges not be represented publicly through the art. Ironically, however, for many of the participants, the art installation in MACLA's gallery, which respectfully avoided these stories, provided a welcoming and safe space for them to speak about the more difficult aspects of intermarriage *in public*. Anthropologist Renato Rosaldo, involved as a *Ties That Bind* interviewer and later a *Critical Perspectives* writer, wrote:

> What moved me most during the civic dialogue was how a woman—one of the interview subjects—spoke about tensions in her marriage. She did not name the sources of tension, but the fact that she was speaking made the tensions vividly present. At that point, the visual art became verbal, embodied in spoken words. I was moved and grateful that the art installation opened into a productive and moving civic dialogue. The art exhibit thus became a conversation piece that built on the interviews and led to the main show, which was the civic dialogue.[7]

[7] Renato Rosaldo, "The Social Life of an Art Installation," in *Critical Perspectives: Writings on Art and Civic Dialogue* (Washington, DC: Americans for the Arts, 2005).

In pilot dialogues about white privilege stimulated by her film *Traces of the Trade*, Katrina Browne pointed to the potential for people, however unwittingly, to tell stories that help them feel "off the hook" and blame "the other" for their circumstances. She observed a common response among white working class dialogue participants to the story of her ancestors' slave trade:

> More recent immigrants feel that slavery is not their history and eschew the idea of white privilege and its economic benefits. Participants will say, "this is not my story" and relay their family's struggle out of famine or war or persecution, enduring hardship and generations of struggle. Such stories are potentially derailing, but also provide useful fodder for dialogue with a skilled facilitator who can help support parallels but also draw out differences, and enable people to view the broader systemic benefits of being white in U.S. society.

Browne reports that, on occasion, a dialogue participant breaks through his or her reaction of dissociation to connect to the history in a new way. One dialogue participant said:

> On first watching the rough assembly, I started to cross my arms and then crossed my legs thinking these WASPs don't have anything to do with me. My family came here on the bottom of a famine ship. But then it hit me in a different way. My education, the opportunities I enjoy, an assured sense of belonging, the institutions I can engage—much of this was built in the nineteenth century—on the backs of slaves.

Arts-based civic dialogue can carve out public space for emotion.

This is a culture that looks at a purely emotional response as a lower gear to shift from.
—Jessica Gogan, The Andy Warhol Museum

You need to find ways to build capacity for communities to accept discord. Civic dialogue is not a panacea. It's about the long term, and sometimes things get worse before they get better.

—*Kinshasha Conwill, Museum Consultant*

Arts-based civic dialogue requires an understanding of the relationship between feeling and thinking, and a rethinking of the assumption that emotion is private, not public, or that public dialogue equals rational dialogue. Emotion is an unavoidable, and even welcome, presence in civic dialogue. In the dialogue field, practitioners are more and more frequently emphasizing that emotion and conflict can be appropriate and positive aspects of exchange. Their absence can signify that participants lack trust in the process or the facilitators, or that diverse perspectives have been excluded. As pointed out earlier, in some non-Western cultures emotion is an indicator that someone is speaking from the heart and therefore is speaking honestly.

Jack Tchen observed that people who have been excluded from the public sphere want to be a part of it. However, he says, once civic dialogue is opened up to include multiple communities with different cultural and historical experiences, "you have to acknowledge the emotional dimensions." Further, he noted, "We need to come up with better practices of analysis, including people in creating them." Sometimes the dialogue needs to include feelings about what it means to be emotional or to be analytic about issues. Jessica Gogan of The Warhol Museum reflected on the relationship between feeling and thinking, and the role of emotion in public dialogue:

"There exists a paradox of dialogue: the most important stories are intimate stories, and ...the connection between the personal and the social is not simply a matter of staging dialogue moments, but, in fact, entails an arduous process of translation that sometimes can be unforeseen until you are deep in the project and people's lives."

> Although the images in *Without Sanctuary* functioned as universal lightning rods for diverse individual response, it was difficult to ever get beyond the emotional and specific response of one person's or of one community's experience to address universal themes inherent in the images. At times this proved challenging for the museum and the artistic and academic culture within which it is embedded that is naturally inclined to move from the emotional to the more intellectual plane. This is a culture that looks at a purely emotional response as a lower gear to shift from. Conversely many of those from African-American communities with whom we worked were suspicious of a non-emotional response, regarding the intellectualization of these images as avoidance of dealing with racism and were extremely weary of universal themes and any extension to other biases and bigotries which they saw as another way to bury a history that has not been told, as a refusal to mourn. This push and pull between specificity and universality, emotion and intellect and one community's oppression and the oppressions of many was a struggle in the planning stages working together with community and within the institution.

Arts-based civic dialogue often taps and validates emotions. Art makes a unique contribution to civic discourse in this way; it gives permission to feel and, in the context of a communal experience including dialogue, gives permission for emotion to exist in public space. Shared emotional experience sometimes creates a bond among strangers

that encourages exchange. Art fosters emotion at a human and empathic level that is productive in civic dialogue. Art is effective in bringing to the surface deep-seated emotions based on unresolved conflict between people or even within an individual. Projects responsibly used the emotional effect of the art or humanities experience to get beyond superficial, restrained dialogue to a more honest and empathic place. Organizers of *The Slave Galleries Restoration Project* at St. Augustine's Church knew that the experience of sitting in the slave galleries was potent in and of itself. Community dialogues were, therefore, always preceded by brief historical context, but then people were invited to imagine themselves in the shoes of those who sat there. Sitting silently in the slave gallery for several minutes often stirred strong feelings. This simple but powerful sequence brought people to a different emotional place, dislodging or disorienting rigid beliefs and opening them to dialogue on difficult issues.

Deacon Edgar W. Hopper with visitors to the slave galleries in St. Augustine's Church, 2005. Photo © Hector Peña.

Arts-based civic dialogue requires sensitivity to the emotional response that the art, or the issue itself, might invoke, and calls upon skilled facilitators to provide productive mechanisms for emotional expression and response. In intergroup dialogue, for example, there are often competing languages and histories that vie for equal recognition. Without careful attention to power, differences in experience, language, and cultural norms, civic dialogue can erupt into conflict. A facilitator may need to deal with ongoing tensions or emotional flashpoints in a group, possibly deciding with the group if and when to shift from the original agenda and take up another issue that has surfaced. Facilitators in the Center for Cultural Exchange's *African in Maine* project were constantly navigating these challenges among and within divided African refugee communities whose emotional exchanges often could not get beyond clan, tribal, and cultural conflicts.

There are different ways to position personal focus on the issue within arts-based civic dialogue efforts. The artistic experience often serves to give public space for the "personal moment." For the interracial family participants in MACLA's *Ties That Bind* project, the very act of sharing their stories in the public space of the gallery exhibition had civic implications. Previously, these stories, captured in art as well as conversation, had been mostly private, not part of the larger social or civic consciousness. Giving public and artistic voice to these personal stories was itself a civic act.

One-time arts-based dialogues often aim to embrace a range of personal and civic dimensions, but organizers may find it challenging to give sufficient attention to both within a limited time frame. For the dialogues to have the greatest impact, facilitators need to be familiar with the art and adept at drawing out both the personal and civic dimensions in a strategic way. In cases like Urban Bush Women's (UBW) *Hair Parties Project,* artists trained in dialogue facilitation proved effective in drawing both realms together into an integrated dialogue. UBW developed probing questions that were customized to specific groups to encourage critical thinking: the motivations for black women to straighten their hair; the legacy of slavery; the influence of family, church, community, and workplace on

hair choices; and what lies underneath concepts of "good hair" and "bad hair." Combined with excerpts from *HairStories,* these questions helped people unpack the social and political meanings of personal experiences. UBW's alternating approach allowed one-time dialogues to move back and forth from the personal to the civic, from the micro to the macro. Rather than leaving the personal behind, they probed the personal more deeply from a different civic angle.

Curators constructed the experience of a single visit to The Warhol Museum to view the *Without Sanctuary* lynching photos and postcards, with the aim of allowing participants the choice of remaining in a private reflective space, engaging more publicly with others, or both. Knowing the likely emotional impact on both white and black visitors, the museum respected people's need for private reflection and expression by letting them write in a comment book or record a video comment in a private booth. The museum also offered various ways for visitors to make their private reflections public. The diverse voices on the videos and in print were available to all visitors, allowing them an opportunity to

Postcards with messages for tolerance written by visitors to themselves. The Without Sanctuary Project, *The Andy Warhol Museum, 2001–2002. Photo © Richard Stoner.*

read, listen, and appreciate other points of view. Visitors could complete a postcard with a message to themselves and then pin it up on a wall for public view. (The museum later mailed postcards to the people who completed them.) They could also participate in a facilitated "daily dialogue" group, or in any number of public presentations and discussions over the run of the exhibition. Many visitors availed themselves of these opportunities.

Other projects deliberately gave people space and time after they experienced art that was emotionally and/or personally charged, and before they participated in issue-based dialogues. Flint Youth Theatre's (FYT) whole project design reflected deep concern for the personal and communal emotions that many people in Flint still felt, even a year after the fatal local school shooting. Knowing that its play about school violence would prompt emotional and sometimes intense responses from audiences, FYT separated most dialogues from the play, giving people time to process their emotions. However, study circle dialogue participants—who had already convened twice in small groups—met in their own study circle groups immediately after seeing the play because they had already established the degree of safety and trust they needed to address painful feelings after seeing the play.

Extended projects that offer multiple opportunities for experiencing art and dialogue allow for a cumulative experience in which personal stories enter the public realm in different ways and settings. These personal reflections deepen understanding of the human implications of an issue and contribute to broader public discourse. *Without Sanctuary,* FYT's ...*My Soul to Take,* and many other projects—like those led by experienced community-based artists such as Marty Pottenger, Sojourn Theatre, Liz Lerman Dance Exchange, Cornerstone Theater Company, SPARC, the Esperanza Center, Junebug Productions, and Los Angeles Poverty Department—maximized this interplay of personal and public dialogue.

Many Voices,
Many Perspectives

ENSURING PARTICIPATION

> *…conservatives didn't come…my experience would tell me that when people hear [the
> project question] they just say, "if that's where you're going, I am outta here."*
>
> —*Dialogue participant in the* Understanding Neighbors *project*

Not surprisingly, one of the most common and difficult challenges identified by cultural
organizations (and seconded by those in the civic dialogue field) is attracting and engaging
the range of people who could—and should—be talking about an issue. The obstacles are
sometimes practical, like the difficulty of getting people to stay for dialogue after a two-
hour performance or overcoming limited public transportation to a program location.
More often, though, barriers are conceptual or perceptual. If people do not find the issue
expressed in terms relevant to their own lives, they will not see the value in participating.
If they do not see people like themselves involved in project leadership, they will be skepti-
cal that their views will be really welcomed and respected. People dealing with a history of
inequality or oppression often find it difficult to think of themselves as participants in pub-
lic or civic spaces. Likewise, racial identity, class status, and gender can affect intergroup

dialogue. Issues of confidentiality, a sense of safety in speaking in a group, and possibly even personal safety once outside the dialogue setting make some people apprehensive about participating. Sometimes art itself has the potential to pose a barrier to participation, since people less familiar with art sometimes worry they will not understand the art or know "the right way" to behave in response to it. Finally, the notion of "civic dialogue" itself can seem stuffy, intimidating, or outside of people's comfort zone.

Art can help break down some of the typical barriers to participation by offering an inclusive invitation, a compelling format, a reflection of various publics, and a safe space for dialogue. Much of the work of arts-based civic dialogue lies in inspiring and motivating people to come together in dialogue and in creating space where people feel safe and supported to participate fully. Common practices of community-based cultural work come into play frequently and are effective in increasing and enhancing participation, especially among disenfranchised segments of the community. The arts are not by any means a panacea for either the problem of getting people to the table or engaging them once there, but sensitive collaborations with community and dialogue partners and thoughtful dialogue design and facilitation can help overcome barriers to participation.

Scene from Body of Faith, *part of Cornerstone Theater Company's Faith-Based Theater Cycle, 2003. Photo © 2003 Craig Schwartz.*

Art and arts-based civic dialogue projects frequently offer an inclusive invitation. Often, projects target populations typically not invited to participate in public dialogues, even when those issues directly affect them. The documentary film *Imagining Robert* portrayed issues in the mental health care system by focusing on the story of one mentally ill person and his family caretaker. This focus validated the perspective of the mentally ill individual. With the help of its partner organizations, the Massachusetts Foundation for the Humanities encouraged people with mental illness to attend screenings and participate in dialogues. In Hawai'i, native and long-term residents felt welcomed into public process in large part because the statue of King Kamehameha I, as well as traditional *hula ki'i* programs organized around the restoration of the statue, provided a comfortable and respectful focal point for discussion of issues related to the future of the region. Conservator Glenn Wharton believes that, had these traditional forms not been the artistic focus, native Hawai'ians disinclined to participate in public process would have stayed home.

People often find art events more compelling than traditional dialogue formats as an impetus for participating in civic dialogue. Urban Bush Women's Hair Parties were highly anticipated because people expected them to be fun as well as thought provoking. Residents of Amery, WI, found the different artistic presentations organized by the Northern Lakes Center for the Arts a novel entry point for discussing water issues in their community. The center, with a track record of attracting a large percentage of its rural population, drew 65 percent of the entire community to an interdisciplinary

program that included poetry readings, an Amery adaptation of Ibsen's *An Enemy of the People*, a concert featuring water-related classical repertoire, a newly commissioned public art work, and an exhibition of photography chronicling life along Amery's Apple River. The center's surveys showed that audiences overwhelmingly came to the performances and exhibits because of the art and not the issue.

People feel invested to participate when they know they might see themselves or their friends and neighbors reflected in the art. Often, community members are asked to share their experiences and their perspectives about issues through interviews, oral histories, artmaking, and/or workshopping material. This kind of involvement sets the stage for subsequent participation. In MACLA's *Ties That Bind* Project, artists Lissa Jones and Jennifer Ahn, along with ethnographers, interviewed Latino-Asian families formed by intermarriage for a new installation for MACLA's gallery space, which included photos and objects from people's homes. Curious to see the work created with their images and belongings, these families—who neither frequented MACLA nor participated in public dialogues—felt respected and honored by the process. They came out to the exhibition enthusiastically and participated in meaningful dialogue with other families.

Many theater projects drew in community members at various stages during the artistic development process. Sojourn Theatre's process in Lima, OH, involved nearly 300 people in interviews as part of the development of the play *Passing Glances: Mirrors and Windows in Allen County*. Michael Rohd and company presented the work in progress for feedback twice at early stages of development. Just before the culminating performance events, Sojourn Theatre toured excerpts of the finished play around the county in an extremely effective set of "barnstorming" presentations—reaching 3,800 farmers, city council members, church congregations, and other groups, and building significant interest for the weekend performance.

People want to be able to trust that the intentions for dialogue are authentic, that confidences will be respected...

People want to be able to trust that the intentions for dialogue are authentic, that confidences will be respected and, if the art incorporates stories or histories of individuals and/or the community, that they will be sensitively portrayed. Cultural organizations and artists need to be aware of their own biases or others' perceptions of their power. Dell'Arte's theater was perceived as neither a neutral nor a totally comfortable place to meet to talk about community issues. Michael Fields noted, "Everyone was leery of talking with a Dell'Arte person in the room, as they worried that their words would end up on stage." Thus, the dialogues were conducted in a grange hall with no company members present. Wendy Morris, choreographer for Intermedia Arts' *People Places Connections* project, was aware of her privilege and power, and recalled her self-scrutiny during her deliberate recruitment process to engage diverse immigrant communities in her project. "As a white woman I've worked hard in my life not to need things from people of color just because they are people of color," she said. "Yet here I was, actively recruiting people from communities of color to create a 'cultural mix' to accomplish the goals of my project. Midway through my residency I had an ethical meltdown about this. It helped to name the situation honestly."

Understanding what makes people feel safe or unsafe is paramount in creating the best conditions for participation. In dialogue, people need to feel safe enough to honestly express their views and to say and hear things that are sometimes upsetting and painful. In their *Hair Parties Project*, Urban Bush Women (UBW) called this "kitchen talk…honest, straight-up conversation that people have in the kitchen, in contrast to sugar-coated living room conversation that is too polite to get to the heart of the matter." The language being spoken, accessibility of terms, and familiarity and comfort of the setting are some conditions that UBW addressed directly in order to create safe space. They held parties in spaces such as private homes and barbershops. Basic ground rules allowed participants to feel confident that their opinions would be respected and that they would not be judged. UBW dancers received training from dialogue consultants to help them deal with conflict and to develop awareness of what's under the table as well as on it. They learned to respond to cultural references and identify the ways that people might feel like outsiders. Rather than avoiding discomfort, they created a space for people to sit with it awhile and look to other participants to help them navigate it.

Art is particularly effective in fostering empathy for others who hold different viewpoints. Personal stories that tap the emotional dimensions of individual experience related to an issue help people connect to one another.

Arts and humanities projects can unsettle traditional power dynamics that privilege certain viewpoints, or ways of working in a community, and can help equalize power in the dialogue experience. As Daniel Yankelovich, author of *The Magic of Dialogue,* explains, "Subtle coercive influences are often present in discussion and when they are they undermine equality and, hence, dialogue." Therefore, balancing power dynamics among dialogue participants is difficult but essential. Cultural organizations and artists have to invest in understanding the history of various participants, their current power dynamics, and the perceptions they hold of each other. Urban Bush Women found that holding Hair Parties in corporations (where there may be regulations about how hair can be worn) was particularly challenging because participants were fearful of disagreeing with their bosses. There was too much risk in speaking honestly. Artistic techniques such as story circles—which are inherently democratic in their structure—fostered safety, equality, and trust. Sometimes artwork was consciously chosen or created, knowing it would challenge authority and thereby bring new voices into the dialogue. In its *Mirroring Evil* exhibition, The Jewish Museum—by featuring young artists whose work challenged the status quo of Holocaust representation—also challenged the authoritative voice of survivors and those who lived the Holocaust experience. The exhibition attracted many more young adults to The Jewish Museum than ever before.

In another instance, shifting power relationships within a community necessitated dialogue. Dell'Arte's *Dentalium Project* responded to this very circumstance in Blue Lake. Michael Fields wrote:

Our goal in this project, in essence, was to stimulate and provoke, via the art, new ways to talk about and imagine the future of this place. The casino was a catalyst, one that has turned the normal economic status quo on its head. The standard paradigm is that the minority culture is seeking equity either through economics or cultural validity, and that struggle becomes the basis of the conflict. Here, the culture that has been suppressed and depressed since the arrival of the white culture suddenly has superior economic power and is positioned, both through federal law and sheer resources, to determine the future of this place to a large extent. It can simply bypass the standard democratic process. There is irony here. There is also fear. This is where the dialogue component of this project was particularly valuable, and where we learned how to best employ it in our community.[1]

It is significant, given the generations of injustice endured by Native Americans, that *The Dentalium Project* was the first time members of both the Blue Lake and Rancheria communities ever came together in dialogue without a pressing controversy or agenda. As tribal chairwoman Arla Ramsey explained at an Animating Democracy gathering, "The federal government came to the Indian homes and took the children at age five, and sent them off to boarding school. They didn't come home until they were 15, if at all. The children lost their tribal identity, their culture, their spiritual heritage—disconnecting the tribe. When you deal with tribal communities, they don't want to deal with the general public. They stay to themselves."

Partners with authentic relationships to both stakeholders and prospective dialogue participants are key to effective recruitment and the design of meaningful arts-based dialogue experiences. It is often true (although certainly not always) that cultural organizations are not directly connected with those members of the public who have a vested interest in the issue. In this situation, arts institutions need to identify and work in consort with partner organizations who can help make appropriate connections, advise on the design of the project, and extend the invitation to participate. Advisory groups representing stakeholders and project participants can be crucial.

Issues, principles, and practices of effective partner relations and collaborative arts-based civic dialogue work are discussed in the section "Institutional Practice."

Neither the promise of excellent art nor safe space for dialogue necessarily ensures participation when issues are deeply rooted in historical injustices, fundamentally held values, or preconceptions or misconceptions of "the other." Composer John Adams reflected that preconceptions about the Brooklyn Philharmonic Orchestra's (BPO) staging of his opera, *The Death of Klinghoffer,* prevented both Palestinians and Jews from participating in dialogues in relation to it. Although Adams saw his work as giving voice to both peoples' tragedies, for Palestinians it was just another chance for people to focus on the death of a Jew rather than the oppression of Palestinians; and for Jews it showcased the murder of a Jew. A facilitator for the

[1] Michael Fields, "A Response to the Essays," in *Critical Perspectives: Writings on Art and Civic Dialogue.* (Washington, DC: Americans for the Arts, 2005).

Dialogue Project, the BPO's dialogue partner, suggested that the title of the opera itself might have suggested to Muslims and Arabs that the piece focuses on Jewish suffering and demonizes Palestinians.

The Coordinating Committee for the *Understanding Neighbors* project discovered that, despite much initial positive response to exploring the role of same-sex couples in society, when the time for the actual dialogues approached, broad sectors of the Anchorage, AK, community were *not*, in fact, ready for a dialogue on this topic. Project organizers reported that:

> Some church leaders who initially expressed support for the project curtailed their involvement during the developmental phase—a reflection of concerns over the project topic, sponsorship, lack of conservative presence and other factors such as the time required...even with conscious design to recruit across a wide spectrum of opinion on this issue, there was certainly a process of self-selection involved in volunteering to participate...the participants were, for the most part, centrists on the topic of same-sex couples. A small number of religious conservatives did participate...while many in our community were ready for respectful dialogue, and many churches continue to address this issue in their congregations, there remains much work to be done before the wider spectrum of views is well represented in face-to-face dialogue.

HONORING CULTURAL PERSPECTIVES

...We have learned that social and political divisions cannot be bridged without accurate and respectful cultural understanding...

—*Graciela Sánchez, The Esperanza Peace and Justice Center*

Animating Democracy projects raised valuable questions and concerns about cultural assumptions and expectations that may arise in arts-based civic dialogue efforts: What constitutes civic dialogue or participation in different cultural contexts or traditions? How do we reconcile tensions between indigenous, non-Western, or international approaches and Western, European, or U.S.-centered approaches to art, dialogue, and engagement? How do histories of prejudice, exploitation, or exclusion affect a community's or cultural group's view of participating in public discourse? How do we work together given these histories?

Projects that focused on culturally specific populations in particular helped to understand how cultural norms mediate public space and participation. From these projects, Animating Democracy gained substantial knowledge concerning culture itself as a civic issue; "cultural grounding" and intragroup dialogue as strategies to encourage civic participation; the connotations of language; and dialogic and artistic practices that may contain cultural assumptions or biases.[2] This section provides principles, practices, and cautions primarily from efforts with cultures based in race, ethnicity, and class; however, there are applications relevant to cultures based in faith, sexuality, or other shared practices.

[2] Culture is defined as a set of practices and expressions (including language, behavior, ritual, values, and art) shared by a group of people. It is distinguished from the biological basis of race and the national basis of ethnicity. Hip-hop culture, for example, crosses race and ethnicity but reflects a cohesive creative practice and expression.

Culture as an essential dimension of civic life

Culture is an important dimension of *civic* life, but culture is not often considered for its civic value. Negotiation of cultural priorities, especially for disenfranchised cultural groups wanting to stake claim in the public sphere, has civic import not only for these groups, but also for the community at large. Issues of cultural preservation, equity, and representation are gaining increasing visibility as they link to growth and development, economics, tourism, public funding, and other civic concerns.

Issues of **cultural preservation** were at the heart of the *King Kamehameha I Statue Conservation Project* in Hawai'i. As important ancient heritage sites are threatened by tourist industry development in the rural Kohala region, the community's choice of how to restore this statue came to symbolize the need for citizen participation and prepared people for future decisions that will affect the island's cultural heritage and the community's quality of life.

Kumu Raylene Lancaster participates in a ceremony for the King Kamehameha I statue rededication, 2001.

In San Antonio, issues of **cultural equity,** as well as issues of cultural representation and preservation, have been at the center of The Esperanza Peace and Justice Center's work for decades. The Esperanza won a lawsuit against the city to regain public arts funding, based on a claim of discriminatory resource allocation. Its *Arte es Vida* efforts have, among other goals, sought equal recognition of Latino and Chicano historic sites in San Antonio's historic preservation.

Issues of **cultural representation** were at the core of the Center for Cultural Exchange's (CCE) *African in Maine* project. Culture was a way for refugee groups seeking to stake a claim in the civic life of their new home to stay centered in their own ethnicity, while at the same time establishing identity by which others in the community could know them. The center created the opportunity for cultural productions and community-building within each of three national groups by facilitating the dialogue and decision-making necessary to accomplish these productions. *African in Maine* demonstrated that negotiation of cultural representation and priorities—which traditions to exhibit, what popular contemporary forms to "show off," what emergent cultural forms to encourage or discourage—often brought forward issues of assimilation, public dress, and public behavior. Culturally based forums such as festivals and performances provided a context for voicing frustrations, humiliations, and fears related to U.S. systems and culture, a theme that was often below the surface.

Disenfranchised cultural communities took seriously opportunities to portray themselves in order to dispel misperceptions. In Maine, for example, although internal divisions rooted in homeland, tribal, and political issues were significant within the Sudanese refugee population, the Sudanese community wanted very much to present a positive image to the larger community, highlighting their common national roots in Sudan but also retaining the cultural differences based in different tribal customs. CCE Director Bau Graves noted, "Finding some consensus on the identity issues was an a priori condition for even beginning the discussion about artistic specifics. Only after communities got clear about

who they were and how they wanted to be perceived, could they take up question about what kind of art could reflect that clarity." In San Antonio, where the economy depends heavily on tourism, the Esperanza Center has been diligent in its efforts to accurately portray the complexities of both traditional and contemporary Latino/Chicano culture. Graciela Sánchez observed, "Cities and governments, their only interest is to promote cultural tourism, and that leads to stereotyping our culture—sombreros, lazy Mexicans, Chihuahuas—and that's what our leaders want to promote."

Through the assertion of culture as an essential facet of civic life, progress has been made in building awareness among civic leaders that racial, cultural, sexual, and faith-based diversity is a prominent and permanent dimension of community, not to be ignored or relegated.

Cultural grounding as a source of power

Cultural grounding empowers people to participate in civic life, particularly those who have experienced a history of prejudice, exclusion, or exploitation. The idea of cultural grounding emerged strongly in the above-mentioned projects in relation to tensions that existed between the dominant culture and groups outside of that culture. Cultural grounding is based on the idea that a strong sense of selfhood and

identity, rooted in one's own creative expression and cultural practice, is fundamental to help people feel empowered to actively participate in a dominant political structure. In the face of pressures to assimilate, the opportunity to practice one's own culture through festivals, rituals, holiday celebrations, and art provides grounding. Being able to claim public space for such activity in the context of the dominant culture is empowering. Such opportunities for cultural grounding can encourage people to offer their voice to public dialogues and engage with others outside their community.

Women share Sudanese fashions at the Sudanese Festival, part of African *in Maine,* Center for Cultural Exchange, 2002. *Photo © Bob Coven.*

Within the context of a dominant culture, participating in culturally specific activity can advance a community in its own understanding of itself, revealing differences and commonalities. While racial and ethnic groups often have to dispel monolithic perceptions about their culture held by outsiders, there is also a need within groups to explore differences, conflicts, and the variety of viewpoints held by its own members. Intragroup dialogue is an important precursor to intergroup work, in order to explore these differences. In San Antonio, Graciela Sánchez said, "We couldn't talk to the white people, or the business people, or the people on the other side, until we talked to our own communities. Because of racism, sexism and homophobia [within our own community], we don't even feel comfortable talking to ourselves, and we had to do that grounding first." She subsequently reported:

> We have learned that in order to participate fully in democratic civic life, individuals must be culturally grounded, confident of their own voices, and certain of the value of their contributions. Art and culture give us this grounding...con-

sistent throughout our work [is] the importance of cultural grounding and the need for participants to develop their creative skills, and to recover skills of storytelling and conversation that are essential to mutual understanding and alliance building…we also found that a crucial part of cultural grounding and community empowerment is developing ways for community members to imagine that they have choices in their lives, to envision alternative ways of responding to the limitations imposed upon them, and to act on these alternatives.

Cultural organizers should not assume that members of a group all value the same cultural expressions and forms. Differences are often most pronounced between generations. In Maine, elders in the Somali community tried to dominate decisions about what cultural traditions should be presented in Somali cultural programs. Young people, on the other hand, favored popular cultural forms and asserted that opinion in community meetings to plan their events. After several conflict-laden discussions and much political maneuvering, some of the Somali elders relaxed their stance for several school-based productions despite their disapproval of modern music or dancing. This, CCE believes, was probably the result of the dialogue between the elders and youth**.** City Lore's *Poetry Dialogues* project effectively brought together traditional and contemporary forms of poetry and spoken word based in three cultures—African, Filipino, and Muslim—in order to bridge generational differences and promote dialogue and artmaking that crossed boundaries.

Greg Howard of Appalshop, a cultural organization in rural Kentucky that has worked intimately for decades with the communities of Appalachia, cautions cultural practitioners, partners, and funders not to "freeze" culture, but to support the evolution of contemporary as well as traditional forms within a culture. However, if cultural grounding should encourage and embrace the spectrum of traditional and contemporary cultural practices, difficult issues may surface in terms of which cultural practices are perpetuated, and which are left behind. Male dominance in African cultures was a source of conflict in the *African in Maine* project. To the disapproval of the men, women increasingly asserted their leadership in organizing *African in Maine* project activities and expressed greater desire for recognition and equality in general. The Center for Cultural Exchange found it challenging to balance its desire to respect self-determination while certain cultural norms perpetuated gender- or age-based inequities.

Cultural norms and forms of communication

Understanding and respecting the norms of communication of specific cultures is essential to creating the most conducive environment for participation. Cultural norms affect the way people engage in the civic realm. For instance, norms of the dominant culture that usually mediate public space and dialogue can intentionally or unintentionally exclude people of minority cultures. They can cause people to feel unable to participate in public dialogue. Histories of racial inequality or oppression also affect the desire or ability of people to participate, or even think of themselves as participants, in public forums. As art and dialogue practices are employed to foster civic engagement, it is important to be aware that they may contain cultural assumptions or biases.

"We have learned that in order to participate fully in democratic civic life, individuals must be culturally grounded, confident of their own voices, and certain of the value of their contributions. Art and culture give us this grounding…"

Carmen Luhan creates a work in clay about the murders of young women in Juarez, Mexico, in the Esperanza's Arte es Vida project.

Western approaches to dialogue such as town hall-style forums or structured small group dialogues, for example, often do not work in cultures where norms and forms of public exchange and decision-making specific to the culture operate. In Hawai'ian culture, it is unwritten but understood among long-time and native residents that the decision-making process is based on a Hawai'ian kind of conversation called "talk story," a culture of 'ae like (consensus), and respect for the wisdom and approval of the kupuna (elders). Talk story is defined as "a complex art consisting of recalled personal events, parts of legends, joking, verbal play, and ordinary conversation…people often talk story as a means of searching for and recognizing shared feelings."[3] Hawai'ians recognize talk story as one of the few cultural traditions that did not die out when Western ways supplanted most others. Town meeting-style public deliberation did not become part of local process until Caucasian newcomers arrived. Agenda-driven meetings intended to resolve issues quickly are not geared toward consensus and are not a zone of comfort for most long-time Hawai'ians. Marilyn Cristofori wrote, "…we knew that talk story, along with other traditional community sharing activities, would be the only way to ensure a full and active community participation in this project." However, she noted, they found it difficult to describe talk story fully to colleagues on the mainland. In Hawai'i, where cultures have blended over time, cultural traditions and modern democratic processes co-exist in the public sphere. Democratic processes of voting and public forums (such as an opinion poll and a high school debate that locals organized to decide the restoration fate of the King Kamehameha I statue) operated alongside traditional talk story and protocols like seeking advice and blessings of kupuna.

[3] S. Boggs, K. Watson-Gegeo, and G. McMillan, *Speaking, Relating and Learning: A Study of Hawai'ian Children at Home and at School* (Norwood, NJ: Ablex Publishing Company, 1985).

A high school debate about how to conserve the King Kamehameha I statue also engaged community members in "talk story" about the region's future, 2001.

Norms of public behavior such as argumentation or emotion vary in different cultures. Latino and African-American participants in Animating Democracy pointed out that a lot of cultures, including their own, reject the Western preference for "rationality" and "civility." They view emotion as a sign that dialogue is coming from a heartfelt and true place. African Americans who participated in pilot dialogues about the *Traces of the Trade* film were skeptical of whites who did not express emotion as they confronted white privilege, questioning the authenticity and honesty of their words.

Dealing with layered divisions and heated conflict within each of the Somali, Sudanese, and Congolese communities was an ongoing challenge of the *African in Maine* project. Center for Cultural Exchange organizers reported:

> The thicker the conflicts, the more time they require…the dynamic between individuals within each community often pushed our attempts to create an environment of inclusive dialogue aside. In good facilitative style, we would generate a list of ground rules at the outset, but in practice preexisting interpersonal dynamics overrode such efforts. This problem was enormously exacerbated by the language barriers that prevented facilitators and some participants from even basic understanding of what was being said. Our attempts to generate open dialogue were also challenged by individuals and sometimes organized groups who resisted participation, usually by simply

failing to attend meetings, but on a couple of occasions by showing up and pointedly refusing to enter the discussion. Of course, outside of our meetings, they were very vocal about their feelings. Some, perhaps most, of the actual communication that eventually brought people together took place offsite, in personal conversations, rather than in the forum that the center created. It made us wonder about the useful limits of an accepted definition of dialogue, which assumes a willingness to participate by all parties that is not always a given.

Listening, another norm of public exchange, is assumed to be valued across cultures, but there are cultural differences in how people are made to feel heard and respected. Participants from identity groups that have been historically suppressed or silenced, such as people of color or women, say that methods controlling or regulating responses (especially when led by white or male facilitators) can recreate the sensation of silencing, causing resistance or discord in the dialogue group. They assert that balancing all voices equally is not enough, because dominant identity groups have been heard far more.

Native American journalist David Rooks, a writer for Animating Democracy's *Critical Perspectives*, conveyed the Native American community's issues about listening: "...we have a Native saying, 'Don't listen to what they say, watch what they do.'" How might this cultural directive—*not* to listen, but to watch—potentially affect intergroup dialogue efforts if "listening" is emphasized as a prerequisite for dialogue but Native American experience and wisdom supposes otherwise? Knowledge of the Native American experience and perspective might move an artist or facilitator to creatively explore the relationship between statements and subsequent actions.

Within cultures—or across them—the lack of a common language posed practical challenges to facilitating, translating, and encouraging dialogue, as well as creating art as the focal point for dialogue. Working across cultures, artists in Intermedia Arts' *People Places Connections* project used the nonverbal language of visual art, movement, or music as a common language, at least to begin the process of communication. Artist Marilyn Lindstrom, when working with young people of various ethnicities at Hope Community, asked them to research and create culturally centered icons in mosaics. The creative process became an entry point to all sorts of cross-cultural discussions. In addition, which language is privileged in a multilingual project sets up power dynamics and can deter participation of people who do not speak the privileged language.

See the sidebar on San Diego REPertory Theatre and the challenges it faced in creating a bilingual play about U.S.-Mexico border issues through its Nuevo California *project.*

The Esperanza Center's *Arte es Vida* activities pointed to language issues that went beyond language to issues of economic development and class. The Esperanza Center's audiences are predominantly Spanish-speaking (meaning that they speak Spanish at home or work and that they feel most comfortable conversing in Spanish). A majority of them are, or were raised, poor or working class. Graciela Sánchez explains:

Latino and African-American participants in Animating Democracy pointed out that a lot of cultures, including their own, reject the Western preference for "rationality" and "civility." They view emotion as a sign that dialogue is coming from a heartfelt and true place.

For numerous reasons, many of the people in our audiences do not feel comfortable speaking in a public gathering. They have been told they do not speak clearly or do not speak English or Spanish well. They hear others speak and feel they are not as smart or not as knowledgeable. They are afraid they will not be understood; that they will speak for too long; or they will say the wrong word. This hesitation or uncertainty is especially evident in women.

Accessibility and acceptance of vocabulary can also hamper dialogue. At one of Animating Democracy's own gatherings, a participant objected to a presenter's use of particular terms, suggesting that it privileged those who had a certain expertise in civic affairs and alienated those who did not. The exchange prompted frustrations about the absolute necessity of working through such language barriers, while the presenter and some others wanted to respect, but "put aside," the language question in order to move on with the content at hand. This led one participant to remark in near despair, "I don't know if dialogue is possible, if every word that comes out of my mouth is tainted, if I am so concerned about my ability to talk that I can't have dialogue." In its *Hair Parties Project,* Urban Bush Women (UBW) learned to identify when people might feel outside of the story because of culturally specific terms such as "nappy hair" and "kitchen" that related to African-American hair culture. UBW developed performance-based dialogues to include a character called Dr. Professor, who helped clarify references that diverse audiences might not understand. Dancer-facilitators also learned how to facilitate the dialogue so that the translation of certain unfamiliar vocabulary and humor could grow out of the group.

Aesthetic choices in a cultural context

Aesthetic choices can intentionally—or inadvertently—empower or exclude participants. Different aesthetic traditions have histories of power and legitimacy within a culture, suggesting the importance of considering the historical meaning and context of a form and asking how that may help or hinder the overall goals of a project.

"part of dialogic process is being able to share authority."

Culturally specific aesthetic forms can help open the space for multiple modes of expression, sometimes because they communicate in the language of culturally specific groups, incorporate traditional ritual, or are nonverbal forms such as music or movement. In some cases, artistic or cultural expressions that are dialogic in nature encourage conversation. For example, in the traditional image dance form of *hula ki'i,* puppet characters express all manner of human behavior through drama, movement, humor, and song. In Hawai'ian history, hula sometimes served to communicate messages that otherwise could not be expressed publicly or directly. Many layers could be added to the story. For the *Kamehameha Statue Conservation Project, hula ki'i* workshops, in which local people made puppets and learned a hula created to tell the statue's story, provided a cultural context for conversation about history and cultural traditions and the value of preserving them.

City Lore's *Poetry Dialogues* project consciously employed forms of poetry that are inherently dialogic in nature and that explored poetry's potential contributions to broader civic dialogue. Debate or dialogue happened within the performances, especially of *balagtasan*

(a Filipino genre, often practiced in Tagalog, one of the major languages spoken in the Philippines, in which poets debate issues and challenge one another's positions in rhyme) and freestyling (in hip-hop aesthetics, an improvisational form of rap). Through *balagtasan*, Filipino youths debated in Tagalog the question of whether or not to attend college, while English translations were provided on an overhead projector. A dialogue facilitator then led an intense dialogue with 40 Filipino teenagers in which they related a wide variety of personal issues on both sides of the argument. This ultimately led to a second dialogue on Filipino-American identity, a key issue for the students in the aftermath of September 11 when a wave of patriotism made it difficult to sustain multiple identities.

Poet Toni Blackman in a cipher with fellow artists, The Poetry Dialogues, City Lore, 2001–2003.

"Of all the poetry forms with which we experimented, freestyle rap clearly showed the greatest potential for generating dialogue," reported City Lore Director Steve Zeitlin. For example, at one poetry dialogue the topic of "ghettos are beautiful/ghettos are not" was executed in freestyle debates performed by the African-American poetry team led by Toni Blackman. Many issues of civic dimension were touched upon: poverty in African-American neighborhoods, drug abuse, gun violence, lack of jobs and opportunity, for example. Following the performance, the discussion of race, identity, and language—particularly around the use of the word "nigger" historically, in music and media, and in black communities now—was deeply sociopolitical. Zeitlin observed, "Toni Blackman's ability to ask community audiences for subjects that they would like to discuss, and then work them into a discussion in freestyle form is simply astonishing dialogic presentation. Although the dialogues are 'in your face,' they are able to raise intelligent arguments and at the same time vent emotions in a way that leads to a reasoned conversation." Zeitlin contends that poetry is an intensification of language that inspires heightened response. He believes that moving from poetry to dialogue—influenced by both the talents of the youth and facilitator poets and the wise commentaries of the elder poets—"elevated" the ensuing conversations. Not only were audiences more open, offering personal experiences as well as both emotional and intellectual responses, but they also communicated in heightened language, using repetition, rhythm, and metaphors that might not have been elicited otherwise.

Cultural considerations in civic dialogue practice

Animating Democracy projects suggest a set of cultural considerations and best practices to help ensure appropriate sensitivity and responsiveness to cultural differences in arts-based civic dialogue endeavors.

Understanding fundamental cultural values. Beyond barriers of language and protocol, communicating effectively within and across cultures requires deep understanding of fundamental cultural values. Education about these values is both a prerequisite to, and a part of, the process of public dialogue, and demands commitment, time, and patience from all participants. Native Hawai'ian and hula master Raylene Lancaster has offered this insight into understanding fundamental cultural values:

San Diego REP brought together a binational ensemble to create *Nuevo California*, a multilingual play that explores physical and cultural boundaries along the United States/ Mexico border. The play's development process aimed to engage citizens on both sides of the border in dialogue centered around a catalytic question: Should we tear down the fence that separates San Diego and Tijuana, or should we build it higher?

The border fence between the United States and Mexico, the dramatic focus of San Diego REPertory Theatre's Nuevo California, *2001–2003.*

SAN DIEGO REPERTORY THEATRE: CHALLENGES IN CREATING A MULTILINGUAL PRODUCTION

Though the binational project team intended to create one multilingual production for presentation in the United States and Mexico, the play ultimately evolved into two—one in English, one in Spanish. The challenges of cross-cultural work, coupled with time and financial constraints, made the goal of creating one play for both U.S. and Mexican audiences unreachable, especially given the project's time frame. In the end, only the English version of the *Nuevo California* script was completed and presented in San Diego; the Spanish version was left unfinished. Thus, what was envisioned as a binational project evolved into one with a U.S. focus.

Working in a bilingual environment proved a formidable challenge for the project team as they conducted research and developed the script, and for the cast in presenting readings in both countries. Most Mexican and U.S. cast members had not worked in the other country before. Some spoke only their native language. While dialogue events were facilitated with professional English-Spanish interpreters, the creative workshops and rehearsals were not.

In this setting, monolingual artists—both Mexican and U.S.— faced the real life challenges of cross-border communication. "Language has become a major

issue for rehearsals," Sam Woodhouse observes. "[The rehearsals] are conducted nearly simultaneously in two languages, challenging artists who are monolingual to learn to perceive and communicate in another language…"

While both Mexican and U.S. artists struggled together to find "common language," the fact that much of the project team's work took place on the U.S. side of the border privileged the team's English-speakers and, however unwittingly, placed the Mexican artists at a disadvantage in communicating ideas and participating in decision-making. Dora Arreola notes that the challenges of communicating in a bilingual setting also prolonged the creative process. She suggests that the use of professional interpreters would have helped balance language inequities and enabled the project team to use workshop time more efficiently. Says Arreola, "It would have helped to have professional interpreters to keep things more focused. We understood the subtleties in the particular language of theater, but it would have been helpful to have English–Spanish professional interpreters in the workshops."

Language issues played a decisive role in the project's artistic outcome. At the work-in-progress presentations, open rehearsals, and public readings in San Diego and Tijuana, the project team repeatedly confronted the challenge of making a text-driven play like *Nuevo California* accessible to monolingual

speakers on both sides of the border. As Woodhouse explains, the project team decided to create two versions of the play—one English, one Spanish:

Audiences in the USA are accustomed to monolingual performance in English. Audiences in Mexico expect primarily Spanish. During our Open Rehearsals we challenged them to comprehend and enjoy a work that is multilingual. During the process we became committed to creating a work of theater that could play in two countries with NO CHANGES. We have now moved to the concept of two versions of the play: the English version and the Spanish version. The theme of our play is the uniting of a bilingual region. The play will be bilingual. But the difficulty of creating a text-driven work that can simultaneously reach people who speak only English, others who speak only Spanish, and others who are bilingual is beyond our current reach.

Could the project's original goal of creating one multilingual production for presentation in the United States and Mexico be realized at some point in the future? Woodhouse believes it could, though such an endeavor would require placing greater emphasis on the play's nonverbal elements. Animating Democracy staff member Andrea Assaf points out that the regional theater aesthetic sets up expectations of accessibility. She imagined that a multilingual play in a more experimental mode might help offset those expectations.

...it's been my experience that whether I'm talking to a developer or someone who might perceive things differently or value them differently than I do, I want to understand what they value, what's important to them, so I know where they're coming from. I can say to them "I understand what you're saying, but I want you to know why I value this stone, which you see as rock, but I see as an ancestor. This stone has a whole story that impacts my family." Once they see it as heritage not rock, then we have a common language.

Recognizing issues of power within and between cultures, both historical and contemporary. Jack Tchen commented that, "part of dialogic process is being able to share authority." Power imbalances exist not only between dominant and minority cultures, but also within a culture. As the Center for Cultural Exchange (CCE) learned in its *African in Maine* project, historical roots of authority (male and elder dominated) within certain African cultures proved extremely difficult to overcome for the purposes of dialogue. The dynamics between individuals within each African community based on kin, personality, or political conflicts required CCE to shift its expectation that an environment of "inclusive" dialogue could be achieved.

Understanding the importance of cultural protocols. Who does the inviting, and *how* an invitation is made, affects who comes to the table. Because past interventions may have made a community protective of its members or suspicious of outsiders, work in disenfranchised cultural communities requires a high level of internal leadership, commitment of time, and understanding of etiquette/protocol. As is commonly recognized, many cultures value food and ample social time as essential aspects of civic gatherings. Where people gather—in spaces that are familiar and comfortable for community members—is also important. Bau Graves recalls conversations with Juan Lado, a Sudanese organizer hired by the center to coordinate the *African in Maine* project:

> There were entire days when Juan would be out of the office. When asked what she'd been doing, she would say, 'Well, I had to meet with the parents of the girls who want to dance in the next presentation. You can't just go knock on their door and tell them what you want! No, first you must come in, share some food and conversation, interact with the whole family. Only then can you introduce the topic at hand. It's the African way.' It is unlikely that any other CCE staff member could have either employed the proper etiquette, or taken the requisite time to gather the pertinent information.

Being conscious that art and dialogue practices may contain cultural assumptions and biases. This calls for sensitivity and planning regarding the language(s) in which dialogue is conducted, but also an understanding of behavioral norms, protocols, and forms of exchange that can encourage or discourage civic participation by people of different cultures. In addition, because artistic practices and cultural forms embody cultural values, perspectives, and assumptions, they also have the potential to encourage or discourage participation. It is therefore important to consider how a particular genre, aesthetic, or cultural form might help or hinder the overall goals of a project.

"There's no one-size-fits-all approach to dialogue. It can and should happen anywhere. And it shouldn't always be called 'dialogue.' Sometimes you need to call it something else—conversation, story...it's different in every community."

Assessing the value of intragroup dialogue as a potentially important precursor to cross-cultural dialogue. Dialogue among the members of a particular culture may be an important step before dialogue takes place between different cultures, in order to understand differences and find common ground. Art and cultural activity help people become grounded and confident in their own cultural identity and sense of self, and may empower them to actively participate in civic dialogue.

Considering when insiders or outsiders may be most effective as artists or facilitators. The advantages of community members as organizers and facilitators are obvious: shared language, knowledge of the community, and cultural protocols. Artists and cultural practitioners from within the community were often more highly valued and more effective than artists from the outside. Both the Center for Cultural Exchange (CCE) and the Esperanza Center chose to place community members as artists at the center of their work. Although CCE did find that outsider musicians brought popular cultural forms much valued by certain segments of the African communities, generally the community-based presentations held the greatest meaning for the most people. The Esperanza Center chose to concentrate on local artists and cultural practitioners and to train them as facilitators of *pláticas* (conversations). This supported the belief inherent in Mexican culture that all people are creative, visionaries, and bridge builders, and that people of the community are likely most effective in fostering dialogue. In some instances, using an outside facilitator who is perceived to be without an agenda can be an advantage in divisive cultural contexts. However, he or she must still be knowledgeable about, and sensitive to, politics and cultural norms.

Adapting approaches to accommodate participants rather than making them conform. Many dialogue practitioners and community organizers point to the "privilege of dialogue." People who hold multiple jobs, have fewer financial resources, and lead complex lives may not have the privilege of leisure time, transportation, babysitters, etc. Organizers need to adapt to these realities; for example, they might integrate efforts into the regular cultural, educational, or social service contexts.

Reflecting upon his experience working with Iñupiat whaling captains in Barrow, AK, Perseverance Theatre's Artistic Director Peter DuBois concluded that, "There's no one-size-fits-all approach to dialogue. It can and should happen anywhere. And it shouldn't always be called 'dialogue.' Sometimes you need to call it something else—conversation, story…it's different in every community. Every community has specific ways of engaging people."

Working through "sticky moments." The work of cross-cultural, and even intracultural, dialogue can be difficult. It can test one's patience and challenge old convictions about what needs to be talked about, and how. Engaging in these dialogues with humility and openness to the challenges that come along, as well as the commitment to reach a place of understanding, goes a long way. The "sticky moments," as one participant called them, are often the ripest moments for learning and change, adding, "they are worth the work."

Civic Dialogue Practices

EXTENDING OPPORTUNITY FOR DIALOGUE

Cultural organizations may plan dialogue activities to augment the experience of the creative product or, as fully explored in the section "Dialogue as an Integral Part of Artistic Practice," they may employ dialogue as an integral part of the creative process or product. Approaches often include a combination that helps engage people at both the creative development stage and when the artwork is finished.

Multiple engagements with the same group over time are more likely than single-session events to result in meaningful dialogue. Multiple sessions clearly offer a group of dialogue participants the chance to develop intellectual and emotional intimacy, trust, and self-knowledge. Dialogue specialists Tammy Bormann and Marcia Kannry, working with the Brooklyn Philharmonic Orchestra, described how personal transformation typically occurs over time. A group moves from "meaning-making" in response to a shared experience (which could be art), to self-inquiry ("Why do I think the way I do?"), to exploring a "larger reality" as it is expressed by others in the group, to expanding one's own view of reality to incorporate realities experienced by other people, to personal transformation (one's own understanding of reality and truth is changed by engagement

with others), and, ultimately, to group transformation (our collective reality is changed, and we are empowered to do something about the issues we care about).

Several Animating Democracy projects designed their dialogue efforts so that small groups would meet over several sessions. The *Abundance* project offered a running monthly dialogue group session, almost a year in duration, into which artist Marty Pottenger integrated artmaking activities. Participants made collages of their financial papers and then described to fellow participants their personal experiences with money; they also wrote refrigerator poems. In each workshop, Pottenger activated a model of aware, structured listening, often in one-on-one exchanges. She reported its powerful effect:

> The privacy that the confidential one-on-one exchanges delivers makes it possible for people to arrive at and express their thoughts outside of the potentially embarrassing, possibly scary group context. This makes it more possible that participants will choose to share what they have thought to the group as a whole more readily... it [also] establishes an environment of respect...assumably permitting participants to more fully commit themselves to the creative act; risking the visibility that creating art brings.

Pottenger also used creative exercises to help build a sense of community in the group; for example, participants ventured in trios into the neighborhood to take Polaroid photos. She

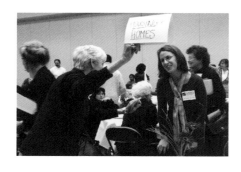

Action teams formed at a community conference culminating the Allen County Common Threads Theater Project *in Lima, OH, led by the Arts Council of Greater Lima, 2001–2002.*

experimented with when and how to position artmaking in relation to dialogue and discovered its power when experienced at the beginning of a session as a means of unlocking ideas and experiences: "Starting with the art is definitely the way to go. It opens up everyone's sense of possibility, imagination, intelligence and fun. Initially I had thought the dialogues would inform the art and take it deeper, but now I think the opposite may be true."

In some cases, such as Cornerstone Theater Company's Weekly Wednesdays and Flint Youth Theatre's study circles, the larger art project provided a backdrop or reference point and dialogue participants had the opportunity to connect to artistic events happening in the same general time frame as their dialogue experience. Flint Youth Theatre's (FYT) 10 study circle groups met separately once a week over five weeks, facilitated by trained peers, to explore the causes and effects of school violence in their community. All groups (116 people total) attended FYT's play, ...*My Soul to Take*, at their third session. Before the play they ate dinner together in their groups, and after the play they returned to their groups for dialogue. The small independent group meetings allowed focused and deep conversation. Participants felt that experiencing the artwork made a difference in the quality of dialogue that followed. People often referred to the play in subsequent dialogues. Facilitators also noted that the groups' dialogues about the issue of school violence before seeing the play enriched their experience of the play. This kind of reciprocal benefit between art and dialogue occurred with the Brooklyn Philharmonic's *Klinghoffer Dialogue Project*. Whereas

dialogue participants responded on an ideological level to reading the libretto in their first meeting (before seeing the production), their responses to the libretto differed greatly *after* seeing it completely staged with music. Afterward, dialoguers noted that many of the characters, including the terrorists, were presented more as individuals with personal stories than as icons, and that this aspect of the work was less evident in a reading of the libretto than in the complete staging with music.

Pre-existing relationships may help or hinder the effort to get to honest dialogue. People who know each other may be more willing to open up and be honest or critical; the deepest dialogues within the *Traces of the Trade* pilot effort in Rhode Island were within a church group and a group of school system administrators and educators, both of which had already been discussing issues of race together. On the other hand, filmmaker Katrina Browne observed that, among people who know each other, the opposite dynamics can also occur as people choose to be more gentle in order not to create bad feelings.

When creative products become a part of the company's repertory, they can be drawn upon over time with different groups, extending the reach and effects of arts-based civic dialogue efforts. Urban Bush Women's (UBW) *Hair Parties Project* format proved adaptable to different settings and responsive to the interests of various community groups, but could also be staged in full. UBW continues to draw upon this work.

FRAMING EFFECTIVE QUESTIONS FOR DIALOGUE

> *I have no answer for anything, really. I have shelves and shelves of books in my apartment, but none of them has answers—only questions. In the word question, there is a beautiful word—quest. I love that word. We are all partners in a quest. The essential questions have no answers. You are my question, and I am yours—and then there is dialogue. The moment we have answers, there is no dialogue. Questions unite people.*
>
> —*Elie Wiesel, interview in* O, The Oprah Magazine

Elie Wiesel's words reflect the centrality of generative questions in dialogue, and the related challenge of effectively framing them.

Artists and cultural organizations offer new lenses for framing generative questions. Intermedia Arts' *People Places Connections* project used the question, "What makes you feel safe?" as a structural tool with which to examine concerns within various communities surrounding the Greenway. Civic leaders and artists wrought variations on the question. Artist Victor Yepez, for example, used the question, "What objects have power?" in his work with youth to create power sculptures out of objects found in the community.

The Jewish Museum's interpretive approach to the exhibition *Mirroring Evil: Nazi Imagery/ Recent Art* placed key questions for museum visitors at the beginning of the gallery experience: Who can speak for the Holocaust? How has art used Nazi imagery to represent

evil? What are the limits of irreverence? Why must we confront evil? How has art helped to break the silence? These questions were intended to resonate in visitors' minds as they moved through the exhibition. At the end of the exhibition, visitors saw a video featuring responses by a wide range of individuals holding diverse perspectives on the questions. These same questions were embedded in several of the related dialogue forums as well.

The core team of San Diego REPertory Theatre's *Nuevo California* project spent many hours formulating the "burning civic question" that would become the springboard for the project's dialogue component, as well as the theme for the new play. Their deliberations crystallized the complex issues surrounding the International Border Fence into two questions: Should the United States and Mexico tear down the border fence and create a unified San Juana? Or, should we build the fence taller and stronger under the theory that "good fences make good neighbors?" In addition to these core questions, the artistic team helped the dialogue partners formulate questions aimed at eliciting personal, metaphoric responses that summoned participants' imaginations, such as:

- Describe the region as if it were a person (its physical, psychological characteristics).
- If you could change something that people on the other side think of you, what would that be?
- When you think of the region, what do you see, touch, taste, hear, smell?
- If the fence itself could speak, what would it say?

These questions not only brought forth a wealth of startling images and ideas for the artistic process, but they also influenced the tenor of the dialogue by encouraging participants to look at the project's civic issue in personal terms and from other perspectives. Sam Woodhouse explained, "We found that often the most 'off the wall' questions led to the most intimate, personal, subjective, and artistic responses. We also found that asking these kinds of questions required a 'safe house' setting and if we reached too quickly for the personal, the dialogue would retreat to the shielded and formulaic." The skillful framing of the questions was a key ingredient in eliciting candid and/or imaginative responses.

CONSIDERING THE FACILITATOR'S ROLE

Whether dialogue occurs once or in multiple engagements, the question is who can best facilitate it? Is a professional dialogue facilitator necessary? Are there certain times when an artist, a cultural organization representative, or a dialogue practitioner is better suited?

Dialogue practitioners can bring valuable experience with particular issues and certain constituencies, as well as their skills as facilitators. Having a professional's expertise can contribute to the integrity of dialogue facilitation. Project organizers and artists may be happy to put facilitation in skilled hands and to not have this responsibility. The National Conference for Community and Justice/Los Angeles, for example, brought its specialized experience in interfaith dialogues as well as pre-existing experience using theater in dialogue to Cornerstone Theater's *Faith-Based Theater Cycle*.

> *"We found that often the most 'off the wall' questions led to the most intimate, personal, subjective, and artistic responses..."*

Dialogue facilitator Maggie Herzig brought her experience to bear in a challenging dialogue moment that followed Flint Youth Theatre's production of *Strands: Legacy of 9/11*. Although the large Arab and Arab-American community in Michigan had been deeply affected by post-September 11 incidents, few of them attended the play. Someone noted the apparent absence of Arab-American perspective in the audience. In postevent reflections, Herzig explained how she chose to facilitate dialogue in that moment and cautioned about making assumptions regarding participants' connections to an issue or a community:

> I noted that it's sometimes hard to tell by looks alone what someone's background is; also there may be people who are not Arab-American but whose spouse or best friend is. I mentioned this as a way of inviting anyone who might be able to speak to Arab-American perspectives to speak up if they felt willing. A young African-American man whose best friend was Arab-American then spoke. My intervention was grounded in three things: 1) resistance to the idea that you can tell by looks alone what someone's identity is or whether they can offer something of value about an identity group; 2) a worry that if someone pronounced a group to be absent and a person of that group felt regularly silenced or made invisible, it could add to the problem; and 3) an interest in noting assets in a group (not just deficits). That African-American man was an asset on Arab-American perspectives. He may not have spoken without my intervention, feeling that it would be presumptuous to say what he knew if there were, in fact, Arab-Americans who could speak with more authenticity than he could. When none raised their hand, he felt that he could.

P.Q. Phan, composer, American Composers Orchestra's Coming to America: Immigrant Sounds/Immigrant Voices, *2000–2001.*

Artists serving as dialogue facilitators may add to or detract from the desired focus on the art and the civic issue. Many artists are highly skilled and comfortable in the role of facilitator, particularly artists whose work integrates a dialogic process. These artists may draw on strong intuition; creative, pedagogical, and activist practice; or explicit training in dialogue methods. Other artists, however, question whether their knowledge of the issue or their facilitation skills will be adequate for the task, and some find it challenging to put their point of view on an issue aside when in a facilitation role. Some simply prefer to engage in an exploration of aesthetics, allowing someone else to take the lead in facilitating discussion about issues.

See the section "Dialogue as an Integral Part of Artistic Practice" for more.

In collaboration with dialogue facilitators, artists can be especially effective in providing direct insights into the artistic work and making connections between the work and the issue. In dialogues related to the American Composers Orchestra's (ACO) *Coming to America: Immigrant Sounds/Immigrant Voices* project, composer P.Q. Phan proved essential to audiences' experience of his contemporary orchestral music and to drawing meaning from the work as they discussed their experiences as immigrants. At one pre-performance dialogue at Lehman College, Phan and Dialogue Facilitator Tracy Fredericks sat on the edge of the stage, and Phan talked about his own refugee experiences and what motivates his

music. His stories were riveting and rang true for many in the audience. A trio from ACO played Phan's composition, *Unexpected Desire*. Afterward, people who had emigrated from various countries engaged in a lively dialogue about racism, identity, homeland, self-expression, biculturalism, violence, and cultural absorption, with the musicians taking part as well. About 25 people stayed on for additional dialogue.

Perseverance Theatre artists were concerned that their presence at *Moby Dick* dialogues would too easily allow participants to slip into a focus on the aesthetics of the play. Local facilitators affirmed that the artists' absence probably did help to move the discussion more easily to the civic issue. In Barrow, however, Artistic Director Peter DuBois facilitated a dialogue. He was anxious about leading dialogues surrounding the play, believing deep down that dialogue would jeopardize the artistic integrity of the work. To the contrary, he found that, "rather than fencing in the play, the dialogues cracked the performance open to a range of interpretations I had not imagined." He went on to say:

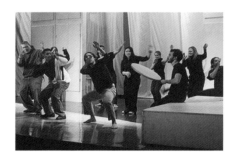

Scene from an Alaskan adaptation of Moby Dick, *Perseverance Theatre, 2002.*

I think that when people feel passion, they are looking for a frame to put it in. I think a facilitator needs to provide that frame, so that the emotions are able to connect to our thoughts and then, ideally, to action. In the dialogues I facilitated in Fairbanks and Barrow, I used questions about the play as a framing method: What does Ahab have in common with an Iñupiat whaling captain? What does he have in common with an oil speculator? What do the interview captains have in common with Ishmael? With Ahab? In general, I felt the play served as an excellent springboard for dialogue because it had a level of ambiguity and did not stake out a position. It therefore helped people get to both the gray areas and the areas of common ground quicker…in Barrow it led to conversations about Shamanism and the incarceration of Shamans in asylums; in Anchorage a surprising number of people were interested in seeing white Alaskans participate more in Native cultural rituals; in Fairbanks it exposed prejudice and cynicism about dialogue in the Native community. Exposing this prejudice became important to individuals who are working statewide to educate in the areas of subsistence and the urban/rural divide.

Similarly, The Jewish Museum did not feel it necessary for the artists whose work formed the *Mirroring Evil* exhibition to facilitate or be present at dialogue forums. In addition, given the controversial nature of the work, the museum did not want the artists to be in a position of defending their choices.

Regardless of whether artists participate in dialogues, it is valuable to have their help in designing dialogue activities since they can inform facilitators about the artistic work and help frame questions in relation to the artistic work.

While experts and scholars play a valuable role in bringing depth to content on both art and civic issues, their authority must be mitigated and their contributions made accessible to a broad public. Scholars sometimes serve as facilitators but

more often provide context, information, and even a point of view about the issue. In either case, there are often challenges in ensuring accessibility of information and language for a broad base of participants, as well as in managing dynamics so that experts do not dominate discussions, intimidate others with their knowledge, or end up as arbiters for disagreements or conflicts.

From the outset, scholars were conceived as a key part of New WORLD Theater's *Project 2050* summer retreats for youth. Exploring the implications of demographic shifts in the United States now and in the future, scholars led Knowledge for Power sessions during the retreats, presenting material from their spheres of expertise that spoke to the project themes. New WORLD Theater (NWT) looked for academics who could communicate their expertise to a young, nonacademic audience. However, in the first *2050* retreat, young people found most scholar-facilitated workshops unengaging; it was too often a one-way transfer of information, and not the dialogic exchange NWT wanted to create. In addition, as NWT's then-artistic director Roberta Uno acknowledged, "The scholar sessions will always be problematic for the kids, because of the baggage they bring from school."

For the second summer of *Project 2050*, youth organizer Diana Coryat came on board and helped scholars think about creative ways to present material and engage young people, applying innovative pedagogical strategies to illustrate issues and draw people into dialogue. In the very first session, participants were divided into five groups in different sections of the large room, and all five scholars engaged in a round-robin, going to each group in turn to present a quick overview of their own topic area within the retreat's themes of Identification, Immigration, Incarceration, Exploitation, and Negotiation. This fast-moving, small-group format engaged and intrigued participants, gave them latitude for interaction, and left them hungry for more information, which would be satisfied in further Knowledge for Power sessions. NWT reflects, "In each successive summer we have made the scholar sessions more interactive and interesting, but the emphasis on scholarly excellence has continued to be an uneasy match with our youths' need for accessibility."

Simple strategies sometimes helped. A symposium related to Henry Art Gallery's *Gene(sis)* exhibition literally situated experts within the audience rather than on a stage or in a panel configuration, to physically create a more equal relationship with other participants and audiences.

Dialogue practitioner Tammy Bormann underscored the educational value of dialogue, such as the "expert presentations" on the libretto, music, and production before performances of *The Death of Klinghoffer*. These sessions were extremely valuable in understanding the creative work and provided new pathways to consideration of the issue. However, they took time and focus away from the issue-based dialogue. Consequently, Bormann and the Brooklyn Philharmonic Orchestra have seen that future dialogue programs might separate a learning session from a dialogue session in order to make the most of the intent and character of each.

The approach of trained "nonexpert" community members as facilitators creates an environment where expertise is more organically vested in the group. Dialogue consultants can train local community members, or the artists themselves, to facilitate dialogues. This approach involves a greater number of people more deeply in the project. *The Water Project* organizers recognized that dialogue in small groups would necessitate additional facilitators—who were scarce in rural Amery, WI—so the Northern Lakes Center for the Arts (NCLA) invested in training community members in intergenerational facilitator teams made up of one young person and one adult. This strategy expanded NLCA's capacity to implement the project, and strengthened the community's commitment to the project and to the issue itself.

Even modest training and orientation for nonexpert facilitators regarding the intended dialogue goals and how different situations might be handled can enhance the quality of dialogue. It is helpful to have detailed printed instructions for both the facilitators and dialogue participants so that group members can share responsibility for the process.

Training community members as facilitators means that a cadre of individuals skilled in designing and leading dialogues remains in the community. Facilitators in Lima, OH, stepped up to help lead action groups in the months following the *Common Threads Project*, and are poised for other civic dialogue duties as well. Both *The Slave Galleries Project*, that trained "community preservationists" from among leaders of various community segments on the Lower East Side, and the *Understanding Neighbors* project viewed this investment seriously. Community preservationists will continue to link their own constituencies to the slave galleries setting and are also helping identify and preserve other historic sites in the neighborhood as focuses for civic dialogue.

CREATING MEANINGFUL DIALOGUE AT ARTS EVENTS

> *When people are asked to do something with a certain spirit and to steer clear of a free-for-all mode, it does take a bit more thought. Dialogue is usually more thoughtful, less reactive, and a bit slower in pace.*
>
> —Maggie Herzig, Public Conversations Project

> *Meaning making can be a profoundly important contribution that dialogue can make to the world of the arts and, in turn, that the arts can make to the world of dialogue. …dialogue, even as a single-event, gives the audience a mechanism for deeper exploration of the work and of their own response to it.*
>
> —Ted Wiprud, Brooklyn Philharmonic Orchestra

Conventional post-performance discussions generally offer opportunities for audiences to ask questions about the artistic work, to hear from artists about creative intent and process, and to share how the work affected them. Animating Democracy participants aimed to bring these discussions to another level. While some assumed that it would be easy

to improve on traditional discussion models, it was actually harder than expected due to time limitations, physical challenges of spaces such as auditoria or galleries, audience fatigue, and expectations. Nonetheless, participants worked to address these challenges and draw upon the art to engage people more deeply in the civic issue.

To effectively engage audiences in civic dialogue often requires changing the structure and format of arts events or activities. Even when there is intent for people to engage in content and issue, discussions often remain at the level of Q & A, testimonial, critique of the art, or soapbox oratory. They may be superficial, in part, due to lack of clear purpose for the dialogue. Organizers need a clear and shared sense of purpose to effectively focus the dialogue on the issue. New formats and structures require that the audience shift expectations and that the cultural organization and dialogue facilitator create overt strategies to assist with this shift. Promotional materials need to emphasize that this is not "the usual night out at the theater or symphony." Sometimes, framing the questions for dialogue before the performance, in anticipation of the post-performance dialogue, is a simple but helpful way to encourage people to think about the artwork in relation to the issue. Orientation and introduction are also important to help convey purpose and set the tone of the event.

Other factors to consider in designing dialogue experiences include setting, time of day, time available for dialogue, and techniques for maximizing the role of art as catalyst and reference point. Using small group formats or alternating between large and small group formats are most effective in encouraging participation and enabling focused, in-depth dialogue.

Preparatory activities can heighten interest in the civic issue and enhance the quality of the dialogue at the event. Audience preparation may include a pre-event introduction by the organizers to provide the context for the overall project, frame the civic issue, and explain what organizers hope people will get from participating in the dialogue. A caution: such introductions should not get in the way of a pure experience of the art. Seasoned facilitators affiliated with the National Conference for Community and Justice/Southern New England (NCCJ) felt that the large amount of context they provided in introducing the film *Traces of the Trade* "seemed to frustrate the audience." Participants were eager to see the film, though the ground rules and contextual information about the project may have intimidated some people, who suddenly got a sense of their role in a much larger endeavor. NCCJ later felt that "less was more" in this case, and would more judiciously and sparingly frame the session for future dialogues.

Theater for young people, typically shorter in length to begin with (60–75 minutes), lends itself to dialogue. For productions of *...My Soul to Take* and the play *Strands: Legacy of 9/11*, Flint Youth Theatre orchestrated a preshow dinner in the theater's lobby, which allowed participants to get oriented to the evening and to warm up to the issue via a series of questions answered round-robin style by each participant at their dinner table.

Using small group formats or alternating between large and small group formats are most effective in encouraging participation and enabling focused, in-depth dialogue.

It is more difficult to orient dialogue around full-length performance works without making the whole experience too long. In Animating Democracy, some cultural organizations experimented with ways to structure the dialogue, often separating it from the performance. For its production of *The Death of Klinghoffer*, the Brooklyn Philharmonic Orchestra (BPO) held a series of three pre-production dialogues to prepare participants for what, to many, was an unfamiliar art form: contemporary opera. BPO collaborated with The Dialogue Project, which had been facilitating Arab-Jewish dialogues for some time in Brooklyn, NY. The partners felt that the addition of a relevant artistic experience would enhance the ongoing dialogue. Hosted by the Brooklyn Society for Ethical Culture, these dialogues aimed to create a safe, moderated place for Dialogue Project participants and others who might sign up, so they could constructively explore issues of identity, nationalism, and the roots of violence in the context of the Israeli-Palestinian conflict as addressed in the opera. Each dialogue focused on one aspect of the opera—text, production, or music—in order to inform the dialogue with understanding of the opera.

Perseverance Theatre's dialogues about subsistence rights related to its Alaskan adaptation of *Moby Dick* took place as many as five days after the performance in community spaces including a coffeehouse, a school, and the Native American Heritage Center. In addition, the director and cast were not present, mostly because they were traveling across the state to the next touring site. Artistic Director Peter DuBois reflected:

> What worked was that people weren't feeling tired or rushed, as is often the case at post-show discussions. I also believe that, in some ways, people recalled the play better with distance; the work had time to settle in. As a result, I think participants were able to achieve a deeper level of discussion and analysis. What didn't work was that...without artists in the room, the goal of having the work inspire the dialogue lost some steam. We also had to rely on second-hand accounts of how the work interacted with the ideas raised in the dialogues. If we could do it all over again, I would place the dialogues closer in time to the performances and make sure they are scheduled so that at least one artist is at each event. That way we could better keep the art at the center of the dialogue.

Attendance at the various dialogues was small with a few exceptions, which suggests that holding dialogues separate from the artistic events requires clear, aggressive promotion.

Cornerstone Theater Company, known for its interaction with a community when developing plays, saw Animating Democracy as an opportunity to explore how to link dialogue more directly to the finished work. Cornerstone observed that theater, even in a meditative mood, sets a brisk pace. To keep the evening lively theatrically, the dialogue needed to be short and punchy. For the Festival of Faith, which included five short plays in an evening, Lucky Altman, a dialogue partner from the National Conference for Community and Justice/Los Angeles region (NCCJ), observed that there was insufficient time for audiences to engage in "a true dialogue about the themes presented"—and that, at any

rate, they were not prepared to do so at a theatrical event. NCCJ dialogue facilitators worked in tandem with the festival's theater artists to develop short dialogue exercises that would elicit reflection and evoke responses. They sought to set up informal audience exchanges rather than extended group inquiry. These exercises were built into the experience of the play. For the Festival of Faith at the Baha'i Center, audience members thought silently about their response to a question, then wrote their responses on paper in the shape of leaves (relating to an image in one of the plays). Leaves were exchanged silently among nearby audience members. The leaves were collected during an intermission, and the actors read selected responses at the end of the evening. At another Festival of Faith at Temple Emanuel, the artists and dialogue facilitators employed a "forced choice" exercise. To move from one physical performance space to another in the temple, participants had to cross through a series of paired portals, choosing the threshold that best described themselves and their beliefs. Portal pairs were labeled, for example: "I believe in God/I don't believe in God," "At Home/Just Visiting," "U.S. Citizen/Citizen of the World." They discussed "choices" with each other before walking through the doorways.

Cultural organizations need to recruit targeted groups, even for single events, to ensure that those most affected by issues will participate. The desired diversity of participants and perspectives will not necessarily exist in single event audiences without working to ensure such diversity. Unlike participants in dialogue groups that meet together over time, audiences at arts events are often nominal groups. Sometimes they are also relatively homogenous, at least in terms of demographics or their attitudes about an issue.

Making the transition from the art experience to dialogue is pivotal and challenging. One challenge is keeping the art present in the dialogue, respecting people's natural desires to address the artistic work but also drawing upon it to move the dialogue. Perhaps the most successful dialogue held during The Kitchen's two-week run of *The Three Willies* was a panel on a Saturday afternoon *not* linked directly to a performance. *The Three Willies* was a multimedia jazz opera that addressed the image of the black male as perpetual suspect, and the ways in which such stereotyping has affected different generations and classes of African Americans. The panel, "Outlaw and Saint: Media Manipulation of the Black Man," referred frequently and deeply to *The Three Willies* performance that some (but not all) attendees had seen the weekend or the night before. Several strategies immediately engaged the 40 or so participants and kept the artwork alive in the discussion. Panelists had seen the artistic work and made frequent references to it. The moderator clearly framed the subject and included several film and media references, both historic and contemporary, to help frame the topic. Audience members were asked to introduce themselves by including a brief statement as to how the issue resonated for them. Librettist Homer Jackson offered a compelling description of the piece and its intent. The Kitchen's director of community outreach, who coordinated the project, was also present as a participant. Audience members drew on specific scenes, images, and dialogue from the opera to bolster points. The panelists established an atmosphere of honesty from the

outset and created an interactive dynamic in which they asked each other and audience members challenging questions. Compared with post-performance discussions of *The Three Willies*, which tended to focus on the artists and their experiences, this one was deeply engaged in the issue *and* the art.

Provocative or controversial art requires more proactive work to lead to safe and productive dialogue. Some of the most potent artistic experiences are those that affect people at a profoundly visceral, emotional, or spiritual level. Valuing and respecting these kinds of responses to the artwork, but also moving to a more analytic plane, is a challenge. Heavy-handed shifts to a formal dialogue mode can deflate the energy, emotion, and passion generated by the experience of the art—setting off what has been called "the dialogue bomb."

Flint Youth Theatre (FYT) knew that its play on school violence could have a highly emotional effect on local audiences. In making aesthetic choices, FYT did not shy away from the emotional and spiritual; the play's ending was hopeful but not falsely uplifting. FYT, like Perseverance Theatre, came to see that sometimes the work requires decompression time to let the emotional effects settle, before engaging with the issue. For the most part, FYT chose not to hold post-performance discussions, and when it did, people were gathered outside the theater space to help create distance from the emotional experience in the theater. FYT invested more heavily in the multisession study circle dialogues before and after the play and in resource guides for teachers, who helped prepare young people before the play and facilitated dialogue with students at an appropriate time afterward.

The Jewish Museum and The Andy Warhol Museum, also anticipating that the controversial and horrific images in their exhibitions would raise highly emotional responses in some visitors, provided interpretive materials to prepare visitors as they entered the exhibitions. Both museums offered "daily dialogues" that created safe spaces to reflect and talk.

ADAPTING A MUSEUM EDUCATION METHOD FOR DIALOGUE

Henry Art Gallery adapted a standard museum education methodology—Visual Thinking Strategy (VTS), a method of inquiry developed by the Museum of Modern Art—to engage people in dialogue in the gallery. VTS draws viewer response through inquiry and explores information about an artwork meaningful to the viewer. Described by the Henry staff as an "interactive looking experience," VTS initiates dialogue by posing simple questions that encourage viewers to bring their own personal associations, stories, and interpretations to the work. This questioning strategy leads viewers in progressive steps to explore the complex and sometimes disturbing ideas embedded in the work.

Visitors in a gallery dialogue, Gene(sis): Contemporary Art Explores Human Genomics, *Henry Art Gallery, 2002.*

An example of VTS was used in relation to a specific work of art in the Henry's exhibition, *Gene(sis): Contemporary Art and Human Genomics.* Artist Catherine Chalmers's *Transgenic Mice* (2002) documents the production of genetically engineered mice, a burgeoning industry fueled by recent genetic discoveries. Her photographs spotlight the "mouse ranch" industry, calling into question the ethics of animal research. A questioning strategy for this work is excerpted from the Henry's *Gene(sis)* teacher curriculum guide, an extensive resource created to prepare students for seeing the exhibition and to provide tools for facilitating dialogues in the gallery with their students. The excerpt offers a snapshot of how the Henry's version of VTS guides the viewer(s) in dialogue. Selected questions included:

Describe what you see in these photographs. How many mice? What size? Texture? Shape? Color? Note the way in which the artist has framed the mice, and their size within the frame. How does this effect the portrayal of the mice? Note the manner in which they have been photographed (glossy paper, professionally lit). How does this style influence your response to the image?

The curator or educator then moved to more interpretive questioning:

Are these mouse portraits emotional or scientific? Why or why not? What do you think is the artist's intent by photographing these mice? Does she seem for or against animal experimentation? What clues does the artwork give you to support your opinion?

The questions then shifted to the inherent ethical dimensions of animal experimentation:

How are these mice normal? Abnormal? Is it right to use animals in research to explore human illness and its treatments? If they are not used for research, what about the humans who might suffer and die because of lack of treatment? Is it any more ethical to experiment on one type of living creature than another? Where do we draw the line?

In the visual arts, the physical presence of art works enabled experimentation in dialogue. The Northern Lakes Center for the Arts drew upon dialogue practice for the opening of its photography exhibition related to water issues in the region, taking full advantage of the

fact that people would be standing in the midst of the photographs. Using the "Take a Stand" technique, a facilitator read a series of statements and asked participants to move to parts of the room designated as strongly agree, agree, disagree, and strongly disagree. Statements included: "The photos represent perceptions of the river that I have never considered. Tubers are careless about waste when they tube down the river. I am concerned about the health of the water in our area. It is the job of elected officials to take care of water problems." The group talked about the reasons for individual choices, a dialogue that transitioned into a series of questions prompting more personal

Dialogue participants draw and make notes on table-cloths during World Café-style dialogues, Common Threads Theater Project, *Arts Council of Greater Lima, 2002.*

reactions to the art and the content of the photos. Individuals were asked to personalize responses by standing next to the photo that best demonstrated where they might most like or least like to live, and were encouraged to question the photographers about the circumstances of particular photographs. This probing brought out fruitful conversation about the issue and, in particular, acknowledgement of fellow residents' blind eye to the implications of their abusive actions.

The most successful dialogues at arts events result when facilitators tailor the format and approach of the dialogue specifically to the artistic work. The Lima *Common Threads* conference was distinctive for two reasons: It drew upon the artistic work and the key metaphors within it to frame questions, and it employed creative techniques for eliciting response. After participants viewed the full performance of *Passing Glances: Mirrors and Windows in Allen County*, dialogue facilitators framed questions that asked people to recall the metaphors of the play: What in the performance you just saw most mirrors your life in Allen County? What opened a new window into someone else's experience? What are the connections to the themes of trust and respect? The conference also adopted a creative strategy from the World Café model—covering participants' small group tables with paper, supplying colored markers, and encouraging creative note-taking, doodling, and visual depictions of ideas as the group talked. As people were instructed to periodically shift table locations, they would view what was "documented" on tabletops. According to the World Café model, ideas can filter from small group to large group.[1]

The many examples in this section underscore the value of drawing upon nonverbal as well as verbal ways of processing the art experience and participating in dialogue. This gives people with different styles of learning and expression the opportunity to participate in a way that is a good fit for them. Providing options for participation reduces the sense that dialogue is being "imposed."

[1] World Café Conversations are a method for creating a living network of collaborative dialogue around questions that matter in life, work, or community. The model allows large numbers of people to be in a dialogue. Small conversation clusters occur in progressive rounds. World Cafés are distinguished by the physical movement of people to new, small groups with each round of dialogue questions. This encourages the linking and connection of ideas, questions, and themes. World Cafés also create and encourage writing, doodling, and drawing key ideas on "café tables" covered with paper as a means of expressing and sharing ideas as participants move around. www.theworldcafe.com.

Organizers need to provide resources for audience members who are spurred by the experience to learn more about the issue, connect to other dialogue opportunities, or figure out how they might take action. When arts groups are unprepared to respond to interest with suggested next steps, participants can feel a lack of closure—a sense of "so what?"—and may even lose the sense of the original value of dialogue. Cultural organizations can help sustain attention to an issue by anticipating the question, "What can I do now?" Partner organizations might provide printed information at events or speak briefly at the conclusion to inform people about ways to connect. Facilitators can invite audience members who are involved with relevant efforts and organizations to alert others about opportunities.

Over time, an arts organization can create a "dialogue culture" in which audiences expect dialogue as a part of their art experience. The Center for Cultural Exchange, Northern Lakes Center for the Arts, and Out North Contemporary Art House noted that, over time, their educational strategies to help audiences understand unfamiliar art forms have included different interactive modes. As a result, audiences have come to expect exchanges around the form and content of artistic work, and so the notion of civic dialogue was a relatively easy leap for them.

Given the difficulty of engaging individuals in repeat attendance, Ted Wiprud of the Brooklyn Philharmonic Orchestra places a good deal of hope on the possibility of structuring single events to foster a dialogic exchange of ideas.

> The more rewarding people find these exchanges, the more likely they are to return for more of them and the deeper dialogues will go. There will always be new participants and one-time participants. We hope to develop a cadre of people who seek these events out because they know they will hear good music excellently performed; that they will learn about a range of views on a given issue; and that they will have the chance to exchange ideas and possibly grow a bit as a person. At the same time, sustainable dialogue obviously offers a wholly different level of personal growth and through that growth, civic impact. But here also we hope to develop a cadre of regular participants, people motivated and capable of devoting three to five evenings at a stretch to dialogue and music. There is value in both approaches to both participants and orchestra. Both ways, the orchestra places music at the center of dialogue, and both ways participants derive greater value from music and from each other than in a conventional concert setting.

Understanding Neighbors
artists engage with the
audience at Out North
Contemporary Art House, 2003.
Photo by Jay Brause.

COLLABORATIONS BETWEEN ARTS AND DIALOGUE PRACTITIONERS

In many instances, cultural organizations may feel that they—or the participating artists—lack the necessary dialogue expertise. If so, they may choose to use dialogue professionals as consultants to help conceptualize and design the dialogue components of their projects, to train community members or artists, or to actually facilitate dialogue. Cultural organizations in Animating Democracy engaged Study Circles Resource Center, the National Conference

for Community and Justice, Public Conversations Project, and San Diego Dialogue, as well as independent consultants. Some artist organizations known for their dialogic way of working, such as Urban Bush Women and Cornerstone Theater Company, sought out relationships with dialogue professionals to bring specific expertise to their projects and to enhance artists' practices.

The most effective collaborations occur when dialogue consultants and facilitators are a good fit for the organization. In the dialogue field, there is a wide range of approaches suited to different desired outcomes. The process of securing a dialogue consultant often helps clarify the civic goals of dialogue. Early in the conceptualization of the *Understanding Neighbors* project, organizers gravitated to Study Circles Resource Center due to the communitywide reach of its multiple small group approach. But discussion revealed that Study Circles' orientation toward action as an outcome of dialogue was not the best fit because partners were not yet ready to identify action as a desired outcome. Instead, Out North and partners chose to work with a consultant who followed a Public Conversations Project model geared toward mining personal values from issues that are often rooted in fundamentally polarized value systems.

There are different opinions about whether a dialogue consultant needs experience and knowledge about the specific issue. Patricia Romney was effective as advisor and trainer to Northern Lakes Center for the Arts' *Water Project* despite having no particular knowledge about water conservation issues. However, her background in cultural diversity issues and organizational development was crucial to her work in Lima, OH, where issues of race and leadership were central. Beth Waterhouse, dialogue consultant and facilitator for Children's Theatre Company's *Land Bridge Project* in Montevideo, MN, felt strongly that, to engage people in rural Minnesota, the facilitator needed to know about the issues rural people face. She reflected, "What we did *not* need was an urban play about rural issues in Minnesota that did not get rural people into the design or dialogue of it. Rural is sub-consciously glorified; there is a great deal of nostalgia about it yet much of what is actually going on is quite complex, stressful, global, and marginalized."

Dialogue facilitators also need to be sensitive to cultural norms in various intra- and inter-group dialogue situations. At an early point in its *Arte es Vida* project, the Esperanza Center decided to train community members as "*animadoras/os*" who would facilitate community dialogues as peers. They hired a professional facilitator, well-regarded for her professional credentials, her experience with anti-oppression training, her alignment with the Esperanza's vision and work, and because she is a Latina. After launching into the training, however, the Esperanza found that the "New Bridges" approach used by the consultant was not the best fit for the project. Graciela Sánchez noted:

> The audience/participants in *Arte es Vida* events have included some people who can speak easily in public and many more who are hesitant to speak. Working with groups of this sort, we focus on ensuring full participation. We have found the initial "rule-setting" phase of the New Bridges approach conveyed the

unintended message that people should not speak unless they can talk in a particular way, and frequently people did not understand what the rules required. The effect was that many people remained silent and those who spoke seemed hesitant and self-conscious. We also found that many members of the audience resisted participating in dyads or small groups because they feared they would miss interesting stories told by other participants.

In San Diego, project leaders originally thought the pairing of the San Diego REPertory Theatre and San Diego Dialogue (SDD) would be mutually beneficial because they had a shared concern: to promote public dialogue on the complex regional issues surrounding the border fence between the United States and Mexico. SDD project liaison Judy Harper, the linchpin of that partnership, had expertise in both civic dialogue and the arts (having previously worked at San Diego REP). It seemed that she had exactly the skills and sensibilities to ensure that SDD would play an active role in the artistic process, and

Scene from Crossings *in Cornerstone Theater Company's* Faith-Based Theater Cycle, *2002. Photo © Craig Schwartz.*

that the REP would be involved in the design of dialogue activities. When she unexpectedly departed, it became apparent that the two organizations had fundamental differences in approaching dialogue, as well as divergent goals for the project's dialogue. While SDD stressed the importance of policy change through dialogue, the REP's dialogue goal—to stimulate public dialogue on both sides of the border about the project's civic question—was more broadly defined and less solution-oriented. In assessing the project's dialogue outcome, SDD's Martha Lima acknowledged that *Nuevo California* was effective in raising awareness about regional issues but questioned whether the arts-based approach to civic dialogue would ultimately lead to the policy solutions that SDD was seeking. Although Harper's departure likely affected the way things played out, a more deliberate articulation of civic intents at the project's outset would have determined whether the two partners were suitably matched. As REP Artistic Director Sam Woodhouse summed it up, "The next time out of the gate I will spend much more time identifying shared goals and objectives with a dialogue partner."

The philosophies and needs of artists and dialogue facilitators are sometimes in conflict. In some projects, a healthy degree of caution will coexist with the excitement of intersecting practices. Cornerstone Theater Company and its partner, the National Conference for Community and Justice (NCCJ), experienced many bumps along the way but they were committed to the relationship and excited about what each could learn from the other. Cornerstone reported that many of the artists involved in creating new works for the *Faith-Based Theater Cycle* vigorously guarded their autonomy. At the same time, Cornerstone observed that NCCJ staff wondered whether the artists were fully respecting the faith venues and their congregations. To the facilitators, the artists

appeared overly cavalier about the stake people had in the dialogue, and were unwilling to go deep. The facilitators were also concerned about possible ethical issues related to using stories heard in dialogue for public productions. Each group questioned whether the other took their process seriously, and if there was a perceived hierarchy of art and dialogue. They raised issues about achieving balance and sharing control. Cornerstone asked, "How much control are we as artists willing to give up if our goal is to get the audience speaking?" For NCCJ, this meant that "facilitation coordinators needed to get out of the way." Cornerstone's play, *Zones,* raised questions for both about "speaking truth with strangers." How can theater authentically engage audiences in civic dialogue when there isn't a mutual commitment? When might it make sense to preserve the separateness of approaches of a theater company and a human relations group?

When might it make sense to preserve the separateness of approaches of a theater company and a human relations group?

When both artists and dialogue professionals were sharing responsibility for facilitation, roles had to be sorted out and defined. In Cornerstone's project, artists continued to facilitate community gatherings intended to inform script development but learned new techniques from NCCJ, while NCCJ facilitators tended to design and facilitate performance-related dialogues.

The division of responsibility was less clear in the case of Lima's *Common Threads Project.* There were points during the project when dialogue consultant Patricia Romney questioned her role. Why was a dialogue specialist needed when Rohd himself often facilitated dialogue regarding his work? On his part, Rohd expressed concern that Romney, coming from a nonarts background, might inadvertently neglect aesthetic issues when crafting dialogue questions. At the same time, each was playing a significant role in the community during the development phase. While Rohd conducted interviews for script development, Romney met with civic leaders and coached local project leaders in forging relationships in the black community. As the two became familiar with each other's work, the trust between them grew. But clarity about their roles required continuous and careful attention and honest communication as problems emerged and unforeseen situations developed.

Cost and the need for dialogue facilitators to be flexible and available are sometimes prohibitive for cultural organizations hiring dialogue professionals, especially for longer-term projects. Collaboration requires time and space to work together, a challenge for many partnerships. For the Center for Cultural Exchange's (CCE) *African in Maine* project, the protracted nature of the internal dialogues in many meetings made it impossible to bring the professional facilitator to Portland, ME, for every session—or even most of them. This presented a substantial problem, since a facilitator returning to the program after a hiatus that may have spanned numerous meetings was not up to speed with the unfolding community dynamic. CCE Co-Director Bau Graves recalled, "We could try to brief them as thoroughly as possible, but it soon became clear that the process required a facilitator who was fully participatory if it was to move forward." Ultimately, CCE ended the relationship with the consultant, and Graves and Juan Lado, a member of the African community whom CCE hired to coordinate the project, facilitated the meetings. They

relied successfully on relationships with the community and skills that both had learned in years of work as well as from training by the consultant.

The benefits on both sides of arts–dialogue practitioner collaborations include new skills and insights into practice. Poet Regie Cabico learned useful techniques from dialogue training in the *Poetry Dialogues* project. He said, "I got into dialogue. I enjoyed the training. It helped me establish what ground rules are and how to use them in my teaching." In addition to providing new skills, the community events and performances opened Cabico to new possibilities in combining poetic and dialogic approaches. "People really did talk. It's the first time I've experienced that performatively," he said. With the help of dialogue facilitators Tammy Bormann and David Campt, Urban Bush Women (UBW) company members came to distinguish between debate and dialogue, learned about the role of conflict in dialogue, and received training as facilitators and in working as teams. Bormann and Campt offered UBW a common language about dialogue, giving form to impulses the company already had but had not developed. Bormann described it as helping UBW to "bridge artistry with another skill set, which has an art of its own." Initially concerned that formal dialogue approaches could squelch the natural, informal conversation that they valued, UBW concluded that a meaningful exchange was more likely to happen when they had intent—and boundaries. The parties, which had started out free form, became more structured as a container for dialogue that was both organic and purposeful. UBW, in turn, encouraged Bormann and Campt to further incorporate movement and nonverbal expression into their workshops.

"The models of dialogue that we developed together required considerable time and effort to make them work because we refused to settle for an 'after performance' large group discussion in the theater where few people get a chance to talk."

Since its Animating Democracy projects, Cornerstone has become more deliberate and structured in its approach to dialogue and is formalizing and teaching its methodologies. It has incorporated National Conference for Community and Justice (NCCJ) values and used its facilitation processes to conduct company meetings and to navigate difficult moments during rehearsals. Over the course of the project its has moved from ceding responsibility for dialogue to the expert NCCJ, to working together to develop a collaborative arts-based approach. Dialogue professionals learned from artists and from the arts projects in ways that enhanced their work, as well. NCCJ has become more open to nonverbal forms of dialogue and has tapped further into its own creativity. NCCJ Program Director Lucky Altman elaborated:

> NCCJ has expanded our repertoire of processes that we use in promoting interfaith acceptance and understanding. We have incorporated processes that allow people to express their feelings and ideas in a more artistic manner and in some cases, using movement to express what they want to communicate. We no longer assume that everyone who engages in dialogues about religion and faith are believers themselves. The models of dialogue that we developed together required considerable time and effort to make them work because we refused to settle for an "after performance" large group discussion in the theater where few people get a chance to talk. Our goal was thoughtful engagement around the issues raised.

Some dialogue practitioners, like those mentioned above, become very interested in incorporating artists' practices into their own dialogue methodologies. However, this raises questions about replicability, and the specific skills and sensibilities that artists use. Do dialogue facilitators need particular artistic skills to be effective? What happens if exercises or methodologies created with aesthetic or art-making goals in mind are adapted to serve dialogue goals? Is something lost in removing them from the context of art? If dialogue is part of an aesthetic strategy, what is the artist's role in directing or managing the dialogue?

Dialogue facilitators discovered there are some things about artistic process that may differ from standard models of dialogue. Artists have an intuitive awareness of nonverbal elements—as well as for metaphor, symbolism, abstraction, and juxtaposition—and have developed techniques for using them in their work. Beyond the creative *process,* artists may also have particular objectives in completing the cycle of creation in order to give participants a sense of accomplishment and empowerment from what they have made. Because an unsatisfying aesthetic experience can be disheartening, or even counterproductive, skilled aesthetic leadership—which can be profoundly meaningful—may even be necessary.

Many dialogue facilitators see collaboration as the most viable way to ensure the integrity of creative practice, but many artists have, in fact, identified exercises and methodologies that are applicable in multiple contexts. Story circles, for example, are being used by an increasing number of dialogue practitioners. Michael Rohd has published theater exercises and techniques for resolving conflict and encouraging dialogue, many of which may be executed without theater training. Dance Exchange, too, is creating a "toolbox" series of exercises in how-to format, with accompanying stories of on-site applications, specifically for cross-disciplinary distribution. As more and more dialogue practitioners and artists work together, they are exchanging techniques and methodologies, and sharing resources that will increase their skills in both fields.

What happens if exercises or methodologies created with aesthetic or art-making goals in mind are adapted to serve dialogue goals? Is something lost in removing them from the context of art?

ASSESSING CIVIC IMPACT

We have to tell stories about [civic] impact of the work and we won't get off the arts page until we do that. We should be making the case to the public. It's very vital at this moment.

—Judi Jennings, Kentucky Foundation for Women

Dell'Arte's rambunctious comedy Wild Card *has had its first verifiable political impact—a candidate for Blue Lake City Council, Marlene Smith…an emerging interest in the office was catalyzed by the mutant vision of a future Blue Lake expressed in* Wild Card. *During her campaign, Smith (one of two people prompted by the play to run for council) discovered that only one of the five current council members had actually visited the Rancheria to learn about the casino. With two issues on her mind (annexation as a key to managed growth, and community relations between the city and the Rancheria), Smith was elected in the November 2002 elections. Since her*

election, she has created a formal Rancheria/Blue Lake liaison. Tribal chair Ramsey
reports that the Rancheria and the City are now "working together on quite a few
projects," thanks to a new city manager and a growing awareness of the common
ground of "how we feel about where we live."

—Excerpt from a news story by Kevin Hoover, The Arcata Eye, *July 2002*

The notion of assessing *civic* impact poses new challenges and raises many questions. More accustomed to evaluating organizational and artistic outcomes, cultural groups are pressed to define what is meant by "civic" impact, whose standards to apply, what evidence to look for, and what to document and track. Evaluators brought on for the *Understanding Neighbors* project, for example, probed the civic goal inherent in the project's name: "What does *understanding* mean in the context of this project? Who exactly are the *neighbors?*" The evidence was seldom so immediate and obviously "civic" as it was in the case of Dell'Arte's *Wild Card* play. In many Animating Democracy projects, cultural leaders wondered how to gauge hard-to-measure outcomes such as shifts in attitude or understanding. They did not know whether they could attribute civic effects to their arts-based civic dialogue efforts, or to other factors. How, they asked, do you document dialogue when dialogue facilitators raise concerns about maintaining the confidentiality and trust that are established in dialogue groups? Which dialogues do you document? How much documentation is enough to learn what you want to know, and how do you sort and use such material? Finally, recognizing that some civic effects might not be felt until well after a project concluded, many asked what cultural organizations can do realistically to track evidence of change over a longer term.

The challenge in gauging the civic effects of arts-based civic dialogue efforts raises a variety of considerations about documenting and evaluating this work.

One consideration is, who gets to define success? Although cultural organizations may conceive their projects with certain civic intents in mind, the planning process typically reveals nuanced—or divergent—concerns and goals. These translate into different views of success and underscore the importance of involving various stakeholders in both framing the purpose of evaluation and participating in the evaluation. *Understanding Neighbors* took a formal approach to mapping issues, that is, interviewing a range of people holding different views on issues related to same-sex couples in order to gauge what prospective dialogue participants would define as a successful dialogue experience. Stakeholders' perspectives on success, gathered early in planning, did not always carry through to actual evaluation activities. For example, in planning the *Common Threads Project,* white leaders felt that greater understanding of racial issues would mark progress for Allen County, while black planning team members expressed repeatedly that the black community wanted concrete change, particularly in the areas of jobs and empowerment, and was tired of just talk. This knowledge helped shape the project, but organizers did not formally assess the African-American community's perceptions after the project, with the exception of certain key stakeholders.

Pre- and post-experience surveys are helpful in discerning less tangible outcomes such as shifts in attitudes or understanding. The social sciences, education, and even the dialogue field have employed pre- and post-survey methods to assess project participants' "before" and "after" attitudes. *Understanding Neighbors'* pre-dialogue survey ascertained what drew participants to the project and calculated participants' comfort level and familiarity with controversial conversation and the topic of same-sex couples. The post-dialogue survey measured changes that occurred in the latter two areas. Additional focus-group meetings of significant project stakeholders, held after the analysis of the survey data, provided a qualitative barometer of artistic, civic, and dialogue impact. In the *Understanding Neighbors* project, attitudes did not substantially shift as a result of participation in arts-based civic dialogues, but most of the participants had already considered themselves open to the topic, unafraid of controversy, and receptive to art. The Arts Council of Lima's surveys showed that 73 percent of respondents indicated they were more likely to get involved in civic issues than before their participation in *Common Threads*, and 97 percent indicated that elected officials needed to take part in more public conversations like the theater-based opportunities afforded by *Common Threads*. An equal number further noted they had a better understanding of how the arts could play a catalytic role in public conversations.

Standard survey forms, questionnaires, and other conventional evaluation methods were not well suited to certain cultural contexts. The Center for Cultural Exchange (CCE) distributed evaluation forms to the audience at its Congolese Cultural Festival, for example, but most of the African refugees found the form too complex. Because a more culturally-suitable, face-to-face approach to collecting data would have been too time-intensive, CCE staff assessed effects of the *African in Maine* project mostly based on anecdotal and subjective information. Likewise, in the small community of Kohala on the island of Hawai'i, local project organizers were confident in their ability to read and gauge the civic effects of the project to restore the statue of King Kamehameha I. In a place where oral

cultural traditions are still strong, gauging effects of the project naturally occurred in the way of "talk story" as the project's cultural activities unfolded. Formal written surveys or focus groups were unnecessary and, in fact, would likely not have been well received.

Anecdotal evidence can substantiate civic impact. Many cultural organizations relied heavily upon anecdotes and testimonial evidence to interpret the effects of projects on participants. Some project organizers asked whether anecdotes might even trump data, especially in cases when data can be either ignored or mistrusted. A case in point was Perseverance Theatre's *Moby Dick* project. A Barrow citizen related the phenomenon of "Hit and Run Science" to Perseverance members:

> Scientists have been in and out of Barrow for decades. They come study the whales, the people, the ice, the cold. They ask a lot of questions, take a lot of readings. Then they go away. They don't come back. 'We' don't ever know what 'they've' learned. That's 'Hit and Run Science.' I have to tell you, this is the first time I remember the 'scientists' coming back!

Community members found it significant that Perseverance visited Barrow more than once to research and hear the community's stories, and then brought the play *Moby Dick* "back" to Barrow, inviting the community to see and talk about it.

Many feel that anecdotal evidence is sometimes more illuminating when it comes to the harder to discern goals of individual transformation—enhanced understanding, increased tolerance, or attitude shifts. Children's Theatre Company provided several anecdotes from its *Land Bridge Project*. For example, following their experience of seeing *Montevideo Stories*, two farmers who held opposing political views about farming issues spoke to each other for the first time in many years, opening the door for further conversation. In another case, one man complained in the local coffee shop that the play did not address the success of the large agribusiness farms. Just then, one of those farmers walked in and responded that he was successful only because he had kept growing his farm when, in his heart, he didn't want to do it. He asked, "When is it going to end? 3,000 acres? 5,000?" These stories captured the after-effects of the play; people were still thinking about the issues it raised, and seemed to feel that the play gave permission, in a sense, for them to continue talking with one another.

Nonetheless, many people feel that anecdotal evidence should complement rather than replace more conventional, data-based information, particularly because it is difficult to sustain the effort to seek out and record anecdotal information.

Is it possible to take the long view in evaluating civic impact? Most cultural organizations found it difficult to imagine sustaining attention on the effects of a particular project for more than a few months after the project ended. Organizational resources naturally shift to more immediate priorities. Cultural organizations deeply rooted in their communities, with ongoing links to community agencies and constituencies, such as the Esperanza Center, Dell'Arte, and Intermedia Arts, are better positioned to observe and document

Many feel that anecdotal evidence is sometimes more illuminating when it comes to the harder to discern goals of individual transformation— enhanced understanding, increased tolerance, or attitude shifts.

change over time. The Social and Public Art Resource Center (SPARC) has been visited by adults who were involved decades ago, when they were young, in *The Great Wall of Los Angeles* mural project. SPARC has elicited stories and testimonials of personal transformation as a result of individuals' experiences with *The Great Wall* as evidence of long-term civic impact. The Esperanza Center has made video and written documentation an ongoing part of its cultural activism efforts. Close observation, and the resulting archive, has enabled it to observe, over time, the increasing participation of average community members in cultural and civic concerns. As a multiyear process, the *Faith-Based Theater Cycle* had a cumulative impact, gaining depth and acting as a catalyst for developments that Cornerstone Theater Company feels are yet to be revealed. Mark Valdez, Cornerstone's former associate artistic director, addressed this impact as he reflected on the Muslim project: "This play and this process made a difference. Because of the dialogue and the experience, someone grew to accept another person as a valuable member of her community. Who knows what the ripple effect will be? What matters, is that it's begun." Sometimes project partners or other organizations are in a position to watch for those ripple effects. The New Hampshire State Arts Council observed the creation of a local arts agency and other civic efforts resulting from partnerships and relationship formed during Liz Lerman Dance Exchange's *Shipyard Project* in Portsmouth, NH, (not an Animating Democracy project) eight years earlier.

A NEW CONTEXT FOR COMMUNITY CONNECTIONS

The stories of Animating Democracy projects point to the range of effects that arts-based civic dialogue can have on civic concerns. The dynamics of civic life can't be fully anticipated, and it can be as challenging to frame what civic difference a cultural project will make as it is to achieve that goal. As goals and outcomes are so inextricably related, this section began by exploring both. With the many and varied examples in this section in mind, we can conclude that arts-based civic dialogue:

Expands participation in civic dialogue by increasing the numbers and/or diversity of people who would typically engage. Arts and cultural projects compelled more people than might have otherwise to participate in civic dialogue by focused and often sustained attention to the issue at hand, and by attracting people to and involving them through arts and culture. Arts-based civic dialogue provided new access to civic life for people of color, youth, recent immigrants and refugees, and the poor—people typically excluded or on the margins of civic discourse. Groups were empowered to stake claim to civic space—literal and symbolic—and, through art and culture, found safe space, points of entry, and confidence to participate in public conversation.

Enhances public awareness and understanding of civic issues. Arts-based civic dialogue projects consciously contributed new angles, stories, and perspectives to existing civic discourse. Projects deepened understanding of the complex dimensions of civic issues, focusing on both human and political dimensions, and on gray areas not typically explored via the media or public debates. Arts-based civic dialogue fostered empathy and understanding of perspectives held by others. Some projects opened a wider lens, connecting local issues

with national and global concerns and enabling people to see the interrelatedness of issues. Media coverage of projects contributed to public discourse about the issue.

Effects shifts in thinking about an issue. Often the result was a greater openness to listening and considering other views, and increased respect for different perspectives. Sometimes actual shifts in attitude occurred. Sustained projects promoted greater interaction and improved relations between people holding different perspectives, either within a particular community or between different communities. Art and dialogue projects often fostered a feeling of hope that deeper understanding of the sources of civic issues and progress in public discourse could lead to positive change.

Increases participants' sense of individual and collective efficacy to take action. Arts-based civic dialogue projects caused individuals to reflect on their own relationship to civic issues, often bringing about a realization of an individual's role in, and responsibility for, community norms and values. Motivated by projects, people made efforts, sometimes small and personal, sometimes connected to larger civic endeavors to take action related to the given issue. In some cases, they stepped up to assume leadership roles in civic organizations or local government, or to influence others in those spheres. Collective efforts occurred most often when projects created structures to facilitate such efforts.

Enhances the quality of, and capacity for, civic dialogue. In general, the unique qualities of dialogue, as distinguished from other forms of public exchange and debate, were better understood, and the value of dialogue as a means toward deeper understanding and respect among people was embraced. Some projects helped shift the contentious tenor of public debate to a more open and receptive space for hearing and expressing alternative views. The value of structured dialogue was established within community leadership and among citizens. Cultural organizations and communities increased their capacity to convene and facilitate civic dialogue, often through the training of individuals in dialogue facilitation skills. In many cases, projects stimulated new or extended efforts in arts-based civic dialogue or engagement.

Engages civic leaders in a mutually responsive environment with citizens and stakeholders. Arts-based civic dialogue created an environment and a new context in which civic leaders connected with citizens about issues in their communities. Civic leaders became informed about the issues in question at new and different levels. They often heard and publicly recognized voices within the community that were otherwise not heard from or considered within civic discourse. In a couple of cases, increased trust and improved relations resulted from arts-based civic dialogue efforts among leaders or between citizens and leaders. In addition, new civic leaders developed.

The table in the Appendix provides selected specific outcomes from Animating Democracy projects. Projects with multiple notations were among those that focused primarily on civic goals (as opposed to artistic, organizational, or audience goals) and carried out some form of evaluation in order to understand civic effects.

"This play and this process made a difference. Because of the dialogue and the experience, someone grew to accept another person as a valuable member of her community. Who knows what the ripple effect will be? What matters, is that it's begun."

3 Artistic Practice

Toward More Complex Truths

...the awareness of dialogue, the need for it, the opportunities that it offered (even when these were only partially realized), and the earnest efforts made throughout the project to "do" dialogic things left a mark on MACLA's artistic vision and mission that has continued to provoke reflection and learning since.

—*Maribel Alvarez, MACLA*

[The Poetry Dialogues workshops were] an exercise in exploring your authentic feelings, your true emotions on paper, so that we could then inspire a community to want to say something meaningful, and say something real—say something with depth.

—*Toni Blackman, Poet*

The intent for civic dialogue offers fertile ground for artistic investigation by artists, curators, and programmers. Artists, curators, and programmers can call upon qualities and strategies of art such as metaphor, abstraction, and humor, as well as a range of documentary approaches, for their most potent effects in generating civic dialogue.

San Diego REPertory Theatre looked to civic dialogue to understand deeper, more complex truths about U.S. and Mexican citizens' views of the border. From those truths, they created excellent theater. Museums and symphonies experimented beyond the conventions of educational and audience development formats, adapting and creating new programmatic approaches that built civic purpose into curatorial intent. Youth-based projects, like the ones executed by Flint Youth Theatre, used civic dialogue as a strategy to further challenge standard narrative structures and the "message and moral" norms prevalent in much theater for young audiences. In youth projects developed by City Lore and New WORLD Theater, the intent for civic dialogue sharpened young poets' public presentation skills, as well as the ideas conveyed in the work. Many artists and artist-driven companies, such as SPARC and Liz Lerman Dance Exchange, looked deeply into creative practices that already embody dialogic means in order to better understand the relationship between artistic intent and civic effect.

Aesthetic inquiries at the heart of Animating Democracy projects raised a host of questions about what could be learned from artists whose creative processes and/or products are inherently dialogic, or for whom dialogue is an aesthetic strategy. If respecting multiple points of view is a fundamental premise of dialogue, what are the implications when art provokes or communicates a particular point of view on an issue? What considerations regarding program design will support and advance civic dialogue? Based on the civic purpose of dialogue, what aesthetic choices could support or inadvertently undermine dialogue? What effects, for better or worse, does the intent for civic dialogue have on the artistic work? And what are the unique concerns in assessing quality of civically engaged art? These questions and others are explored further in this section.

What Art Has to Offer

DURING ANIMATING DEMOCRACY'S STUDY PHASE, dialogue advisor Wayne Winborne provoked fellow advisors—mostly from the arts community—by asking them what it is about art that makes it a potent generator of dialogue. He pressed, "Couldn't Little League be just as effective in bringing people together to talk about issues?" He pointed out that this question would likely be asked by prospective community partners and participants as artists and cultural organizations ventured forth to talk to people about using art to stimulate civic dialogue. In fact, arts-based civic dialogue efforts demonstrate that many of the basic elements of art itself—such as metaphor, abstraction, and humor— set the conditions for meaningful and productive dialogue by evoking emotional, as well as intellectual, responses and by opening new ways of perceiving and communicating multiple dimensions of an issue.

METAPHOR creates fresh associations and expands the form, vocabulary, or mode of dialogue. Peter DuBois, artistic director for Perseverance Theatre's production of *Moby Dick*, wrote, "The best art leads me to engage new questions and fresh associations." Such qualities inherent in art contribute new dimensions to discourse, helping to create safe space, or to move people beyond what they already know.

Detail, "The Red Scare and McCarthyism," The Great Wall of Los Angeles, Judy Baca, 1976–2001. Photo © Judith F. Baca, SPARC.

What is the power of metaphor? When is metaphor more powerful than explication? What is the unique power of art to create the potential for a different kind of dialogue? According to Flint Youth Theatre organizers, Process Drama took the discussion of school shootings into the imaginative realm through the use of a strong metaphor. Process Drama, a British form of experiential improvisation and role-playing, engages groups in active speculation about issues suggested by a "pre-text," or dilemma, put forward by the leader. Metaphor distanced participants from the harsh realities of the topic and enabled them to express "in role" feelings and ideas that may have been too difficult to share otherwise. Dialogue during Gillian Eaton's Process Drama workshops in Flint probed social values, morals, and circumstances related to youth violence without explicitly addressing the community's own tragedy. Using the Pied Piper of Hamelin pretext, participants took the role of townspeople arguing with the Piper about his payment, and among themselves

What can poetry offer us in times of challenge? Can it help us solve an argument? Can it help us see each other in a new light? Can it find a word that rhymes with annexation, and in so doing, remove the tension of an issue forever. Maybe… Maybe not. But can it give us a sense of things larger than ourselves? Larger than our own perspective? Can it make us consider why things are as they are?

Faith. Memory. History. We all swim in a sea of our own experience. Poetry like tonight's puts the seas of many into one ocean…Up here. What does poetry mean to us? Images. Movement. Music. Words…the words of a white farmer performed by a black man…the story of a black woman told by a white man. Poetry is permission to let daily life and identity have surprising meaning. To change… Even water…

— *Excerpt from* Passing Glances: Mirrors and Windows in Allen County, *by Michael Rohd and Sojourn Theatre, for the* Allen County Common Threads Theater Project, *Lima, OH.*

about who was to blame for the tragedy of their lost children. This later became the central metaphor of the play, *...My Soul to Take.*

Metaphorically articulating historic issues helped generate images for *The Great Wall of Los Angeles* mural as SPARC (Social and Public Art Resource Center) worked to depict the final four decades of the 20th century. Artist Judy Baca and SPARC conducted "metaphor workshops," at which community members suggested metaphors for the defining events, conditions, and experiences in their lives during these decades. Phrases such as "blind patriotism" and "sleepwalking democracy," for example, stimulated rich discussion of issues from white flight to Desert Storm, and entered SPARC's repository of images.

Metaphor also brings into focus what is yet unclear and opens up alternative pathways for exploring an issue. It can shine light on particular aspects of an issue and help people make unexpected associations, prompting new understanding. In the Arts Council of Greater Lima's *Common Threads Project*, water was a real resource issue, causing conflict between the city and the surrounding county. Although, in the end, persistent underlying issues of trust among leaders and between races emerged as the focal points for public dialogue, water served as a central metaphor in the play created by Michael Rohd and Sojourn Theatre. For Lima, OH, organizer Martie MacDonell, the metaphor was rich with associations: "...no rain, too much rain, water as a political issue, water as a symbol of cleansing one's self of fear and prejudices, water as a religious symbol, closing your umbrella for protection and baring oneself to rain so as to witness the truth."

In some cases, cultural organizers cautioned about the potential for metaphor to misappropriate meaning. Regarding *The Slave Galleries Restoration Project* of St. Augustine's Church and the Lower East Side Tenement Museum, organizer Lisa Chice saw the power of the church's slave galleries as symbols of many ethnic and religious groups' experiences of marginalization. But, she wrote:

Scene from Passing Glances: Mirrors and Windows in Allen County, *Sojourn Theatre, 2002. Photo* © The Lima News.

1 Lisa Chice, "Building Upon a Strange and Startling Truth," in *Critical Perspectives: Writings on Art and Civic Dialogue* (Washington, DC: Americans for the Arts, 2005).

Although the slave galleries have been the stimulus for healing dialogue across different backgrounds, I have been wary of overplaying the slave galleries as a metaphor for other instances of hidden oppression in history. I have feared that this might somehow be an unfair appropriation of the meaning the slave galleries have as a concrete artifact from one particular group's history—the experience of African Americans who were enslaved and subjugated.[1]

ABSTRACTION opens space for multiple interpretations, thereby inviting multiple perspectives. "Many have questioned whether a fundamentally nonrepresentational non-narrative art such as concert music can be effectively employed to encourage dialogue…" observed American Composers Orchestra's Michael Geller. Text-based and representational work may have the advantage of conveying content more directly, but abstract art forms demonstrate the power to unlock core emotional and visceral responses to issues by, as one participant described it, "bypassing the brain." For participants in the American Composer's Orchestra's *Coming to America: Immigrant Sounds/Immigrant Voices* project, new orchestral music by immigrant composers elicited strong emotional associations of home and memories of displacement for immigrant participants. Geller adds, "Our experience suggests that it is precisely the nonrepresentational, ambiguous nature of music that can help to liberate both the dialogue and the art, making both more effective."

The role of emotion in civic dialogue is discussed further in "The Relationship of the Personal to the Public" in the "Civic Implications" section.

In addition, nonlinear structures, challenging juxtapositions, and ambiguity in art can create new possibilities of conceptualization and help reveal the assumptions of a community or individual. Though some dialogue practitioners have expressed concern that abstract or nonliteral forms might cause confusion or stall dialogue, the shared experience of abstract or symbolic art can lead to breakthroughs in public dialogue; with perceptive facilitation, this shared experience can lead to breakthroughs in public dialogue.

HUMOR breaks down barriers and can establish common ground in regard to serious issues. Humor can function as both artistic content and dialogic strategy; it can relax and engage a group, or prompt self-reflection. "Laughter is a biological response of recognition," suggests Michael Fields of Dell'Arte theater, whose work centers on satire and commedia dell'arte. "If you can laugh at something, you are recognizing it in yourself." Laughter can also make difficult or sensitive areas of discussion more approachable.

For example, a performance excerpt called the "Hot Comb Blues" got particularly strong response at Hair Parties. Urban Bush Women company member Wanjiru Kamuyu reflected, "With humor, [the Blues] physicalized the burn of a hot comb, the itch of a perm, and the yanking and tugging of a mother combing her daughter's hair. The performance evoked much laughter along with the visceral memories among Hair Party participants and inspired them to tell stories about their own 'hair hell moments.' The performances allowed participants to breathe and laugh at themselves and others, rather than letting the barriers drain them."

Dialogue as an Integral Part of Artistic Practice

ARTISTS SUCH AS SUZANNE LACY consider staging dialogue, or creating spaces for dialogue, part of their creative practice; for them, process and dialogue are *aesthetic* dimensions of art. Stimulated by her encounter with Animating Democracy participants at a Learning Exchange, and considering her own work, Lacy observed that, "while Animating Democracy might advertise its goal as an invigorated public life, it poses a provocative question about the form, not just the function, of art. Although some of its sponsored projects might aspire to be art that is surrounded, enhanced by, or used in the service of civic discourse, others will, no doubt, aspire to creating new forms of *dialogic art*."

"while Animating Democracy might advertise its goal as an invigorated public life, it poses a provocative question about the form, not just the function, of art..."

This section explores the ways in which artistic products and processes are inherently dialogic. It looks at how creative activity can be a *form* of dialogue—dialogue practices are woven into the artistic experience, or the art form contains dialogue or dialogic exchanges within its very structure. It also looks at the ways that dialogue may occur in the process of creating art. Understanding the various ways that creative processes and artistic products can embody dialogue broadens the artistic palette and opens up possibilities for expanding dialogue opportunity through art in projects.

Nonverbal art forms such as movement and music, and artistic strategies such as juxtaposition, can indeed create and contain dialogic exchange. Other art forms, such as storytelling and theater, are based on actual dialogue or dialogic exchange.

The use of personal story allows participants to speak freely about feelings; connect with civic issues on an intimate, visceral level; gain respect and empathy for each other; and form lasting bonds. Many artists use story as a basis for creative process and/or artistic product. There are many different approaches to the use of story, but one particularly well-known and influential approach is Story Circles, formalized by John O'Neal in his work with Junebug Productions. In fact, the Story Circles concept is the foundation of Junebug's work, and the *Color Line Project*. John O'Neal believes that the Story Circles process is not only dialogic, but also innately democratic. O'Neal asserts that, "The use of a circle where everyone can see each other is critical, as it implies an equal, active and democratic role for each participant." As Junebug Productions said in its Animating Democracy report:

*John O'Neal of
Junebug Productions.*

> The premise behind the process is that by allowing people to hear each other's viewpoints or experiences in the form of stories, they gain a much fuller understanding of alternative ideas and experiences without unnecessary confrontation, and without feeling that their own ideas are being threatened or rejected. Rather, communication between opposing groups becomes possible, common problems can be identified, and solutions can be developed.

> The process, like the stories that people use it to share, is essentially oral in nature. When things are written down, we have a tendency to treat them as more final than they need to be. On the other hand, when people sit down to actually talk together, [you] have the chance to look at the body language, to listen to the tone of the voice, to question if you're not clear about something, or to challenge if you think that's in order.

During the story circles, listening to others and organically responding with your own story is emphasized. Dialogue then results from, and is based in, personal knowledge, experience, and connections. Mark Fields, director of the Glassboro Center for the Arts in New Jersey, one of the pilot sites for the *Color Line Project*, commented, "The process is one that continues to surprise and move us with the depth of connection and communication that it makes possible. It is amazing how personal and intimate a group of strangers can become in a short time, given the proper atmosphere and ground rules."

In addition to being a valuable dialogue methodology, Story Circles is an artistic practice out of which new plays are developed and created. Palm Beach Community College (also a *Color Line Project* site) theater professor Tony Tassa described how, in working with students to create a new play, the group was also "able to use the story circle when the

"When things are written down, we have a tendency to treat them as more final than they need to be. On the other hand, when people sit down to actually talk together, [you] have the chance to look at the body language, to listen to the tone of the voice, to question if you're not clear about something, or to challenge if you think that's in order."

creative process became bogged down. This helped free the actors up again, and opened us up to greater creative development and discussion of the issues."

Nonverbal physical or imagistic exchanges communicate ideas and experiences in a way that contributes to meaning and understanding. Dance Exchange members included in their investigations the question of whether dialogue must necessarily be verbal. They believe that nonverbal signs and exchanges in movement can communicate experience, share information, reveal assumptions, balance power, and more. In addition, they point out that an emphasis on verbal dialogue can privilege people who are good at expressing themselves with words or speaking in groups, and disadvantage those who aren't. Because it takes diverse modes of learning and multiple intelligences into consideration, a nonverbal approach can make dialogue more inclusive.

For example, *One to Ten*, an introductory exercise that Dance Exchange often used in its *Hallelujah* project, takes "body language" beyond gestural cues and into the realm of physical "conversation." One person makes a "statement" in movement, and the other responds with movement, repeating this back-and-forth exchange until they reach 10 movements. There is no "topic," but the interchange mirrors the structure of dialogue, and provides the experience of communication in which participants are introduced to notions of "bodily listening," responding without judgment, and understanding how space —closeness, distance, who's above, and who's below—creates meaning.

Physical techniques like this help make subconscious body language conscious and meaningful. In addition, people may more easily express through movement the things that they are afraid, reluctant, or unable to express verbally. Participants find a kind of "safe space" in silent or abstract creative activity, when words make them feel more vulnerable, when an experience is too intense, or when the stakes are too high. This is especially important when working with issues of trauma, or handling extremely delicate power dynamics.

Wendy Morris, working with the Intermedia Arts project, *People Places Connections*, asked participants to map their Minneapolis community on the floor, and then ride a tricycle through it, in the path of the Midtown Greenway, a proposed stretch of development. She said that this experience of spatial awareness provided community residents with "another connection to the questions and reality of change that was occurring." Artists and dialogue practitioners often used other kinds of physical mapping exercises, for example, asking participants to move their bodies along an imaginary continuum of agree/disagree in response to statements about an issue, visions of a new future, or other concepts. Such physical mapping offered a creative nonverbal alternative to verbal dialogue, in which individuals could see themselves in relation to others and assess how the group's attitudes were weighted, including the degrees of ambivalence in people's choices.

The use of touch in dance and theater exercises can lead to profound shifts in group dynamics. Respectful, creative use of touch can build trust and a shared sense of safety within a group. Touch also communicates power dynamics and relationships; it also reveals assumptions in very subtle, personal ways. Whereas naming these outright might cause some participants to become defensive, touch can break down barriers between them. Some people, however, are uncomfortable touching or being touched, particularly in a group of strangers. Establishing a level of trust may be important before some will participate in touch-oriented activities, and many artists allow participants to opt out of these kinds of exercises.

Dialogue often occurs among artists and community participants during the process of creating art, as they collaborate, deliberate about aesthetic choices, or explore content.

Creating a shared language of movement, gestural vocabulary, or image base may make an extremely valuable contribution to dialogue by introducing different groups to each other and creating common ground from the beginning of, or even before, their first encounter. During the *Hallelujah* project, Dance Exchange company members often created movement phrases with one community group and transported them, along with the stories from which they were created, to other community groups in different locations. When the different groups met, "they already share[d] a body of movement and spoken lore that [formed] one of the foundations of their work together." Similarly, visual artist Ta-coumba Aiken, working with Intermedia Arts, "cross-pollinated" wooden blocks painted by community participants from one site to another, allowing them to interpret each other's images and begin their creative explorations where the last group ended.

Certain forms of poetry and other oral art forms that are inherently dialogic present multiple perspectives through aesthetic expressions. City Lore's project, *The Poetry Dialogues*, brought forward two such forms—Filipino *balagtasan* and freestyle

rap. *Balagtasan* is a poetic form based on debate, in which two poets take opposing sides of an issue, and express their points of view in a particular rhyme scheme (usually in Tagalog, one of the major languages spoken in the Philippines), leaving the audience to discuss further based on what they heard. Freestyling, on the other hand, can include multiple points of view, depending on how many poets join in. In freestyling, artist/facilitators such as Toni Blackman request topics from the audience, so that poets can engage issues that are important to the community or group. Because the form is improvisational, it has the potential to touch deep complexities within a topic as freestylers respond directly to each other's statements (rather than presuming what the arguments will be and writing counter-arguments in advance). Unlike literal debate, these forms utilize metaphor, rhythm, imagery, and rhyme, and give creative structure to the expression of strong emotions. Presenting the argument by aesthetic means opens the audience to new ways of hearing differing points of view, and prepares them to engage in their own dialogue in more creative, sensitive ways that may offer surprising new insights.

Poet Toni Blackman (left) in a cipher with fellow artists, The Poetry Dialogues, City Lore, 2001–2003.

Participatory forms of theater or interactive performance art may incorporate dialogic exchange in the aesthetic structure. By integrating dialogue exercises into the play, *Zones (or, Where does your soul live and is there sufficient parking?),* Cornerstone Theater Company created an artistic product that consciously used dialogue exercises as part of the art experience. *Zones* cast the audience as participants in a fictional public hearing, at which a religious group's right to construct a new place of worship in the neighborhood was at stake. Although the play—written by Cornerstone ensemble playwright Peter Howard—is highly scripted, it has five distinct interactive dialogue sections when audience members talk about their own experiences, prompted by characters and circumstances in the play.

Another example is the Critical Art Ensemble's faux scientific experiments as part of Henry Art Gallery's exhibit, *Gene(sis): Contemporary Art Explores Human Genomics,* which engaged passers-by in encounters that prompted interaction about issues of biogenetic engineering. The ensemble "scientists" put the audience in the position of collectively making a choice, without which the performance could not continue. The resulting conversations were integral to the form and meaning of the piece.

WHEN THE PROCESS OF ART IS DIALOGIC

Many artists who facilitate community-based arts—such as Liz Lerman, Judy Baca, John O'Neal, Michael Rohd, and Wendy Morris—specialize in artistic practices that contain dialogic elements, both in form and process. As Animating Democracy liaison Caron Atlas

Cult of the New Eve *by*
Critical Art Ensemble, an
installation within Henry Art
Gallery's exhibition Gene(sis):
Contemporary Art Explores
Human Genomics, *2002.*

explained, "Dialogue is part of aesthetics for [these artists]. They're interested in the creation of methodologies that embody aesthetics. Exciting methodologies. Judy's notion of going from history to metaphor and from metaphor to image is an aesthetic process... it is aesthetic stretching through dialogue." Participatory arts practice can indeed include elements and skills that are identified and recognized as important elements of dialogue, such as creating safe space, listening for meaning, revealing assumptions, and leveling power dynamics.

The process of making art generates dialogue among participants. Dialogue often occurs among artists and community participants during the process of creating art, as they collaborate, deliberate about aesthetic choices, or explore content. As John O'Neal has said, "knowledge is a product of what we do together." Creative activity brings people into dialogue through *doing* things. Telling stories, painting cubes, or creating choreography together helps people feel more comfortable engaging in dialogue about issues and ideas, often at a deeper level, because they are engaged in an artmaking process.

At Intermedia Arts, artists reported that making art "engenders a sense of safety and re-establishes trust or sense of common ground among community residents of different cultural backgrounds and social strata." In addition, artmaking helps "level the encounter"—people who usually exist in hierarchical relationships experience themselves, in the creative process, as equals in the new experience of artmaking, or may find within themselves new, unexpected authority, expertise, or talent.

Liz Lerman has long held that "the goal is art...[Art] becomes the framework by which the dialogue begins." If the stated focus is civic dialogue, personal transformation, or social change, she contends, those things may never be achieved, or one risks maintaining

The "typical" activities and sequencing of a Dance Exchange workshop can be tracked along three distinct but parallel trajectories to show how the activity advances values conducive to dialogue and community building as well as artmaking. For a more detailed analysis, see the Appendix item, "The Dialogue: How a Dance Exchange Workshop Develops Artistically, Dialogically, and Civically."

Collaborative product
▲
Collaborative skills developed
▲
Collaborative development of content
▲
Individual skills built
▲
Dance principles demonstrated
▲
Content introduced and generated in increasingly complex structures
▲
Warm-up of bodies and skills
▲
Clarity of purpose

Trajectory of ARTMAKING

Reflection and consolidation
▲
Full group response
▲
Group-think structures, mutual learning
▲
Collaboration
▲
Circle-talking/listening; multiple viewpoints revealed
▲
Nonverbal, freeform interaction
▲
Individuals take turns
▲
Leader to individual

Trajectory of DIALOGUE

Group action, community foundation in place
▲
Capacity to make connections, gain new awareness
▲
Commonalities and differences unearthed
▲
Multiple viewpoints revealed
▲
Trust and equality established
▲
Neighbors are known; equality is established
▲
Strangers gather

Trajectory of COMMUNITY BUILDING or CIVIC DEVELOPMENT

too narrow a focus; but if the goal is making the best art, together, all these things will happen in the process. Because people have to talk, explore, express themselves, listen, collaborate and support each other in order to make aesthetic and content decisions together, participants learn new ways of communicating and working together. Also, she says, something magical happens in a group when they have a performance deadline: everyone pulls together, for better or worse, to make it happen, and to make it the best it can be. The artistic experience, then, provides a positive model for civic experience. Dance Exchange humanities director John Borstel emphasizes that "the process doesn't always look like civic dialogue, but has important civic impact."

Artist Marty Pottenger considers constructing creative and meaningful opportunities for dialogue, an art in itself. In her *Abundance* project, she facilitated dialogues on attitudes about money and economic inequities with people of various incomes, from millionaires to workers who earn less than minimum wage. The *Abundance* workshops looked like dialogue, and were introduced as dialogues, but contained surprising artistic elements that shifted the content and changed the experience. Participants were invited to make drawings, collages, refrigerator poems, and other art in the course of the dialogue; this offered them ways to visualize systems, express dreams, and break personal taboos about discussing money honestly and openly with others.

Pottenger's year-long dialogue group allowed the time for a fixed group of people to experiment with different art forms, including movement, poetry, and Pottenger's primary area of expertise—theater. She also experimented with the sequence of activities. After trying artmaking activities as a follow-up to dialogue, she decided to position the artmaking at the beginning and found that dialogue grew more naturally, and in deeper ways, from the art experience. "It was incredible, the energy and concentration," she recalled after the session in which participants made collages out of their own financial papers. She writes:

> Each person spoke about what they had made and their relationships to financial papers which blossomed into a spontaneous open dialogue about money filled with new questions and ideas: "spending as a religion," "thinking about money the same way we think about natural resource," "money, like land in Native American cultures, belonging to no one but being understood as the realized fruit of all our labor"…the words that appeared in the collages became humorous deconstructions of the language of money: invitation, carrot, promise, denial, threat, betrayal and punishment. At the beginning I spoke about determining where the scarier dialogues among us might be…At the end, several people spoke about their willingness to head in that direction in future dialogues. Starting with the art…opens up everyone's sense of possibility, imagination, intelligence and fun. Initially I had thought the dialogues would inform the art and take it deeper, but now I think the opposite may be true.

Art Seen Through
a Civic Lens

CIVIC INTENT AND ARTISTIC PROCESS

Civic purpose can give rise to a sense of responsibility, which in turn may prompt greater rigor in research on the civic issue, as well as new use of dialogue itself as a research method. In some projects, the program staff at arts institutions, and artists as well, became more conscious of the relationship between artistic process and product in relation to civic dialogue and civic intent, allowing the art or the artistic process to take priority at various stages of a project. Artists and programmers sometimes ventured into disciplines outside their own or worked in cross-disciplinary ways with other artists or dialogue practitioners.

Dialogue is a productive research and planning tool that strengthens the issue-oriented content of the creative work. In the creative development stage of many projects, dialogue served to uncover perspectives not often heard—of Iñupiat whaling captains or minimum-wage workers or millionaires—and thus deepened understanding of an issue. Seeking to imbue a new theater work with more nuanced perspectives about the border between the United States and Mexico, San Diego REPertory Theatre embarked on research and creative development that involved extensive interviews, community

163

round table dialogues, and town hall forums; this was a more comprehensive approach than the theater had ever taken before. "We made a concerted effort to include as many voices of differing opinions regarding the issues of the play," said playwright Bernardo Solano. This approach lent greater authenticity to the plot elements, and added multidimensionality to the play's characters, thereby creating a more thought-provoking work of art—one that invited audiences to contemplate perspectives other than their own.

When "real people's" words are incorporated into art works, they serve to mirror and validate a community's own voices. Audience members in Lima, OH, were impressed by the veracity of community feelings about issues of race and trust that Sojourn Theatre captured in its play, *Passing Glances*. A farmer who attended a "barnstorming performance" (a preview excerpted from the full play) at the Farm Bureau remarked, "You got us right, so I have to trust you got the others right also." The juxtaposition of multiple voices in the finished work created another level of dialogue, as different perspectives played off each other to reveal assumptions about characters and points of view. Michael Rohd commented that having the opportunity to explore this style of developing new work "away from the company's home base, over such a length of time and in collaboration with partners who treated us well, and whom we respect offered Sojourn a real gift—depth…our work since is deeper, and builds on successes and lessons from Allen County." In fact, the process in Lima, OH, prepared Sojourn for its subsequent large-scale project, *Witness Our Schools*, a touring theater project that is engaging the entire state of Oregon in dialogue about issues in education.

Civic intent can inspire artists and programmers to try different approaches to dramaturgy, including community feedback, in order to ensure authenticity of voices, context, and content. In these approaches, key stakeholders and community members are invested with increased creative authority. Advisory groups, common in such projects, often challenge the way people and issues are represented. Advisory groups played roles in defining interpretive strategies used for the exhibitions at The Jewish Museum and The Andy Warhol Museum. In the humanities, the intent for civic dialogue resulted in new or refined models for historic preservation and art conservation that intimately involved community. The *King Kamehameha I Statue Conservation Project* in Hawai'i pioneered a new approach to conservation that engaged and empowered the community, challenging not only the conservation field's ethical standard of honoring artists' original intent, but also preconceived ideas about who has the right to make decisions about conserving cultural properties, and how those decisions are made. Calling this "participatory conservation," conservator Glenn Wharton observed, "We have not only engaged community in thinking critically about its past and participating in conservation decision making, but the process itself became a vehicle to construct new meanings for the sculpture." *The Slave Galleries Restoration Project* also explored a model combining preservation and civic dialogue. The project integrated civic dialogue into the preservation process and into the quest to understand how best to interpret the slave galleries site so it would have meaning for multiple publics and would foster civic dialogue on community issues.

[1] According to The Dramaturgy Pages (www.dramaturgy.net/dramaturgy), a dramaturg has a number of functions in the development of a play and/or during rehearsals and performance. In the development of a play or preparation of a text for performance, the dramaturg helps those involved in the production to better understand the piece. He or she may conduct research, work with the playwright in the construction of the text, adapt or translate language among other things. During the play's rehearsal, the dramaturg helps the production to remain in line with the vision for the production. He or she is both a representative of the script or author and the audience.

Theater directors and playwrights often engaged community members and other stake-holders in dramaturgical roles.[1] San Diego REP Artistic Director Sam Woodhouse wanted to involve community members as dramaturges during script development for the play *Nuevo California*. These volunteer "participant-observers," recruited from the project's initial "Conversations" events, represented a range of community members from both sides of the border—university professors, journalists, nonprofit leaders, and government officials, among others—and were uniquely positioned to comment as the artists distilled raw material from interviews into art. In some instances, they played a checks-and-balances role to preserve the authenticity and nuance of a snippet of dialogue garnered from the community. Playwright Bernardo Solano commented, "Their responses to the ways that characters interact with each other, when and how [characters] express themselves through song, and many other facets of the style of the play made us think hard about some of our choices; in many cases, we went back to the drawing board." On the whole, however, Sam Woodhouse saw that those who volunteered tended to respond in an "agenda-driven" way, which contributed to spirited dialogue but not necessarily to rigorous feedback that advanced a great work of art. After multiple script drafts went through community dramaturgy, Woodhouse and Solano engaged a colleague who could bring fresh perspective and a rigorous critique to the final draft of the play. Although Woodhouse has not abandoned the idea of community dramaturges, in the future, he would work with a smaller cohort of community members carefully selected to represent a range of perspectives and knowledge about a specific civic issue, and also some familiarity with the artistic process. A core group would be involved more frequently over a sustained period of time.

Scene from Nuevo California, *San Diego REPertory Theatre, 2003.*

Actors themselves began to view the artistic work with a dramaturgical eye when they focused through a civic lens. Putting its Alaskan adaptation of *Moby Dick* on statewide tour, Perseverance Theatre actors considered how to further refine the work to best generate meaningful dialogue. Peter DuBois, artistic director at the time, noted:

> …I found that when the audience is able to talk about the work, the artists are able to see what is reading—what is coming across—and what isn't. Building a stronger bridge between the actors and the audiences through dialogue activities also made the actors more concerned with the clarity of their artistic intentions: The actors and I had to ask, more diligently than ever, "What is this moment communicating?" because if we weren't clear, it might come back and haunt us during a dialogue. This differs from usual character development work because it is more inclusive of the spectator.

In a couple cases, works were actually remounted based on what was learned from civic dialogue or critical feedback. Dell'Arte reprised its *Wild Card* play a year after the original production to address issues raised by Animating Democracy peers and *Critical Perspectives* writers about the lack of Native Americans in the show. A native character played by a native actor was included in the new version.

See "Ethical Concerns in Creating Art from Dialogue," page 180.

Cornerstone Theater Company revised *Zones* based on responses to the original production, including some audience members' perceptions of an anti-Christian bias that the playwright didn't intend. The revised *Zones* also included refinements of the audience-interactive sequences. Some introductory material was trimmed, and the actors' facilitation of dialogue was scripted in more detail.

The function of dramaturgy typically thought of only in relation to theater has broader application in the processes of arts-based civic dialogue. Other artistic disciplines may also benefit from the kind of overview, as well as collaborative stimulus, that a dramaturge provides. Further, extending the role of a dramaturge beyond that of trained expert—to include work with community and dialogue partners, and participating community members—is increasingly becoming a part of creative practice and lends authenticity and accountability to the work.

CIVIC INTENT AND ARTISTIC PRODUCT

Efforts to unite art and dialogue can result in innovative artistic forms and programmatic formats. Creators, audiences, partners, and participants all acknowledge the innovation, reinvigoration, and new layers of meaning in artistic works at the center of arts-based civic dialogue projects. Many artists and cultural organizations feel that the particular goal of civic dialogue caused them to stretch to new creative heights. Urban Bush Women's alternating format of performance and dialogue in its *Hair Parties Project* became sharper and more effective with focused attention on dialogue and the advisory support of dialogue specialists Tammy Bormann and David Campt. Hair Parties are now a standard offering adaptable to a wide range of settings, from intimate living rooms to large public forums. For the American Composers Orchestra, holding a civic dialogue in conjunction with a concert in Carnegie Hall was a radical programmatic departure. The pre- and post-performance discussions about immigration (augmented by a brief written "quiz" about immigration statistics administered and tabulated during the performance) were lively and substantive, and enhanced many audience members' experience of the music, as well as their awareness of immigration issues. Museums experimented with adaptations of conventional educational and interpretive approaches, as well as ways to link the art with dialogue activities in the museum and gallery spaces.

For Cornerstone Theater Company, civic dialogue about what unites and divides people when it comes to faith motivated a new investigation into theatrical realities. Playwright

Scene from HairStories, *a performance work by Urban Bush Women upon which the company drew for its* Hair Parties Project, *2002–2003.*

Peter Howard explained Cornerstone's motivation in a *Back Stage West* article: "… at Cornerstone [we] have a continuing interest in playing creatively with audience relationship, with theatrical realities, and we find a certain amount of joy exploring that—purely artistically. But we became very interested in the extra challenges that might happen if we attempted to mix up that dynamic a little bit—to find out what would happen if real audience response was allowed on some level as the piece was unfolding."[2] Cornerstone reported, "*Zones* taught us that it is possible to combine theater and dialogue in a way that is artful, dynamic, interesting, and engaging."

[2] Scott Proudfit, "In Your Faith," *Back Stage West,* October 4, 2001.

The intent for civic dialogue can reinvigorate traditional art forms, extant works, and works from the canon. Historic objects and sites were imbued with new meaning when linked to contemporary issues and opportunities for civic dialogue. Both the slave galleries in St. Augustine's Church and Hawai'i's statue of King Kamehameha I came to symbolize their respective cultural communities' own resolve toward self determination. The galleries and the statue accumulated new layers of meaning through dialogue that illuminated associated historic injustices and related current issues of cultural preservation and marginalization. Traditional forms of poetry (African *griot* and Filipino *balagtasan* in *The Poetry Dialogues* project) and dance (*hula ki'i* in the Hawai'i project) gained new currency. In *The Poetry Dialogues*, intergenerational dialogues between youth and elder poets brought traditional poetry, contemporary poetry, and other spoken word forms together. Within the African-American *Poetry Dialogues* team, for example, elder *griot* poet Kewulay Kamara encouraged African-American youth to express praises in their Spoken Word and "spitting," and to try the polyrhythms of African music, which is different from rhythms typical in freestyle or rap. In doing so, traditional forms took on new value to youth.

Works from the canon may gain contemporary relevance when used as a creative space and structure for dialogue. In Amery, WI, Northern Lakes Center for the Arts remounted the local theater guild's production of Ibsen's *An Enemy of the People*. The actors adapted the play to reflect present-day Amery and the issues facing its shoreline development. This included the play's town meeting climax in the form of a dialogue between actors and audience. A surprising moment occurred at one performance when 95 percent of the audience responded that they would be willing to have their taxes increased to clean up local waterways. Audience members enjoyed the fresh experience of this classic as it became directly connected to immediate community concerns.

In presenting existing work, it is incumbent upon cultural organizations to investigate historic and political "baggage," as well as rich associations in order to reposition the work effectively in a contemporary civic context.

In presenting existing work, it is incumbent upon cultural organizations to investigate historic and political "baggage," as well as rich associations in order to reposition the work effectively in a contemporary civic context. The Brooklyn Philharmonic Orchestra's (BPO) restaging of the controversial opera *The Death of Klinghoffer* presented a promising opportunity for dialogue about current crises in the Middle East and how they were affecting people in Brooklyn—Jews, Arabs, Muslims, and others. BPO looked into controversial past attempts to present *The Death of Klinghoffer* (in Brooklyn and elsewhere), seeking to understand what had occurred, and why. For the 2003 production, BPO carefully

designed opportunities to foster constructive dialogue about the art and the issues the art raises, and in the process give an important musical work a public presentation.

More about BPO's considerations and approach can be found in the "Civic Implications" and the "Institutional Practice" sections.

Arts-based civic dialogue work often requires that planners consider the core artistic product as part of an integrated "project." For some, this is already par for the course. Community-based cultural organizations like Junebug Productions, Liz Lerman Dance Exchange, SPARC, and Urban Bush Women, all of which use a holistic and process driven approach, have come to understand how the finished artwork fits within a larger framework of program activities, developmental process, and even what occurs once the "project" has concluded. In fact, some of these organizations, as well as others like the Esperanza Center and the Center for Cultural Exchange, whose civic engagement work is ongoing and deeply rooted in mission, took issue with the notion of "project" altogether. For them, cultural and civic work is ongoing and organic, with unexpected twists, turns, and opportunities. While there may be definable activities around which to draw a "project" circle, to do so ignores the importance of long-term commitment and flexibility, and creates an artificial start and end that can also translate to community members as seduction and abandonment.

It is important to involve artists early, when civic issues are being framed and the project is being designed. This is especially important when new work is commissioned.

For organizations not traditionally centered in community-based work, the intent for civic dialogue often means a more radical shift to the notion of a whole "project." In larger institutions like Henry Art Gallery, American Composers Orchestra, and the New Jersey Symphony Orchestra, the predominant focus is traditionally on the artistic presentation—with education, interpretation, and other programming in a supporting role. These institutions began to see that the art might be brought to the foreground at times, and at other times serve more as a backdrop to civic dialogue. They saw the full range of project elements—research and planning, relationship building, partnering, curation, production, education, interpretation, and public programming—as viable "moments" in which civic dialogue might occur.

The Warhol Museum's education curator, Jessica Gogan, wrote about the museum's conscious choice to use the term "project" rather than "exhibition" as a way to think and act more inclusively and collaboratively:

> At times during the project we wondered what would have happened if we had just shown the images without the accompanying "project" and all its interpretive displays, community dialogues and initiatives...it is likely that it would have been interpreted as a deliberately sensational gesture, in line with a general public perception of Warhol and the museum, or, as the museum's director Tom Sokolowski noted, a "patriarchal" one. Instead, *The Without Sanctuary Project* inscribed the museum's larger project in the local community and by extension Warhol's work, without detracting from its playful and avant-garde status, with newfound percep-

Understanding Neighbors
artists Peter Carpenter and
Sara Felder in "Ambivalence,"
a video created for dia-
logue groups, performed by
Carpenter and Felder,
filmed by Stephan Mazurek.
Photo by Stephan Mazurek.

tions of seriousness and responsibility. This also opens up new possibilities for the museum's programming. As Janet Sarbaugh, Director of The Heinz Endowments Arts and Culture Program remarked "*Without Sanctuary* shows they can take on controversial subjects with sensitivity and without pulling punches. This gives them permission to attempt even more as they continue to explore popular culture."

It is important to involve artists early, when civic issues are being framed and the project is being designed. This is especially important when new work is commissioned, so that artists can understand intimately how issues have come to be critical in a community, since it will enable them to frame them in relation to the artistic work and the project as a whole. Artists' creative work might be stronger, too, as they work from a solid, and commonly-held, understanding of the civic issues and project goals. Organizers and artists in the *Understanding Neighbors* project now agree that a major flaw in the process was that artists were not involved at key decision-making points, as the civic intent of the project shifted and the emphasis of dialogue sessions was defined and refined. Artists completed video artworks too early in this process and, unfortunately, budget constraints made it impossible to rework the creative material. While the videos were very effective in some ways, all agreed that more interaction at the right points between artists and the coordinating committee would have reaped a better result.

Projects that do not incorporate the art and dialogue as parts of an integrated whole may fall short of maximizing the potential for dialogue. Planners may not see opportune timing for the art in relation to dialogue activities, or realize that dialogue might move in a sequential way—for example, moving from conversations among people with common cultural or ideological bonds to conversations among different groups. Jessica Gogan suggests that, although the term "project" may appear merely semantic, it signaled internally for The Warhol, and for other groups as well, a new way of working that in turn influenced how the museum communicated to, and worked with, the public from the planning stages to the actual displays.

Artists face challenges in transforming documentary materials into work that meets artistic as well as civic objectives. Creating new work with the raw material of dialogue (as well as other source materials such as statistics and facts from public records, reports, and media excerpts) sometimes poses both artistic challenges and ethical concerns for artists. As compelling as such literal material can be, it can be equally didactic, boring, or biased. Filmmaker Katrina Browne reflected, "Portraying dialogue in the final art can, at minimum come across as artificial or forced. At worst, it may make the viewer feel manipulated and thus resist the message, even if sympathetic to the issue at hand."

Using music, humor, abstraction, and other creative means, artists can couch information in different guises, and reconstitute it in more entertaining aesthetic terms. Working with material from community dialogues, Dell'Arte theater company decided to make its play, *Wild Card,* a musical. "We hired the most popular local band and placed a lot of the content of the piece in the original music and songs," Michael Fields said. "This simply made it less heavy and didactic." Artists constantly evaluated the effectiveness of these aesthetic strategies. For example, a frequent "visitor" to Urban Bush Women's (UBW) early Hair Parties, the over-the-top comical character named Dr. Professor (from UBW's *HairStories* performance piece), helped explain African-American hair history, clarify references that diverse audiences might not understand, and engage in a social and political analysis. As UBW company members became more skilled in facilitating Hair Party dialogues, they found they no longer needed this purely didactic character, and relied more on participants to draw meanings from the performance segments and dialogues themselves. Artistic director Jawole Zollar saw that Dr. Professor "outlived her purpose," and she cut the character from both the stage show and the Hair Parties.

Scene from Agents &
Assets, *Los Angeles Poverty
Department, First Unitarian
Church in Detroit, 2002.
Photo © Sjoerd Wagenaar.*

To create its theatrical work about drug policy, the Los Angeles Poverty Department's (LAPD) *Agents & Assets* project utilized literal transcripts from 1998 hearings investigating alleged CIA involvement in crack cocaine trafficking into the Los Angeles area. As always, the performers—real people affected by the issue, who perform alongside LAPD actors—contributed to the powerful impact of LAPD's work. When *Agents & Assets* was performed in Detroit with real people working from the transcripts used for the play's Los Angeles premiere, a very important social issue was dramatized in a way that it never had been before. People took notice. LAPD company member Rickey Mantley said, "[I] was really impressed that we were able to take dull conventional transcripts and add all elements of dramatic conflict, protagonists, antagonists [to make] drama. Through editing, staging, selecting who are the heroes, [we made] it as compelling as the Shakespearean drama hero, villain, chorus...It was an artistically compelling way to stimulate discussion."

Most dialogue practitioners assert that creating a "neutral" space for dialogue reassures individuals that different and even conflicting perspectives are welcome and will be heard. As Animating Democracy participants launched into their projects, this notion of neutrality made many artists and cultural leaders nervous. They questioned whether neutrality is necessary in art, or even desirable. What if the strongest aesthetic choice is *not* to balance all voices equally? What happens to the artist's voice? Artists feared they would be asked to abandon point of view or be so inclusive of every perspective that the aesthetic integrity of the work would be compromised. For artists who choose to develop work that is deliberately provocative or confrontational, what are the respon-

Self Portrait at Buchenwald: It's the Real Thing. *Alan Schechner, 1991–1993. In the exhibition* Mirroring Evil: Nazi Imagery/Recent Art, *The Jewish Museum, 2002. Courtesy of the artist.*

sibilities that go along with provocation? Could certain aesthetic choices support, or inadvertently undermine, civic dialogue? Some questioned whether neutrality is ever possible, in dialogue or in art. Artists reckoned with these questions in seeking to find the appropriate balance between point of view in the art and the multiple perspectives that are the intent of civic dialogue.

At an Animating Democracy convening, dialogue specialist and Animating Democracy advisor Wayne Winborne offered the idea that artists need not be constrained in their creative process by the goals of creating neutral space or ensuring multiple perspectives. He said, "It's fascinating that artists experience this angst. If you make good art, it will stimulate dialogue…You don't have to worry about whether you should represent all voices in the art." Indeed, provocative art and art with a strong point of view are often compelling catalysts that get people talking. Winborne and others came to see that it's how you work with such art— for example, engaging a skilled dialogue facilitator and/or contextualizing the art—that can make the difference in the artwork's ultimate effect on dialogue.

Provocative art often requires proactive programming and contextualization in order to lead to constructive dialogue. Sometimes, extraordinary measures have to be taken—careful framing of the project and its intent, explaining why the particular artwork was chosen, thoughtful designing of dialogue opportunities, and involving experienced facilitators who can navigate potential conflict and challenges. To mount The Jewish Museum's *Mirroring Evil: Nazi Imagery/Recent Art* exhibition responsibly demanded this level of internal and external dialogue, as well as a full complement of interpretive and dialogue activities. *Mirroring Evil* began with curator Norman Kleeblatt's interest in the work of young artists, generations removed from the Holocaust. He was interested in a body of work that "eschewed the deeply entrenched Holocaust imagery that focuses on the victim," and "instead uses images of perpetrators—Nazis—to provoke viewers

to explore the culture of victimhood," as well as the question of who can speak for the Holocaust. (It should be noted that the curator selected extant artworks; that the artists did not create works with this exhibition in mind.) This bold curatorial choice, which The Jewish Museum knew would be objectionable to many in its own community, was thoroughly vetted at all levels of the museum. For purposes of dialogue, the museum and its many advisors, particularly within the Jewish community, thought long and hard about exactly how to frame the issues. They drew connections to the broader civic realm, presenting the exhibition and related programs as a "springboard for dialogue about the complicity and complacency toward evil in today's society." Extensive interpretation and contextualization occurred through the exhibition catalogue and in the galleries where entry and exit videos raised the central questions of the exhibition, and labels provided substantive insight into artists' intents. Staff members were on hand to facilitate daily dialogues to process visitors' emotional and intellectual responses to the work, as well as to hear others' perspectives.

Scene from You Can't Take It with You, *Cornerstone Theater Company,* Faith-Based Theater Cycle, *2003. Photo © Craig Schwartz.*

Artists and cultural organizations sometimes need to reconcile their own strong positions on issues in the context of arts-based civic dialogue projects and decide if and when to take a stand. Artists and staff for Cornerstone's *Faith-Based Theater Cycle* struggled deeply with the issues of sexuality raised by their project and the degree to which they could remain neutral and open to perspectives that opposed their own values and beliefs as gay individuals. Cornerstone's overall work is based on tolerance and inclusion, and its project began with a challenging question: when does tolerance lead to a betrayal of one's beliefs? Following a reading of the script initially written to support Cornerstone's work with the Muslim community, there were some painful "hot button" dialogues about faith and sexuality. In what Cornerstone artists described as a "lopsided" dialogue, participants reacted to an implicitly sexual scene involving the gay son character; most felt for one reason or another that the homosexual scene should not be retained. Cornerstone artists kept silent even though some were pained by what they were hearing. Although this play was eventually replaced by another because the outside playwright would not change the script, Cornerstone's ensemble members seriously questioned when it might be important to take a stand. Cornerstone's artists were torn between the need to be respectful listeners to the community and the desire to express their own thoughts and opinions. Associate Artistic Director Mark Valdez said:

> The idea of taking a stand is always complicated. More often than not we are outsiders and we have to balance the needs for and time to take a stand without imposing our views on the community. Including dialogue enabled us to do what we do well:

ask questions and listen. It's less of a goal to change minds than to open and broaden perspectives and build bridges.

For some artists and cultural organizations with a strong stake in an issue, the idea of framing art or dialogue neutrally proved, in the end, to be too much of a compromise of fundamental values and beliefs. The tension was strongly felt by Out North Contemporary Art House, whose project, *Understanding Neighbors*, sought to address "the legal, moral, and cultural place of same-sex couples in our society." Two questions about neutrality emerged. First, could Out North, whose co-leaders are a gay couple known for their political activism around gay rights issues, be an effective neutral convener of arts-based civic dialogue, given their open and widely known position on the issue? *The challenges surrounding the organizational partnership and independent coordinating committee formed in response to this question are explored in the section "Institutional Practice."* Second, could the art created as a focal point for the project's dialogues have a point of view about same-sex couples and be effective in stimulating dialogue among conservatives as well as progressives on the issue?

The goal of *Understanding Neighbors* was to foster tolerance, inclusion, and acceptance of gay and lesbian couples through a more respectful kind of conversation than had been present in Anchorage, AK, in the past when various controversies fueled polarization. Although great measures were taken to create an independent coordinating committee that would be perceived as neutral about the issue, Out North co-directors Jay Brause and Gene Dugan stressed the fact that the three artists (two of them gay) commissioned to create video artworks for the dialogues should have license to create work that reflected their aesthetic interests and points of view. Dugan and Brause chose the artists—Peter Carpenter, Sara Felder, and Stephan Mazurek—because they felt they could create works with sensitivity and humor that would also convey the issues as felt by same-sex couples. The works did explore gay couples' perspectives, both abstractly and more overtly. One

Understanding Neighbors artist Peter Carpenter in "Clipped," a video performance created for dialogue groups by Peter Carpenter and Stephan Mazurek, 2003. Photo by Stephan Mazurek.

scene, for example, presents a lesbian woman's side to the "conversation" with her straight sister about the pain of not being able to share stories of their respective girlfriends and boyfriends. Local dialogue facilitators differed about whether the works could be effective in creating a neutral and open environment for dialogues. Although everyone recognized it would be inappropriate for the artists to speak from a point of view outside their experience, some were nonetheless troubled that the artwork plainly empathized with the struggles of lesbian and gay persons. As the facilitator training process went on, "Most facilitators grew comfortable framing the artwork as 'having a point of view,' and 'representing a voice' in the dialogue process. Some, however, continued to see the art as plainly biased." Some of the videos were not used in the dialogue groups in the end. While the expertise of the artists and dialogue consultant was never questioned, it became apparent to all involved, including the artists, that a more collaborative process between the dialogue team and the artistic team would have been more effective.

Probably counter to most of her colleagues, whom she believes would be skeptical about using art that has a strong point of view, dialogue practitioner Maggie Herzig believes the idea of "art as participant" has merit. "I don't see that art has to be flat and inauthentic. All the art has to do is be a respectful participant—represent its truth, but not slap others with it. ...[Art] will provoke but with love. It will say what it says then leave space—lots of space—for others."

The idea of "multipartiality" may be helpful to artists in reconciling artistic dilemmas posed by notions of neutrality. At an early Learning Exchange, dialogue specialist Patricia Romney introduced Animating Democracy participants to the concept of multipartiality, which is commonly used in family psychology as well as in the dialogue field. Multipartiality is the ability of the facilitator to see all parts of the whole, and to be on each person's side simultaneously—in other words, to work on everyone's behalf for constructive and equitable dialogue. For many artists, the idea of multipartiality, if extended to the work of art, allowed for multiple perspectives—even strong ones—in the art itself without neutralizing any voices.

In its *Moby Dick* project, Perseverance Theatre wanted to change the tenor of the ongoing, highly polarized debate about subsistence hunting rights in Alaska by creating a space for the complex feelings about the issue to come forward, and not just focusing on the extremes. Project leaders consciously chose not to stake out a position in the play, but to portray multiple views. By editing out strong positions, Artistic Director Peter DuBois believes the company's production improved as art, by offering more nuance on the issue and demanding more thought on the audience's part. He wrote:

> Thinking about civic dialogue also got me thinking about how the best art leads me to engage new questions and fresh associations. This realization allowed me to go into the work and edit out strong "positions" so that the audience might create their own positions from what they saw. For example, we cut an entire scene about "leavers and takers" between the original Juneau production and the statewide tour

as it appeared to be a heavy-handed critique about Western culture. I felt this critique would limit the dialogue and polarize communities…In general, I felt the play served as an excellent springboard for dialogue because it had a level of ambiguity and did not stake out a position. It therefore helped people get to both the gray areas and the areas of common ground quicker.

The artistic team for San Diego REP's *Nuevo California* project struggled with tensions inherent in creating a work, that was at once "multipartial" and provocative, around the central question of whether the border wall between the United States and Mexico should come down. Members of the artistic team had different takes. For Sam Woodhouse, the REP's commitment to the project arose, in part, from frustration about U.S. citizens' misperceptions about Mexico. He had both a personal and an artistic motivation to be a provocateur. While acknowledging the artist's role as provocateur, the project's choreographer, Dora Arreola, placed emphasis on the artist as a reflector of reality. "In addition to provoking, our work is to describe artistically the reality of the environment in which we live," she said. "In this manner, the dialogue is both ways. It's not about having a fixed position. It's about points of view, not one point of view. Our job as artists is the description."

But can art embody multiple viewpoints and still be provocative? Woodhouse questioned how to build multiple points of view into a story, without diminishing the work's dramatic tension, saying, "Can we walk a mile in different shoes as artists? [Even] if we are able to do that, we still have to write a story with a point of view. We will have to make a choice." But Arroela suggested that the opposite may be true. "If we take the position that the wall should be down," she says, "we won't reach the interesting point." Playwright Bernardo Solano was concerned, too, about creating extremes. "Our feeling was that if we vilify certain characters, then we lose some of the very audience members we wanted to speak directly to and beseech them to perhaps see the world of the border in ways they previously had not seen it."

The question of how the play should end engendered much dialogue among the artistic team, as well as with community dramaturges and audiences at the open rehearsals. In the end, the play's closing image—the wall being dismantled—evokes unequivocally the point of view that the fence should come down. At the same time, the artistic team believed, and many critics agreed, that the play did achieve a nuanced view of the issue through interesting and entertaining characters. *Nuevo California* asserted a clear point of view by the choice of ending, but delivered the spectrum of perspectives leading to that conclusion. Because SDR did not use the finished play for issue-based dialogue, it is impossible to know how these artistic choices would have affected dialogue about the border issue.

Working in the rural farm community of Montevideo, MN, as visiting playwright with Children's Theatre Company of Minneapolis, Rebecca Brown found it was important to not go into a community with preconceived ideas about what the issues may be. The more open the mindset of the artist, the more likely that he or she could create an environment

Scene from Stories from Montevideo, The Land Bridge Project, *Children's Theatre Company, 2002–2003.*

TIES THAT BIND: PROTECTING CONFIDENCES

For their photography-based installation for MACLA's (Movimiento de Arte y Cultura Latino Americana) *Ties That Bind* project, artists Lissa Jones and Jennifer Ahn were trained by anthropologists associated with the project to interview members of families in the San Jose area who had experienced recent or past intermarriage. The anthropologists also accompanied them to interviews. Renato Rosaldo, who served as both an advisor to the ethnographic interviewing process with the families and an essayist in Animating Democracy's *Critical Perspectives* writing project, described the core of the ethical issue faced by interviewers, but especially by the artists:

> The interviews, as I saw them, were shaped by what I call an "implicit contract" and that contract set the direction of the art installation. The interviews took place in the subjects' homes. The fact that the subjects were in their own homes and the interview team (including both the interviewers and the artists) were visitors set up a special relationship between the interview team and the interview subjects. The fact that two or more people were in the interview team and that a number of family members were present made the social situation a relatively formal visit. The subjects became the hosts and the interviewers became their guests. The interviewers could not, as good guests, violate their subjects' privacy. The interviewers, without saying a word, agreed to protect their hosts' secrets, not to embarrass them in public. They felt obliged to respect how their subjects wanted to appear in public.

> The visual artists were even more constrained by the implicit contract than the scholars and activists who did the interviews. The interviewers did not have to see their subjects after the interviews ended, but the artists saw a number of the subjects after they were interviewed. All of the subjects were invited, and a number came to the opening of the exhibit [and]...later...the civic dialogue. So, the artists were accountable to them. They were among the critics of the art installation. They could talk back to the artists.[3]

Ties That Bind project leaders believed it was valuable for the artists to know they would have this final connection with participating community members, because with that knowledge came responsibility. According to project director Maribel Alvarez, "both artists had felt 'empowered' and were effective as impromptu anthropologists but they struggled with what to produce out of their ethnographic interventions." In the dialogues between the artists and families, the families shared intimate, often painful stories, and they themselves raised the question of privacy. Recognizing the high stakes of representation, Jones and Ahn struggled with this issue. Alvarez recounts:

> They were asked to serve not two, but three masters: MACLA asked that they "respond to the community" but still deliver a compelling visual statement using the most transparent of all art media, photography; project participants asked that they not reveal the "painful" aspects of intermarriage (some of the participants were the offspring of broken inter-racial marriages and had grown up all their lives hearing one or the other parent impute racial stereotypes to their former spouse, half of whose "heritage" these children also embodied); and the artworld in which they had developed and emerged as artists asked that they "be true to their vision" and create work that "push the envelope" if necessary.

3 Renato Rosaldo, "The Social Life of an Art Installation," in *Critical Perspectives: Writings on Art and Civic Dialogue* (Washington, DC: Americans for the Arts, 2005).

Shadow box installation by Jennifer Ahn and Lissa Jones, Ties That Bind, MACLA, *2002. Photo © Bubu Alvarez.*

4 Maribel Alvarez, "Dialogic Gestures: Doing Artistic Things with Ethnographic Methods," in *Critical Perspectives: Writings on Art and Civic Dialogue* (Washington, DC: Americans for the Arts, 2005).

ethnography (a methodology borrowed from the social sciences) to aid in this task. And yet, the paradox of it all was that in order to engage a broader community in the conversation we chose the ways and means of visual representation in a gallery to manifest the things we had learned.[4]

Ultimately, the artists did not want to close down communication with their subjects and wanted the exhibit to be welcoming to them. They focused on affirmative symbols of intermarriage, such as the blending of foods in the household. When the challenges of intermarriage were addressed, as in the exhibit's display of dirty laundry, the artists presented the metaphor without revealing, as Rosaldo observed, "what had soiled it or whose it was." Rosaldo further observed in his essay that:

...We were not only mining stories for "content" but were modeling a process that upset the balance of power between artist and subject, moving away from the archetype of the idiosyncratic/genius artist who sees and represents as he/ she wishes, to one where listening and learning was more important than representing. We called upon

The civic dialogue that took place inside the art installation [among participating families and the public] showed the wisdom of the choice not to offend and to create a welcoming space... to open a conversation rather than to be authoritative. They [the artists] wanted to invite people to a dialogue and not to give themselves the last word...I still wish the art had more edge, though I'm not sure of how much edge would have enhanced the work of art without inhibiting the civic dialogue...The interviews and the work of art were part of a longer process that culminated in a civic dialogue where the interview subjects felt safe enough to speak relatively freely in front of their parents, their children, the artists, the writers, and media people.

of safety where people could speak their minds and also empathize with others who hold different views. Brown explains:

> We purposefully left out farm issues in the initial interview questions...I wanted to go into the community and listen to what was important to a variety of people, so that the issues of the play evolved from what was on people's minds. I suspect there were lots of values and experiences that don't get focus [in Montevideo]. We provided a neutral wall where people could express those values...then what we were able to do was to create a dialogue between these values in the play. I don't think the theater is neutral or unbiased, but I think this was an opportunity to be in a community with strong opinions and for us to try and share those experiences. This

then created a space in which people could feel empathy...I think it was important that we didn't set up conflict between [organic and corporate] farmers...if the intent is to create dialogue, then how you handle conflict is important. I wasn't conscious of it in that way at first, but I kept asking that question, "Should I set up the conflict?" and I kept saying, "No." I don't know if I knew why until we started having audiences. It was in my heart, but it wasn't conscious. The creative process is so instinctual.

The idea of multipartiality can also help artists and programmers distinguish their role as artists from their potential dual role as dialogue facilitators. As artists, retaining point of view in the artistic work seems a clear prerogative. Patricia Romney suggested, however, that artists and cultural organizers "have to move out of an advocate's position" when they are actually in the position of facilitating dialogue. Urban Bush Women's (UBW) Elizabeth Herron described the dancers' dilemma when they shifted to the role of dialogue facilitators. "We all had to get comfortable with dialogue work. A lot of us have strong personal views on hair. In early Hair Parties, company members had a tendency to dominate the conversation and appear too judgmental. We had to evolve ourselves to a place where we could hear other perspectives on black hair." As dancers conducted more and more Hair Parties, it became clearer that UBW could most appropriately share its point of view as a company through the performance elements of the Hair Parties. By allowing the art to acknowledge and convey their perspective, dancers became more comfortable facilitating multiple points of view during the dialogues and leaving it up to group members to form their own opinions.

"Tomorrow Belongs to Me,"
Wild Card, *2002.*
Photo © Carol Eckstein.

THE DENTALIUM PROJECT: REPRESENTING MISSING VOICES

How to represent Native Americans in Dell'Arte's *Wild Card* became a troubling artistic issue. The play was developed from dialogues between citizens of the small town of Blue Lake, CA, and Native American members of the adjacent Blue Lake Rancheria, whose casino construction prompted concerns about quality of life, shift in economic power in the community, and the future of the place. While the play itself generally reflected the sentiments of the Native American community based on the community dialogues, there were, as one of the songs in the show blatantly points out, "no Indians in the show." Michael Fields deciphered Dell'Arte's aesthetic dilemma:

In the past 10 years we have rarely hired anyone into the company who has not gone through the training program. This is what gives the company its ensemble style and value. In this project, where we sought a Native American voice, ensemble experience became particularly problematic as we did not want a symbolic Native American spokesperson, which we felt would be more demeaning than valuable and would make that point of view especially sacred, which it is not, especially around the casino issue. Ultimately we could not find a resolution to this problem that we all felt good about. And that concerns us deeply.

[5] David Rooks, "To save paradise they put up a parking lot," in *Critical Perspectives: Writings on Art and Civic Dialogue* (Washington, DC: Americans for the Arts, 2005).

David Rooks, a Native American journalist from South Dakota who was one of the Animating Democracy *Critical Perspectives* writers on *The Dentalium Project,* offered a view as both an outsider to the Blue Lake community and an insider to native concerns:

For me, that painfully illustrated, dramatically, that there is no Native voice in this community. They are not seen, the local government has not taken them seriously…My experience in border towns is that people stop being curious about a story. It's been happening for so many generations that people don't even notice that certain stories aren't there…So what you have is a play about how all the non-Native people are upset about the casino, and you never hear the Native perspective. I have to honor

that they were presenting the truth that they could present, under the circumstances, but it was a repetition of the same historical situation.[5]

In addition to the absence of a native voice and native actors, the production revealed another fault line. Fields wrote, "…my regret as a playwright, and a problem of the (first) piece, was that I did not feel comfortable making fun of the Native American community in the same way I felt comfortable making satire of all the other elements of the…community. The fact that we could not find the appropriate humorous angle on that community was a drawback in the work." Rancheria chairwoman Arla Ramsey agreed. "With everything going on at the time, the political correctness, they went out of their way not to offend the tribe. It was an enjoyable production,

but it really didn't address some of the issues it could have."

At a meeting of *Critical Perspectives* writers, some found the play problematic, while others emphasized that, as with the *Ties That Bind* exhibition, the art was only one element of a much longer project, and advocated looking closely at the theater group's history and process, its long-term relationship to its local community, and the complexities of this particular political event (the opening of the casino).

A year after the initial production of *Wild Card,* Dell'Arte rewrote the play and presented *Wild Card 1.5* to include a local Native American actress who plays O'Hanlan's former sweetheart. The allusion to the two characters' long, complicated, and ultimately reconciled relationship was offered as a metaphor for the history of tensions and potential for reconciliation between the Rancheria and the city of Blue Lake. Dell'Arte is also talking with the Rancheria about offering a Native American scholarship to the Dell'Arte International professional training program each year. Hopefully, this training would provide equity of craft and could be employed to support multiple points of view. But, Fields has cautioned, "It is our belief that this has to be addressed in an organic, comprehensive fashion, not a symbolic one."

A reprised Wild Card *includes a Native American character,* Wild Card *1.5, 2003. Photo © Carol Eckstein.*

ETHICAL CONCERNS IN CREATING ART FROM DIALOGUE

In the interview I did, the subjects asked us not to mention one topic. We honored their request. Even so, they were visibly nervous about having their lives exposed to public view. I sensed a concern about display and exposure, trust and violation, fear and assurance, silence and speech, power and inequality. They were afraid that we—their guests—might violate their hospitality by revealing their secrets and embarrassing them.

—Renato Rosaldo, anthropologist, advisor,
Critical Perspectives writer, MACLA's Ties That Bind *project*

Ethical concerns frequently emerge as artists work with dialogue materials to create the art. Such concerns arose in Animating Democracy when artists edited, fictionalized, created composite characters, or simply presented publicly the actual words of real people. Artists were sensitive not to betray the trust they had established with their subjects. Playwright Bernardo Solano reflected, "My background in writing community-based [plays] led me to always bear in mind what I consider to be an immense responsibility to the people who shared their stories and inspired the play in the first place." As Solano created characters for San Diego REP's play, *Nuevo California*, for example, he was conscious of superimposing his own opinions on the border issues central to the play. "I personally might be offended by an interviewee's perspective, but if I pass judgment on that person in the play, then am I betraying that person's trust in me who told me their story in good faith?" But how much leeway is there in editing or manipulating dialogue material for artistic or dramatic purposes without exploiting it, making the subject vulnerable, or making work that comes out contrary to what the subject intended? Artists agree that ethical issues are inevitable and there is no easy answer. Solano said, "It's an

impossible dilemma for the artist in this kind of work, but that's part of the challenge and what makes it so interesting."

Creative choices often require decisions about whose interests prevail—the subject's, the community's, or the artist's—and to what degree. The civic intent in arts-based civic dialogue projects put into play complex dynamics between the artistic, the civic, the dialogic, and the democratic. Filmmaker Katrina Browne found that, in editing footage from *Traces of the Trade*, some of the most heated exchanges among her family members reflected the very same struggles that other white people have in confronting issues of white privilege, and she decided that these were the scenes that would best serve dramatic and dialogue purposes. But because they put the family members in their worst light, she felt a responsibility to protect and respect them, too. This dilemma raised the question of who makes choices of representation and emphasized the challenges of being an insider to the story of the film, as well as creator of the artwork about that story. It underscores the value of an outside editor's eye in helping sort out such artistic choices, as well as careful articulation of the subject's role in approving the final artistic product. With postproduction still in progress, Browne is finding that reconciling responsibility to her family with telling a good story remains one of her most difficult creative challenges.

Transparency of process is critical to helping participants and organizers understand how dialogue material will be used and transformed in the final artistic work. Project organizers are quite naturally committed to sustaining an honest and open relationship with participants over the course of a project, but they must also honor artistic imperatives. Dance Exchange takes great pains to be transparent in its processes; however, as they put it, "To assure quality in the artistic outcome…the power to sequence, edit and re-synthesize the work of others—is necessary." Company member Margot Greenlee said, "A moment in the process that is really hard for participants is when we start editing…the give-and-take ceases and the artistic stakes take over; the bounds between person and artmaking are redefined." Does the editing process counteract community building? Dance Exchange explores this shift in creative authority:

> Early on, the artists do function more as facilitators; the community and the creative processes call on them to value and acknowledge all opinions and encourage an environment that's conducive to the co-existence of many viewpoints. But at the same time these very elements help to set the foundation for an outcome where distinctly civic values prevail: Where regardless of whose voices are ultimately reflected, everyone is invested in the outcome; where participants are willing to empower someone else to speak for them; where each person in the project is willing to share a stage with someone whose viewpoint may be different from their own; where individuals are willing to sacrifice their own movement, story or moment in the spotlight to endorse the collective voice of the piece. The values of dialogue may prevail at the start of the process; the values of civitas may prevail at the end of the process.

In two Animating Democracy projects, however, artists had aesthetic reasons for not disclosing aspects of the work, and this caused peers to raise questions about transparency and people's choice to participate. Promotional materials for Cornerstone Theater Company's performance of *Zones* mentioned the interactive nature of the piece, but audiences were not told that they would, in effect, be put in the role of community members attending a fictitious zoning meeting and would be asked throughout the play to participate in dialogue with fellow audience members about issues of faith. Creator and director Peter Howard admitted, "this wasn't to everyone's taste. Not everyone wanted to get that involved." Cornerstone and dialogue collaborator, the National Conference for Community and Justice (NCCJ) did ask itself if this approach was ethical, but decided to go forward as long as promotion suggested participation; once there, people could opt out. Although given the option not to participate, only a few opted out. Dialogue advisor Diane Burbie observed that it was hard for people not to want to be involved. "We felt that *Zones* came closest to NCCJ's goals of dialogue," she said. "There was time for the audience to do something with those emotions. They were able to engage with each other and the characters, knowingly or unknowingly. As a participant, it was hard to get out of it. You were pulled in, and you had to talk about it."

ART AND CIVIC INTENT: A COMPLEX SYMBIOSIS

With so much focus on "art as catalyst for civic dialogue," some artists and programmers question whether art drives dialogue or dialogue drives the art. Dell'Arte's Michael Fields observed:

> ...many people [in the Animating Democracy Lab] were approaching the work almost from a biographical or political point of view, emphasizing content over artistic style, and placing a priority on the design of dialogue over the creation of art. After much discussion we chose to take the opposite tack...because of our knowledge of our own community—how we are perceived as artists within this community and the community's expectation of our art—and because of our predilection to make sure that we entertain, not preach, to make the art provoke the questions. In the question of who leads the dance—the art or the dialogue—for us it was clearly the art.

Likewise, museums and orchestras, while recognizing the potential for exhibitions and concerts to provide a compelling point of departure for civic dialogue, asserted the centrality of the art throughout project activities. In contrast, *Traces of the Trade* filmmaker Katrina Browne said, "If anything, my allegiance to the civic goals is a stronger calling than that of artist." Yet others sought out (and found) a symbiotic interplay between dialogue and art in which the two worked hand in hand, such as in Marty Pottenger's *Abundance* workshops or Urban Bush Women's Hair Parties. For the Esperanza Center and local organizers in rural Hawai'i, where art and culture are traditionally and inextricably bound to civic and social life, the question of which comes first, art or dialogue, proved immaterial.

Expanding the
Critical Framework

I want to talk about aesthetics. It's critical. I want to be involved in dialogue that says that this can be excellent art.

—Judy Baca, SPARC (Social and Public Art Resource Center)

[1] Suzanne Lacy, "Seeking an American Identity (Working Inward from the Margins)," see page 191 of this book.

It's an imperfect art, this working in public, and its aesthetic hallmarks, when we learn to see them clearly, will be based on vulnerability and transparency and complexity.[1]

—Suzanne Lacy artist

[2] Bill Rauch, "Critical Relations: The Artist and Writer in Conversation," University of Minnesota Symposium, April 26, 2002.

Critical assessment is important, in fact, vital to artists' aesthetic investigations. According to Cornerstone Theater Company's Bill Rauch, good critical writing about Cornerstone's work "has changed the way the company thinks and talks about its work."[2] However, many artists observe that critics frequently take the easy way out when considering civically engaged art, either failing to apply rigorous standards or dismissing the work out of hand. Existing models for critical analysis rarely recognize the unique features of civically engaged art. Vocabulary and criteria are often inadequate for communicating the multidimensional nature of the work. In addition, who gets to say what is important; at the moment, it is still typically the single arts writer, journalist, or critic. Various partners, community partici-

[3] These concerns were expressed at a meeting in 2000 of artists, scholars, critics, writers, and cultural leaders convened by Animating Democracy. Participants included, among others, Bill Rauch (founding member and artistic director, Cornerstone Theater Company), Judy Baca (co-founding artist and artistic director, SPARC), Amalia Mesa-Bains (artist and director, Institute of Visual and Public Art, California State University, Monterey), Suzanne Lacy (artist), Jan Cohen-Cruz (faculty, Tisch School for the Arts, New York University; Center for Art and Public Policy), and Ann Daly (dance and theater critic and writer; faculty, Department of Theater & Dance, University of Texas, Austin).

pants, and even the artists and cultural organizers who have interests in the project rarely have an opportunity to offer reflections in a focused and serious way.[3]

Artists working in this arena want their work considered on its artistic merit and legitimized within the arts community. Many feel the existing framework for describing and analyzing civically engaged art is inadequate, and they argue that it is possible to articulate the qualities of excellent work and excellent process, as well as the qualities of work that is inauthentic, exploitative, or ineffective. Expanded models for writing about this work would describe and analyze its full aesthetic and civic dimensions; articulate useful criteria for assessing efficacy; and open up the writing to a wider range of voices and perspectives.

The projects supported by Animating Democracy offered an opportunity to experiment with a different, multivoiced approach to critical and reflective writing. The *Critical Perspectives* project enabled different sets of writers from various artistic, scholarly, and community vantage points to write about three projects: Dell'Arte's *Dentalium Project*, MACLA's *Ties That Bind*, and St. Augustine's Church and the Lower East Side Tenement Museum's *Slave Galleries Restoration Project*.

By supporting multiple writers (including the project director) in writing about each project, and by affording them opportunity to connect amply with the projects and each other, *Critical Perspectives* worked on two levels: first, to demonstrate how multiple writings could deepen understanding of arts-based civic dialogue work; and second, to suggest what an expanded critical framework might consider, including meaningful and useful criteria for assessing the effectiveness of civically engaged art. Such criteria apply rigorous standards to the artistic or cultural form and consider the degree to which the work exhibits a compelling artistic-cultural vision, takes risks, is valued by the people for whom it is intended, shows integrity of intent, and demonstrates accountability.

EXPLORING A NEW CRITICAL FRAMEWORK

What would be the possible elements of an expanded critical framework for arts-based civic dialogue and other art with a civic component? The fundamentals of critical practice still hold true: description (what does it look like?); analysis (how does it work?); interpretation (what does it mean?); and evaluation (does it succeed?). But what else is needed to take into account the multidimensional nature of the work and its civic intents? New possibilities include a multivoiced approach to critical assessment; an expanded role for the critic; assessment of the work that considers artistic process as an aesthetic dimension of the work; and, finally, assessment of the work in relation to the artist's intention, to the artwork's meaning to its intended public, and to its civic intents.

Based on the experience of *Critical Perspectives* and the broader Animating Democracy initiative, as well as other conversations in the field, an expanded critical framework would:

Consider the civic or social dimensions of the work along with the aesthetic dimensions; and consider artistic process as well as product to be integral to civically engaged art. Conventional critical assessment has focused on artistic product. In community-based, dialogue-oriented, or civically engaged work, with its many layers of process and impact, to look only at a finished "product" such as an exhibit or performance is a limited, incomplete, and inaccurate view. Those working in civically engaged art advocate for an integrative aesthetic language that considers the social dimensions and the public engagement processes that are fundamental to the concept, activity, intent, and form of this work. Rather than coming in at the end of a project, critical writers might be engaged early on and throughout the project in order to get a full view of its complexities and evolution.

Reconsider who can function in a critical role, and acknowledge the value of multiple perspectives by various writers. Because civically engaged art intersects with different civic spheres such as justice, education, the environment, and immigration, writing might explore these contexts and intersections. Criticism is usually an external critique from professional art or theory disciplines, seldom including inside perspectives of community participants or the artist. At the same time, when internal documentation of art projects does include participant perspectives, it is often testimony—"how it felt to be part of the project"—that does not really empower them as critical voices. Critics are part of the larger discourse about civically engaged art but not the only ones who can contribute to its analysis. Artists, cultural essayists, anthropologists, community partners, dialogue practitioners, and citizens all contribute to understanding of the work. Project participants, including artists and community members, are voices of reflection and critique, valued for their perspectives on the meaning and impact of the whole.

Expand the critic's relationship to a project to include collaborator or advocate, as well as documenter, witness, or critic. Depending on the goals of critical writing, a writer might assume one or more roles. In a collaborative role, the writer and the project and/or artistic director might define a mutually beneficial relationship. This more intimate relationship requires an understanding of how the artist's interests and intents are taken into account. Sonja Kuftinec reported artist John O'Neal's perspective voiced at Alternate ROOTS's 2002 FOCAS gathering:

> …theater artist and activist John O'Neal claims that this relationship becomes productive when artists, audiences, and writers share mutual goals, particularly agreeing that the best art provides insight into the social circumstances that prevail at the time the artwork is created. "The aesthetic function, the function of art, is to raise the question and explore the answers of 'How do we make it better?' The critic's job is to say to the artist whatever seems appropriate to help explore this question, and also to consult with the third party of this communication experience, the audience. As long as all three parties share the same big mission of what it is and how to make it better, then all three come together in their diverse relationships to the 'it,' which is possessed curiously enough by none of them."[4]

4 O'Neal expands on these points in "The Thing About Criticism," in *Reimaging America: The Arts of Social Change,* ed. Mark O'Brien and Craig Little (Philadelphia: New Society Publishers, 1990), 199–204.

Ferdinand Lewis, who wrote about Dell'Arte's *Dentalium Project* for *Critical Perspectives*, proposes that writers consider the role of "advocate," balancing critique with an "asset oriented" approach to writing. Instead of looking for what's lacking, Lewis offers that writers see projects as "an abundance that needs to be shared," revealing positive lessons and progress points even within the struggles or shortcomings of a civically engaged art endeavor.

These different roles of critical practice would be integrated into the evolution of civically engaged art projects, ensuring first-hand understanding of artistic intent, processes, and the complexities of art and civic engagement as the work unfolds. It would allow the writer to be in closer relationship to the work and its various players, rather than keeping the expected critical distance. This more intimate relationship raises questions, however, regarding the subjective versus objective position of the critic in the interpretation of the work. Journalist and *Critical Perspectives* writer David Rooks asks, "How much participation should writers have, and at what point does it interfere? Are there observational biases in the writers that *should* be welcomed into the dialogue?" As some experienced, the closer to the inside a critic gets, the more difficult it becomes to be objective. Some *Critical Perspectives* writers had reservations about the degree to which the process should be collaborative. They prefer to focus on the particularity of what they do rather than to blur the boundaries of disciplines, or risk compromise in their own distinct choices.

Finally, while the writer's inside perspective offers an intimate and detailed account that can be useful to others—a kind of witnessing as visual arts critic, educator, and *Critical Perspectives* writer Lydia Matthews suggests—it is also subject to potential pressure from internal relationships and power dynamics. Participants may be either less or more inclined to disclose things to someone who is "inside" the project. The writer may feel a more direct sense of accountability, which arguably all writers should embrace, but may also feel limited by knowing that he or she will have to live with the repercussions of what is made public.

Shift the language of evaluation from notions of "success" and "failure" to a more complex view of what is important: "value," "accountability," "effectiveness," and "risk taking," in addition to aesthetics. There are many other ways to approach the question of assessment, particularly of community-based or civically engaged art. Ben Cameron, executive director of Theatre Communications Group, suggests that, in reflecting on community-based work, critics should consider not only the aesthetic "quality" of artistic work, but the *value* of the overall project within its social context. In two 1998 editorials, Cameron emphasizes the need for artists to articulate their value to society, as opposed to focusing only on determinants of artistic quality.[5] The "value" of a project is understood as the extent to which it benefits a community. His emphasis on "project" also expands the critic's field of view beyond the product to include artistic and community *processes*.

Critical Perspectives writers have been averse to the word "failure" when assessing the efficacy of civically engaged art efforts. The various aesthetic and civic intents embraced by projects and by a range of creators, organizers, partners, and participants means that efforts are likely to be more effective on some terms and less so on others. In addition, a

[5] Ben Cameron, "The Missing Link," *American Theater*, November 1998, 6; and "Essential Values," *American Theater*, December 1998, 6.

single project may need to be considered in relation to the long-term efforts of an organization—what has happened before and what will happen after. Particularly for cultural organizations that are deeply a part of a community, the ability to present programs over months or years can mitigate against the individual success or failure of a particular effort. Where one project may be more effective than another, the long view gives perspective on the cumulative effect of the work.

Assessing the impact a project has on community or civic life is one of the key challenges of writing about this work. Both artists and cultural organizations become keenly aware of the ethical and political issues that a project raises and the repercussions of their artistic process and product. Accountability to those civic interests is seen as a key evaluative criterion.

An expanded critical framework would consider effectiveness in relation to original intent and planning, but also in relation to what actually happened. The essays by Renato Rosaldo and Maribel Alvarez about *Ties That Bind* get at the complex negotiation of artistic and civic expectations and realities. According to Alvarez, respectful restraint on the part of the artists in the treatment of personal information on the one hand limited the intensity of the artistic statement but also contributed to the success of the artwork in opening up a lively dialogue about social identity.

Consider the degree to which artists, organizers, and even community participants take risks to advance civic and aesthetic goals, and how responsibly they do so. Risk is inherent in developing art with civic intent; some degree of risk taking is necessary to realize social, civic, and/or artistic goals. Artists and cultural organizations take risks sometimes by virtue of taking on a civic issue in the first place, by reframing it, or by forming challenging partnerships. They take risks in terms of aesthetic choices, content, and form. In different contexts, artistic provocation or artistic restraint could each be considered a risky approach.

Because civically engaged art efforts touch real people who are affected by issues, some actions may jeopardize trust, destabilize relationships, or exacerbate issues as much as they may lead to new and exciting artistic forms or increased understanding about an issue. Therefore, *Critical Perspectives* writers view risk taking as a factor to consider when assessing effectiveness of the work, weighing outcomes against the desire to break through aesthetic and/or civic boundaries in some way. Just as artists and organizations anticipate and weigh the potential for positive or negative effects, it is crucial for writers to understand these risks as well in order to fairly assess the efficacy of civically engaged art and to produce writing that is at once generous, generative, and challenging.

Consider the power issues embedded in the writer-practitioner relationship and emphasize the critic's own accountability in relation to the impact of his or her work. Writers call upon themselves to be conscious of the impact of their writing, particularly when projects may be less than effective. Jack Tchen asks, "How comfortable do we feel airing out complicated issues that fix the way in which the artists and other players are characterized?" Renato Rosaldo agrees that it's not about jumping on a group for what

went wrong, but trying to look ahead to what could be done in the future—taking the larger view without diminishing standards or rigor.

Standards and criteria

Artists, cultural organizers, and critics versed in civically engaged art argue that it is possible to articulate standards of excellence for this work. Community participants share a desire and need for excellent art. From decades of experience creating murals with community members, Judy Baca observes that community participants value rigor and quality in the aesthetics of a work. "Young people and seniors make critical judgments about what they see on the street. Young people don't want to be involved in a kiddie art project. They want to be part of something that has aesthetic value." As the amount of art in the public realm increases, public demand for quality becomes greater. "If there is going to be another [work of art], it better be damn good and it better add to the artistry. Bad aesthetics in the name of good community work is not acceptable anymore."

Criteria for assessing excellence need to reflect rigor and cultural specificity, and be relevant to the particular art form and genre. Standards are not higher for professional work than for work originating from nonprofessional community members. There are high standards in each realm, although they are likely to be different. Whether aesthetic assessment is

AFRICAN IN MAINE: WHAT CONSTITUTES "QUALITY"?

American arts professionals often decry the lack of "professionalism" and "quality" in community-based art. However, communities themselves rarely make such distinctions. *African in Maine* offered moments of extreme artistic virtuosity, such as the performances by Papa Wemba or Kanda Bongo Man. It included events that held special significance for the insider communities, such as the performances by Emanuel Kembe and the Shego Band. But it also included many events that were amateur attempts by local community members to represent themselves.

From the perspectives of the participants and their communities, this is irrelevant. Indeed, the events that featured community members acting, singing, and dancing onstage had an emotional resonance with their audiences that exceeded the response to the stars. This does not imply that community members lack insight into aesthetic nuance; they know very well what constitutes quality within their own cultural sphere, and they want that, too. It does state that issues of quality are often secondary considerations in the value of cultural events to insiders. Who is onstage can be far more important than what is

onstage. The imposition of outsiders' views of what constitutes "quality," puts a frame around ethnic performance that is foreign to the experience of most community members. This particular, often-voiced preoccupation with "quality" within the American public arts community (especially among funders), is a red herring, itself a reflection of the elitism that still prevails in too much public cultural work.

—Bau Graves,
Center for Cultural Exchange

intended to add to the discourse within the arts fields or to benefit a broader community, its integrity relies on grounding in an understanding of the forms and meaning of that work.

Within *Critical Perspectives* and Animating Democracy, criteria have emerged for assessing the effectiveness of civically engaged art. Although these criteria sort readily according to *aesthetic* and *civic* dimensions of the work, the interrelationship of the two is especially important in the analysis and interpretation of the work.

Civically engaged art that is effective on *aesthetic* terms:

Aesthetic Criteria

- **Offers a compelling artistic-cultural vision.** There is clarity of artistic and civic intent and a philosophical basis that guides the work. The choice of the creative process and/or form is well suited to the aesthetic and civic goals. Program design is responsive to the needs of the community and to shifting conditions and circumstances while also advancing the artist's own aesthetic investigation. The work is engaging, imaginative, innovative, and culturally relevant.

- **Reflects rigor according to standards relevant to the artistic or cultural form.** The work demonstrates excellence in skill and craft. Cultural work is authentically grounded in tradition and/or contemporary artists' work, as appropriate to the project.

- **Embraces risk taking in creation, programming, and/or connecting art with audiences that allows new possibilities to develop and advances artistic and cultural vision.** Artists and cultural leaders are evolving artistic and programmatic practice. They, along with project partners, embrace tensions inherent in the relationship between fostering meaningful dialogue and civic engagement, and maintaining the integrity of the creative work (i.e., what's the best way to present the art and the dialogue?). The relationships of project leadership, artists, and partners challenge one another and advance the artistic work.

- **Stimulates audiences, the public, stakeholders, and/or direct participants to draw social or civic meaning from the artistic experience.** Artistic choices in terms of form, content, and presentation of the work deepen meaning around the civic issue.

Civically engaged art that is effective on *civic* terms:

Civic Criteria

- **Demonstrates integrity of intent and accountability in execution to partners, participants, and others involved.** The work effectively considers relevant historical, social, and civic contexts. It operates from intimate knowledge of the community(ies) affected by the project through either sustained commitment to the community or commitment of necessary time and process to get to know the community(ies) involved. The organization or artist is able to identify and work with partners toward

authentic mutual benefit and is sensitive to issues of authority, ownership, and power. The project leaders recognize, respect, and foster self-determination and authority of disenfranchised communities. Project design and process are flexible, enabling a continual sharing of perspectives about the nature of the artwork and the effects of the project as it unfolds. Flexibility allows for change when needed.

· **Engages the intended public or participants in meaningful civic dialogue and/ or other forms of civic participation.** The effects of civic engagement may be at a personal level or systemic level. Civic intent may enhance appreciation for the artistic work, and deepen its meaning.

· **Is valued by the people for whom the project is intended.** Stakeholders, participants, and public(s) find meaning in the work, value it, and see it as relevant to and reflective of their interests and concerns.

TONI BLACKMAN

Concluding a City Lore *Poetry Dialogues* free-style
at the Bowery Poetry Club, September 2002

Ghettos are Beautiful vs. Ghettos are not
That is the topic that we drop
You, Natasha, kick in the beat box—
Don't you understand, this is the way we rock!
See, we try to have the conversation
through the rhyme
that's what we do, yes all the time
This is the aspect of Hip Hop
that you might not see on D-TV,
or the radio,
I said, sometimes, we flow
That's the way we battle life,
without fists, you know,
without the guns, without the knives,
without the violence—
that's the way we keep the hood in peaceful silence!

Ghettos are beautiful vs. ghettos are not
I said, at the end of the day,
who cares, as long as you rock the spot
As long as you live, your life will be true,
understand about the God that is within you!
You got to be clear, you got to stay real,
you got to open your ears so that you can hear
you got to understand, as we break it down
turn up the volume as we end this sound,
You see…

This was the debate we did for you this afternoon.
This was the debate we freestyled,
not a moment too soon.
This was the debate, the dialogue that we did start.
I'm sure that it won't end today,
but this is the end of this part!

Seeking an American Identity

(WORKING INWARD FROM THE MARGINS)

AN ESSAY BY SUZANNE LACY

IN NOVEMBER 2001, *artist, writer, and educator Suzanne Lacy participated in an Animating Democracy Learning Exchange in Chicago. She joined more than a hundred artists, cultural organization leaders, community partners, and scholars from around the country who are involved in arts-based civic dialogue work, most through the Animating Democracy Lab. In the shadow of September 11 and stimulated by artist Marty Pottenger's exploration of the meaning of U.S. citizenship at the gathering, Lacy considers anew what it means to participate as an artist in civic life. Her essay, "Seeking an American Identity (Working Inward from the Margins)," pursues a host of questions about "civic discourse art" related to identity, representation, transparency, aesthetics, and gauging effect, prompted by the arts-based civic dialogue endeavors of Animating Democracy project organizers and artists. Lacy weaves an eloquent exploration of these questions through a fabric of historical context and her own artistic and personal experience, opening up the issues and possibilities at the intersection of art and civic dialogue for fresh investigation.*

INTRODUCTION

I've never liked the red, white, and navy blue colors that come into periodic vogue, more so earlier in my life than now, thankfully. I'm not sure whether my distaste was purely aesthetic (primary colors aren't my cup of tea) or a vague foreshadowing of a future conflicted relationship to my U.S. citizenship.

It's been a long journey: from the swelling of pride in my prepubescent and extremely flat chest as we saluted the flag in elementary school; to civic volunteerism in high school; to the basically patriotic civil rights movement (and later, in my region, the United Farm Workers); to the down-and-out disenfranchisement of the Vietnam era (with still an undercurrent of civic optimism—we could change things); to growing suspicion about the nature of the U.S. government's involvement in Chile and Colombia; to deep cynicism about American business's version of globalism; and finally, 9/11, precipitating the red, white, and blue media event of a decade, a veritable orgy of flag waving.

I was dismayed at how much I wanted to check out when artist Marty Pottenger introduced a discussion of citizenship.

Growing up white and working class in a small California farm town, but for a slow erosion of belief I, too, could have become the patriot that circumstances of background dictated for most of my schoolmates. Still and yet (a compelling phrase borrowed from an African-American friend), I am not in a fixed position with reference to my identity as a United States citizen. I am marginalized by age, class, and gender, but centralized by education, sexual preference, and race. I have access to institutions denied to many of my friends, yet I remain substantially outside most places of power, even in my own profession. In reference to my country and its place in the world, I alternate between horror and pride, between repulsion and fascination, between the acceptance of tacit privilege and deep shame.

All of which came up for me at the Animating Democracy Learning Exchange in Chicago in November 2001. I came to observe presentations by earnest artists and cultural organization leaders working in partnership with their communities to foster civic dialogue. In the aftermath of the destruction of the World Trade Center and subsequent war on Afghanistan (or War on Terrorism—you choose), I was dismayed at how much I wanted to check out when artist Marty Pottenger introduced a discussion of citizenship. I expected to be a fly on the wall. Instead, I was plunged into a fascinating three-day discussion on belonging, exclusion, language, space, cultural tradition, and the roles of art in public discourse. I left feeling rejuvenated, confused, and stimulated to consider anew what it means to participate as an artist in civic life.

GHOSTS AND THE SPACES THEY INHABIT (WHOSE PLACE IS THIS?)

Some of us listen to ghosts; we can't help it. These ghosts have an important story to tell. What does it mean not to be seen? We worked to preserve the space where we found them and to tap into what they were saying.

—The Reverend Deacon Edgar W. Hopper, St. Augustine's Episcopal Church, New York City

A year after slavery was abolished, two slave galleries were constructed for the Negro parishioners of what is now St. Augustine's Episcopal Church in the Lower East Side of Manhattan. In these galleries above the sanctuary, free and indentured African Americans could see, but not be seen. Closed off for decades, discovery of the galleries freed ghosts from former times to engage in contemporary civic dialogue.

Each new immigrant group that arrives in the Lower East Side competes for cultural and political presence—housing, schools, and jobs. History can divide people, justifying claims to resources: I've been here longer than you have. The slave galleries and their invisible residents spoke of an historical experience that was particular to African Americans, but Deacon Hopper, minister of the now African-American congregation of St. Augustine's, saw both the power of this particular story and the space's relevance to the broader community grappling with ongoing issues of marginalization. He asked, "How do we balance between offering the history of the slave galleries as a metaphor that can inspire connections among diverse communities, while maintaining specificities of African-American heritage?" Working with the Lower East Side Tenement Museum, they invited other communities to consider and talk with each other about how the slave galleries might stand as a symbol for their own experiences. So a recent Chinese immigrant sat in the gallery to listen. A Latina heard whispers blown on hot border wind; an Orthodox Jew attended to the murmured prayers from women hidden behind curtains in the synagogue.

For 30 years, activist artists have testified to specific histories of excluded people, understanding that personal stories are how one enters civic discourse with dignity. Whether those people were black or poor, women or prison inmates, workers or immigrants, young or old, one of the major strategies of social justice art was to *name* and *give presence* in a society that preferred the silence of well-behaved ghosts. The disappeared experiences of America's marginalized were reclaimed to public life through art, media, and protest. Farm workers' stories were told at dinner tables, prisoners' longings escaped cells via the airwaves, the voices of murdered wives shouted in feminist-led antiviolence demonstrations.

Sometime in the late 80s, these voices grew in volume and audibly conflicted in a cacophonous American landscape. Discrepancies began to emerge: representation became contested in a territory of multiple identities. An oppressed person in one situation becomes an oppressor in another. Cultural practices were located in an interconnected network of customs that changed their appearance and meaning when transplanted through the drift of immigration. At the Animating Democracy Learning Exchange, Bau Graves of the Center for Cultural Exchange's *African in Maine* project was conflicted. When the Afghan community uses its theater for cultural events, they segregate themselves by gender. The upstairs balcony that accommodates 40 people is crammed with 60 or 70 women and children, while 30 men luxuriate below in the space that accommodates 200. In the next century, he wondered, will someone look back and remark on the arcane use of their own gallery where women were, like the African Americans of St. Augustine's Church, disappeared?

The vacant sealed galleries of St. Augustine's are empty spaces, and their filling will be an exercise in framing a contemporary metaphor of multiplicity. Artists no longer have the luxury of a single strategy in our art, that of making a singular voice audible and revealing particular ghosts. Formerly we aligned ourselves with these voices based on accidents of our birth, but as we moved into alignment based instead on our values, contradictions appeared. Finding ourselves occasionally on shaky ethical ground (based on our own identities), we are not to be blamed if we look occasionally back to a time when things were simpler and we, too, could claim a singular identity. The galleries have been unboarded; what it signified at the turn of the last century is vastly different now, over 100 years later, and a new story is required.

BEARING WITNESS (WHO OWNS THIS HISTORY?)

> There is a wall between my parents and I when it comes to wanting to identify with the legacy of the Holocaust. My friends don't identify with it, and there is not much interest in getting knowledge.
>
> —Joanna Lindenbaum,
> The Jewish Museum, New York City

Often the Holocaust was not spoken of in families of escaped Jews. It was passed on through silence and inexplicable depressions, as if the house was filled with ghosts. For those of us born in the U.S. after 1945, experience of the Holocaust was, for the most part, mediated. Whatever U.S. citizens might or might not have known before that date, during the liberation of the camps the first visual representations that arrived in this country were graphic documentary films and photographs.

Firsthand accounts came from the survivors, when they could talk, and from journalists and soldiers. My father, a pilot stationed in England, transported Jews from Africa back to Europe after the war. When he came home to California, I was almost a year old, and his nightmares of the war and its camps may have insinuated themselves into my dreams. Although there were no Jews in town and I do not remember specific conversations about it with my dad, the Holocaust was my memory too, a strong and influential one, but one that perhaps—I can't be sure—derived only from picture spreads in *Life Magazine* and the movies I attended weekly. Holocaust representation passed into popular culture, memories colluding with fiction.

Mirroring Evil: Nazi Imagery/Recent Art, an exhibition of The Jewish Museum in New York, plunged its curators, trustees, and staff into intense self-examination. As curator Norman Kleeblatt explained, the Holocaust was a signal event in which Jewish history and mainstream history intersected. For the first 25 years after the war, Holocaust images were abstract. When representational imagery did evolve, it was influenced by the photos taken in the days after the liberation—piles of bodies and emaciated prisoners at fences. While the museum still receives weekly submissions of this type of artwork, the staff wondered, "Is something else needed at this particular moment?" Their answer was an exhibition of works of art they

believed reflected questions of contemporary morality and issues of evil, and their installation strategies and contextual writing would, they hoped, support a complex civic discourse.

The exhibition featured artworks by artists two and three generations removed from the events of WWII, who have eschewed the deeply entrenched Holocaust imagery that focuses on the victim. These artists did not claim to represent survivors' experiences. Instead, employing the challenging language of conceptual art, they used images of perpetrators—Nazis—to provoke viewers to explore the seduction of power as well as contemporary manifestations of evil in the forms of bigotry, war, and genocide.

Mirroring Evil challenged traditional representations of that historical moment—how it operates in Jewish and U.S. cultural memories—but for some survivors it generated a rage around ownership of representation. Standing on the authenticity of lived experience, survivors of the Holocaust are victims, yes, but they are also empowered through the representation of their own stories, their claim to *cultural voice*. Curators anticipated controversy that might arise in challenging traditional perspectives of the Holocaust. It was, of course, not only tradition that was being challenged; the museum became a contest in power, the power to shape meaning through representation. Pitted against each other, it appeared as if a fundamental shift had taken place between generations of Jews, each desiring to explore and find meaning in a common heritage. The exhibition provoked heated ethical debate in the Jewish community, raising provocative questions. Did the museum ignore, in its attempt to raise current questions for a generation virtually untouched by the Holocaust, the nonnegotiable visceral experience of pain for those who endured it? Or is it possible that, as consumers of an over-mediated Holocaust, we've become complacent and inured to the predictable accounts of the direct experience, needing ever more provocation? Who has "the right" to speak on the Holocaust, those with direct experience, or those whose experiences were mediated, in this case through popular culture, associative inferences, and, consequently, fantasy?

These questions are not unique to this exhibition, or to art museums in general. They come up wherever power and representation occupy the same forum. While the same questions apply to advertising, commercial entertainment, and news media, however, it is often in the visual arts—somehow seen as more assessable—that people often choose to make their stand. Whether at The Jewish Museum or in Congress deciding on the future of the National Endowment for the Arts, visual art production has become a touchstone for the examination of representation and authority. At the local level in community-engaged art, these issues are incorporated daily in a practiced negotiation between direct experience, and representations of it for various ends.

We want to believe in the unassailability of direct experience. (In Oakland, CA, young teen mothers tell me they heed most the words of other teen moms…those who've been there.) A man cannot speak for a woman, nor a white person for a person of color. Here, even expressions of empathy are suspect. Where once imagination was sufficient passport to the representation of another's experience, our awareness of the dynamics of power has challenged empathy as sufficient motivation for art making. If an artist works with any experi-

Where once imagination was sufficient passport to the representation of another's experience, our awareness of the dynamics of power has challenged empathy as sufficient motivation for art making.

ences other than his or her own, inevitable when one leaves the solitude of the studio and embraces potential social and political functions of art making, how close in experiences must he or she be to her collaborators? Can women make art authentically with other women on women's issues? What if the class positions between artists and community are different? Or the ethnic backgrounds? Can non-Jews comment upon the Holocaust? (To be sure, artists in *Mirroring Evil* were not purporting to do community-based work, but that does not mitigate the essential ethical dilemma. Representations of the Holocaust, it might be argued, continue to be historically contested in ways that directly affect the experience of Jewish people.)

Many of the forms we have come to assume as part of community-engaged art...are aesthetic evolutions developed through confrontation and resolution of conflict during the making.

While the essential question of who owns representation of, in particular, painful experiences with political import for specific groups of people is pertinent to all representation, in *Mirroring Evil* it became foregrounded not in the production of the work, but in the museum's decision to present it. Thus, it was not the artists per se who were picketed, but the exhibition venue.

With community-based artists, operating as they do closer to the nexus of community experience and critique, this dilemma figures significantly in the actual production of the work. For these artists, strategies grow out of negotiations, each work posing questions that are answered as action and as theory. Many of the forms we have come to assume as part of community-engaged art—its multivocality, for example, its pluralism of styles of presentation and its postscript-like conversations—are aesthetic evolutions developed through confrontation and resolution of conflict during the making. The aesthetic and (simultaneously) political negotiation of differences in experience and the ways experiences are represented, more volatile when focused on inequity and pain, produces evolving, rough-edged, and imperfect art forms that are particularly adept at modeling civic discourse.

From this central conflict in community-engaged art—origination of experience and communication of it by another, no matter how sympathetic or aligned in features of identity—a long history of shape making has evolved. There is another approach, one that reconfigures the central voice in the work as that of the perpetrator, rather than aligning with those on whom injustice was perpetrated. The creator of the film, *Traces of the Trade*, is descended from one of New England's largest slave trading families. It was the North's maritime economy that fueled the slave trade through its profitable engagement in the industrial revolution launched by Southern cotton. Filmmaker Katrina Browne, whose ancestors are from Rhode Island, set out to explore the legacy of slavery on white people—the denial, shame, and guilt—on a literal family voyage from Rhode Island to Ghana to Cuba, tracing the Triangle Trade Route and interviewing white family members and the descendents of African, Cuban, and African-American people impacted by her family business. The finished film aims to address the denial, defensiveness, and shame among whites that pose barriers to engaging in dialogue about race.

In *Traces of the Trade*, the filmmaker positioned her voice centrally in the work, looking square in the face of her ethnic and familial privilege and listening to those upon whose backs it was earned. In postmodernist reflexivity, but with modernist moral engagement,

she adopted one of the few positions left to white folks in the terrain of race and ethnicity. The filmmaker understood a moral obligation to attend to the pain that participants would inevitably experience as a result of their filming. Family members who were interviewed, people they interviewed in Africa and Cuba, even the filmmakers themselves—all were deeply impacted by the project. Filmmakers wondered how much of this pain should be professionally monitored and how to deal with their own pain as makers? Of particular interest here, they wondered how much to reveal of this process, including the questioning, in their finished product? The provocation of aroused pain translated into the aesthetic and moral searching that is characteristic of engaged community work, often finding its way into the art as a transparent process.

One way or another, the identity of maker and the identity of community, the constituency, the subject, or the collaborators (however these are framed) is central to this work, and on this template of process we play out all the social injustices and misrepresentations that constitute our history and our present civic life. Perhaps laughable because of how little power artists actually command in this culture, nevertheless these inventions become prototypical laboratories for the enactment of public life. In this public realm, who speaks for whom? Should an artist work with a constituency base not their own by virtue of an assortment of identity characteristics? When these characteristics overlap in some ways, who determines the priorities that justify an artist's engagement? Though in some cases artists evolve from and continue to work in a specific location with only their exact equivalences, even there differences in age and gender eventually result. More often the artist's identity is in fact different—whether through age, gender, ethnicity, religion, sexual preference, geographic location, or class.

The discussion on insider and outsider is of necessity a conversation on risk, privilege, and resources that is echoed in all civic discourse.

Irrespective of the perceived "correctness" of the artwork, when reduced to its essence, community-engaged art is most often a process of collectively making meaning via subjectivity that is translated into an aesthetic frame made most often by someone who does not have the exact same experience. The discussion on *insider* and *outsider* is of necessity a conversation on risk, privilege, and resources that is echoed in all civic discourse. A subtle and often unconscious undercurrent makes discussion painful and evasive in the arts, as if one day someone shared the secret—to be an insider was the only moral way to work as an artist in a field of difference, given the dangers of misrepresentation—and from that day forward we found ourselves justifying our positions as *insider* of one or more marginalized groups—more black than white, more female than male, more poor than rich—or claiming a validity based on association.

The question of one's membership comes up depending on the potency of cultural signifiers, with particular pain around race and class. In 2003 in the United States, would we expect anything else? While none of us experience all forms of oppression, or even recognize them, to some degree most of the artists at the Animating Democracy convening had some working knowledge of what it felt like to be excluded. We all agreed that it is political dynamite for white artists to appropriate the stories of people of color. What we did not agree upon was what constituted appropriation. Labeling oppression is best done by the oppressed,

but who is entitled to speak for the entire group where there are countless differences of perspective within any given group? If, as with *Traces of the Trade*, makers critically align themselves with white oppression, do they run the risk of recentralizing the discourse to white, albeit contrite white, experience? If we do cross borders, work with experiences not our own, where do we locate *voice* and *agency* in our art?

In 1978, the actress Kathleen Chang and I created a performance piece on a boat in the San Francisco Bay and on a hill on top of Angel Island, the major port for 19th- and 20th-century Asian immigrants to the West Coast. We were two characters from the turn of the last century: her husband's grandmother, Leung Ken-sun who ran away from her home in China, and Donaldina Cameron, a Scottish Presbyterian missionary who rescued Chinese children smuggled into San Francisco for sexual slavery. As we searched for our respective voices within the work, we ran into the very questions that would impede us today, perplexing questions of cultural appropriation, colonization, and assimilation. Struggling for an authentic approach to our collaboration, we chose strategies of representing ourselves according to our race, representing different perspectives on history in discrete narratives, and ending with a present-time discussion that deconstructed the ethical and political issues that had arisen for us during the making of the performance. While I liked the transparency of the work and its layering, the performance has always seemed somewhat unresolved, with disjointed narratives on gender, race, nationality, and friendship, as incomplete, fraught, and vulnerable as are today's civic discourses.

Two decades later, at the Animating Democracy Learning Exchange, the notion of transparency was not just seen as good civic value, but fundamental to the practice. Many felt that transparency held a key to both ethics and aesthetics of this troublesome practice, a transparency that was not only about locating one's own voice honestly within the work, but also about the art process itself, how information is edited, shaped, and presented. How much of the soup of experience—of the artists, collaborators, and community members—roused in making art should be revealed in the art, and how much is indulgence? Could our own emotions, like beacons, lead us as makers to the heart of the work? As one of the filmmakers of *Traces of the Trade* suggested, "You don't edit out the messy stuff."

The changeful nature of this work is its strength and its difficulty. All assumptions within a transparent process are open to challenge: dominant cultural assumptions about what makes a good story—choice of subject, narrator's voice, the style, shape, and choice of medium; the availability of economic resources, ownership of venues, and choice of audience; the methods of entering a community, researching, enlisting support, and consensus building. Perhaps most important, even the aesthetic expression is open to negotiation. This scrutiny that actually gives birth to form suggests that *process* is interesting in terms of both structure and content of the art. *Discourse* thus becomes an important brushstroke in the representation of process. Today's work must reflect the questioning that took place during the production, these questions often sharing the same cacophony, contradiction, hybridity, confusion, and fusion evident in today's public life.

This messiness might appear to be a threat to effective civic dialogue; despite the discipline required in making, art revels in the accidental, the unexpected, and the innovative. Artists seek an unpredictable kind of knowing, safer perhaps when the exploration is confined to the studio. In the civic realm, with high stakes issues and unpredictable occurrences, artists' interests in new shapes and forms can be (and often are) seen as dangerous. This tension between the need to control, providing safe spaces for our audience to approach difficult subjects, and the tolerance for the ambiguous and unexpected must be recognized as we craft and name civically engaged art.

THE ETHICS OF STORYTELLING (WHAT SHOULD NOT BE TOLD?)

When you have to sit in that audience and realize that you are the people in those photos watching that horrible lynching, how do the facilitators help white people to face this?

—Margery King,
The Andy Warhol Museum, Pittsburgh

The Andy Warhol Museum decided to exhibit *Without Sanctuary*, an exhibition of 100 photos of lynchings of mostly African-American men from the late 19th to the middle of the 20th century. Pittsburgh, home to the museum whose mission is to be a vital center for the community, is also home to nationally visible race problems. Within recent memory of the Chicago gathering, two racially motivated killing sprees, one by a black man and one by a white man, demonstrated the tensions that periodically strike this city. What were you afraid of? We asked The Warhol Museum's curator, educator, and community advisor at the Animating Democracy Learning Exchange. They replied, "What will be the effect of the photos? What if no one comes? Where was the art? What if there is violence in the galleries? Will we be accused of robbing African-American legacies? Are there things that should not be seen?"

The museum with its mostly white staff couldn't present this exhibition alone; now, perhaps for the first time, they *really* needed the community. When the director of the Center for Race Relations of the YWCA presented the information about the proposed exhibition to staff member Sherry Cottom she reacted viscerally: "Who in the hell do they think they are, a white museum showing the history of lynching? I went down to the museum with a whole bunch of my own people…I was their worst enemy." Mutually wary at first, the museum and members of the community embarked upon a planning process.

There were bumps in the road. Early on during a Pittsburgh conference, a white woman spoke on the history of lynching to a mostly white audience. As Sherry reported, the speaker's presentation had all the quality of "describing a vacation trip to the Bahamas." In response, an African-American historian took a more personal and emotional approach, remembering how, on his first job as one of few blacks in the Center City business district, a white gay man verbally attacked him. The museum staffers, among them several gay white men, were in their turn incensed. Jessica Gogan, education curator for The Warhol,

discussed her own learning. "I had been dealing with issues around race programmatically and theoretically, a framework of safety that prevented me from really examining the issues. We had differences to negotiate. How can we deal with such emotional issues safely, but rigorously, within institutions?"

Members of the Pittsburgh black community emphasized the importance of showing these historical photographs in the context of the struggle and achievements of African Americans. Showing community assets rather than focusing on victimization has long been a strategy of activist artists. One of the most important additions to community-based art was a rethinking of the audience on both ethical and aesthetic grounds, integrating a new relationship into both choice of venue and shape of the artwork. Nowhere is this more urgently necessary than when trauma is the subject of the work. In *Three Weeks in May* (1977), I took on the still largely unexplored topic of rape in Los Angeles. Rape reports from police blotters were recorded on a large public map of the city. Next to it, a second map revealed the location of activities and institutions of resistance, including three weeks of art performances, media events, and activist interventions throughout the city. The exhibition format at The Warhol was a page out of the text of this and other earlier art projects: elicit community participation from the beginning; form partnerships with churches, clubs, and other relevant organizations and institutions; provide facilitated dialogues for a broad public audience, co-led by community members; contextualize images of oppression with historical displays and art of resistance; engage local media; and develop avenues for audience response—at The Warhol a video comment booth, daily discussions facilitated by museum staff and community members, special events, and personalized postcards mailed at a later date by the museum.

It is reasonable to argue that the 70s feminist art movement and its focus on physical violence provided a significant historical contribution to artists' need to take audience reactions into account while making their work, thus influencing its shape. Women's deeply personal and experiential understanding of trauma through sexual violence resulted in a necessary evolution toward audience-centeredness. This was not simply about creating a context for art but rather an example of necessity prompting an evolution in form language. While the content of text and image in activist art manifests its pedagogy, less understood is how the artwork's structure produces learning in experiential and transformative ways.

[1] On the West Coast, Labowitz and I developed this pedagogic model, one theorized from an amalgam of feminist politics, media theory, community organizing strategies, and the populist applications of lifelike art ideas of our teachers, Joseph Beuys and Allan Kaprow. A host of artists contributed to this shaping of theory and practice, including Sheila de Bretteville, Judy Baca, Arlene Raven, Cheri Gaulke, and Jerri Allyn, to name a very few. It is likely that at the same time other visual and theater artists were inventing similar forms.

Take, for example, a video installation in 1979 by the artist Nancy Angelo as part of a larger public art project at the Los Angeles Woman's Building. *The Incest Awareness Project* (1979, Labowitz, Lowe, et al.) was, like the exhibition at The Warhol, an artful civic discourse on an obscured social experience through performances, installations, exhibitions, mass media reports, speak-outs, and interdisciplinary symposia.[1] In Angelo's installation, the audience sat on one of approximately 15 chairs arranged on a pink circle painted on the floor. On five of these chairs video monitors were installed, screens at head height. As the event began, faces appeared on the monitors and talked to each other, via carefully orchestrated nondigital technology. It was an electronic consciousness-raising group talking intimately, emotionally, and with a sense of primary revelation. Quickly, audience members in the circle of chairs found themselves included in this intense discussion, more

impactful because such information was not yet in the public realm. At the end of the media-relayed but scarcely mediated group discussion, the audience sat in stunned silence. Because she knew (based on emerging statistics) that many audience members probably had experienced incest, Angelo created a second component to her installation: a facilitated postperformance discussion led by a social worker trained in incest counseling. The discussion itself was part of the performance, rather than its interpretation, an innovative and populist audience-based practice inserted into both a minimalist art discourse and a virtually nonexistent civic dialogue on violence against women.

At The Warhol Museum the stakes were high. Should they exhibit photos of lynching with their graphic violence and open display of racial hatred? If they did not, would they be hiding an important historical experience that still disfigures contemporary civic life? Would they risk evoking intense and present pain among African Americans, and whites, for that matter? I steeled myself in advance to be able to look at a total of five photos, one on each wall, before I literally ran out of the gallery, transported by an awful and murderous rage. Is it possible the photos might provide prurient entertainment for some white folks? Or simply inure the audience further to the daily present humiliation of being black in America? Or would this exhibition provide an important historical context, otherwise not viscerally available, to a present-day community interested in overcoming racism?

One of the most important additions to community-based art was a rethinking of the audience on both ethical and aesthetic grounds, integrating a new relationship into both choice of venue and shape of the artwork.

One of the lessons from the 70s, exercised with great care by The Warhol staff and community committee, was to frame the violence from the experience of the violated, rather than those who can view from the safe distance of nonexperience. This lesson can assist us as we frame civic discourse as a practice within the arts.

HUNTING THE WHALE (IS CIVIC DISCOURSE ART?)

In the Iñupiat culture, the whaling tradition is not just about hunting to eat, but subsistence on all levels. Every part of the whale is used. Bones become homes, fat becomes fuel, skins become boats. Whaling is a ritual of life for us.

—Jeff Herrmann, Perseverance Theatre, Juneau, AK

Barrow, AK, is a small town of 5,000 people accessible only by plane, boat, dogsled, and snow machine. When Perseverance Theatre decided to present *Moby Dick,* it was not so interested in translating Melville. Rather, the theater group wondered what it *means* to tell that story in Alaska. They began with interviews of whaling captains in Barrow and an exploration of the Iñupiat people's whaling traditions. Perhaps unexpectedly, the work took on a political cast, revealing fundamentally different cultural approaches to hunting. In the city, white people don't want the natives to have a legal advantage; to them hunting is a sport. To the Iñupiat, hunting is a means of survival, a ritual, and a way of life.

Perseverance Theatre's exchange with the whalers of Barrow exposed differences between the white and native approaches to art as well as hunting, including the link between Iñupiat

art and its communal and spiritual life. Said Mike Travis, a native Alaskan attending the Learning Exchange (connected not to Perseverance's project but another), "We show who we are by our objects. We dance with our objects to show our connection with the spiritual world." At the Animating Democracy Learning Exchange, Kewulay Kamara, an artist from Africa, observed that in the United States "you always have to market your work in some way, so you have to make a case for its existence," pointing out the divorce of art practice from its integrated functionality in our lives.

Animating Democracy, founded as it was to enhance the practices of a relatively obscure area of art, is in part an exercise in naming. This is not as simple as it might first appear, because this art sits at the intersection of creative practice, relationship, and civic life. On one hand, pairing art with civic process is a simple matter. According to Animating Democracy national advisor and former dialogue specialist with the National Conference for Community and Justice, Wayne Winborne, "We are talking about consciously cata-lyzing the political issues of the day. Art allows us to get at things that people can't get at on their own." There is art, and there is dialogue, and they join hands in a venture to operationalize art in the service of a public agenda.

Is civic dialogue art an explanatory text for art...Is it an aesthetic slant on other cultural projects...Or is civic dialogue art an evolution in form and practice of community art?

While such art does in fact engage local communities and often speaks to them (or allows them to speak) across differences in culture and class, it doesn't always play well in the higher regions of American cultural life. Not everyone sees it as art. Even in the one visual arts area that routinely incorporates dialogic practice—museum education—there is a tendency to separate the art from the discursive process. In commenting upon the *Without Sanctuary* exhibition at The Andy Warhol Museum in Pittsburgh, the curator stressed that art comes first, suggesting that dialogue was an *enhancement* to the visual art. Acknowledging multipo-sitionality among the collaborators, "What makes it work is a total integration; [a situation] where each one of us wants to do this project for our own reasons." Museum staff neverthe-less stressed their position: the exhibition, while it addressed race and racism, was *not* an anti-racism workshop. The dialogue framed in the museum had to be about the images, and while audiences were to be met "where they were at," the role of the presenters, staff, and community partners was to guide attendees to focus on the exhibition.

When we consider the totality of our public projects *as art*, including intention at the opening edge and impact on the closing, with all the process in between, one question repeatedly arises: does the art match the formal sophistication of other contemporary art in its genre as seen in museums and theaters, or does it have a demonstrable and measurable effect in public life? Good art versus good serviceable cultural development: this dual encumbrance creates evaluative criteria that appear to randomly migrate in various critical texts, from a discussion of its *appearance* (usually in the context of art derived from quite different ideas) to *function* (in a public context where art is seen by many as having no function). While in some instances we can talk about the results of the artwork in concrete terms, e.g., the artwork stopped a gentrification process, created a police training program for youth sensitivity, left an anthology of oral histories in the care of local residents, or changed the lives of some homeless people, such evidence is mostly

anecdotal. Even if we could measure social worth, what would that tell us about aesthetics under the terms of the current critical discourse?

Held as they are (at least on the civic side) to the demands of demonstrating worth within a confused notion of the value of art in general, civically engaged artists often feel they need to leave something (hopefully of aesthetic value) for people with whom they have worked. I suspect this notion may have developed to counter the critique raised during the 90s, on itinerant public artists. In flailing around to respond to funders or to their own notions of ethics and impact, artists can become programmatic and predictable, bound to deliver objects of some sort. And so civic-minded artists leave murals, videotapes, anthologies of oral histories, even ongoing programs within communities, causing us to wonder whether the art is that which is left behind, or whether what is left behind is instead evidence that art did occur here?

Even artists (including those benefiting from Animating Democracy's grants) are not convinced civic discourse art is an art form in and of itself, complaining of a continuing need to morph language and the look of what one does in order to attract funding. (Outside this funded circle the critique is even more intense). Said one attendee, "Civic dialogue seems to describe something we were doing already, and it feels like the art is being trivialized. Why can't art just be funded to be great art instead of having to be disguised to get funding?" Wayne Winborne expressed amusement at artists (like me) who spend time on definitions and distinctions. In one intense discussion questioning whether civic dialogue art must embrace multiple viewpoints, Winborne responded, "It's fascinating that artists experience this angst. If you make good art, it will stimulate dialogue. A good facilitator will get it there. You don't have to worry about whether you should represent all voices in the art...the dialogue folks can handle that stuff." United by common cause, we are nevertheless faced with radically different concepts: Is civic dialogue art an explanatory text for art, a more or less inventive art education program? Is it an aesthetic slant on other cultural projects: e.g., revising history, building tourism, engaging gentrification, increasing public discourse? Or is civic dialogue art an evolution in form and practice of community art?

While Animating Democracy might advertise its goal as an invigorated public life, it poses a provocative question about the form, not just the function, of art. Although some of its sponsored projects might aspire to be art that is surrounded, enhanced by, or used in the service of civic discourse, others will, no doubt, aspire to creating new forms of *dialogic art.* Rather than retreating from questions that challenge prevailing notions of aesthetic form or artistic practice, we can take them as challenges of redefinition. In my revisionist history, I would suggest that at least since the early 1900s we could locate this exploration on form and function in the civic realm within many international avant-garde arts practices. In a sense one might see this as a quest to reconnect art to meaning in civic life. As former connections to materiality have decayed in contemporary arts practices, we might look to more ephemeral and publicly located processes as a new "materiality."

Is hunting the whale, finding the art in this practice, a futile exercise? Is distinguishing between civic art and civic activism really necessary? Could we just say that we are all working toward similar goals and leave it at that? I argue it is of critical importance to the arts to locate these art practices within the trajectory of art history, to give real texture and meaning to the notion of artist citizenship and in so doing accomplish the reconstruction of the civic relevance of art. Whatever we call it (and each new naming functions to further discourse), this art is fundamentally a process of research and exploration. In an important way, such art is not about language per se, but about the space language takes place in, about speakers and their relationship to each other, and about the direction, intention, and effects of the conversation. It is about values and listening and inclusion. To be sure, political realities as well as the pragmatic nature of American character demand certain concrete deliverables in civic action. Within this paradigm, the role of art in getting people to talk with each other, and perhaps as a result to think or act differently, is just about the only certain role for civic artists. On this we can deliver.

FINDING OUR WAY TO THE FLAG (IS ART A CITIZENSHIP PRACTICE?)

If you don't have a strong stomach for this work (and some muscle), get out of it.
—Neill Archer Roan

The Animating Democracy Learning Exchange took place mid-November 2001, a scant two months after the September 11 bombing of the World Trade Center, an event that quickly became a referendum on government policies, race, and citizenship. Artist Marty Pottenger created an artwork asking participants to consider our feelings about the United States. Intense emotional responses erupted, including dire pronouncements from some that since 9/11 the world had "forever changed" and from others, like an African-born Kewulay Kamara: "What has changed about the world…5,000 people died in one shot? Is that something new?"

Throughout the daylong discussions on citizenship, I was discomforted, particularly when holding, gingerly and at arm's length, a miniature flag distributed to each participant. Pottenger encouraged us to express through it our sentiments on citizenship. Immediately I recalled Jimmi Hendrix's unmercifully distorted rendition of the National Anthem. I remembered students marching with Chavez in the grape fields and burning down the Bank of America in Santa Barbara. Product of the 60s, I tore the tiny flag into strips then reunited them as braids, a gratuitous and facile act in the face of my own history.

It is interesting for someone from my activist generation to consider the seemingly vast ennui in U.S. public life today. The transience and urgency of lifestyles, the sense of not enough time and constant movement creates a lack of grounding in geographic and emotional terms. A deep sense of futility seems to pervade. Overwhelmed from the scale of institutions, the reach of communication, and the scope and intransigence of the problems to be solved provokes even greater investment in the very personal feelings of impotency in the public realm.

…the role of art in getting people to talk with each other, and perhaps as a result to think or act differently, is just about the only certain role for civic artists. On this we can deliver.

The promise of 70s' activist artists was cultural change, a transformation that in significant ways has not occurred. For those of us who have worked in community for 20 or 30 years, [we've] likely taken civic institutions in various forms as venues, as materiality, or as content for our work. In the evolution of community-responsive art, institutional intractability is a factor to be reckoned with on both social and artistic levels.

It is undeniable that personal transformation does take place during the making and exhibiting of public art projects. Testimonies over time attest to the impact on individual lives. This is not unexpected; engaged art is precisely about the experiencing participant. However, hopes for lasting and large-scale social change through individual awareness and working on art projects are perhaps naïve in today's terms. The artist seeking to participate in social justice movements ultimately faces questions not unlike those confronting urban planners, educators, and politicians. Artists working in ambitious scale within communities encounter institutions as a potential *site for change* and institutional *resistance to change*. The institutional trajectory is to maintain itself and to change only if necessary, and slowly. While institutions can be affected by transient energy of art projects, the question is how profound and lasting will such influence be? Once the art project is over, what is its legacy within the various institutions that carry our vision and values? Can change be embedded in ongoing ways that retain the radical nature of the originating artwork?

I am challenging artists who work with public themes and processes to explore with me a rigorous standard of social (not individual) change.

We are not without road maps here. The longer an artist works within an institutional territory, the more effective he or she becomes within it, the greater the chances for institutional change. Artists and journalists in the prison reform movement, for example, were able in limited ways to develop programs, influence the lives of some prisoners, and bring public awareness to inequities in incarceration rates. But during the three decades of this activity, the number of prisons grew exponentially and our partners in communities raised the bar, setting a higher standard for our efforts. Artists who tackled political issues, from violence against women to public school education, hoped for more: to impact public policies, voting tendencies, social values, distribution of funding, and the general enhancement of equity.

Not to discount the impact of art on individuals, for purposes of discussion I am challenging artists who work with public themes and processes to explore with me a rigorous standard of social (not individual) change. In my own work with youth in Oakland, CA, over several years I managed to gain enough credibility both within public school, health, and police institutions to navigate freely, command resources, and create a series of performances and installations with rather fulsome civic cooperation. Many, many youth participated over the 10 years of this work, and several continued working with the loose-knit team of artists that became an ongoing community: We went to high school graduations, taught video skills, found internships and jobs, visited detention centers, testified in court, wrote letters of recommendation, and helped with college applications. But after 10 years of highly public programming, several large performances, scores of televised reports and documentaries, over 1,000 youth in art and video workshops, and models for police training programs and interventions between teachers and students, the institutions that would continue to affect the lives of Oakland youth remained *substantially and programmatically* unchanged. Though

it is difficult to calculate the shift in public attitude created by long-term artistic work in a community, it is safe to say that such work contributes over time in incremental and collective ways to the public perception. But if the goal of social change through art is to change the conditions of people's lives, that change will take place perhaps in large part by embedding it within the institutions that create and maintain public policies.

On the last morning of the conference, Rich Harwood, founder and president of The Harwood Institute, was invited to present a workshop on civic processes and strategies of engagement. As often happens within the public and uncontrollable territories of our discourses, the intentions of planners were subverted by real life. We went on one final merry-go-round that left some participants exhausted and dismayed. It left me quite energized. The problems that came up in the discussion—on race, gender, authority, centrism, language, expectations, and power—were those I face daily in the production of my own work. Rha Goddess, artist and dialogue facilitator, objected to some of Harwood's use of language. Acknowledging her objectives, he asked if the audience could set the discussion about language aside in the interests of covering the material he had been invited to present.

Many could not. As emotions and opinions bounced around the room, I saw through the eyes of first one then the other speaker, moving from position to position. Perhaps the biggest barrier to a full and democratic participation in civic life is fear, our insecurities growing along with our understanding of the scale of global inequities. As the weekend of the Animating Democracy Learning Exchange progressed, the notion of safe space, which in the beginning we perhaps unwittingly assumed—after all we were in the company of kindred spirits—slowly eroded. In the end we found ourselves like an old married couple, in the middle of a distressingly familiar argument.

As with civic discourse itself, art that attempts to provide an arena for multiple perspectives can be extremely painful, particularly as it approaches real life. I watched the Animating Democracy Learning Exchange become a compelling example of real time civic discourse. Intelligent and well-intentioned people revealed themselves to each other in unrehearsed and often difficult ways. I saw beached whales, exposed skin, and bare white bones scaffolding new ideas. I saw inchoate and nonfixed form emerging, questions without answers that cover the page like a sketch with wide-open spaces. Somehow it felt like raw citizenship was being enacted, the compelling aesthetic shape of civic discourse:

> "If we get hung up on straightening out language, we will be here all day and not get to the presentation on public engagement."

> "What doesn't work for me is that *public* is often in handcuffs on the seven o' clock news. Some of these same words have delivered horrific news to us."

> "The terms of the debate have been shaped by someone who is not most of *us*, someone who is white and male and wealthy, for example. In order to have civic discourse how much do we have to agree to let certain things 'ride'?"

Intelligent and well-intentioned people revealed themselves to each other in unrehearsed and often difficult ways. I saw beached whales, exposed skin, and bare white bones scaffolding new ideas.

"I checked out when we began to talk about language. I don't even know if dialogue is possible, if every word that comes out of my mouth is tainted, if I am so concerned about my ability to talk that I can't have dialogue."

The producers of Animating Democracy have long been committed to an authentic interrogation of effective practice. "By our own definitions, I don't think we aspired to staging a civic dialogue at this Learning Exchange," said Barbara Schaffer Bacon. "The only explicit civic issue addressed was citizenship. We have a lot of mixed feelings about which elements of the weekend achieved civic dialogue." Self-critical and curious about form, they concluded that several elements made this weekend not *public dialogue*: intention wasn't there in the beginning, ground rules (such as instructions in careful listening and equity among participants) weren't established, issues to be discussed were not clearly articulated, and too many topics were considered simultaneously. Not to discount the need to instill rigor in this practice, for me the experience was *in fact* a civic dialogue, in form as well as content, the same volatile subjects simmering just under the skin of public life. The issues of this discourse may not have been presented clearly in the beginning, but in reflecting upon the whole weekend they were everywhere evident, the messy stuff of our civic life. As someone from the conference said, "We have no idea of the effects of what we set in motion."

Code 33: Emergency Clear the Air, *a public art work by Suzanne Lacy, Julio Morales, and Unique Holland, Oakland, CA, 1999.*

Perhaps I saw it this way because I was not the producer of this learning lab. If it was my own artwork (and I've been there many times) I might have been more consumed with doubt. As I watched the unfolding, from my vantage point as respondent, I saw an aesthetic of civic process I have seen many times before, most memorable in recent experience during the performance of *Code 33: Emergency Clear the Air* (Lacy, Julio Morales, and Unique Holland, 1999). As 150 Oakland teenagers and 100 police officers settled in small groups on the roof of a downtown parking garage between the head lights of parked red, white, and black cars, 2,000 audience members lined up outside. Across the street, a small, hundred-strong group of mostly college-aged protesters arrived intent on gaining access to television cameras gathering for the extensively publicized performance. They came to bring attention to the case of Mumia Abu Jamal, convicted of the murder of a policeman in Philadelphia and sentenced to death. As we watched the protestors trying to interrupt the conversations between young people and police, *Code 33*'s multicultural and leftist team of artist-directors were bemused: on the same end of the political spectrum, many of us active in anti-prison work, we initiated an invitation to the protestors to have a platform within the performance, but were refused. Over two years in the making, the performance lumbered forward, with its spectacle of 30 television monitors with

youth-made videos, intense youth and police conversations, heated discussion between 80 neighborhood residents representing the community perspectives, 50 youth dancers, mentorship sign-up tables, police cars, low riders' cars, and a helicopter. But it certainly was not a stage-perfect show in timing and choreography, with behind-the-scenes interruptions from protestors that made it feel more like trouble-shooting a demonstration than directing a performance.

The Animating Democracy Learning Exchange had strong resemblance to a public artwork on a controversial topic in an exposed public space. If one seeks perfect and controlled solutions, many conundrums—the scale of the social problems we face made larger through our awareness of global forces, the inevitability of having to examine one's own participation in oppression, the seeming impossibility of maneuvering across differences, and the paradoxical need to make art that is beautiful, coherent, disciplined, and meaningful—will lead to paralysis. The activist-artist strategy of optimistic movement forward in the face of pessimism, contradiction, and imperfection keeps us honest. If we are willing to drop our defenses and listen, we will learn how we each, unwitting or not, bear the burden of our identity. It's a burden worth taking up. The shift from an identity-fixed citizenship by virtue of one's birth to a global one with allegiances to humanity rather than countries is not a facile personal choice but a process that begins in proximity and often-difficult conversation.

The activist-artist strategy of optimistic movement forward in the face of pessimism, contradiction, and imperfection keeps us honest.

While I remain cynical about the United States government, I did come away from the Animating Democracy convening, not with patriotic spirit filling my (still flat) chest, but with something very akin to love swelling there. Is patriotism finally, in the words of Harwood, a devotion to something you love? Participants were divided in their perceptions of what was happening that last morning, but even when they left the room in varying modes of despair or anger, they returned once again to the debate. As Jessica Gogan from The Warhol Museum said, "I am still reeling from the issue of civic and personal, and the importance of acknowledging the personal…to me the first time we began to get to dialogue was this morning when things got unsafe."

I left Chicago wondering if, bolstered by projects such as Animating Democracy, art in the U.S. is heading toward *full civic engagement*. Certainly the trajectory of this work over 30 years with its challenges to governmental and corporate motivations; its presentation of the larger historical frame of power relations; its deep commitment to the enfranchisement of all; its naïve belief in the ability of the public agenda to right itself with enough information; its practice of bringing the voiceless into the public sphere with dignity, through their stories; its increasingly adept strategies of dissent, community organizing, and political critique; its ethical questions; its hybridity of thought, media, and approaches is one that mimics a trajectory of civic life.

Seeking centers from the margins, artists are defining a Bill of Rights for cultural citizenship consisting of dignity, respect, history, sufficiency, identity, and freedom from visual and cultural assault. I left in love with the people in that room, intelligent, committed, talented

people, willing to stick out the dialogue, the lack of which has dismantled much of our public life. I left with my heart holding their desire to be fair-minded and just in the face of their own needs, their ability to listen and to hold their position on the most difficult topics facing us today, far deeper than terrorist threat. I left with images of their willingness to stick out the process, to continue to exert their own shape on our collective interaction, to stay.

Like the Iñupiat, artists dance with art through our embrace of processes, even civic ones. For an artist, art is commitment. For a certain kind of artist, like those in Animating Democracy projects, that commitment is linked inextricably to social justice and public good, and gives us a fortitude that delivers us through the pains and doubts of public life. For these artists, their art is rarely completely controllable, often unpredictable. But when it works, it is beautiful. It feels important. One struggles with finding and holding its shape within a messy "life" process. Something real has taken place, and it is not always safe, not always understandable in its entirety. It's an imperfect art, this working in public, and its aesthetic hallmarks, when we learn to see them clearly, will be based on vulnerability and transparency and complexity. We will, in Harwood's words, "be emotional, we will cry, walk out. That is what democracy is all about." I don't know about democracy, but I do know about the passion to make something, and how that passion stands strong in the face of all kinds of pain in order to give shape. If that urge to make finds its way into public life, so much the better.

Suzanne Lacy is an artist, writer, and educator of international reputation, whose work includes large scale performances on urban themes. She is a theorist of public art and a pioneer in community development through art. Lacy's best known work to date is "The Crystal Quilt," created for the IDS Building, a Phillip Johnson-designed landmark in Minneapolis, with 430 older women performers. The project was aired live on PBS. Her work "Full Circle," honoring women's accomplishments, featured 100 boulder/monuments which were placed overnight on the streets of Chicago's Loop. This three month public event was nationally covered by The Associated Press and *The Wall Street Journal.* In Oakland, CA, her work with inner-city teenagers has been documented by CNN and in a one hour documentary by NBC. Lacy has exhibited at Museums of Contemporary Art in London, San Francisco, New York, and Los Angeles, among others, and has published over 60 articles and a book, *Mapping the Terrain: New Genre Public Art,* that serves as a seminal textbook on public art. She has been reviewed in major magazines, books, and newspapers, including the *Los Angeles Times*, the *New York Times*, and *Art in America*. She is the recipient of fellowships from the Guggenheim Foundation, the National Endowment for the Arts, Lila Wallace Reader's Digest, and Arts International and has consulted for the Ford Foundation.

Seeking centers from the margins, artists are defining a Bill of Rights for cultural citizenship consisting of dignity, respect, history, sufficiency, identity, and freedom from visual and cultural assault.

4

Institutional Practice

Success Factors

WHAT DOES IT TAKE for cultural organizations to do arts-based civic dialogue work effectively? What is needed to strengthen their role within a community, and their capacity to advance civic dialogue goals? A careful examination of the full range of organizations participating in Animating Democracy identified a core set of values, qualities, and characteristics that commonly made efforts successful. Cultivating these attributes within an institution can lay the foundation for success as a leader or partner in arts-based civic dialogue work.

Success Factors

The cultural organization sees arts-based civic dialogue as central to the mission, vision, and values of the organization. There is integrity of purpose based in an authentic desire to make a difference in relation to civic concerns and issues. The organization, including board and staff, sees a clear relationship between its mission, and the value, and intent in doing arts-based civic dialogue work.

Executive and artistic leaders are supportive and involved, and help to ensure an integrative approach to the work across the institution. The most effective projects are the ones in which artistic and/or managing directors are connected and committed to the work. Although this alone does not guarantee success, engaged executive leaders offer a critical boost to the project, helping to position it as a priority endeavor and not a temporary detour. Executive leaders who believe in arts-based civic dialogue work help others in the institution to internalize it, which in turn increases the potential to sustain it over time.

The cultural organization has the program vision, expertise, and commitment to plan and implement effective arts-based civic engagement work. There is clarity of artistic and civic intent, and a philosophy that guides the work. In working with artists, dialogue professionals, and community partners, program staff and other organizational leaders embrace the tensions inherent in fostering meaningful civic engagement and maintaining the integrity of the creative work, determining the best way to facilitate excellent art *and* meaningful dialogue. Often this translates to an organizational willingness to take a risk and stretch beyond usual practice.

The cultural organization is both proactive and responsive to the needs of the community and to shifting conditions and circumstances. Cultural organizations most effective in civic work have intimate knowledge of the communities affected by their efforts, either because of a pre-existing commitment to the community or the willingness to invest necessary time to get to know the community. This knowledge enables the organization to assess needs and opportunities, and to know how and when to act. The organization and its leaders recognize, respect, and foster self-determination in disenfranchised communities that are involved in a project.

Audience enjoying performance of Wild Card, *Dell'Arte, 2002. Photo © Carol Eckstein.*

The cultural organization is able to work effectively in partnership with other organizations. It is able to identify and work with a wide range of partners toward authentic mutual benefit and is sensitive to issues of authority, ownership, power, and cultural specificity.

The cultural organization commits the management resources necessary to effectively carry out the work. The organization has an internal champion on staff who is able to galvanize the institution and the community interactions in ways that help realize the project's full potential. In the most successful arts-based civic dialogue efforts, the leadership invests in dedicated staff to manage project complexities, makes financial resources available, and allocates the time required to plan and carry out projects.

The cultural organization thinks and acts as a learning organization. There is a culture of critical thinking about the work. Inquiry and learning are organizational values that motivate a continuous process of expanding, deepening, and honing the theoretical underpinnings, and the practice, of the work. Documentation and evaluation are valued as ways to understand and improve the work. The organization learns from challenges and failures, has the ability to rethink and adjust as the process evolves, and is open to change. Dialogue is viewed as an institutional way of working that helps to support organizational advancement as well as the arts-based civic dialogue project itself.

The cultural organization plans for sustainability of the work. The cultural organization considers follow-up activities that it, or its project partners, might implement in order to responsibly sustain attention to the civic issue addressed. Within the organization, there is a consciousness to develop leadership and skill so that a broad base of staff becomes skilled in developing and coordinating arts-based civic dialogue and engagement work.

Organizational Grounding

CULTURAL ORGANIZATIONS may find that arts-based civic dialogue projects give them the opportunity to link their creative work to civic interests. Organizations whose core missions embrace community-based work already have the foundation to undertake arts-based civic dialogue. In Animating Democracy, organizations such as SPARC, the Esperanza Center, Cornerstone Theater Company, Junebug Productions, and Liz Lerman Dance Exchange already had buy-in at board and staff levels, community relationships to call on, staff experienced in working authentically within the community, and the confidence—and experience—to know if, when, and how their own intervention in regard to an issue might have greatest benefit.

Organizations newer to the work of civic engagement may find themselves simultaneously establishing this foundation while trying to design and implement projects. Organizations like the American Composers Orchestra (ACO), Henry Art Gallery, Wintergreen Performing Arts, Inc. (WPAI), and Perseverance Theatre gained impetus for an arts-based civic dialogue project from an individual—a curator, programmer, managing director, or artistic director. These organizations had to educate their boards and staff members about how the civic focus fit with the other work of the arts institution.

Expertise in audience development or education programming does not necessarily translate automatically to civic engagement and dialogue. Organizations must commit to a planning process, and devote adequate staff time and energy in order to build a strong community base for the project. The American Composers Orchestra, for example, saw potential for *Coming to America,* an already programmed series of concerts featuring the work of immigrant composers, to spur dialogue about immigrant issues. But, they soon learned that the composers were not all equally on board with the project's civic dialogue components, and that ACO's strong educational framework would not suffice to meet the civic dialogue intent of the project. A deeper understanding of the issue and participants' interests, as well as more developed partnerships with community organizations, would have established a stronger conceptual basis for the project.

But even organizations experienced in community-based cultural work faced institutional challenges. Companies such as Urban Bush Women and Liz Lerman Dance Exchange sought to build skills for this work among staff and artists, and not just rely on the abilities of artistic or managing leadership. When there was turnover in artistic or administrative players, organizations were sometimes left with gaps in knowledge and skill that had to be reconstituted. (This was also an issue for mainstream cultural organizations.) Sometimes, such groups were challenged to rethink their usual approaches to community work in order to meet the project's civic goals. Junebug Productions, for example, realized that, to sustain activist work over the long-term in communities to which its *Color Line Project* toured, it needed activist, rather than cultural, organizations in those communities to serve as lead organizers. This realization, in turn, forced Junebug to regroup in considering how to plan projects.

While organizations whose core missions embrace community-based work may encounter fewer institutional obstacles in mounting arts-based civic dialogue projects, many groups newer to the work achieve great successes despite a sharp learning curve. In fact, some will make strong steps toward institutionalizing arts-based civic engagement work in their organizations.

Expertise in audience development or education programming does not necessarily translate automatically to civic engagement and dialogue. Organizations must commit to a planning process, and devote adequate staff time and energy in order to build a strong community base for the project.

SHIFTING EXTERNAL AND INTERNAL PERCEPTIONS

Many cultural organizations are active participants in civic life. For example, state humanities councils are well situated in the civic sphere based on their history of linking the humanities to public policy, and arts organizations rooted in a specific community are already acknowledged as civic participants. To a wide range of stakeholders in Intermedia Arts' Minneapolis neighborhood, the organization's years of community cultural development work suggested natural connections between art, culture, and civic life. Similarly, the Lower East Side Tenement Museum's mission to convey the history of its neighborhood put it in continual contact with neighborhood associations and preservation efforts, making it a well-suited partner to St. Augustine's Church for *The Slave Galleries Restoration Project.*

Cultural organizations newly entering the civic arena often challenge existing perceptions of their roles and raise new expectations with audiences, the public,

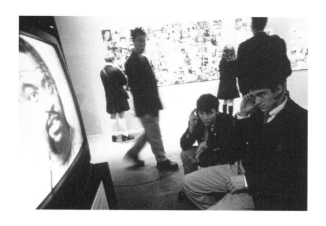

Students watching video
from Video Booth testimonies,
Without Sanctuary *exhibition,*
The Andy Warhol Museum, 2002.
Photo © Lyn Johnson.

civic leaders, partners, the media, and stakeholders. For the broader community to view artists and cultural institutions as serious convenors of civic forums, those institutions may have to overcome fundamental perceptions that they are strictly arts purveyors. In some projects, community stakeholders worried that an arts organization would not have the knowledge to play a leadership role in a dialogue effort, or that they might romanticize or simplify the issue. Conversely, some worried that art or the arts organization might push a particular point of view, as was the case with Out North's initial leadership role in its project about same-sex couples. Some community members had general impressions of the arts as elite, which led them to believe that arts organizations would be less effective in engaging the broadest range of people. Jeff Herrmann of Perseverance Theatre described one civic leader's skepticism about the *Moby Dick* project:

> I remember speaking to a young Republican legislative staffer from Fairbanks, who saw the tour's kick-off performance in Juneau. After the performance, he told me, "When I first realized that you were twisting what I thought was going to be a straight-up adaptation of *Moby Dick* into a forum on subsistence, I got really angry…'Who the hell are they to weigh in on this issue?'…but as the play drew me in more I started saying to myself 'Why not them?'" I heard many similar comments from individuals at both the performances and the dialogue activities.

Even for museums, which in recent years have made strides to strengthen the relationship with their communities, long-entrenched perceptions and attitudes proved especially challenging. Museum studies scholar Selma Holo pointed out that the public perception of the role of the museum as "arbiter of meaning" has been challenged by new assertions of "museum as forum for civic dialogue," in which ambiguity is acceptable, and even valued. In relation to the three museum projects involved in Animating Democracy, she wrote:

> Museums are traditionally considered [by the public] to be places that clarify issues and positions with respect to culture. From curatorial positions advanced through the shows to unsigned didactic labels, from authoritative catalogues to expensive buildings and projects, we have paved the way to be considered as such in the public's mind. So that, when we decide to transform our museums (especially museums that are not identified as primarily contemporary art museums) into morally ambiguous sites, we find that not everyone feels comfortable with this shift…This latter role encourages members of the public to think as individuals and as communities about the complex dimensions of sensitive issues.[1]

[1] Selma Holo, "Conducting Civic Dialogue: A Challenging Role for Museums," (Washington, DC: Americans for the Arts, 2002), www.AmericansForTheArts.org/ AnimatingDemocracy

Although The Warhol Museum did much to build a strong relationship with the African-American community in order to mount the *Without Sanctuary* exhibition, education curator

Jessica Gogan believes that the pre-existing perception of The Warhol as an alternative art museum with a strong community interest helped to prepare audiences. She reported:

> Even prior to *The Without Sanctuary Project*...the museum had already telegraphed itself to the wider local community as being a forum and a risk-taker both due to its programming and its vocal and provocative director, never shy to take a public stance on an issue...for most community participants this was rationale enough for The Warhol to take on such a non-traditional show for an art museum. Indeed, once the project opened the question "why at The Warhol" was hardly ever raised by most community participants or visitors other than academics, museum, and culture professionals. The museum used and touted its civic role and position and it did so boldly. We were proud of being the catalyst and place for such important discussion, however controversial it may be...If we felt this project was within our mission there was no reason to withdraw to a less daring position because of the highly sensitive nature of its content. Critically, however, we knew that our unapologetic bravado was fully supported by advisory committee members and diverse community organizations. The impact of this on our confidence to carry out the project, being able to respect the opinion of those who disagreed but firmly advocate our position without apology, cannot be overestimated. Significantly this confidence was also broadcast to all those working on the project. Here, being collectively clear-voiced about the rationale for the project, for all involved from advisory committee members to museum frontline staff was extremely important for an endeavor so large-scale and potentially controversial.

As the Perseverance Theatre skeptic's comment suggests, it often took the actual experience of the art and participation in dialogue to dispel reservations about the potential for arts organizations to create effective civic forums. After viewing The Jewish Museum's *Mirroring Evil* exhibition, many visitors' attitudes about the museum's role and responsibility in mounting this show (shaped largely by media controversy before seeing it) changed. *See "A Case in Point: The Jewish Museum's* Mirroring Evil" *in this section for additional discussion.* Successful projects, in fact, led community leaders and agencies to invite cultural organizations to help make sense of other local and national issues. The Warhol Museum was asked by both Amnesty International and the Pittsburgh Opera to collaborate on separate efforts to explore the death penalty in conjunction with Amnesty's national conference and the opera's production of *Dead Man Walking*, respectively.

On the flip side, organizations that are successful in creating civic forums sometimes have concerns about retaining their primary artistic identity. Flint Youth Theatre (FYT) mounted two well-received civic dialogue initiatives that had strong local funding, but FYT's artistic director and some board and company members want to ensure that FYT not become pigeonholed as a social issue theater by funders or community leaders. They prefer instead to make choices, as they have done in the past, based first and foremost in artistic interests and/or timely issues.

Arts and cultural institutions need to assess and often realign internal philosophies, norms, staffing, and operating practices to support effective arts-based civic dialogue work. Arts-based civic dialogue work that has meaningful civic effects is not business as usual. It may be difficult to shift out of usual ways of working. The seasonal momentum of some producing and presenting organizations, for instance, makes it difficult to deviate from set schedules and respond to shifts in a civic engagement project. Institutions not driven by a community-based mission sometimes find it hard to break outside of conventional program models in education, outreach, or audience development, or to surmount expectations geared to product over process. Being seen in a different public eye, these organizations may take on a new burden of responsibility in terms of partner relations and civic expectations. Many organizations like American Composers Orchestra learned, through the challenges of their Animating Democracy projects, to see themselves in relation to others' goals and interests, not just in terms of their own organizational or programmatic interests, and they refined approaches to future projects with this heightened understanding.

Arts-based civic dialogue work that has meaningful civic effects is not business as usual.

Orchestras and arts-based civic dialogue: A special challenge

Michael Geller, managing director of the American Composers Orchestra (ACO), reflected on the orchestra world in general as he made sense of ACO's experience with its *Coming to America* project: "Often with conservative boards and moneyed patrons, it would be fair to say that orchestras may well be the most risk-averse arts organizations in existence. As a tool for change, civic dialogue then makes for a somewhat uneasy fit in the orchestra world." Based on ACO's experience, Geller identified challenges he expects other orchestras might confront in implementing a civic dialogue project:

- The concepts and practices of arts-based civic dialogue require fairly extensive education for artistic and administrative leadership. It is a difficult concept to grasp upon first introduction.
- Conductors, boards, and/or administrative personnel may view civic dialogue efforts simply as a community relations endeavor of little true artistic merit.
- The challenge presented by a nonrepresentational art form can make conceptual program development problematic; conversely, concert musicians and composers have a general distrust of overly-representational elements in music.
- The needs, skills, and knowledge required to plan and implement a program are not generally found among orchestras' artistic and administrative staffs; the project may not easily mesh with existing administrative departments and functions.
- Because civic dialogue goals require different sorts of partnerships, orchestras may find it challenging to identify community partners and work with them in this new way. Working with community partners in arts-based civic dialogue projects can be challenging for orchestras; each organization may have differing needs or expectations in adapting approaches to partnerships that will meet the goal of civic dialogue
- Orchestras may be reluctant to commit the extensive resources required to adequately plan and carry out the project.

In fact, Wintergreen Performing Arts, which was also supported by Animating Democracy, faced some of these obstacles. But despite the difficulties, *Coming to America* confirmed for Geller that civic engagement efforts can make orchestras more vital and relevant for their audiences and communities.

> Still, most enlightened orchestra artistic and administrative professionals, and even boards, recognize that the world is a changing place, and that in some ways orchestras can, should and must change, too…The experience of [American Composer's Orchestra] through the *Coming to America* project is that civic dialogue, when properly conceptualized and implemented, can be one of the most powerful and successful mechanisms by which to advance and confirm the relevancy of this music to people's lives today. Civic dialogue achieves this by being both incredibly personal and universal, by being both inward looking toward the art and artist, and outward looking toward the audience and the world around them.

The Brooklyn Philharmonic Orchestra's (BPO) *Klinghoffer Dialogue Project* benefited from Ted Wiprud's leadership. Wiprud had moved on to the Philharmonic after coordinating American Composers Orchestra's *Coming to America* dialogues, and took with him lessons from that experience. BPO observed current dialogue in Brooklyn about Arab-Israeli relations, developed a program in partnership with Arab and Jewish dialogue groups in order to bring the art into these dialogues, and worked with dialogue facilitators to connect the discussions to the music and libretto in specific ways. These successes suggested to the philharmonic's CEO Catherine Cahill that the organization should continue on this path. "Following a strategic planning process completed in 2001, the board, administration, and musicians set a course to reinvent how an orchestra lives within its home city…The board first learned about civic dialogue with the *Klinghoffer Dialogue Project*, but their response was positive and united in that this is what the orchestra should be doing more of in the future. At their direction, we are already planning to expand our work and we are all very excited with the possible subject matters that could be explored." BPO is considering how its programming might focus on a single issue over multiple years in order to provide opportunities to engage different people and to achieve depth in the dialogue over time.

While challenged by size, structure, and other factors, larger institutions such as American Composers Orchestra and Brooklyn Philharmonic Orchestra proved they could deepen their commitment to authentic civic roles and effectively carry out arts-based civic engagement and dialogue. They moved deliberately and with integrity to plan and implement programs that would challenge segments of their communities. Significant internal board and staff planning, reliance upon community advisory committees in developing and implementing the projects, and consultation with colleagues resulted in authentic community relationships and responsible dialogue efforts that illuminated the issues.

One orchestra in Animating Democracy decided not to shift program practices or redefine its core mission. Ultimately, despite artistic success and some good inroads made within the local schools through its *Preserving the Rural Soundscape* project, Wintergreen

Performing Arts, Inc. (WPAI), a music presenter in rural Virginia, chose not to further pursue civic concerns. Some board members remained unconvinced of a civic role for WPAI and disinclined toward a dialogue orientation in future projects.

At the beginning of the project, we saw the "dialogue" aspect as being less organic and more structured. We had planned to conduct formal dialogues after some informal relationship building and teaching the basics of mosaic art…But a major insight after the project was completed is that the entire project was a dialogue. The whole art-making process itself was, by necessity, a process of community engaged in constant dialogue together as it expressed itself through the mosaic images.

—Mary Keefe, Hope Community, Minneapolis

"…civic dialogue, when properly conceptualized and implemented, can be one of the most powerful and successful mechanisms by which to advance and confirm the relevancy of this music to people's lives today. Civic dialogue achieves this by being both incredibly personal and universal, by being both inward looking toward the art and artist, and outward looking toward the audience and the world around them."

Almost every arts organization that creates a civic forum relies significantly on partners and/or community advisory groups representing a range of civic, social, religious, and educational interests. These partners and advisors provide necessary understanding of the civic issue as well as links to stakeholders. They also help to design projects in which the art will have the most generative opportunities to advance civic dialogue. In Urban Bush Women's (UBW) *Hair Parties Project* in Brooklyn, 4W Circle of Art & Enterprise, a cooperative incubator for small businesses, played an important role. 4W Circle helped UBW organize Hair Parties in a wide range of settings, from hair parlors to neighborhood development coalition meetings, making contacts and vouching for the company, effectively building trust and new relationships for UBW. Selma Jackson, one of 4W Circle's leaders, saw that the *Hair Parties Project* also helped to validate her organization's efforts in the community, "opening many doors for my business that I may have opened but it would have taken longer."

Intermedia Arts' *People Places Connections* program addressed the impact of the development of a new transit corridor on more than 16 neighborhoods in Minneapolis, many including immigrants, students, artists, and others with lower incomes. Community partnerships with organizations located in, and regularly serving, these diverse neighborhoods were the key to engaging community members not used to taking part in public dialogue about safety, accessibility, and housing. Partners included an arts-focused charter school serving Latino students; the YWCA; a nonprofit coalition that facilitates community involvement in developing and improving the Midtown Greenway; and Hope Community, a community-building organization located in one of the city's poorest neighborhoods, with a thriving campus where families live in attractive, affordable rental housing. The project's five artists worked with these partners for a year. Hope Community welcomed mosaic muralist Marilyn Lindstrom, and found that the project's creative process paralleled Hope's own "Community Listening" projects, in which people of all ages and cultures talk in small groups about issues such as gentrification. Hope Community offered an entry point and a support system for the artist to work deeply over time with an important

part of the community. And while Hope Community had long believed in the community-building power of the arts, this project enabled them to create a deeper engagement with artists and develop new learning about the relationship of art and dialogue.

Faith-based institutions were central partners in a number of Animating Democracy projects. In Cornerstone Theater Company's *Faith-Based Theater Cycle,* they became sites for Festivals of Faith and Weekly Wednesday dialogues. They linked Cornerstone artists to members of the faith communities for story circles that gathered insights in script development. The National Jewish Center for Learning and Leadership (CLAL) was a critical partner for The Jewish Museum's *Mirroring Evil* exhibition and programs. A think tank, leadership-training institute, and resource center, CLAL has earned a reputation for provocative programming that embodies the principles of pluralism. The Jewish Museum met with CLAL regularly to discuss issues pertinent to the exhibition and saw this engagement as particularly important and helpful in framing approaches to engaging both Jewish and non-Jewish communities. In addition, CLAL organized three dialogue programs for Jewish community leaders and philanthropists, rabbis and religious leaders from other faiths, and the public. These efforts challenged CLAL to structure such forums in new ways, by engaging participants in discussion of particular pieces of art, as well as the controversy around them, and by mediating between the museum and various segments of the Jewish community.

Some cultural organizations linked up with college and university presenters to serve as local partners to national projects (*Color Line Project*). Some built upon civic programs instigated by colleges (Arts Council of Lima's *Common Threads Project)*, and others engaged scholars in dialogue programs (New WORLD Theater, The Esperanza Peace and Justice Center). Organizations experienced in working with youth, such as Facing History and Ourselves, assisted The Warhol and The Jewish Museum in developing dialogue-based programs in conjunction with their exhibitions.

Tory Peterson of the Perpich Center for Arts Education, a partner with Children's Theatre Company on the Land Bridge Project, *engages with students in Montevideo, MN, 2002–2003.*

Collaborating organizations experience the challenges as well as the rewards of partnership. Questions emerge: Who owns the project? How should power relations and political dynamics within the community be acknowledged and addressed? Who will maintain the relationships and activities developed through the project into the future? The following section explores the roles and activities of organizational partners in arts-based civic dialogue work.

Collaborations between artists/cultural organizations and dialogue practitioners are discussed in the "Civic Implications" section.

Who owns the project? How should power relations and political dynamics within the community be acknowledged and addressed? Who will maintain the relationships and activities developed through the project into the future?

Cultural organizations collaborating with civic and community organizations may encounter challenges regarding project ownership, decision-making power and authority, and distribution and control of resources. Negotiating the needs, interests, and priorities of artists, cultural institutions, and community partners can be one of the most challenging aspects of civically engaged cultural work. Lead cultural organizations have to work hard to sufficiently engage key partners in early planning and project design stages; not to do so can leave partners feeling disempowered and frustrated by things that could have been better dealt with had they been more involved. In some projects, artists, dialogue professionals and community partners felt that resources were not allocated equitably among all key partners; this might have been better dealt with when grants were being written and in early planning. Philosophical or practice-based differences were sometimes at the heart of challenging collaborations. According to David O'Fallon, who was director of the Perpich Center for Arts Education (PCAE) when it partnered with Children's Theatre Company (CTC) on the *Land Bridge Project*, the two organizations:

> …had to learn to work together and that was not always easy. Personnel changed in each agency. CTC, from my view, seemed in the beginning to be more focused on performing a play rather than discovering the story in Montevideo through careful listening. PCAE as a state agency had its own barriers and issues, and housed people with special expertise in bringing young people into the theater practice of discovering their own voice. I think that over time these two different cultures did work well together. How much each changed is open to debate.

Partnering organizations that deal with difficulties, rather than smoothing over them, are often the most effective and lasting. The right to claim ownership of the civic issue was a fundamental concern in multiple Animating Democracy projects. In the early phase of collaboration between The Andy Warhol Museum and the YWCA Center for Race Relations, the YWCA's African-American dialogue staff questioned the museum's right, as a primarily white institution, to mount the *Without Sanctuary* exhibition and lead a civic dialogue about race. In the end, The Warhol and the YWCA gained each other's trust and saw their partnership solidify to their mutual benefit because The Warhol staff acknowledged their position, reached out for help, listened, and grew. Both point to the one-to-one relationship among staff members of the two organizations, and their focused

energy on real action steps, as key to a successful collaboration for *The Without Sanctuary Project*. In other projects, too, the deepest and most productive relationships frequently occurred at the level of program staff, who worked hard together over many months or even years on projects. The visible effects of their individual relationship building and program development efforts often made executive leaders more attuned to the benefits of investing in such partnerships.

See also "Understanding Civic Context" in the "Civic Implications" section.

St. Augustine's Episcopal Church, Lower East Side, New York City. The Slave Galleries Restoration Project.

Arts-based civic dialogue partnerships raised questions about where project leadership resides, who sets goals and establishes priorities, and who has control of resources. St. Augustine's Episcopal Church approached the Lower East Side Tenement Museum as a partner in restoring and interpreting the church's slave galleries, based on their working relationship in the neighborhood and the Lower East Side Tenement Museum's expertise in historic preservation. The church, lacking the infrastructure and separate nonprofit status to seek grants, further recognized that the museum could secure funds from a variety of sources and manage grants that were not available to St. Augustine's. This included Animating Democracy, with its specific interest in linking arts and humanities to civic dialogue. The museum applied for and received the Animating Democracy grant.

The church had a great deal at stake. It wanted to restore the slave galleries as an important historic landmark for African Americans, and to extend the galleries' educational value to all cultures on the Lower East Side of Manhattan. An existing church-based slave galleries committee was ever vigilant of the congregation's concerns, including keeping the physical restoration of the space the highest priority. As a supporting partner to the church, the Tenement Museum was keenly aware of the issues of ownership, power, and control, and was diligent in lending its coordination capacity to the dialogue project while still keeping St. Augustine's in a leadership role. Museum staff intimately involved church leaders in defining how the dialogue component would be designed, and how the project would link the slave galleries space and history to current issues.

Still, tension occurred because the dialogue effort was the focus of the project. Animating Democracy granted the funds to the cultural institution—the Lower East Side Tenement Museum—even though the project originated with St. Augustine's, and this sometimes caused friction regarding how funds were allocated within the project, and even the order in which partners' names appeared on materials. (Ultimately, Animating Democracy revised materials to read "a project of St. Augustine's Church in collaboration with the Lower East Side Tenement Museum.") Although St. Augustine's believed deeply in the site's potency as a setting and catalyst for dialogue about issues of marginalization on the Lower East Side, church leaders felt that too much time and money was being invested in the dialogue effort. The partners had carefully negotiated allocations of grant funds to ensure support for church leaders' time and related costs; nonetheless, the fact that the museum held the purse strings was at times a source of frustration for the church. Both museum and church leaders agreed that the partnership might have worked better if St.

Augustine's had received the grant directly and contracted the Tenement Museum to perform specific services. This said, the Tenement Museum and St. Augustine's Church respected each other and cultivated an open, honest, and productive relationship that addressed these concerns as they occurred, and ultimately advanced restoration, interpretation, and community dialogue goals.

Community advisory, steering, and coordinating committees that share ownership can more effectively extend the reach of projects to various stakeholders and constituencies. The steering committee formed for Flint Youth Theatre's project on school violence was essential to the project's goal of coalescing fragmented efforts in dealing with youth violence among educators, human service providers, civic leaders, and youth organizations. Lima, OH's, *Common Threads Project* created "circles" of community members who were instrumental in getting buy-in from rural farmers, suburban residents, city and county officials, and African Americans—all of whom were considered key constituents. The leadership structure was a series of three concentric circles: in the middle, a core team of 11 people steering and implementing the project; the next circle included 20 Sector Leaders, opinion leaders in various sectors of the county who functioned as advisors. In the most outer circle were the community residents who were tapped by the various Sector Leaders to be interviewed by Sojourn Theatre Company members or to participate in dialogue activities.

As with the Lima and Flint efforts, projects benefit most from advisory groups when they give them meaningful opportunity for input, and sometimes action. The Warhol Museum created an advisory committee that engaged a large number of African-American community leaders. The committee helped vet any issues that arose; for example, the degree to which this project about the lynching history of African Americans in this country should be used to call attention to injustices to other groups. They also shaped the exhibition. Community advisors advocated for elements that would affirm the accomplishments and acts of resistance of African Americans at historic moments parallel to the lynchings portrayed in the exhibition. This resulted in an extensive time line that filled one gallery wall and served as a crucial counterpoint to the victim focus of the lynching images.

As partners and community advisory groups become more deeply engaged in planning and implementation, they often assume significant ownership of a project, taking seriously responsibilities and decisions. Sometimes this has unforeseen consequences. The *Understanding Neighbors* project achieved this level of investment with its coordinating committee; but, as a result, the cultural organization, Out North Contemporary Art House, felt its role was diminished. Out North's managing and artistic directors, Jay Brause and Gene Dugan, a gay couple well known in Alaska for their political activism around gay rights issues, had recognized at the beginning that public perception of Out North might limit participation in the project. Much effort went into establishing a neutral, credible organizational foundation for the *Understanding Neighbors* project that would encourage people with divergent views to participate in dialogue about the role of same sex couples in society. Two partners, the Anchorage Interfaith Council and Alaska Common Ground,

As partners and community advisory groups become more deeply engaged in planning and implementation, they often assume significant ownership of a project, taking seriously responsibilities and decisions.

were invited to share responsibility for governance and implementation of the project. The volunteer coordinating committee comprised an equal number of members of each partner organization to oversee the design and implementation of the project. To further separate the project's identity from Out North, the committee hired a project administrator, and rented a separate project office space in Anchorage.

While all involved supported the creation of the coordinating committee—and although the committee's work resulted in a strong arts-based civic dialogue program—the dynamics among committee members, Out North leaders, and the hired project staff were often difficult. Tensions were sometimes rooted in the typical challenges of communication, sometimes in personalities and work styles, and sometimes they arose from substantive concerns such as how the artists' video works would support the dialogues.

See also "Artistic Point of View and Neutrality" in the "Artistic Practice" section.

In their report on the project, organizers reflected:

> This structure was a major change in business practices for Out North. It entailed much ambiguity and required an enormous effort by the coordinating committee and the Out North senior staff in building and sustaining an effective working relationship. In retrospect, coordinating committee members are of different opinions about the wisdom of these organization choices. For some, it was a necessary struggle to establish a new, independent, and credible foundation, while for others, the project would have been better served by an advisory committee with more conventional project leadership by Out North.

...even when frameworks are created with the greatest care, partnerships can be fraught with complexity, and challenges are amplified with hot-button issues.

Despite the overall effectiveness of the coordinating committee's work, Out North and the rest of the committee diverged in their assessment of community impact, and their satisfaction in how the project played out. The committee wanted to take a next step to advance specific dialogue efforts related to same sex couples, believing that this had been a productive first step. But Out North was dissatisfied that more conservatives had not participated in the dialogue, and that artists did not have enough of a direct role in shaping the project. In addition, Out North had doubts about what structure would support a next phase, and whether it wanted to continue working as part of the coordinating committee. The *Understanding Neighbors* experience suggests that even when frameworks are created with the greatest care, partnerships can be fraught with complexity, and challenges are amplified with hot-button issues.

Arts-based civic dialogue projects can cement partnerships between cultural organizations and civic, community, and dialogue organizations. Both Cornerstone Theater Company and Urban Bush Women invited dialogue practitioners onto their boards following their projects. Interestingly, three projects focusing on neighborhood development issues have built lasting and significant partnerships. Intermedia Arts and Hope Community see each other as long-term friends and collaborators who share

deep and common values in regard to their shared neighborhood. Through the Esperanza Center's efforts to save La Gloria, a historically significant building for the Mexicano/Chicano community, the Esperanza formed a bond with the predominantly white and middle-class Office of Historic Preservation. Honest conversations grew into shared understanding of the need for racial justice in the work of historic preservation, and the director of the historic preservation office is now actively working with the Esperanza and other Chicano organizations to stop the demolition of other historic buildings. Urban Bush Women has also formed a lasting bond with its *Hair Parties Project* partner, 4W Circle of Art & Enterprise, as well as other community groups.

Even partners who experienced tensions reaped rewards when the players persevered in working through issues and applying their newfound knowledge to new opportunity. Steve Zeitlin, director of City Lore, said, "With such an experimental program [as *The Poetry Dialogues*], it is not surprising to learn that, in the realization, the needs and partnerships differed from the way they were envisioned in the proposal. Urban Word turned out to be a crucial link to the teenage community…once the *Poetry Dialogues* were under way, we recognized that we might have established an even closer relationship with Urban Word." For the next iteration of *The Poetry Dialogues*, City Lore and Urban Word have forged an equitable relationship, one that engaged Urban Word from the start in conceiving, planning, and budgeting for the endeavor. New projects will call fully upon Urban Word's experience with youth pedagogy and community organizing.

A DIALOGIC WAY OF WORKING

Giving staff, board, and volunteers their own in-house opportunity to participate in arts-based civic dialogue fosters critical understanding of the civic issue and how art and dialogue relate in the public's experience of the project. Many organizations find that it is critical to give staff and board members a chance to experience firsthand what the public's arts-based civic dialogue experience might be. The facilitator working with Dell'Arte on *The Dentalium Project* engaged the entire staff in their own dialogue about issues related to the new casino in this small rural town. As company members tested the dialogue structure and process, many heard each other's views about the casino for the first time. Urban Bush Women (UBW) held a Hair Party exclusively for board members so the board, including several new members, would understand this core piece of their work and could better help envision its potential for community building in Brooklyn, NY, UBW's new home base. Several groups that did not provide this kind of direct experience for staff or board acknowledged in retrospect that it would have helped considerably to make real the abstract idea of arts-based civic dialogue.

Organizations can adopt dialogue concepts and practices not only in planning and implementing arts-based civic dialogue projects, but also as an overall way of working. Many organizations adopt a more dialogic way of working, both in planning and implementing their projects and in general. They become more purposeful about

the intent of an exchange and more open to different views, avoiding judgment, listening intently, and aiming for equality. Particularly for organizations newer to this work, drawing staff and board members into dialogue with one another is crucial to building understanding and buy-in, framing the project's goals, and designing a viable project. Said one organization leader, "We need internal dialogue that begins early so that you get everyone's issues on the table and can begin working together and not making any assumptions about doing good work and having everyone behind you."

In the process of designing educational and public programming for the *Mirroring Evil* exhibition, The Jewish Museum went to great lengths to engage staff at all levels of the institution, from board members to executive and department directors to docents, guards, and gift shop staff. Because the artwork featured in the exhibition was by younger artists, curators wanted to capture the responses of a younger generation, born in the 1970s and 1980s. They organized a meeting with the museum's junior staff, all under age 32, who reflected a diverse range of religious and nonreligious orientation: observant Jews, nonobservant Jews, grandchildren of Holocaust survivors, Germans, African Americans and others. Associate Curator Joanna Lindenbaum reported, "Contrary to what we had expected, many members of this younger group were very disturbed by the works and the subject matter. A heated discussion developed about whether or not it was appropriate for the artists to single out specific consumer brands [in their art works] and about whether the group's Jewish participants should respond differently from non-Jewish participants to the issues at hand."

Museum curators noted that many concrete suggestions made during internal dialogues such as these, as well as in dialogues with outside advisors and constituents, were incorporated into the exhibition's design. Staff noted that "the project evolved and transformed, changing and improving time and again," as a result of their dialogic process. Internal dialogue also served in developing the exhibition and its interpretive materials effectively, and in forming a cohesive team that was broadly representative of the institution. The degree of internal communication and consensus enabled the institution to speak as one voice at the height of the controversy surrounding *Mirroring Evil*.

Arts-based civic dialogue efforts can foster and strengthen cross-departmental ways of working, especially in larger mainstream cultural institutions. Perhaps as a result of a dialogic approach to planning, organizations such as The Warhol and The Jewish Museum, which traditionally work in more compartmentalized ways, worked in a more integrated fashion. The Jewish Museum was determined to forge a new model of how a museum could work with such challenging artwork and to fully integrate public programming within the curatorial plan. While there were occasional clashes, The Jewish Museum developed an interdepartmental model that was predicated on mutual respect and a commitment to internal dialogue. Museum staff reported:

> Responsibilities and functions within the institution shifted during the course of the *Mirroring Evil* project. Each and every department of the museum participated in the

planning or implementation…Throughout the planning stages, the curatorial team worked much more closely with the education, public programming, and public relations departments of the museum than for past exhibitions.

Museum Director Joan Rosenbaum was frequently involved, and played an important role in supporting the curatorial vision to trustees and others in the community.

In some cases, a dialogic way of working advances organizational development. For Urban Bush Women, the *Hair Parties Project* took place during a time of organizational revitalization and rebirth. The company's work with dialogue consultants Tammy Bormann and David Campt, and its embrace of dialogue as a learning process and tool for meaning making, played a role in this transformation. Bormann and Campt facilitated a session that explored the culture of Urban Bush Women, focusing on the company's core values and helping the company move forward in a process that empowered leadership and codified their work. According to Artistic Director Jawole Zollar, dialogue enabled the company to include feelings and experiences as well as facts, and, as described by managing director Amy Cassello, "[It] made all of us more conscious of and responsible for word choices, for not making assumptions, for seeking clarity and making a commitment to building better communication networks, both internally and externally."

Nora Chipaumire, a dancer with Urban Bush Women, speaking with David Campt, dialogue advisor, 2003. Photo by Tony Caldwell.

Across Animating Democracy projects, the more opportunity for in-house dialogue, the more committed the organization became to weathering the rough spots, changing course as needed, and making the best use of organizational resources to make an effective project.

Artists have an opportunity to break outside of standard production, performance, or artist–educator modes to engage with audiences and community members about the meaning and civic dimensions of their work. In the orchestra community, musicians typically "show up and play." However, several musicians who were part of the American Composers Orchestra and the New Jersey Symphony Orchestra (NJSO) projects were interested in playing a role—not just sitting in their chairs while dialogues took place around them. NJSO trained interested musicians to facilitate youth dialogues on the theme of American identity related to a program featuring Dvořák's *New World Symphony*. Collaborations with dialogue practitioners offered training opportunities for artists involved in projects by Cornerstone Theater Company, Urban Bush Women, and The Andy Warhol Museum, giving them new skills and a deeper understanding of the

dialogic qualities of existing practice. Artist-educators were central to The Warhol's dialogue activities both within the museum and outside, in community-based activities held well after the *Without Sanctuary* exhibition closed. Artist educator Krista Connerly reflected:

> *The Without Sanctuary Project* was an intense experience, both challenging and rewarding. It was really satisfying to participate in the dialogues, particularly ones which involved the communication between diverse groups of people…More than once we found participants engrossed in conversation with someone they didn't know (and possibly would have never talked to) prior to the dialogue. Probably, what was most satisfying about this project was the way it was carried outside of the Museum. Dialogues continued way past the given dialogue space and I think *The Without Sanctuary Project* provoked a lot of people to rethink the way they address issues of race and tolerance that manifest themselves in everyday life. This is understandable. *The Without Sanctuary Project* completely saturated my life. The power of the images provoked an intense process of questioning. I began to look at things differently and approach things different. I approached my teaching outside of The Warhol from a much different angle and found myself thinking and talking to my students a lot about media literacy and how representation affects us.

Involving artists at some level in the dialogue, or as dialogue facilitators, keeps the artist and the art central in the dialogue. At the same time, it can develop the artist's awareness of civic goals and offer participants direct insight into artistic intent and an enhanced aesthetic understanding of the work.

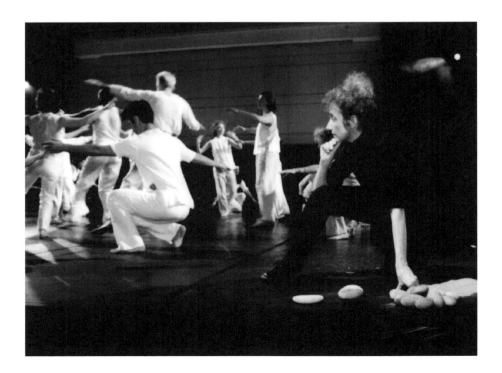

Liz Lerman in "Hallelujah: Stones Will Float, Leaves Will Sink, Paths Will Cross" presented by the Skirball Cultural Center, February 2001. Photo by SheShooters Photography.

Community-based arts groups can ensure the transfer of artistic vision and practice in the organization by deconstructing and codifying practice, and training company artists in dialogic practices. Groups such as Urban Bush Women, Cornerstone Theater Company, SPARC, the Esperanza Center, and Liz Lerman Dance Exchange used their arts-based civic dialogue projects to explore the theoretical underpinnings of their civically engaged art approaches. They compared and contrasted arts-based dialogue work with their other community practices. The purpose of this focused examination was twofold: to transfer knowledge so that leadership could expand beyond veteran artistic directors, and to extend practice to the field. Over a two-year period, Dance Exchange facilitated an internal company dialogue called a "dialogue audit." The company took a focused and structured look at the dialogic within its own creative practice. Dance Exchange's Humanities Director John Borstel wrote that the audit:

> …deepened our ability to interpret, analyze, and explain our work to our own fields, including the dance field, the community arts field, and the presenting/performing world. But more importantly, it has helped us to sit at the other tables with more force and presence because we are secure in a key point of reference that transcends dance or even art. So we have new ways of illuminating our own work when we talk to scientists, historians, politicians, or university administrators…Because the dialogue audit involved analysis by the staff and company at an unprecedented level, it increased everyone's ability to have these conversations—not just Liz. At a point when we are really focusing on "decentralizing the genius" and cultivating multiple artistic voices, the influence of the audit has been very timely.

Involving artists at some level in the dialogue, or as dialogue facilitators, keeps the artist and the art central in the dialogue.

WORKING WITH THE NEWS MEDIA

The media can play a role in engaging a larger community with the issues addressed by projects, and raising the level of awareness of cultural organizations as civic participants. This was certainly true for The Andy Warhol Museum's *Without Sanctuary* exhibition. Many people in the Pittsburgh region talked about the exhibition and the ideas and issues it raised—based on frequent feature coverage, radio talk shows, numerous critical reviews, editorials, and letters to the editor. But cultural organizations were often challenged in framing the coverage of their projects. Projects were, for the most part, covered as arts and entertainment rather than in the context of news or civic concerns. One Animating Democracy participant exhorted, "If we're going to be about civic dialogue then we really have to get off the arts pages and into other areas."

True partnerships with the media to advance civic dialogue through the arts depend on pre-existing relationships and mutual benefit. Although the media are atypical partners in exploring civic issues, one Animating Democracy project demonstrated a highly effective collaboration that supported the civic and artistic goals of the project. In Lima, OH, newspaper, radio, and TV were active players in promoting the *Common Threads Project*. Building on an organizing team member's long relationship with the local media, the Arts

Council of Greater Lima targeted *The Lima News* as a formal partner. The objective was to generate substantive, ongoing print coverage that would increase awareness and encourage participation in the full range of theater residency activities—interviews, script readings, barnstorming previews, dialogues, the culminating performances, and a conference. Not only did the *Lima News* publish 37 feature, editorial, and news articles over 14 months, it also published monologues from Sojourn Theatre's script and kept a photographic record of the project. The project leaders were not surprised that the paper would be supportive, but they were surprised at the depth of the paper's coverage, since the *News* is generally regarded as politically conservative. The partnership succeeded, in part, because *Common Threads Project* organizers were deliberate in making it mutually beneficial. The editor of the *Lima News* was asked to be an advisor to the project. With an inside view and an opportunity to support a long-term project, the paper was able to experiment in "civic journalism," a movement that fosters a more nuanced and humanized reporting and analysis of issues. *Lima News* employees received dialogue facilitation training from the *Common Threads Project* in order to gain skills to be more effective as "civic journalists" in their interviewing and reporting.

Television and radio were also involved. Clear Channel Radio Lima and Fox TV Lima (also generally regarded as conservative) collaborated to produce and air PSAs using excerpts from monologues on the subjects of race and class, farming, and political leadership. Each monologue opened and closed with a description of the *Common Threads Project* and aired to coincide with the publication dates of the *Lima News* print stories. The results of this coordinated strategic effort paid off considerably. Media coverage built momentum and excitement in the community. It increased and diversified audiences for various events and extended awareness about the project to Allen County residents who did not attend barnstorming events, dialogue activities, or performances.

With an inside view and an opportunity to support a long-term project, the paper was able to experiment in "civic journalism," a movement that fosters a more nuanced and humanized reporting and analysis of issues.

If the news media misrepresent, sensationalize, or fuel controversy about the work, cultural organizations will face the challenge of maintaining the intended focus on the art and the issues it explores. Cultural organizations and their community partners in Animating Democracy were keenly conscious that the issues they were addressing often evoked emotional responses and sought to meet this reaction head on so that press coverage would not detract from a fair interpretation of the art and/or the intended civic focus. Leaders in the *Understanding Neighbors* project anticipated the potential for the media to inflame emotional responses to the issues of same-sex couples that were at the heart of the project. Project organizers worked with the media from the outset to encourage balanced reporting. They made strategic efforts to ensure that the spectrum of viewpoints would appear together in the media, arranging, for example, an interview between individuals holding conservative and progressive viewpoints. Project leaders also encouraged use of the editorial section of the newspaper as a forum for reflective expressions of the range of views. What could have been an inflammatory issue in the media was not. The Jewish Museum, on the other hand, could not have anticipated the intense media barrage that occurred in relation to the *Mirroring Evil* exhibition, catalyzed by one sensational statement in an article released months before the exhibition even opened. The media

discourse became a huge dimension of the project, and the museum was challenged to keep the project focused on its originally stated civic dialogue goal.

A case in point: The Jewish Museum's *Mirroring Evil*

The Jewish Museum was unprepared for the timing and intensity of media focus that its *Mirroring Evil* exhibition drew, but with thoughtful organizational planning, it was able to navigate the controversy.

Three months before the exhibition opened, a *Wall Street Journal* reporter ran an inflammatory article, based only on seeing the exhibition catalogue (which was completed but not yet circulating), suggesting that *Mirroring Evil* could become the next art world "sensation" (referring to an exhibition at the Brooklyn Art Museum that had caused a huge media and art world stir). Several challenging artworks were cited, without appropriate context, raising the question about whether The Jewish Museum had gone too far in showing these works, which many in its own community might find offensive. This single article sparked hundreds of stories in print publications and on radio and TV throughout the U.S. and internationally.

The media frenzy effectively subverted the museum's original intent to stimulate through art thinking and dialogue about complicity and complacency toward evil. The focus shifted, instead, to challenging the appropriateness of showing work that some, including many of the museum's own members, felt "glorified" the perpetrators of the Holocaust. The controversy itself became the subject of coverage for many media that ordinarily do not cover art exhibitions. The National Jewish Center for Learning and Leadership (CLAL), a key partner for *Mirroring Evil,* reflected:

Giftgas Giftset, Tom Sachs, 1998, in the exhibition Mirroring Evil: Nazi Imagery/Recent Art, *The Jewish Museum, 2002. Photo courtesy of the artist.*

> We knew from the beginning that the questions the art in *Mirroring Evil* posed about "ownership" over the Holocaust, the power of media to narrate, distort, and persuade, and the processes of identification with perpetrators or victims could make for explosive reactions...The question, with each constituency, was how best to balance "framing" the conversation...so that it would remain focused while, at the same time, leaving room for open, participatory conversation...By the time the exhibition opened, this balancing act between framing and openness had been further complicated by the controversy that played out in the press, which sparked interest in the exhibition but, in a sense, threatened to overshadow the art itself and to pre-set the terms of the discussions.

The Jewish Museum's staff and its public relations consultant made every effort to moderate the tone of these broadcasts and articles, to strongly and clearly communicate

the institution's goals of presenting the exhibition and public programs, to protect the museum's image, and to supply journalists with material that would make the museum's messages about *Mirroring Evil* a part of the news stories. They reported:

> The museum's public relations campaign became a strategic effort to gain the support, or at least the tolerance, of those people who did not instantly make up their minds about *Mirroring Evil*. The museum knew, in advance, that some members of the public would be set against the exhibition from the moment they heard about the "transgressive" artworks in the show. Others could be counted on to endorse *Mirroring Evil* sight unseen, in the name of free speech. Given the art world's recent history, the museum also predicted that some people would cynically dismiss the exhibition precisely because it aroused controversy, as if the museum sought not to provoke meaningful debate and the exchange of the serious and important ideas raised by the art, or plain and simple, just to provoke.

The museum and its partners had to work harder to redirect focus to the original curatorial and civic dialogue goals. CLAL reported, "For each program, we tried to build in time for setting out some central questions (not necessarily those deemed most interesting in the press coverage); contemplating the art; pooling participants' reactions; and facilitating discussion and debate in small groups."

The museum believes its public relations efforts in response to the controversy were a qualified success. Its messages were consistently and widely disseminated; open-minded audiences got the contextual information they needed to judge *Mirroring Evil* for themselves; the museum ensured that objections to the exhibition were answered appropriately *and* in public outlets; the curatorial integrity of the museum and the value of its commitment to contemporary art were upheld; and the museum demonstrated (for open-minded audiences) that it is attentive to the feelings of Holocaust survivors and their families.

Finally, because the extensive media discourse on *Mirroring Evil* became part of its legacy, it is likely that the issues raised by the exhibition will be probed and discussed for years to come.

Sustaining Civic Initiative

No matter their size, organizations face the challenge of building capacity to sustain arts-based civic dialogue work. "Sustainability" echoes as a concern among cultural organizations on two levels; first, whether, and how, to sustain focus and generate public dialogue on a civic issue after a project concludes (discussed in the section "Civic Implications"); and second, how to build or sustain the organization's capacity to continue arts-based civic dialogue work.

Whether Animating Democracy groups wanted to integrate civic engagement into all their cultural work, or to embrace occasional project opportunities, it was commonly understood that "capacity" involved a commitment of board, staff, and financial resources, and the time and energy required to do the work effectively. Because The Jewish and The Warhol Museums, for example, involved board members and multiple levels of staff and worked across conventional department boundaries, their Animating Democracy projects prepared them to seize opportunities to integrate civic dialogue into subsequent exhibitions with the full support of their institutions.

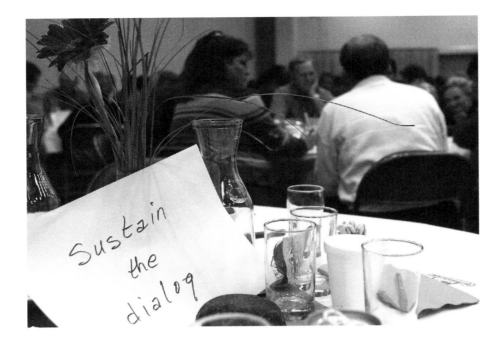

An action group formed to sustain the dialogue, stimulated by the Arts Council of Greater Lima's Common Threads *conference, 2002. Photo © The Lima News.*

RESOURCE ALLOCATION

The funding to support arts-based civic dialogue projects in the short-term, and as an ongoing activity, is a concern for all sizes and types of organizations. For larger institutions, resource challenges are sometimes magnified by the organization's scale and also, perhaps, by systems and structures that might be less flexible than those of smaller organizations. Large institutions are likely to weigh civic goals against primary artistic interests when it comes time to allocate tight resources for their projects. So, for example, although the Brooklyn Philharmonic's success with *The Death of Klinghoffer* acquainted the institution's board and staff with the value of arts-based civic dialogue work, it remains to be seen how far the board will go in shifting resources, or raising money to support future efforts.

There are issues regarding economies of scale, as well. The San Francisco Opera (SFO) candidly admitted its conundrum—that effective civic dialogue typically means orienting activities toward smaller numbers of people. Yet, the processes used to identify participants, build community partnerships, work with dialogue facilitators, and work cross-departmentally within the organization are highly labor-intensive. SFO could not reconcile what it takes to do such programming with the small numbers served. Severe financial stresses at SFO that occurred before its Animating Democracy project got seriously under way forced the opera to withdraw before completing its project. With staff jobs at risk, SFO's arts-based civic dialogue project was not a priority.

These experiences underscore many of the same institutional issues that Michael Geller of American Composers Orchestra identified in committing resources to arts and civic engagement projects.

Some small arts organizations, such as the Northern Lakes Center for the Arts, believe that their size is an advantage, giving them the flexibility to change course during a project, to "do a great deal with a little budget," and to explore new arts-based civic dialogue opportunities with a degree of freedom. But most small organizations are challenged, just like their larger peers, in finding and maintaining the human and financial resources to meet the demands of this work. Even after decades of creating civically engaged art, the Los Angeles Poverty Department (LAPD) relies largely on founding director John Malpede for both artistic and operational management. Junebug Productions, while benefiting from both an artistic and managing director, is challenged by the ambitious national scope of efforts like the *Color Line Project*. Even organizations like SPARC and the Esperanza, whose ongoing cultural work is focused in the local community, must continually seek outside funds.

Martie MacDonell, the primary volunteer leader on Lima's *Common Threads Project* (and the previous director of Lima's arts council), stated: "From my experience I have learned that...arts organizations with long-standing community development missions are the best organizations to do arts-based civic dialogue, but the paradox is...[they] seldom have the financial resources and the human capital to fully pursue this work." The arts council helped spawn a successful first *Common Threads* conference that had broad civic intent, and then took on an even larger role with a second phase of *Common Threads* that brought art into a more central role. Although the Council for the Arts now has greater access to more sectors of the community, it is struggling to find the resources needed to pursue basic arts programs, let alone to administer the *Common Threads Project*. According to executive director Bart Mills: "...[the *Common Threads Project*] grew in scope well past our ability as an organization to manage it." MacDonell and others are exploring an alliance with the United Way to take on the effort, and trying to figure out how to maintain an affiliation with the arts council while not depending on it for human or financial resources. The arts council's marginal financial situation and the reluctance of its current leadership to move in the direction of arts-based civic dialogue make the whole enterprise questionable.

STAFFING

Organizations engaged in arts-based civic dialogue efforts need a designated staff member with the authority to oversee the project and navigate board, artistic, and managerial imperatives. Some cultural organizations already had staff positions for community engagement, or created them in order to ensure expertise in building and maintaining partnerships and in other key responsibilities of arts-based civic dialogue work. In other cases, staff roles were redefined to include arts-based civic dialogue, such as the education curator's role at The Warhol Museum and the education coordinator role at both American Composers Orchestra and Brooklyn Philharmonic Orchestra. At Liz Lerman Dance Exchange, two staff positions ensure focus on this work: Producing Director Jane Hirshberg oversees and coordinates (with company members) what happens in community-based residencies, and Humanities Director John

Borstel leads the companywide analysis and internalization of civically engaged practice. Following its *Land Bridge Project*, Children's Theatre Company (CTC) brought on playwright Rebecca Brown to help define a more central place for community-based work within CTC. Urban Bush Women shifted the responsibilities of its office manager to include oversight of all of its community-based work in Brooklyn so that the *Hair Parties Project* and other efforts could find the anchor they needed. The scope of Cornerstone Theater Company's *Faith-Based Theater Cycle* demanded a designated staff person to serve as community engagement coordinator. Over the five-plus years of the project, this staff person reached a new level in relationships with the Los Angeles community, both in terms of depth and breadth.

Where leadership for arts-based civic dialogue work is centralized in such staff members, there is greater focus and more sustained effort. In addition, the people in these roles deepen their own skills and can transmit them to others. Another benefit is the continual building of community information, relations, and understanding that creates a foundation for sustained work in the community. Some caution, though, that when work gets focused in a designated staff position, it can become ghettoized, decreasing the involvement of others in the organization. Especially when an arts-based civic dialogue effort is funded by grants, and has a clear beginning and end, other staff members may view it as a discrete project rather than an endeavor integral to the organization's work; they may think that the institution can finish and then move on. For this reason, designated staff coordinators emphasize how important it is to keep the whole organization involved.

In a few cases, an organization never found the person with the right mix of skills and sensibilities to seize the project's potential and make it happen most effectively. Even in larger institutions with large staffs, projects often had insufficient staffing or leadership. The work was sometimes an add-on, coordinated by capable development or other administrative staff members who "got" the civic purpose of the project, but could not sustain programmatic vision, energy, or authority for the work. For some projects, coordination was contracted out. Even when the contractor was highly effective, this arrangement diminished the potential for developing staff skills and knowledge and for connecting the community directly with organization's leaders. The benefits of hiring temporary staff with expertise or cultural knowledge needed for the project can be great, but often such staff positions can't be sustained once the project is completed or grant funds run out.

Staff turnover can add to the challenge of sustaining commitment and maintaining continuity of vision and skills over the course of arts-based civic dialogue projects, which generally have extended time frames. Many organizations realized well into their projects the detrimental effects that staff changes could have—a loss of momentum, protracted time frames because of the need to bring new players up to speed, or loss of credibility with artists or partners. Henry Art Gallery's *Gene(sis)* exhibition evolved over three years of planning and implementation. During that time—and

To sustain this work takes a commitment running through several key people, so organizations must plan, as best they can, to establish the requisite vision and skills throughout the organization.

before the public dialogue elements were really planned—two key figures in the project, both of whom were especially inspired by the civic dialogue potential of the exhibition, left the institution. Responsibility shifted to art and education curators and a temporary staff person, with the development director providing some oversight. While the resulting public programming was far-reaching and highly educational, the investigation of civic dialogue never quite matched the vision of those who originally conceived it.

Turnover in artists skilled in arts-based civic dialogue work is a major issue for producing companies. Like most dance companies, Urban Bush Women (UBW) finds it hard to retain dancers since it cannot afford to pay company members for full-time work, yet their busy touring schedule makes it difficult for them to take on additional jobs. After the company made a substantial investment in training dancers, several of them moved on. Although they continue to work with the company on a project-by-project basis, and although the remaining dancers have taken the lead in training new dancers in UBW's dialogue approach, the challenges of turnover will likely continue to be a factor.

Cultural organizations have learned that they need to take into account potential changes in personnel in their own organizations, as well as in partner organizations. To sustain this work takes a commitment running through several key people, so organizations must plan, as best they can, to establish the requisite vision and skills throughout the organization.

ACCOUNTABILITY WITHIN AND WITHOUT

Ultimately, sustainability requires assessing whether, when, and how to remain committed and accountable to a community, and to the civic goals underlying the work. David O'Fallon, former director of the Perpich Center for Arts Education (PCAE), reflected on the interrelated issues in the *Land Bridge Project*, and the delicate balance of organizational, civic, and artistic concerns:

> …The play and the discussion did give public form and color to what had perhaps been felt within a single heart or in a single home or family before. Immediately following the show the voices spoke with purpose and passion. But the story gave rise to the question—now what?…My greatest concern is for the voices in Montevideo—the men and women, young and old, who told their story and/or saw their story played out in front of many others. My observation is that they discovered a power in their voice and rejoiced in that (in a modest, Minnesota way, of course); that they saw a larger picture somewhat more clearly; that they enjoyed and valued the forums for dialogue that were refreshed or created (from a coffee shop to a rehearsal). I feel myself and believe that PCAE and CTC have a responsibility to help with the next step; to take this rebirth of voice and story into public discussion and action. Not to determine the action, of course, but to be clearer about how it might be done. This could be as simple as including other agencies in the on-going partnership (e.g., The Land Stewardship Project with over 1,000 sites

and members). And yet to keep the work of the artist, the mind and heart of the artist, as the basis for the work.

Children's Theatre Company is not alone. Many others, even those who are experienced in this work, still find themselves in a balancing act, honoring the creative impulse, organizational priorities, and civic responsibility while trying to sustain their civically engaged cultural work. In her reflections on Cornerstone Theater Company's experience with the *Faith-Based Theater Cycle*, Caron Atlas highlights questions that cultural organizations mature in their art and civic engagement work may come to face. As the work becomes more intentional and structured, she wonders, "Might this increased structure challenge intuition and encourage safety? When might structure inhibit creative foresight? Can Cornerstone [and other arts organizations like them] ensure that this process does not inhibit the leaps of faith that are at the creative heart of their work by building risk-taking and experimentation into their methodologies?"

It's the Art, Stupid!

AN ESSAY BY MICHAEL MARSICANO

This essay is based on a keynote address given by the author at Creative Connections, Grantmakers in the Arts' 2002 conference. It appeared in the Grantmakers in the Arts Reader, *winter 2003.*

WE LEARNED AN IMPORTANT LESSON through *Angels in America*. It was not an easy one. Before *Angels* came to Charlotte, our community rested on its laurels of tolerance and its track record of diversity. For decades we perceived ourselves as an inclusive community. Charlotte, where Protestant churches helped raise money to build our first Catholic church, where whites escorted blacks to sit with them at segregated lunch counters. Charlotte, where women have broken glass ceilings in locally headquartered Fortune 500 companies, where newcomers are embraced with open arms and expanded places at the table. Our wakeup call took the form of a play by Tony Kushner.

The content of the play would serve to expose a growing evangelical movement that threatened the community of Charlotte. An ultraconservative Republican majority on the County Commission responded to the play with unimaginable intolerance of homosexuality, unprecedented cuts in public art support, and unthinkable attempts at censorship.

Suddenly our citizens were no longer just an audience for *Angels in America*; we were living the play. *Angels* sparked conversation in pulpits and at dinner tables; talks about sexual orientation, censorship and basic rights. Everyone in Charlotte was talking *Angels in America*.

And then a most extraordinary civic process unfolded. Cultural advocates, bolstered by the content of the play, became a political force. They were joined by Catholic, Methodist, Baptist, Lutheran, Episcopal, Presbyterian and Jewish houses of worship united in opposition to the intolerance. In turn, these religious communities were joined by our colleagues at colleges and universities. Our institutions of higher education were joined by major industries and corporations, and all of these individuals and institutions were joined by a galvanized gay community, heretofore largely unorganized. Evidence of these comings together was everywhere to see. The emerging institutional ties were of course the most obvious, but the growing bonds between individuals did not go unnoticed.

I remember opening the newspaper one morning to a poignant story about a gay employee at Bank of America. He had decided to leave Charlotte in face of the controversy. Hugh McCall, Chairman of the Bank, contacted him with a personal appeal to stay, and a promise for change. Stay he did, and change was orchestrated.

In my life I have never witnessed so powerful a local community-building process. Its expressions were very concrete. Hundreds of thousands of new dollars were raised for the arts. Giving to our United Arts Fund increased so dramatically that the campaign became—and still remains—the highest per-capita nationwide. Influential Democrats and Republicans united to raise tens of thousands of dollars, directed toward the election of tolerant politicians. They were successful, and a newly elected County Commission restored public arts dollars with significantly increased allocations.

> *Angels sparked conversation in pulpits and at dinner tables; talks about sexual orientation, censorship and basic rights. Everyone in Charlotte was talking Angels in America.*

To this day, that community-building process continues. Three local election cycles later, tolerance and public art support remain litmus tests for public service. Local major employers now offer same-sex benefits in growing numbers, and just last month our newspaper agreed to print same-sex union announcements in the social column. When intolerance rears its ugly head, we in Charlotte look at each other and remind ourselves of *Angels in America*.

Bob Putnam, in his book *Bowling Alone* calls on the arts to help stem the tide of declining social capital in the United States. Putnam points to the power of artistic and cultural content to allow for public celebration and exploration of community. He notes that an especially moving, shocking, insightful or original work might compel us to discuss social, spiritual, or political issues with friends and family members. Herein lies the community-building power of the arts.

Richard Florida recognized that power in his much-talked-about book, *The Rise of the Creative Class*. While Florida disagrees with Putnam on several fronts, the two agree on the community-building power of the arts. Florida maintains that communities of

the future will be built by a creative class of citizens anchored by individual artists. He describes a society in which the creative ethos is increasingly dominant and effective.

Now this notion, that artistic content builds community, is neither original nor new, but it may be both overlooked and underrated by grantmakers, policy makers, and administrators.

Artistic content has been a critical strategy for fostering connections among citizens and institutions in Charlotte. Children's Theater of Charlotte, for example, commissioned playwright Ed Shockley to create a new play entitled *Stranger on the Bus*. The play's audiences relived school desegregation from decades ago in Charlotte. For a generation of parents and students far removed from that time, the work was a gift of common ground for contemporary school integration discussions.

Artistic content has been a critical strategy for fostering connections among citizens and institutions in Charlotte.

When I was directing the Arts and Science Council, we stumbled over an artistic product that served to build community when we thought we were just funding an arts education program. Now you need to know, right or wrong, good or bad, I was the king of leveraging art support by piggybacking on issues perceived to be more pressing. At that time it was around literacy in the public schools.

In concert with all of our major cultural institutions, we created a massive literacy initiative built around the book *The Wizard of Oz*. An age-appropriate version of the beloved novel was bought and distributed to every third grader in our public school system. Simultaneously, all the teachers in the third-grade classes taught their students to read *The Wizard of Oz*. The arts then brought the words to life.

Each student was bussed downtown to our Main Street. When the students' feet touched the pavement, they found themselves on a yellow brick road painted across the sidewalks, connecting all of our major cultural institutions.

The first stop on the road was Spirit Square Center for the Arts, where young readers saw a full-scale production of the musical *Wizard of Oz*. Afterwards they found themselves back on the yellow brick road taking a trip over to Discovery Place, where "The Science of Oz" exhibition transformed the elements of Oz—from rainbow to hot air balloon—into a science lesson. At one point each child walked past a blue screen placing him or her visually in the film skipping down that yellow brick road with Judy Garland and her merry men.

The opera company turned Oz into a cultural diversity lesson, comparing and contrasting the Judy Garland musical version to the later Michael Jackson version of *The Wiz*, and our African-American Children's Theater staged a full production of *The Wiz*. The North Carolina Dance Theater worked with the children to create their own Dance of the Scarecrows.

Meanwhile, over at Charlotte Repertory Theater, students were writing sequels about questions, like when Oz left in the hot air balloon, where did he go? Or imagine the flying

monkeys coming back and painting the Emerald City blue. What happened next? Even the Performing Arts Center got in on the act, bringing a group of artists who used the witches of East, West, and North to teach a geography lesson.

This project was absolutely magical and stunning in scope and scale. We believe literacy was legitimately advanced.

But for all that energy, creativity, and educational ingenuity, one cultural institution took us to a higher community-building plane. The Light Factory, Charlotte's premiere photography center, commissioned a number of professional artists to photograph Charlotte in search of its heart, like the Tin Man; Charlotte in search of knowledge, like the Scarecrow; and Charlotte in search of its courage, like the Lion. These moving and powerful images of Charlotteans in pursuit of these three virtues stimulated conversation throughout the community, well beyond the target audience of third graders. Everyone was talking *Wizard of Oz*. We talked about what we value as a community; where we're going.

The Oz Project taught me the power of local cultural institutions coming together. In *Bowling Alone*, Putnam makes the observation that such collaboration among arts organizations, where the bridging of constituencies takes place, has enormous implications for building community. He suggests that private and government agencies devote a greater share of their budgets to financing arts projects and productions that are broadly participatory and civically oriented.

Only one other time have I seen our local cultural institutions come together at such a massive a scale so that pride in community leaped forward. It was the day Bank of America opened its 60-story headquarters facility right across the street from this hotel. Collectively we convinced the bank that this was our moment, not theirs, and the opportunity for the arts community was great.

A collaborative arts performance was staged on and in front of the new facility. It was performed twice and attracted 10 percent of our total population to the square, elbow-to-elbow.

The extravaganza began with original music composed for the Charlotte Symphony, which performed at the base of the tower. The momentum built with a massive choir of choral groups and church choirs from throughout the city. A choreographer got hold of our State Military Paratroopers and turned them into dancers. They cascaded down the face of the full-story towers, twirling along the way to the music playing below, as I cringed over insurance costs.

Our professional dance companies placed their dancers on the rooftop edges of adjacent buildings and balconies, spectacularly lit from back and front, and yards and yards of colorful fabric were tossed from balconies up and down the bank tower. These streams of

fabric had great symbolism for our community. You see, the reason Charlotte is home to America's first- and fourth-largest banks is because of fabric.

Years ago, cotton, while harvested in the South, was not processed in the South. It was shipped to Northern textile mills equipped with the necessary electrical power to turn cotton into fabric. When electricity finally reached the South, it became more economical to build Southern textile mills than to ship the cotton north. There was only one problem: the South was without money to build the mills.

This financial need fast-tracked a banking system in Charlotte that would grow beyond anyone's wildest imaginations. Today our city of 700,000 is the second-largest financial center in the United States, with more assets than Chicago, San Francisco, or Los Angeles, all because of fabric. Artists were visibly making the connection for all of us to see, as massive streams of color were repeatedly thrown out of the bank building, rolled up, and thrown out again.

And then photographs six stories high were projected on the face of the tower. Professional artists were commissioned to photograph the places and the people of Charlotte, which and who contributed not only to the building of a banking empire, but to the building of the community the bank calls home. Certainly the day served to celebrate the community we had created.

In spite of these far-reaching celebrations in Charlotte, I find it is often difficult to engage cultural institutions in the community-building experiences. Frequently we find that individual artists are better equipped for the task. *Animating Democracy*, an excellent report by Americans for the Arts on the subject of arts-based civic dialogue, speaks to this issue. The report asserts that artists, often working independently of institutions, have pioneered and advanced art-based civic dialogue work. Unfortunately, within the field's existing infrastructure there are few systems and limited resources for these efforts.

Individual artists often have the flexibility to focus on a particular issue or on a particular segment of the community. *Animating Democracy* suggests the choice of such a focus often emerges from concerns in the community; a galvanizing incident, or personal experiences of the artist. Individual artists have translated these themes and stories into works of regional or national significance, or conversely, have looked at the local implications of national issues.

Perhaps we are witnessing an emerging artistic genre that comes to us by way of "citizen artists." Certainly, many of our best visual artists working in the public art arena could be best described as civic or citizen artists, although citizens artists can be found in any discipline. Two examples come to mind.

Liz Lerman, whom many of you know, is showing us how one artist can serve to build community through dance. Her work at New Hampshire's Portsmouth shipyard is an

These moving and powerful images of Charlotteans in pursuit of these three virtues stimulated conversation throughout the community, well beyond the target audience of third graders.

excellent example. Liz scoured the decks and people at the shipyards for stories about local citizens who built and served on shipping vessels. These life stories were turned into vignettes and performed on the shipyard grounds.

This past summer, just to our south in Union, South Carolina, artists Richard Geer, Jules Corriere, and Kevin Iega collaborated in the creation of a production entitled *Turn the Wash Pots Down*. The cast and crew of 100 local citizens presented theatrical renditions of memories and legends of life in a small mill town. The very purpose of the work was to build community among folks in a declining county with high unemployment.

These projects are powerful because the artist becomes a catalyst, helping people build and participate in community life, articulate their aspirations and grievances, and make art from the material of their daily lives.

When we fund community-building arts projects where artists examine provocative content, we fall short of our goals if we don't consider funding subsequent and accompanying programs. Arts administrators Pam Korza, Andrea Assaf, and Barbara Schaffer Bacon note that the arts can humanize civic issues, bringing forward the human implications. Often this is an emotional journey, and it can be difficult to switch from the intense emotion of the artistic experience to the rational response expected in civic discourse.

Animating Democracy points out that an artwork or activity may not always provide a literal path to that discourse. Interpretations, educational activities, and cumulative programming are avenues that may help people to make the transition from the arts experience to the discussion.

When we fund community-building arts projects where artists examine provocative content, we fall short of our goals if we don't consider funding subsequent and accompanying programs.

Citizen participation is at the core of this work. In my experience funding sources often look with disfavor on civic orchestras, amateur choirs, and the like. Have we forgotten how important it is for us to go see our friends, relatives, and business associates on stage in our local community theater? Have we forgotten how much that experience draws us together? When all of us watch the film or saw the Broadway production *The Full Monty*, didn't we get it? Didn't we see the power of amateur guys bringing together an entire town with their courage to literally expose themselves on stage? As grantmakers in the arts, let's not stick our heads in the sand when it comes to amateur participation in arts.

In another kind of example, a neighborhood in Charlotte recently raised money from households to cast a contemporary statue of a beloved man who lived among them. Hugh McManaway was mentally retarded. He would frequently wander the neighborhood, showing up at one household after another, whenever it suited him. Sometimes appearing in living-room windows, frequently at parties whether invited or not—folks just expected him to show up for dinner from time to time. This sweet man was welcomed with open arms wherever he went and whenever he showed up. Much of Hugh's time was spent directing traffic at the neighborhood intersection. He did so with a favorite towel that he

would wave at the cars, instructing them to stop or go, to move right or left, without any regard to the traffic signals. Most households were connected to one another through Hugh and his antics.

After Hugh passed away the neighbors got together. They raised several thousands of dollars and they asked an artist to create a statue of Hugh directing traffic, with towel in hand. The work of art now stands at the very intersection he enjoyed so much. And this artwork stands as a symbol of community in the middle of the most affluent neighborhood in Charlotte.

On a grander scale, Charlotteans have recently pooled their resources to honor one of their most influential community builders. Rolfe Neill published the *Charlotte Observer* for over 20 years. Most everyone in Charlotte looked forward to his Sunday morning column. Sometimes he made us angry; other times he brought us to tears. Always he stretched us. You could count on Monday morning debates over coffee breaks. He connected us in dialogue about important community concerns. Rolfe is a community-building artist of the pen.

When he retired, we were at a loss. Our citizens channeled that emotion into an artistic enterprise. Folks emptied their pockets to the tune of $400,000. Artist Larry Kirkland was commissioned to create a public artwork in honor of Rolfe. Larry is truly a citizen artist who interviewed residents and read Rolfe's writings to get to know the man.

Larry discovered that Rolfe served as a beacon to our community. A two-story high stack of gigantic books engraved with the titles of Rolfe's writings will be constructed, and on top of the books will be a gold pencil, only the tip of which touches the stack. The pencil appears to be held by the sky. On the ground, several key excerpts of his most influential writings will be engraved on large-scale books scattered on the site. A gigantic keyboard will be constructed for seating. A massive pad of paper will be built as an outdoor stage. Three large ink stamps will be engraved, the first with the words "See the truth," the second "Hear the truth," and the third "Speak the truth." Rolfe taught us to live by all three. The third stamp will be positioned for people to walk up into it like a pulpit, and themselves speak the truth as Rolfe always does.

Kirkland's artwork will be built in front of a $30,000,000 cultural center currently under construction that combines a new children's library with a theater complex for our professional children's theatre company. The entire process has been about building and preservation of community through content.

When I lift up your consideration of these citizen artists and community-focused projects, I have said that individual artists may be particularly adept at this work, but I have not given up on our major cultural institutions. Unfortunately, institutions frequently approach the subject with false notions that community building is somehow at odds with artistic excellence.

Perhaps those of us who promote community building through the arts are in part to blame. When community building is only framed by the big three goals—revitalization, education, and social solutions—cultural institutions often lose interest. By framing the discussion in terms of challenging artistic content and excellence we open rather than close doors.

The current exhibition of Romare Bearden's work at our Mint Museum of Art is a perfect example of community building and artistic excellence, hand-in-glove.

Romare Bearden was an African-American artist born in Charlotte. The Mint convinced Bank of America to donate six important Bearden works to the Museum. The announcement was paired with the opening of the show, our major corporate donor enabling our community to permanently own artworks of our native son at *our* museum of art.

Then the Mint uncovered all the private holdings of Bearden's work in Charlotte and asked their owners to place their works in the exhibition. When you tour the exhibit you are struck by how many Charlotteans own works by this important artist. The Mint has brought together many individuals from diverse backgrounds who share a common appreciation of artistic excellence. On one wall hangs a Bearden owned by Harvey Gantt, architect, first black mayor, two-time Democratic nominee for the Senate, born on one side of the tracks in the South. On another wall hangs a Bearden owned by Hugh McCall, philanthropist, businessman, builder of America's largest bank, born in the South on the other side of the tracks.

But the Mint went deeper, organizing prominent Charlotteans, though not necessarily wealthy benefactors, to comment on the artist, the work, the subject matter, and the exhibition. The quotes run like a ribbon in large letters across the top of the gallery walls. And to add icing on the cake, and coming back to my theme of relevant content, several of Bearden's artworks explore Southern themes that speak to the citizens of Charlotte. Wow! Who says artistic excellence and community building can't come together at major cultural institutions?

Every so often I take my three boys—seven, nine and fourteen—to the Mint Museum of Art for only 30 minutes. I want them to enjoy it but not get bored, and 30 minutes also protects the museum. When I took them to see the exhibition of Romare Bearden I announced it was time to leave after 30 minutes. You can imagine my shock and delight when they asked to stay longer.

I began my remarks by telling you that I stumbled on artistic content as the key to community building after years of promoting everything else. Don't make my mistake. Look deep into the content of the art you find for the strongest and surest means of lifting community. Perhaps my remarks will prevent others from having to look in the mirror and saying to themselves, "It's the art, stupid."

Michael Marsicano is president and CEO of the Foundation for the Carolinas based in Charlotte, North Carolina that serves thirteen counties in both North and South Carolina. Marsicano was previously at the Arts and Science Council in Charlotte, North Carolina, where he served as president and CEO for 10 years.

Copyright 2003, Grantmakers in the Arts

5 Special Opportunities

History as Catalyst
for Civic Dialogue

HISTORIAN DAVID THELEN OBSERVES that people employ the past in ways "as natural as eating and breathing in order to understand why things are the way they are today...Everything that matters—personal identity, religious values, civic practices—can be better engaged in everyday life when individuals understand where they came from and why they had developed as they did."[1]

When history is viewed as active relationships among people and as a series of choices that continually effect change, history itself seems inherently dialogic. When received truths are continually challenged, and when alternative truths emerge through a dynamic telling and retelling of the past from diverse perspectives, history can be a kind of dialogue. Historian Jack Tchen observed that, "Our fixed notions of the past numb us from feeling and understanding the continuity of unresolved and uncontested issues into the present...Hierarchy, inequity, and power are inscribed into all of what we take for granted today. Reclaiming these historical experiences and understanding their roots is powerful. And like all traditions, it can only be kept alive in the engaged retelling. What ongoing meanings does this past have for us today? And as we understand the diversity of struggles today, dialoguers can better ask the historical questions of where these issues originated

[1] Roy Rozenzweig and David Thelen, *Presence of the Past: Popular Uses of History in American Life*, (New York: Columbia University Press, 2000).

253

2 John Kuo Wei Tchen, "Freedom's Perch: The Slave Galleries and the Importance of Historical Dialogue," in *Critical Perspectives: Writings on Art and Civic Dialogue* (Washington, DC: Americans for the Arts, 2005).

and how they played out with earlier residents."[2] As the basis for civic dialogue, history helps people understand the sources and complexities of present-day issues.

Several organizations whose projects were supported by Animating Democracy embraced history to help unravel complex, persistent issues their communities face today. They often investigated history from new and different vantage points, sometimes unearthing dimensions that were taboo, forgotten, or suppressed, helping to clarify current issues and deepen people's understanding of them. In many of these projects, art was a creative means to convey, or interpret, history. Whether initiators were arts organizations, such as The Andy Warhol and Jewish Museums, or humanities-based organizations like the Lower East Side Tenement Museum and state humanities commissions, the fluid interplay between humanities and art demonstrated that both history and cultural organizations are strong leaders in history-based civic dialogue.

TAPPING HISTORY FOR CIVIC DIALOGUE

Opportunities for employing history as a catalyst for civic dialogue can take a number of forms:

Historic sites and heritage tourism

3 Historic sites of memory are places that commemorate important historic events, figures, or ideas through the creation of a monument, museum, or other interpretive means. The sites are considered important to sustain in the public conscience because they represent the triumph of democracy, social justice, or human rights, or because they represent their failure. Many historic sites of memory, nationally and internationally, increasingly view that the power of their stories can inspire and deepen dialogue on contemporary social and civic concerns. Liz Sevcenko of the Lower East Side Tenement Museum describes this role historic sites and historic sites of memory can play in civic dialogue in her essay, "Activating the Past for Civic Action: The International Coalition of Historic Site Museums of Conscience," offered at the Great Places, Great Debates conference in New York City, March 2004.

Contested sites of history and historic sites of memory[3] can serve as potent settings for dialogue. *Evoking History*, a three-year program implemented in conjunction with the Spoleto Festival USA, connected historic sites in the city of Charleston, SC, to contemporary issues of race, cultural tourism, development, and gentrification. The program brought together artists, the festival, and the community to think deeply about the area's heritage by re-examining a range of sites, from high-profile plantations to a parking lot unmarked and unnoticed for its past as the location for a slave market. Through dialogue stimulated by performances, public art, and other cultural projects, *Evoking History* sought to support a long-term process of reconciling competing views of the past and changing long-held attitudes. Heritage tourism, an important piece of the city's economy, provided an impetus for reconsidering the meaning of historic sites and the possibility of finally acknowledging Charleston's slave history.

Historic preservation and research

The processes of historic research and preservation offer opportunities for dialogue about broader civic issues as participants deliberate about strategies for restoration and interpretation. *The Slave Galleries Restoration Project* at St. Augustine's Episcopal Church tapped the power of this site to engage neighborhood residents in dialogue about how to interpret the space across cultures, as well as persistent issues of marginalization on Manhattan's Lower East Side. The restoration of the statue of King Kamehameha I on the big island of Hawai'i symbolized concerns about heritage preservation that are likely to emerge in the face of imminent tourist development, and the need for local participation in such civic decisions. In Junebug Productions' *Color Line Project*, ordinary citizens' previously untold stories of the civil rights movement added to a national archive. They also

fueled the creation of community theater and linked art to future activist work on issues of race and social injustice in local communities where the project took place.

History-based arts presentations

Artworks and art exhibitions, such as Katrina Browne's *Traces of the Trade* film and The Jewish Museum's *Mirroring Evil* exhibition, that take on historical themes and subjects provide compelling opportunities to explore contemporary issues. With intent to stimulate discussion about complicity and complacency toward evil in today's society, The Jewish Museum's *Mirroring Evil: Nazi Imagery/Recent Art* exhibition dramatically shifted the focus of Holocaust representations from victim to perpetrator and gave young artists a voice in discourse about the Holocaust. The Andy Warhol Museum's *Without Sanctuary* exhibition of lynching postcards and photos of the 19th and 20th centuries engaged regional audiences in dialogue about race and bigotry. Katrina Browne's documentary film, *Traces of the Trade,* shifts attention to the lesser-known history of the role of the North in the Slave Trade through her own ancestors' Rhode Island-based slave trading legacy. When completed, the film's primary use will be to encourage dialogue among whites about white privilege. Arts-based civic dialogue projects may draw on

Conservator Glenn Wharton paints the statue of King Kamehameha I on the island of Hawai'i, 2001.

more recent historical situations, connecting still-powerful memories to current issues. Los Angeles Poverty Department's *Agents & Assets*, a play that investigates the advent of the U.S. crack epidemic, used the actual transcript from a 1998 government intelligence hearing as its script in order to catalyze dialogue about current drug treatment reform policy. The Brooklyn Philharmonic Orchestra remounted *The Death of Klinghoffer*, an opera about the 1985 hijacking of the Italian cruise liner by a group of Palestinians and their murder of a wheelchair-bound American Jew. Using the opera as a platform, the *Klinghoffer Dialogue Project* aimed to foster dialogue on issues of identity, nationalism, the roots of violence in the conflict between Israelis and Palestinians, and the impact of this tangled history on people in Brooklyn, NY, today.

School-based history curriculum

Several projects linked exhibitions, productions, and dialogues in substantial ways with history curriculum in schools. The Jewish Museum noted "an urgent need among both high school and college-level programs to find relevance for teaching about World War II and the Holocaust in light of the tragedies and violence that continue to take place today." The Warhol Museum's artist-educators were trained in dialogue facilitation and worked with dialogue facilitators to support student groups attending the exhibition. Both orga-

Photo collage from the play,
An Altar for Emma, part of
The Esperanza Peace and
Justice Center's ongoing
program, Arte es Vida, *2001.*
Photo courtesy of the Esperanza.

nizations partnered with Facing History and Ourselves, which helps students find meaning in the past and recognize the need for participation and responsible decision-making.

Community building and empowerment efforts

In the work of The Esperanza Peace and Justice Center, revisiting histories important to San Antonio's Latino and Chicano communities (histories that are often obscured or even denounced by the white community) is an essential activity to empower disenfranchised and oppressed community members. In one of many projects, for example, the Esperanza mounted an audience participatory play followed by *pláticas* (conversations) focusing on the history of 1930s labor organizer Emma Tenayuca.

The past is indeed always with us, and historic sites and heritage tourism efforts offer great potential for sustained examination of both the history of a community and its contemporary civic and social concerns. Efforts such as exhibitions, anniversaries, and commemorations are compelling in their ability to attract media and public attention. Whatever the particular project, history can be a potent catalyst for meaningful intergenerational, interracial, and cross-cultural dialogue and understanding.

MEMORY, CONSCIENCE, AND HIDDEN TRUTHS
AS TOUCHSTONES FOR CIVIC DIALOGUE

Historic sites can be potent settings for dialogue about contemporary issues. Memory and conscience, when brought into play by the power of historic places, can generate deep dialogue. The *Evoking History* project took as its point of departure Charleston, SC's, practice of denying its slave past in the representation of history at historic sites and monuments. Artists' works have raised public consciousness about this denied or hidden part of history at dozens of sites in the city. For example, in literally marking the graves of slaves at Drayton Hall, the oldest preserved plantation house in America, artist Lonnie Graham sought to capture their presence in this place and to urge visitors to look more critically at what is represented—or not—in our nation's history.

Dialogue facilitator Tammy Bormann, who worked closely with *The Slave Galleries Restoration Project*, observed that real places with deep history give people opportunities for learning. She said, "A historical site such as the slave galleries breaks through the boundary of subjective interpretation with the sheer force of its physical presence. A visitor can feel, smell, touch, and taste the historical reality represented by the existence of the space." She observed that when people go there with each other, the dialogue goes deeper. In community dialogues, a space with a history that resonates for a particular group of people can also serve as a generative metaphor for other people's histories of marginalization and exclusion; Chinese Americans attending *The Slave Galleries Restoration Project*, for example, drew parallels to the coolie trade and the history of segregation in Chinatown. The project also evoked contemporary issues in the neighborhood. Bormann notes,

"A site like the slave galleries in St. Augustine's Church can make abstract ideas such as freedom, justice, and tolerance tangibly understandable."

The search for historical truths in contested, hidden, or previously untold histories can open up deep dialogue on enduring moral issues that resonate in contemporary society. In what David Thelen calls "participatory historical culture," different perspectives and individual voices are welcomed. They represent various truths, all respected and treated as valid. He contrasts this to history as a politicized struggle for authority (i.e., whose memory, account, interpretation is authentic). Unlike much historical research, which is designed to find answers, history as catalyst for civic dialogue often aims instead to bring to light difficult and enduring questions that might get at multiple truths. Project organizers at St. Augustine's Church and the Lower East Side Tenement Museum reported on their experience:

Inside view of the west slave gallery of St. Augustine's Church, The Slave Galleries Restoration Project, *2005. Photo © Hector Peña.*

We sought to use the story of the slave galleries to raise questions that are as pressing and unresolved now as they were a century ago. To pursue that goal, we focused our research around the points of conflict, exploring the debates that took place around them. For instance, a great debate arose among the "Slave Galleries" Committee, community preservationists, and the scholars consulting on the project about the use of the term "slave galleries" to describe the spaces hidden in the church. At the heart of the debate lay the fact that slavery in New York was officially abolished in 1827, one year before the church was constructed. Newspaper accounts from 1916 referred to the spaces as "slave galleries." But would they have been called "slave galleries" when they were built a century earlier? The real question was: Were there slaves sitting in the space? The arguments between historians and "Slave Galleries" Committee members were intense, with one of those historians suggesting that referring to the space as "slave galleries" was irresponsible and inaccurate, and some members of the "Slave Galleries" Committee feeling that not doing so was tantamount to being racist and denying the continuation of slavery after manumission. While we worked to uncover the most accurate information we could about who sat in the galleries (people with a mix of legal statuses) and how segregation flourished after the abolition of slavery (almost all churches in Lower Manhattan had "negro pews" through the mid-nineteenth century), we recognized that the story was more complex than a single truth. Instead, we worked to open this conflict as an opportunity to raise the larger questions that underlie the debate: What difference did it make when slavery was abolished? What difference do legal rights or legal changes make—what is the difference between legal and social freedom? What did "freedom" mean then? What does it mean today?

History-based dialogue can raise the critical questions that break open mythologies about the past that persist in the present. Katrina Browne hopes that her personal documentary, *Traces of the Trade,* about her ancestors' role in the North's slave trade, will help people to examine and talk about how contested histories are often complicated by mythologies that have

evolved over generations. These mythologies have helped some people justify their behavior and cope with the psychological ramifications. She sees the story of New England's role in slavery as pivotally significant because it forces people to revisit the mythology of Northern innocence when, in fact, many middle-class people invested in the slave trade and lower class tradesman and others supported it through their work and wares. This history provides many clues to help white people understand all kinds of institutional oppression today.

In Bristol, RI, historical archives and objects stimulate dialogue among DeWolf family descendents during the making of the documentary film Traces of the Trade, *2001. Photo by Liz Dory.*

Issues of who "owns history," or who has the right to represent it, may arise with the intent to draw new and multiple voices into the discussion. It can be difficult to avoid tensions between new participants and those who have typically held authority in the dialogue about history. The museum community has confronted this issue, not always with self-assurance, in the recent past. Museum scholar Selma Holo wrote for Animating Democracy about the Smithsonian's *Enola Gay* exhibition, which brought different voices forward to discuss the dropping of the atomic bomb on Japan. Some of them challenged accepted beliefs about the bombing. "Because the challenge to prevailing histories was ill-timed and badly handled, with dueling positions established between 'intellectuals' and 'veterans,'" she wrote, "the show had to be radically curtailed and positions froze. One could fairly say that no new learning, either for museums as cultural organizations in a civic context, or for those with a stake in the historic presentation, occurred in this case, because no dialogue occurred."[4]

4 Selma Holo, "Conducting Civic Dialogue: A Challenging Role for Museums," (Washington, DC: Americans for the Arts, 2002), www.AmericansForTheArts.org/ AnimatingDemocracy

Although controversy and a tidal wave of media discourse surrounding The Jewish Museum's *Mirroring Evil* exhibition thwarted the primary "civic" dialogue focus—individual and societal complicity and complacency toward evil today (a ripe topic given the exhibition's debut six months following 9/11)—a wide range of discussion programs, including daily dialogues in the museum, effectively engaged people in the question of who can speak for the Holocaust. *Mirroring Evil* showed the potential for artistic interpretation to dramatically shift fixed notions of history to offer new paradigms for public discourse.

Reconciliation is a critical context in addressing current issues embedded in legacies or histories of social injustice. *The Slave Galleries Project*, *The Without Sanctuary Project*, and *Traces of the Trade* each shared the quest, as Jack Tchen described it, to replace systemic amnesia with a democratic, popular, living understanding of the past. Katrina Browne is considering how *Traces of the Trade* might directly contribute to public discourse on reparations for slavery. In contrast, *The Slave Galleries* and *Evoking History* projects did

not try to link specifically to the issue of reparations. However, the idea of reconciling different views of history and persistent divisions among people regarding specific places has been an ideal to which both aspire. Writer Ferdinand Lewis reflected, "Although achieving a goal as large as reconciliation between [divided] communities would require much more effort than any single civically engaged art project could possibly deliver, making a contribution to that goal would be a reasonable aim. At the very least, the arts could help imagine what such a reconciliation might look like."[5]

[5] Ferdinand Lewis, "The Arts and Development: An Essential Tension," in *Critical Perspectives: Writings on Art and Civic Dialogue* (Washington, DC: Americans for the Arts, 2005).

Jack Tchen urged that cultural organizers not be deterred by the enormity of a goal such as reconciliation. He believes the goal of reconciliation *should* be considered in designing the process of a civically engaged arts and history projects. Tchen and others at an Animating Democracy forum proposed that a strategy would first require an honest collective investigation of the status quo, with an understanding of what's involved in building real dialogue, including work that needs to be done up front to lay the groundwork and identify the terms of that dialogue. Second, it would require a very clear agreement up front, according to criteria mutually agreed upon and shared, recognizing historical grievances and the time it takes to build relationships. Third, they suggested, it would require follow-up with affirmative acts of reconstruction to redress unequal power relationships, as well as evaluation, measuring whether it lived up to its own objectives.

The Borough Project, *Suzanne Lacy, Charleston, SC, part of the* Evoking History program *curated by Mary Jane Jacob for Spoleto Festival USA, 2003.*

Art and history can be mutually supportive in providing access to the past and propelling dialogue about the present. Art can offer history in a new form through story, theater, film, public art, and visual art, and serves as a means for interpreting and reinterpreting history. History offers artists rich ground, allowing them to draw out less frequently heard points of view, to focus on the individual human story, and to challenge fixed notions of history.

The *Evoking History* project curated by Mary Jane Jacob used art to stimulate dialogue about Charleston's history of slavery and colonialism and the present-day civic and social manifestations of that history. Public art installations by international artists focused attention on these dimensions of Charleston's past. For example, in 2002, three artists chose to focus their creative projects on the site of a once-thriving African-American waterfront neighborhood called the "Borough," where residents were displaced by various forces and ignored by the city when they sought to rebuild their homes and lives. *Fortress,* by Nari Ward, was an enormous recycled-glass greenhouse that housed a symbolic gestating group of palmettos. On the walls were etched the erased street names and places of the former African-American neighborhood that once filled the now empty site. The work was a memorial to the people who had lived there and, at the same time, was a testament to the impermanence of place. Suzanne Lacy's project used one of the two surviving Charleston single-style residences in the former "Borough" as a center for collecting oral history, documenting voices from this neighborhood, and replaying them to visitors via video. Lacy came back the following year to

6 Neill Bogan, "The Chain of Memory
Is Not So Long: Violence, Democracy,
and Monuments in Charleston,"
*Reflections on Evoking History:
Listening Across Cultures and
Communities,* Charleston, NC,
Spoleto Festival USA, 2001.

implement an elaborate arts-based dialogue project on the same site, which helped sustain attention on this neighborhood as city officials were entertaining development efforts. In looking closely at historic monuments and contemporary public artworks created for *Evoking History* (2001), artist and writer Neill Bogan observed that, "Art will take us back through that window in a deeper way, into contexts in which we could not place ourselves. Through truth-telling, art can demand acknowledgment of the way things have been."[6]

Art illuminates personal history, providing potent entry points for connecting with larger historic moments, movements, events, and related contemporary civic issues. Through the efforts of Junebug Productions and founder John O'Neal, the *Color Line Project* collected stories from people who had experiences or memories of the civil rights movement to ensure that those stories not be lost or forgotten. In selected cities, O'Neal, a national organizing team, and local partners worked to collect stories, using Story Circles methodology as a democratic dialogue form. Local artists then transformed these stories into public performance of, by, and for the community. In addition, presentation of Junebug's Jabbo Jones plays and scholarly panels provided varied opportunities for public discussion about current issues of race in each community. *Color Line Project* Director Theresa Holden describes the synergistic results:

> In every case, the act of remembering, telling, and collecting stories could not be isolated from the present…By holding up stories from the past, in a new form, an artistic form, a magical synaptic connection can occur—that's something that art alone does for us. The audience members, regardless of their age and experience in the civil rights movement, are able to see the connections between the struggles of the past, losses and gains, and their present, personal lives…This occurs whether we prompt the connection or not."

See also "Dialogue as an Integral Part of Artistic Practice" in the section "Artistic Practice."

Issues of who "owns history," or who has the right to represent it, may arise with the intent to draw new and multiple voices into the discussion. It can be difficult to avoid tensions between new participants and those who have typically held authority in the dialogue about history.

Art helps to dislodge rigid beliefs and open people's hearts to new ways of looking at history and its effects. In her film *Traces of the Trade,* filmmaker Katrina Browne foregrounds her own family's legacy as the largest slave-trading family in early America, following nine family descendants on a journey of self-discovery. Browne's hope is that the immediacy, intimacy, and inherent drama of witnessing her own family's struggle will give permission to white viewers—for whom the film is primarily intended—to explore issues of white privilege and guilt at a personal and emotional level, taking their cues from the film's characters who do the same.

Art and history together can provide access to the past. Each can unlock and deepen the experience of the other. Historic sites and museums use theater to reenact the past in living history formats, or other art forms in interpretive ways. Both art and history draw on story and oral history to excavate the individual dimensions of the historic panorama. As Liz Sevcenko of the Lower East Side Tenement Museum has discovered, the divisions between the arts and humanities are often artificially drawn. Rather than continue such a split, she advocates that

[7] Lisa Chice, "Building Upon a Strange and Startling Truth," in *Critical Perspectives: Writings on Art and Civic Dialogue* (Washington, DC: Americans for the Arts, 2005).

mutual relationships be encouraged and that projects take advantage of the common ground that arts and humanities share, as well as the unique capacity of each to foster civic dialogue.

Focusing on the individual experience in history humanizes what are often depersonalized historic accounts, fostering empathy as people imagine themselves in the shoes of others. For *The Slave Galleries Restoration Project*, the act of being present in the slave gallery space was a potent one, evoking strong emotion. St. Augustine's Church and the Lower East Side Tenement Museum decided to put the individual human experience—of the visitor as well as the enslaved African American—at the center of their research, preservation, and interpretation. Lisa Chice, who coordinated the community dialogues, reflected on the visitor's experience:

> Before he brings people into the space, Deacon Hopper prepares the visitors with a meditative moment. They are asked to close their eyes and imagine themselves as enslaved African Americans. Then they are told to enter the galleries in silence. Often, we have started post-visit discussions by asking, "How did the space make you feel? Was there a time in your life that you felt similarly?"[7]

Putting a human face on the history proved extremely difficult, however, since African Americans were rarely given names in any documents of the period. Painstaking research finally revealed the identities of a few of the slave galleries "ghosts" such as Henry Nichols, a free black saddler who was baptized in the church two years after manumission.

From there, project leaders began to imagine interactions, relationships, and experiences. Organizers wondered: "What were some of the questions Henry Nichols would have asked himself? He would have heard a number of different arguments among African American New Yorkers about segregation. Some said blacks should go to white churches and refuse to sit in the Negro pews. Others said they should establish their own churches. What would he and the people he sat here with have thought? What was his vision for the future of the Lower East Side?" Ultimately, these issues were integrated into dialogue questions and in the way they introduced visitors to the space.

Visitors to the slave gallery in St. Augustine's Church, New York City, The Slave Galleries Restoration Project, *2005. Photo © Hector Peña.*

In developing interpretive strategies for the slave galleries, project organizers engaged storyteller/interpreter Lorraine Johnson-Coleman to lend her imaginative powers to filling in the human story missing from historic record. She wrote a piece for eventual use by docents or for silent reading in the space. Johnson-Coleman sees that historical sites have multiple stories to tell, not a single tale, and sometimes these stories conflict with one another. She reflects:

> The conflict may not be a problem since the ultimate goal is not just telling the story but creating an experience that allows the visitor to learn, to reflect, to dialogue

8 Lorraine Johnson-Coleman, "The Colors of Soul," in *Critical Perspectives: Writings on Art and Civic Dialogue* (Washington, DC: Americans for the Arts, 2005).

critically, and to deepen their understanding of American history, our "civic glue," so to speak. In the case of slave galleries, there are conflicting possibilities as the interpretation/storytelling begins. One possibility is that many who were forced to sit in the segregated seating were outraged and rightly so. Another is that there were many who looked forward to the private fellowship with family and friends, away from folks who were other than their kind. By exploring both possibilities, we open up the discussion in two ways instead of just one. How do we feel when we are separated or marginalized? Isn't it also comforting at times to be around folks that are just like us? Is it necessary at times to separate ourselves in order to maintain our cultural connectiveness?[8]

The Slave Galleries Restoration Project demonstrates the dialogic essence of history and illustrates on many levels the potency of history as a catalyst for civic dialogue. The project demonstrates how historic sites evoke emotion, thought, and dialogue. In drawing upon the human experiences and relationships that comprise history, it shows the promise of tapping people's natural impulse to explore the past in order to make sense of the present. By posing difficult and enduring questions and engaging a wide range of people in the discussion, it reveals how history-based dialogue can help to break down barriers to understanding today's issues.

History as a catalyst for civic dialogue helps people to understand the sources of unresolved and contested issues and how they have manifested themselves over time and into the present. There are far-reaching implications for employing the power of history in civic dialogue. Profound connections can be made between local histories and national, or even international, issues. Neill Bogan wrote about *Evoking History*, "As it seeks to create a new framework for encouraging democratic speech and expression across cultures, the *Evoking History* program also can bring nuanced local knowledge on these subjects into the national

9 Bogan.

arena."[9] In the same way, the specific histories of slavery in Rhode Island and the Lower East Side are also the nation's histories. A local–global reciprocity has emerged through the experiences of member organizations of the National Coalition of Historic Sites of Conscience, a growing worldwide network of organizations and individuals dedicated to exploring how historic sites and museums can inspire social consciousness and action. The National Park Service is taking a cue from this international coalition and from model work by organizations such as the Lower East Side Tenement Museum (a leader in the international coalition) learning how to more effectively tap the power of historic sites, parks, and museums in the United States as settings for, and subjects of, dialogue about contemporary issues.

Civic dialogue designed around history enables, as David Thelen describes it, a "re-inhabiting or re-experiencing" of history and contributes to its role as a dynamic link to the present. As Thelen's studies suggest, there is ample opportunity to take advantage of people's natural interest in history, especially "everyday history." He suggests that, "by using the past on people's own terms (rather than mediated by others with their own agendas), people can reshape the civic forum to better hear their voices and meet their needs."[10]

10 Rozenzweig and Thelen.

Youth, Art, and Civic Dialogue

YOUNG PEOPLE ARE CITIZENS whose voices and perspectives shed valuable light on current issues. Art can provide a vehicle and forum for young people's creative and civic expressions. In Animating Democracy, cultural organizations, ranging from theaters for young audiences to community cultural centers to museums and orchestras, found ample and varied opportunities, through art, to engage youth in critical issues that affect them. They built upon the best of traditional educational methods and, in many cases, also experimented to define new approaches that challenged youth to create and express their views about issues at deep personal and intellectual levels. These projects brought youth into active and meaningful dialogue with adults and the broader community. Their approaches—intergenerational arts-based civic dialogue efforts, working with disenfranchised young people, tapping the aesthetics of youth culture, and pushing the aesthetic conventions of conventional art forms for youth—are explored in this section.

Issues that directly affect youth offer an obvious and critical opportunity to involve young people in dialogue. Issues such as school violence, racial profiling, and, for recent immigrants and refugees, coping with a new culture and home are a part of the day-to-day experiences of many youth. Often there are few outlets for young people to candidly and safely express their fears and concerns. Creative activity can provide not only a personal route to unpacking these issues, but, by presenting these issues in public space, creative activity can validate these issues as not only real, but important for the broader community to address.

By engaging young people as dialogue facilitators in its *Water Project*, the Northern Lakes Center for the Arts in Amery, WI, attracted other youth into dialogue about water conservation issues in this rural region. The Children's Theatre Company of Minneapolis sought input from young people about the future of small communities in the face of the farm crisis in rural America. New WORLD Theater's ongoing *Project 2050* confronts compelling issues arising from the projected changes in racial demographics over the next 50 years, which show that by the year 2050, people of color will be in the majority in the United States *Project 2050* asks youth to consider their prospects in light of this "millennium shift" and, beyond that, to think about power relationships, politics, and social change as a whole.

Some artistic and programming choices provide a particularly ripe opportunity to engage youth in civic dialogue. The Center for Cultural Exchange's interests in popular musical forms and New WORLD Theater's deepening focus on art at the intersection of theater, performance poetry, hip-hop, and contemporary youth culture led to programs which naturally involved young people. Museums, theaters for young people, and orchestras connected their education goals explicitly to civic content, often adapting or reinventing existing school-based programs and pedagogical formats to encourage dialogue. Henry Art Gallery's *Gene(sis)* exhibition of contemporary art that explores the human genome, for instance, engaged students and their teachers in related moral, ethical, social, and economic issues. The civic value of school-based education programs was enhanced with attention to dialogue opportunities, often with only modest adaptation to current practice. The Andy Warhol Museum and Brooklyn Philharmonic Orchestra trained artist-educators in dialogue facilitation and refocused school-based education programs to delve deeply into issues of race and Middle East conflict respectively.

UNIQUE CONCERNS ABOUT ENGAGING YOUTH IN ARTS-BASED CIVIC DIALOGUE

Young people comprise a cultural group with its own norms and identity concerns. To seize opportunities in the most meaningful ways, cultural organizations need to understand youth aesthetics and expressions, communication styles and norms, relationships to power and authority, and learning styles and preferences.

Youth will probably be most responsive and willing to engage in creative and dialogic activity when they are treated with honesty and respect, when there are high expectations about their level of participation, and when difficult subject matter is appropriately embraced, not avoided. The Warhol and The Jewish Museums consciously worked to create these conditions for school groups who saw their exhibitions. The intent for all audiences was to get people to think and talk about society's complacency toward evil, and its complicity in evil acts. Organizers knew that the disturbing images in the *Without Sanctuary* exhibition and the trangressive nature of the art in *Mirroring Evil* had the potential to upset young people. Both organizations partnered with Facing History and Ourselves, an organization experienced in helping young people analyze the contemporary implications of difficult moral and ethical issues in history. Facing History helped museum staff design teacher guides and familiarization visits as well as the dialogue experiences for youth. School groups were only allowed to visit The Jewish Museum if teachers had been through an orientation and were committed to preparing students in advance. Artist-educators based at The Warhol Museum were trained by the local YWCA Center for Race Relations on how to deal with emotional responses to the photographic images and to students' discussion needs. Artist-educator Abby Franzen-Sheehan recalled her experience:

> I found the school group dialogues, while sometimes difficult, to be really powerful. The students made relevant connections to their own experiences—even when they didn't wish to do so. One group I had was relatively contentious between some white and African American boys about music: rap vs. rock. The argument highlighted many stereotypes of people and popular biases that exist. While the boys involved did not resolve their disagreement, the heated discussion itself was good for the rest of the group to witness—they saw how issues of race as they play out in daily life can be talked about safely without resorting to fear, hate, and violence. Their dialogue had never happened in school, in fact, I doubt those kids ever talked with each other about anything.

Arts-based civic dialogue projects can create safe environments to explore identity, culture, personal life experience, history, and contemporary political situations, especially for youth who have experienced trauma or disenfranchisement. Among the young people involved in Intermedia Arts' *People Places Connections* project were homeless youth, refugees, and immigrants beginning a new life in the United States. Already displaced from their homes, these youth were threatened with further displacement as a result of neighborhood development. Artists working with these youth chose to directly address the question, "What is safety to you?" in creative projects, as a step toward understanding civic safety issues for youth and their families. The opportunity to be among peers who were sharing similar experiences was reassuring and powerful, particularly when ideas and feelings could be shared both in creative and dialogue terms. In the tense climate after 9/11, Tahani, a young Palestinian American woman who covers her head, valued the supportive environment of *The Poetry Dialogues* project. "After 9/11, I have had a hard time with just everyday life, but performing was different...*The Poetry*

"Youth bringing youth together, working with a well-known poet, just showed us that we can do it, that we can make it through rough times."

Sheila Mirza and Tahani Salah, youth involved in City Lore's Poetry Dialogues. 2003.

Dialogues was a safe and unforgettable time for everyone. Youth bringing youth together, working with a well-known poet, just showed us that we can do it, that we can make it through rough times."

Making young people's stories public may have consequences for them at home, school, or work. As in community-based cultural work in general, building trust with youth depends in part on being sensitive to issues of privacy and understanding the potential for exploitation when private stories are transferred to the public realm. Young Sudanese men in the *African in Maine* project chose to voice concerns about intergenerational conflicts in their community on a public panel that was part of a Sudanese festival. They were prepared for the challenges that might be put to them by their elders and peers in that forum, and ready to handle them when they did, in fact, arise. However, there were difficult and emotional moments in other cases, even after forethought and planning, and adults were called on to help protect vulnerable youth. Andy Warhol Museum artist-educator Carrie Schneider had such a moment:

> My most surprising experience was with a young man who attended the [*Without Sanctuary*] exhibit with his suburban school's anti-racism group. During our dialogue he revealed to the group that not only was his great-grandfather in the Ku Klux Klan, but he was a southern Baptist minister and a grand wizard of the Klan. In addition, the young man stated that he recognized the face of his great-grandfather in one of the photographs in the exhibit. He appeared to be very shaken by the experience, and we all sat stunned with the reminder that the atrocities pictured in the exhibit are close to home.

Instances like these suggest that cultural organizations consider structured follow up and response with young people—opportunities for further dialogue, one-on-one access to adults if the art or the dialogue has opened up feelings, and resources that point youth to organizations that can engage them in actively working for change. New WORLD Theater (NWT) described how *Project 2050* enables young people, many of whom have experienced extreme circumstances, to be in an environment that is vastly different than the one they normally inhabit. Some hit an emotional threshold when they returned home with a heightened consciousness of their lives in relation to a larger world. NWT has begun to think more specifically about how to help young people reconcile this disparity by linking them to counselors and other services that may be needed.

Recognizing that there is diversity within youth culture, arts organizations need to test assumptions, as well as set up structures that allow for a diversity of perspectives. At one of *Project 2050*'s summer youth retreats, several participants and observers voiced concern that the project seemed to privilege hip-hop aesthetics, which made some participants feel either uncomfortable or marginalized. A similar concern arose about the

Knowledge for Power sessions, which emphasized a critique of the dominant culture of class and power relationships. As one observer put it, "In the process of revealing traditionally subordinated voices, the retreat might have actually subordinated more voices." Talvin Wilks, who participated as one of the artists in the 2002 retreat before joining the NWT staff, felt that this was not at all the case. He observed, "Youth are often reluctant to go against the group in general, but I do remember a number of young people feeling free to strongly express their opinions, even if they weren't necessarily popular. And although the scholars tend to share a general point of view, you can see a wide variety of perspectives." *Project 2050* worked to create a structure for the broadest level of dialogue, and to allow the conversation to be youth-driven. Youth facilitators tried hard to make sure that all points of view were respected.

Elder poet Ishmaili Raishida, who worked with Muslim youth poets in *The Poetry Dialogues*, encouraged them to be open in their aesthetic and social investigations. She said:

> One of the things we talked about in our small groups was what it meant to be the other. Most of us were immigrants, and Muslim, and [some] African…the young people were writing about serious things—confronting their identity, discovering themselves as people of color in a society (in the state of current events). They confronted serious issues, but they didn't make them "problems." The caution I suggested was that, with the same strength they showed in confronting themselves, to have the same strength in finding their own voice and in framing how they want to be heard—not to be locked in one form or style; to use hip-hop, but not be confined by it. I am really so grateful for the space that [City Lore and Urban Word] provide. They provide training, and they provide an environment for critical but non-judgmental expression.

Performance by youth involved in Project 2050, *New WORLD Theater.*

CIVIC AND AESTHETIC EXPRESSION

Young people generally lack power and agency in the civic realm. At the same time, they have passionate feelings about issues. Because their voices are often ignored, devalued, or even suppressed, most have a strong need to "speak out." The arts can provide a vital forum for civic participation and expression by youth. Their creative work may convey anger, seek to expose injustice, condemn systems, criticize authority, and propose radical solutions based on direct and personal experience. As Animating Democracy staffer Andrea Assaf observed, "Creating in your face art is not just about being young, it's about

what cultural, economic, racial group you're coming from." Exciting art work can result, in part, because youth are less bound by expectations of the role of arts in relation to civic issues and tend to be more open to synthesis in form. Arts-based civic dialogue efforts, by virtue of their focus on expression and civic concerns, invite youth to speak openly, honestly, and passionately about issues that they don't otherwise have a public opportunity to address.

Aesthetic forms that are part of contemporary youth culture, such as hip-hop, poetry, spoken word, and popular music are effective routes for youth to explore civic issues because of their aesthetics and political content. From the beginning, hip-hop has been the dominant art form in New WORLD Theater's *Project 2050*. Most of the participating artists work in, or at least have their artistic roots in, one or more hip-hop genres—rapping, break dancing, beat-boxing, graffiti, DJ'ing—and many of the youth are thoroughly steeped in hip-hop culture. These forms readily embrace themes crucial to self-understanding for young people, especially young people of color; and they are attuned to themes that have been framed for *Project 2050* exploration such as immigration, identification, incarceration, exploitation, and negotiation. As expressed in NWT's reporting, "…Perhaps counter-intuitively, we also viewed embracing these 'Future Aesthetics' as an opportunity for intergenerational dialogue—in a language in which youth can interact with artists and scholars attuned to this aesthetic, and in which they can find means of expression that allow honest and meaningful communication of issues and ideas to adults in their communities."

Arts-based civic dialogue efforts, by virtue of their focus on expression and civic concerns, invite youth to speak openly, honestly, and passionately about issues that they don't otherwise have a public opportunity to address.

Artist-youth mentor relationships can be extremely effective in drawing out the best artistic expression. In *The Poetry Dialogues*, younger and older poets in each of three cultural groups—Muslim, African American, and Filipino—explored links between the traditional/folk poetry forms of an older generation and contemporary forms practiced by youth. Natasha, an African-American youth involved in *The Poetry Dialogues*, explained how the opportunity to work with mentor-poet Toni Blackman improved both her written poetry and her freestyle. "When I started, I was just a spitter, a rapper. I was just doing it the way I thought I was supposed to, because that's what everybody else was doing on the street. In *The Poetry Dialogues* workshops, I learned how to sound like me…The truth comes out much better than the lies. Rapping what was real to me made my spitting much better."

Balancing the need to "speak out" (and other natural modes of youth expression and exchange) with "dialogue" is a consideration in this work. Arts-based civic dialogue projects often gave youth their first opportunity to exercise their public voices, as well as affirming environment that built their confidence in speaking out. Speaking out and being heard, though, sometimes seemed to override, or at least de-emphasize, qualities of dialogue such as listening, being open to other points of view, and suspending judgment in order to try to understand other views, even when they are radically in opposition to one's own. Projects that provided sustained opportunity over time for youth to engage with each other, and with adults, on issues more often allowed young people to reach a balance between asserting a point of view and listening with empathy and without

judgment. Contexts in which education, art, and community organizing came together proved to be natural ground in which youth could thrive. Such opportunities point to the many possibilities for nontraditional collaborations in the arts and education as well as youth-based programming outside of schools.

Scene from …My Soul to Take, Flint Youth Theatre, 2001.

The intent for civic dialogue can give creators of theater for young audiences opportunities to explore social issues in more complex ways, both aesthetically and in relation to civic and educational goals. Practitioners of theater for young audiences are often challenged to balance the expectations of parents and teachers who typically want "issue plays" to teach a lesson or impart a message, and their own creative desire to make nonprescriptive work that embraces the ambiguities and complexities of an issue. Flint Youth Theatre reflected:

At FYT we heartily resist the temptation to teach and preach. Our artists do not come from theater for young audiences or education backgrounds. To impose a teaching requirement, which is what the dialogic component often felt like, seemed to deny the value of intuitive and imagistic work. At the same time, we are drawn to community-based work, since the community always wants and needs to talk about work that addresses its issues. We appeared to face four related, often competing, desires as we embarked on this project:

- the desire to break out of the traditional theater for young audiences mold where our choices are message plays, lesson or educational content plays or story plays;
- the desire to create work that is evocative rather than prescriptive, emotionally true rather than factually correct, and image-driven rather than literal—using music, lighting or props to propel the story forward;
- the desire to create work that grows out of community needs and concerns; and
- the desire to create dialogue opportunities that encourage and support, rather than restrict, an intuitive, ambiguous response, and that focus on aesthetic questions as well as content or issues.

Youth and adults in the community, as well as those in the field of theater for young audiences, agreed that FYT's play, …*My Soul to Take*, succeeded in generating dialogue in large measure because the play was excellent—imaginative and richly layered with meaning. The play embodied Artistic Director Bill Ward's continuing desire to address difficult subject matter without condescending to young people and without shying away from complexity and ambiguity. His nonlinear and imagistic aesthetic, and the play's use of a

strong central metaphor, effectively prompted individual contemplation of the issue and supported meaningful dialogue that moved back and forth from art to issue.

Contexts in which education, art, and community organizing came together proved to be natural ground in which youth could thrive. Such opportunities point to the many possibilities for nontraditional collaborations in the arts and education as well as youth-based programming outside of schools.

High levels of artistry are critical to an exceptional experience for participants and audiences, and are necessary to achieve the social or civic goals of the project. Professional artists working with youth all expressed the belief that artmaking should be rigorous. Visiting teaching artists commented consistently that performance projects created under the auspices of *Project 2050* attained a degree of artistic achievement that far surpassed other youth performance-based projects they have participated in or observed. Postshow dialogues also revealed that the *Project 2050* shows far exceeded local audience expectations. Not only did visiting artists set high standards for the young people they worked with, but New WORLD Theater (NWT) continues to "work" material and productions beyond the summer youth retreat as they develop other performance opportunities and respond to community requests throughout the year. As NWT reported, "We strongly believe that in our drive to create urgent, socially relevant art, we have effectively raised the bar of youth performance, not only our expectations but also the expectations our youth have of themselves."

INTERGENERATIONAL EFFORTS

It can be a challenge for cultural organizations and dialogue facilitators to work across generations in ways that value young people, while not disempowering the adult community or undermining traditional cultural values and expressions, especially in immigrant communities. Some of the youth-based projects in Animating Democracy explicitly fostered intergenerational dialogue through art and cultural practice. Projects that fostered mutual learning and respect between youth and adults did so by honoring the creative expression of both and leveling power dynamics in the dialogue. In *The Poetry Dialogues'* intergenerational workshops, younger and older participants explored links between traditional poetry forms such as African *jali* (or *griot*) praise poetry, Muslim prayer-calling, Filipino *balagtasan* (a poetic form of debate), as well as contemporary poetry forms such as hip-hop, spoken word, and slam poetry. One particularly intriguing aspect of *The Poetry Dialogues* proposal was the idea of a dialogue between poetic forms, how one might influence the other through the encounter of the elder and youth poets. Kewulay Kamara worked with the African-American team and transmitted the tradition of praise poetry, encouraging the young poets to express praises in their Spoken Word and "spitting." When West African musicians performed with the team, this further challenged the youth to work with the polyrhythms of African music, which are different from rhythms typical in free-style or rap, and to explore new rhythms in their poetry. City Lore Director Steve Zeitlin contends that, "Throughout the project, the intergenerational dialogue within each group was a powerful force, often affecting both the young and old poets…In all the groups, the young people had to stretch their preconceptions of what was to be written about and discussed, as did the older poets." The elder Filipino poet who brought to the project the debate-like poetic tradition of *balagtasan* vigorously proposed the topic of whether young people should go to college. Although her interest never wavered from

this question, some of the young people were interested in other topics. Notably, by the project's conclusion, the elder poet opened her mind to issues of sexual identity and other issues of concern to youth as a direct result of participating in the dialogues.

Widely divergent aesthetic interests, cultural values, and/or political views among youth and elders proved less easily reconciled in very recently settled refugee communities. The greatest intergenerational challenges may have occurred in the Center for Cultural Exchange's *African in Maine* project. Refugees in the Sudanese, Somali, and Congolese communities of Portland were invited by the center (as part of its long term commitment to support the city's diverse cultures) to define what cultural events and activities would best represent their cultures among themselves and to the broader community. These cultural negotiations brought generational conflicts to the fore. In one instance, a suggestion from within the Somali community to feature popular music such as the Shego Band excited the majority in that community, especially Somali teenagers, but Somali elders adamantly opposed the idea. While clan issues were also at hand, elders disapproved of the way the bands mixed Somali traditional musical styles of *kababey* and *sharah* with funk, reggae, and rap. Some of the elders complained that the music is not Somali but rather American, and that the Center for Cultural Exchange was trying to Americanize Somali youth. Others said the way the youth were dancing and shaking their waists was inappropriate, and that these youth did not represent proper Somali culture.

Youth perform traditional dance at the Sudanese Festival, part of African in Maine, *Center for Cultural Exchange, 2002. Photo © Bob Coven.*

The center sees this generational conflict as common in immigrant communities. As youth get more education and exposure, they tend to adjust faster and are more accepting of new ideas and innovations than adults. How these differences are recognized and dealt with in a project may support intergenerational artistic and dialogue goals, or undermine them. The center continues to be challenged in terms of programming, wanting to vest authority in the communities themselves but concerned about how support for youth or elders at various times may jeopardize relations with the other group.

The Esperanza Center asserts the importance of transferring cultural traditions and aesthetics from one generation to the next. In San Antonio, where there is a long history of Mexicano and Chicano presence, the emphasis has been on reclaiming and sustaining traditions through the cultural memory of elders. Although the *Arte es Vida* project emphasizes the contributions of elders as a source of cultural grounding for the larger community, the work of the Esperanza as a whole includes the development of youth leadership and new aesthetics, such as spoken word, video, and performance art, rooted in appreciation and knowledge of traditional Mexican cultural forms. New WORLD Theater's (NWT) *Project 2050* looks further at the development of future aesthetics and the changing demographics of the United States. Rooted in hip-hop culture, which is global and multiracial, *Project 2050* embraces hybrid identity as a complex experience that has its own progressive political consciousness. At the same time, NWT observes that youth have the capacity to see both traditional and new art forms as equally important, and reinforces this notion.

Honest and meaningful sharing between youth and adults requires conditions of equality among all participants. Artists applied their own creative ways and borrowed techniques from dialogue practitioners to level power inequalities and to uncloak mantles of authority. At a debriefing of a Hair Party for mothers and daughters at which the mothers had dominated the event, Urban Bush Women members agreed that it would have been helpful to separate the mothers and daughters into affinity dialogue groups before bringing them all together. At a subsequent Mother and Daughter Hair Party, they incorporated this improvement and others, such as a ground rule that mothers don't speak for or correct their daughters. Jen Weiss, former director of UrbanWord, partner organization to City Lore on *The Poetry Dialogues,* observes, "A major pitfall of intergenerational work is that older people tend to think they're more knowledgeable. In some things they are, but you have to define what your goals are. Intergenerational work can underestimate what kids can do. Teenagers are *knowledge producers*. They produce knowledge that I can incorporate into programming. That requires a real vision for the role of the elders."

ARTS-BASED CIVIC DIALOGUE APPROACHES WITH YOUTH

Existing educational practices have potential to be adapted for arts-based civic dialogue purposes. As many of the above examples demonstrate, artists and cultural organizations brought to their arts-based civic dialogue efforts a range of sophisticated practices related to cultural work with youth. Henry Art Gallery adapted an interpretive approach used in guided gallery talks—Visual Thinking Strategy (VTS)—a method of inquiry developed by the Museum of Modern Art. An "interactive looking experience," VTS initiates dialogue by posing simple questions that encourage viewers to bring their own personal associations, stories, and interpretations to the work. This questioning strategy leads viewers in progressive steps to explore the complex ideas embedded in the work. The Henry, as well as The Warhol and Jewish Museums and Flint Youth Theatre, developed substantial teacher curriculum guides that included activities for classroom dialogue before and after the artistic experience, as well as questions and discussion points that teachers could use to guide their students' gallery experiences and encourage dialogue about the work and issues.

Students viewing the Without Sanctuary *exhibition, The Andy Warhol Museum, 2002. Photo © Lyn Johnson.*

In *Coming to America: Immigrant Sounds/Immigrant Voices,* American Composers Orchestra (ACO) worked within the framework of its Music Factory program, which is geared toward music education and appreciation. The standard "informance" format, which alternates music with informal discussion about the music, was expanded to include the composers themselves, who conveyed their own immigrant or refugee experiences and talked about how that influenced their music. A dialogue facilitator helped frame and guide the conversation. A music teacher at a high school whose students are recent immigrants observed that the music gave students a way to interpret their feelings

and talk about their own immigration experiences. ACO's managing director observed that dialogue affected young people's experience of music in a way that ACO had not seen before. "People listened as if it mattered," he said. Pre- and post-performance discussion opportunities "advanced the relevancy of the music in people's lives" by being both incredibly personal and universal; by being both inward-looking, toward the art and artist, and outward-looking, toward the audience and the world around them.

The civic value of school education programs is often enhanced, as is the artistic experience, with attention to dialogue opportunity. Projects affected students' engagement in dialogue about civic issues, and teachers, artist-educators, and cultural organization staff came away with skills and resources that assisted in continued linking of art and civic issues.

The research stage in civically engaged arts projects can connect youth in substantive and creative ways to civic and social issues, expanding the possibility for civic dialogue. Youth engagement at the research stage provides a rich source of input at the creative stages of artistic development. Since the 1970s, when artist Judy Baca and SPARC (Social and Public Art Resource Center) began *The Great Wall of Los Angeles* mural, youth have been key participants in creating this mural as well as many others around the city. Baca has developed a pedagogy that continues to situate youth as active partners in education and creation. Youth help identify and research historic moments worthy of representation. Once a historic fact is identified as a focus—for example, that Los Angeles has the largest Central American population outside of Central America—young people analyze the underlying circumstances, reasons, and historic events supporting that fact. The circle is expanded to include artists, community members, activists, scholars, and people who have personal experience, and they all become sources of information and participants along with youth in dialogues. All participants share ideas for imagery and metaphors that can be drawn upon at the artistic development stage. Over the years, SPARC has finely honed its pedagogical approach to helping young people articulate untold histories and relate them to contemporary issues.

Arts-based civic dialogue projects can further the development of models that empower youth as planners, dialogue facilitators, and leaders, as well as artists and dialogue participants. Cultural organizations working close to the ground in community-based practice—like the Esperanza Center, Northern Lakes Center for the Arts, and New WORLD Theater—were more likely to involve youth in highly integrated ways in the design and evaluation of arts-based civic dialogue endeavors. As *Project 2050* evolved, youth became increasingly involved as planners. Following young participants' critiques of the 2000 Knowledge for Power sessions, for example, New WORLD Theater invited several youth leaders to attend a planning workshop. They helped to identify themes of the next retreat and ways to make Knowledge for Power sessions more engaging and accessible. In addition, youth were designated to help recruit other youth and maintain contact with existing troupe members. Drawing on Urban Word's expertise, City Lore will invest in training youth mentors for each cultural team in the next phase of *The Poetry Dialogues* project. Urban Word facilitators will work with elder poets, poet-facilitators, and

> *"A major pitfall of intergenerational work is that older people tend to think they're more knowledgeable. In some things they are, but you have to define what your goals are. Intergenerational work can underestimate what kids can do. Teenagers are knowledge producers."*

youth mentor teams at a weekend retreat to develop teaching strategies aimed at creating student-centered spaces in which to write and talk. Similarly, young poets and the facilitators involved together at the outset will have the opportunity to share, discuss, explore, and trade their own teaching methods, and to see each other as resources.

Youth can serve as effective dialogue facilitators with both peer and mixed groups. At an early point in Northern Lakes Center for the Arts' (NCLA) *The Water Project*, NLCA leaders realized that there were too few dialogue facilitators in their small rural community to hold multiple dialogues over the course of the project, and that they would need to train community members. They created intergenerational facilitator teams comprising one young person and one adult. Twenty-four young people and adults, ages 13 to 70-plus, were trained in the context of *The Water Project*, the issue to be addressed, techniques for facilitating dialogue, and how best to draw upon the artistic works at the center of the dialogues. The training served to establish young people as equal partners with adults and encouraged them to take leadership in the dialogue and other components. Liz Stower, a young facilitator, explained the importance of young people's active involvement: "Students can care…getting involved in projects like this is a way to show people that we do care." The conscious incorporation of different generations' perspectives in the project bolstered the importance of including diverse viewpoints from the broader community.

For dialogues happening both within the youth retreat and at public events, New WORLD Theater also employed a team approach to facilitation. The "D-Team" (for "dialogue")— two youth and two college-student counselors—met with youth arts organizer Diana Coryat in the weeks preceding the summer retreat, and she trained them in basic dialogue skills. She taught them some of the exercises that would be used in the knowledge-sharing workshops so that these sessions would have youth leaders as well as adult leaders and also prepared the youth for the public dialogue that was scheduled to follow the performances at the end of the retreat. They discussed why it was valuable to have a dialogue with the audience, what they would like to get out of a public dialogue, and what they would like the audience to ask them. She also prepared them for possible audience responses to the openly personal nature of some of the work and the nonmainstream aesthetics. She noted that audiences sometimes see things in the work that its creators are not aware of, which can give the artist added perspective on the themes and help make the work more articulate. The youth-led approach proved very successful, not only eliciting useful questions and comments from the audience, but making the youth company feel more comfortable and animated in discussing their work.

"Students can care… getting involved in projects like this is a way to show people that we do care."

THE PROMISE OF YOUTH-CENTERED, ARTS-BASED CIVIC DIALOGUE

Youth-centered activities can provide an entry point for adults to engage in civic dialogue. Civic intent can increase the potential to reach beyond school and youth audiences to engage a broader cross section of the community. The effect may be as simple as parents coming out to see their children in a play. But, in Hawai'i, school-based activities related to the *King Kamehameha I Statue Conservation Project* connected to deeply

held family and education values in this rural community, where parents and community members place the highest value on the children. In Michigan, Flint Youth Theatre's unflinching issue-based plays and high production values have stood up in their own right as compelling theater for adults, who have now become a regular part of FYT's audience. In the case of ...*My Soul to Take*, organizers specifically targeted adults in relation to the project's civic goal of prompting better coordinated efforts in the community to change a pattern of school and youth violence.

Kumu John Lake teaching children and adults the words and chant for a hula ki'i about the history of the King Kamehameha I statue, 2000.

Young people's perceptions of a civic issue may challenge others to think in new ways about issues. Children's Theatre Company's (CTC's) *Land Bridge Project* intended to explore tensions in rural communities of Minnesota between the push for agribusiness and the desire to maintain the family farm. However, the lens broadened as visiting playwright Rebecca Brown and theater teacher Tory Peterson from the Perpich Center for Arts Education did their work in the rural town of Montevideo. A major focus became the question of the future for the young people in this place. Youth made clear their fears of limited opportunities and the challenges of farming, whether on the family farm or for agribusiness. The flight of youth from rural towns concerned adults, who wondered who would take over the farm and who would sustain the community. CTC reported on one dialogue facilitated by Perpich Center for Arts Education's Diane Aldis that took place after youth saw the play *Stories from Montevideo*:

> The students from small towns all agreed that the show rang true. They hated Wal-Mart, but felt it had to be there; they said that everyone knows your business before you do; they understood, as teenagers, the desire to leave town, but agreed it was a good place to grow up. This last issue seemed to be most pressing for the students...Diane led a movement exercise to illustrate this to everyone. She stood on a chair raised her hand and said, "I am Montevideo, your hometown. Show me how close you feel to me right now." There were about 75 students in the room. Some stood immediately next to her while others stood further away. How did they make their choices? The dozen or so students closest to her said, "it's the people, you know everyone and everyone knows you." About another dozen were a little further away. "I have some ties to my home town, but I want to go to new places." And the rest who were the furthest away said, "I like big cities." She then asked them how they felt in relation to her five years after they graduate from high school. Many of the students who originally stood close to her moved and just a few people stayed. Finally she asked them where they thought

they might be 20 years after high school. It was interesting to see many students who were far away return and some that had never left her side finally leave. Diane then asked the students, "I'm your hometown—what can I do to help you feel more welcome?" They answered: "Be more liberal and accepting—be more welcoming and appreciative of differences. ...jobs are needed—we don't all want to farm...Change...Don't change."

Arts-based civic dialogue projects can prepare youth to speak to power through their art as well as directly, in public forums. The creative processes of Flint Youth Theatre, Children's Theatre Company, and New WORLD Theater elicited the opinions and concerns of youth around critical civic and social issues, which found public voice through theater and spoken word. A goal of *Project 2050* was to create a community of professional artists, respected scholars, and area youth communities but, at the same time, to challenge the position of artists and scholars as the established leaders, experts, and knowledge-holders in work with youth. This happened by creating an interactive environment where the three constituencies mutually informed, stimulated, and inspired each other.

Students in dialogue as part of the Land Bridge Project, *Children's Theatre Company, 2002–2003.*

Projects such as *The Poetry Dialogues* and *African in Maine* brought youth into direct relationships with adults in authority at home, school, and in the community to decide civic issues and cultural forms. In the *African in Maine* project, some of the Somali elders, while disapproving of modern music or dancing, relaxed their stance for several school-based productions in which the young people danced to the music of the Shego Band. The Center for Cultural Exchange believes this was probably the result of the dialogue between the elders and youth.

In most projects, youth did not have direct access to civic leaders or others in positions with the power to effect real change in relation to an issue. The Esperanza Center did engage youth in its activist efforts with city leaders, and New WORLD Theater is evolving *Project 2050* to a year-round format that includes opportunities for youth to take action on issues they have explored through creative work. Cultural organizations and/or their civic and community partners have the responsibility to help link youth to leaders, policymakers, and community change agents, if young people want to move beyond art and dialogue to take action.

Young people can grow as people, artists, citizens, and leaders in the context of their participation in arts-based civic engagement projects. Through artmaking and civic dialogue, young people can gain a greater sense of self-worth; develop critical thinking abilities; and find a "sense of place" within their communities, their country, and

the world. Youth participants in City Lore and New WORLD Theatre (NWT) projects moved into leadership positions in these, or other, projects. With the benefit of multiple years to develop *Project 2050*, NWT has created a model program that integrates youth culture and takes an intellectually rigorous approach to the complexities of issues that affect young people and shape the world they want to inhabit. NWT reported these dual intents and effects:

> The design of *Project 2050* and all its components within the retreat succeeded in synthesizing artistic expression with urgent sociopolitical topics concerning the contemporary world and, more intimately, the youths' immediate social realms (home, school, and regional environments). Creative approaches to pedagogy inspired artists and youth alike to inscribe their creative work with themes that engage in an exploration of their world, deter a position of "victim," and grant agency towards making change for the future. The social themes that underlie performances are not merely "lacquered on" to creative expression. Instead, the relevancy of sociopolitical topics is integrated into the making of performance, thereby allowing issues addressed in performance to gain complexity and to be open to intelligent investigation.

> …Works produced by *Project 2050* demonstrate that discussions concerning race and ethnicity can move beyond the thinking of singular or monolithic narratives of identity. Through consistent cross-cultural encounters, we believe our program has inspired youth to examine not only the intricacies of any one racial/ethnic group's story of identity, but also seeded new ways in which youth can find cross-cultural points of affinity. This important strategy has produced for our youth a greater level of empathy, understanding, and cognizance of the intricacies concerning racial/ethnic identity. It has motivated them to expand their dialogues concerning both themselves and their communities of origin. In an artistic register…cross-cultural learning has produced work that does not stem from one singular tradition, but instead interweaves many traditions to produce unique, wholly new, collaborative forms. In this way, cross-cultural artistic work sheds problematic concerns in art making such as "appropriation," and instead builds upon a base of exchange that is given with joy and received with respect.

Animating Democracy did not start with a focus on youth and civic dialogue but, through these projects, came to realize the important benefits of engaging youth in civic issues. The arts proved to be a natural container for young people's perspectives, and a motivating force in helping them express their ideas but also hear and consider others. Young people were valued for their insights and for their roles as "knowledge producers"; their voices were given a place within the broader civic discourse of their communities. Such efforts nurtured a sense of civic responsibility and engagement that is not only valuable in the present, but vital for the future.

6 Looking Forward:
A Map for the Future

This is a map. It shows where things are.
It shows where things are by showing them
in relation to one another. On the map, a
thing is in relation to other things.
By distance or size. Placement. A map is a
representation of the relations that locate
and define the things that are mapped.
Often it seems that the relations become
things in themselves and are the primary
subjects (or should one say masters?)
of the maps. As in the case of street
maps. Is the purpose to show the streets
themselves, to show them in relation to one
another so we can know each one better?
Or is this matrix of relation intended to
serve other purposes? Perhaps to help
define those things that are not themselves
on the map but exist in relationship to
things the map makes thinkable? On the
corners of, at the intersection of lines in the
map. We are the creases between the lines.

—Jake Adam York, poet

From Copper Nickel Journal, Number 3
Copyright © 2005 The Grammata Literary Group
of the University of Colorado at Denver

Looking Forward:
A Map for the Future

MAY 6, 2005: We are back in Flint, MI. It has been five years since Animating Democracy supported Flint Youth Theatre's communitywide project on youth violence and nearly two years since Flint hosted Animating Democracy's National Exchange on Art & Civic Dialogue. Around the table are representatives from the cultural groups with which Animating Democracy worked before, during, and after this national conference, as well as from the foundations that supported the conference and our work in the community. They are telling us about how Animating Democracy has influenced what is happening in Flint currently.

We hear from Jim Barry, curator of the Alfred P. Sloan Museum. He describes how the Sloan, a history and science museum, inspired by participation in the National Exchange on Art & Civic Dialogue and John O'Neal's *Color Line Project*, has shifted its focus from "telling *a* Flint story" to collecting and telling "*all* the stories." He describes a fundamental shift in how the museum views its role in the community and how it understands its most important work as "giving voice." Reflecting on the possibility that Flint will lose its identity as nearby Detroit expands, he calls the museum a "community center that can help the region and the Flint community understand and represent their distinct identities." Barry

observes that people in Flint are looking for a way to have a voice and that "neighbor-hoods are the building blocks of democracy." *A View From the Front Porch,* a central part of Flint's 2005 Sesquicentennial Celebration, is engaging people of all ages in exploring Flint's diverse neighborhoods using oral history, video documentary, visual arts, and performances. Building upon John O'Neal's Story Circles approach, which people learned during the *Color Line Project* residency, young people and their families are taking an active role in documenting, preserving, and celebrating the "grassroots" histories of Flint's diverse neighborhood by telling their own neighborhood stories, collecting multigenerational stories from other residents, creating photo documentaries of their neighborhoods, and developing materials to be placed in the Sloan Museum's *Front Porch* exhibit.

We hear about the Flint Cultural Plan that was in progress when we were planning the National Exchange. Planners report that working together on the Animating Democracy conference—contributing to and learning through it—brought local cultural and civic leaders together. They observe that civic engagement was woven through the planning process itself, which involved more than 200 citizens and leaders in dialogue about culture as a community issue. The concept of civic engagement has yielded a fundamentally new attitude in which the arts and cultural activities are perceived as varied, relevant, inclusive, accessible, and essential to all members of the community. It considers and advances civic goals that envision downtown Flint as a unique, vibrant, and safe central district, featuring a Center for Urban Arts and Culture that houses a Center for Youth Expression and an Artist Resource Center that will provide live/work space for artists. It proposes to involve neighborhood leadership in all planning and dialogue around arts and culture and to implement Neighborhood Public Art Programs (art parks, murals, annual events) to establish an ongoing and highly visible presence of arts and culture to build ownership and connect neighborhoods with communitywide arts and culture resources.

We hear that Liz Lerman Dance Exchange and local performers from Flint Youth Ballet, Bruce Bradley's Creative Expressions tappers, and Neo Griot Spoken Word Collective are weaving together dance and spoken word performance pieces to tackle the challenging choices created by advances in genetic science. Dance Exchange has been working in Flint for the 20 months since the National Exchange on Art & Civic Dialogue happened. Their residency has kept the cross-community collaborations begun with the conference vital and flowing. When Dance Exchange stages Lerman's full-length work *Ferocious Beauty: Genome* in Flint in 2006, it will be accompanied by interactive experiences and workshops, panel discussions and presentations by local artists. This program will continue the Animating Democracy tradition that has taken root in Flint.

We learn that where Animating Democracy directly engaged local artists, cultural institutions, civic leaders, and local funders, synergy was created across cultural, civic, and philanthropic sectors. Sustained interaction and financial support helped leaders in Flint see specific new ways in which the arts could play a role in civic concerns. It deepened understanding of principles and practices of the arts-based civic dialogue and gave artists and institutions the opportunity to practice and build capacity for civic engagement

Artists and cultural institutions in all disciplines and of all sizes are launching exciting new projects with increased sophistication, reach, and frequency. Stories from across the country demonstrate what is possible, and urge continued experimentation and investment in arts- and humanities-based civic engagement.

over time. "Animating democracy," as a concept, an approach to work, and as a learning community has clearly inspired a change in Flint's culture around civic engagement within the arts community. It has created a network, linking together people who may not have previously perceived any common interests—an alternative schematic of Flint, not visible on any map, that charts the way to a new kind of community.

The idea of "animating democracy" has captured the spirit, humanity, and vitality that are unique hallmarks of how the arts and humanities engage people in civic life. This kind of civic engagement has ever-increasing currency in arts and humanities fields. Artists and cultural institutions in all disciplines and of all sizes are launching exciting new projects with increased sophistication, reach, and frequency. Stories from across the country demonstrate what is possible, and urge continued experimentation and investment in arts- and humanities-based civic engagement.

When artists pursue their own visions, and when organizations further their investigation of art as a dialogue strategy and dialogue as an aesthetic strategy, they can expand the repertoire of techniques for both the arts and dialogue communities, and validate and promote the unique contribution of the arts to civic dialogue. With funding, mentoring, networking, and access to practical resources, artists and cultural organizations will grow to be strong and effective civic leaders and partners. Organizations newer to arts-based civic engagement will learn how to take sequential steps to build their capacities in this arena.

Using these findings, readers...are encouraged to place their work in relation to the work of others in the arena of arts-based civic engagement, encouraged to see the gaps that have yet to be charted and to determine for themselves what new directions to explore.

The transfer and evolution of civically engaged arts practice between generations of artists through academic and field-based professional development programs, as well as in ways defined by emerging artists themselves, is critical to ensuring vital and relevant creative contributions to future communities. Cross-disciplinary learning and discipline-specific focus and exchange will continue to advance the field in this work. Continued documentation of practice and theory related to arts-based civic engagement work will create permanent records, advance scholarship, and contribute to critical discourse. As well, further field discourse will continue to advance new approaches to critical and reflective writing that provide vocabulary, standards, and criteria by which to assess both the aesthetic dimensions and efficacy of civically engaged art

Local synergy across different kinds of institutions and networks will make the most of key moments for the arts and humanities to contribute effectively to civic concerns. Local arts agencies can utilize their position and skills, working at the cross section of arts and community interests to proactively organize arts-based civic engagement work with the arts community. Similarly, presenters can extend the civic impact of residencies and commissions. Historic sites, exercising their capacity as important settings and symbols for civic dialogue and civic engagement, can employ artists and the arts as a creative means to convey, or interpret, history. Because the arts have proved to be a natural container and a motivating force to enable youth to not only express their own perspectives but also to hear and consider others, youth-centered efforts in arts-based civic engagement are ripe for development. Local or regional learning networks like those formed at a national level

by Animating Democracy can foster synergy among these varied cultural institutions and assist them and their community partners to learn from each other and to build on their ongoing roles and activities.

Occasionally, landmark opportunities present themselves that have potential for impact on a national level because they address an important far-reaching issue, because they have potential for broad-based civic engagement, and/or because they link the arts to a major civic dialogue or engagement initiatives. Communities with a clear understanding of civic engagement practices will be poised to seize these opportunities.

Finally, in our global culture it is time to promote international exchange on art and civic engagement. In other parts of the world, models merging arts and democracy represent advanced thinking that can inform work in the United States. Similarly, artists and cultural leaders from new democracies and elsewhere look to the United States for best practices in arts-based civic engagement.

"What makes civic life possible, even exciting...is that it inspires and harnesses civic imagination, that new things are constructed in the 'in-between' space which dialogue creates, and that we are given the opportunity to transcend our own personal boundaries and concerns in the service of something larger."

This volume of findings is something of a map. Maps help you navigate in unfamiliar places. They can indicate progress or stimulate a sense of discovery. Here we have mapped the place of the arts and humanities in civic dialogue, the impact being made, the questions being asked, and directions for the future. We have shared what has been learned about the opportunities and challenges of this arena of work, and how our thinking has evolved. Using these findings, readers—including artists, cultural organization leaders, scholars, students, civic leaders, dialogue professionals, and community development practitioners—are encouraged to place their work in relation to the work of others in the arena of arts-based civic engagement, encouraged to see the gaps that have yet to be charted and to determine for themselves what new directions to explore.

Dialogue itself, and particularly arts-based civic dialogue, also works rather like a map. Like a map, dialogue can give or change perspective. It can reveal how things are separated or connected and where the gaps lie. Bliss Brown of Imagine Chicago, an organization that employs art and creativity as fundamental aspects of its civic-action work, reflected after an Animating Democracy convening, "What makes civic life possible, even exciting, in my view, is that it inspires and harnesses civic imagination, that new things are constructed in the 'in-between' space which dialogue creates, and that we are given the opportunity to transcend our own personal boundaries and concerns in the service of something larger." Animating Democracy maintains the proposition that art creates opportunities for transcendence, suspension, or transformation. The "in-between" space of the art and civic dialogue exchange remains ripe with possibility providing fertile ground for animating democracy.

Appendix

Civic Outcomes of Animating Democracy Projects

1	**EXPANDED PARTICIPATION IN CIVIC DIALOGUE BY INCREASING THE NUMBERS AND/OR DIVERSITY OF PEOPLE WHO TYPICALLY WOULD ENGAGE**
More people participating	The *Common Threads Theater Project* engaged 7,000 people from 15 of the 16 villages, cities, and townships in Allen County, OH, (6 percent of the county's population) in thinking and talking about the issues of race and trust among leaders. Sojourn Theatre interviewed 400 people for their views on civic issues of race and trust among leaders. Thirty people were involved as planners and connectors to the broader community by serving on the Core Team and as Sector Leaders.
	Almost 65 percent of the Amery, WI, community attended events and participated in dialogues as part of Northern Lakes Center for the Arts' *Water Project*.
Greater diversity in who participates	The *King Kamehameha I Statue Conservation Project* and community and arts education activities engaged people at almost every level of the community in North Kohala, HI—from preschoolers to elders, from newcomer residents to leaders of important Hawai'ian organizations—in public conversation about their rural community's future in the context of development and cultural preservation issues. Native and long-term residents who previously would not have come forward felt welcomed into the public process because the statue restoration process and traditional cultural programs provided a comfortable and respectful forum for their ideas.
	Recent immigrants, youth, and lower income residents who do not typically participate in public dialogue were involved in discussions about safety and gentrification of their neighborhood in Minneapolis, MN, through creative projects facilitated by five artists in Intermedia Arts' *People Places Connections* project.

2	**INCREASED ACCESS TO THE CIVIC REALM AND EMPOWERED GROUPS TYPICALLY EXCLUDED OR ON THE MARGINS OF CIVIC DISCOURSE**
A point of entry and the confidence to participate in civic dialogue for groups on the fringes of public process	*African in Maine*'s cultural programming process in Portland, ME, gave recent immigrants and refugees from Africa a civic forum to voice frustrations, humiliations, and fears related to U.S. systems and culture, a theme that is often below the surface in their daily communications.
	Cultural activities and dialogue related to the restoration of the King Kamehameha I statue in North Kohala, HI, gave native Hawai'ians confidence to participate in other public arenas such as the new general plan for the county.
	Central American refugees and immigrants in Los Angeles experienced a sense of empowerment by articulating and memorializing their history in a mural through SPARC (Social and Public Art Resource Center).
	Project 2050 youth in western Massachusetts have taken the initiative to perform their creative work for various community and school events, including African American History month; *Aware*, an ongoing project in response to events of 9/11; and through *Project 2050*'s own Call to Action efforts to connect youth work to civic and community issues.
Groups staking claim to civic space	Esperanza Center's *Arte es Vida* mobilized members of the Chicano/a community in San Antonio, TX, in efforts to save a historic building of significance to Chicano/a history. While this effort did not save the building, it led to other preservation efforts and invigorated citizens to take action on public spaces valued by the Chicano/a community.
	People of color gained insight about power dynamics related to civic spaces and issues of access to civic space by attending a New WORLD Theater *Project 2050* event in a downtown Holyoke, MA, auditorium. Many in this largely Puerto Rican city had seen the auditorium as "off limits" to their community and as a forbidding symbol of the split between the city's "old" white majority and its "new" largely Puerto Rican population.

3	ENHANCED PUBLIC AWARENESS AND UNDERSTANDING OF CIVIC ISSUES
Deepened understanding of the complex dimensions of the civic issue	Flint Youth Theatre's Study Circles dialogues in Flint, MI, fostered greater understanding of the causes and effects of youth violence and what works and what doesn't work in funding violence prevention.
	Eighty percent of dialogue participants in the *Understanding Neighbors* project in Anchorage, AK, reported gaining new information or perspectives about issues related to same-sex couples in regard to family experience, church, religion and spirituality, youth perspectives, couple or relationship concerns, and civil rights and legal concerns.
	Henry Art Gallery's *Gene(sis)* project in Seattle, WA, contributed to public discussion and understanding of the complex ideas surrounding biogenetics through the scope of its communitywide public programming, national media attention, and the U.S. tour.
Ability to see relationships between the local, national, global in an issue	Through Story Circle dialogue and theater activities, participants in Junebug Productions' *Color Line Project* connected local stories of the civil rights movement (and current local issues of racial and social injustice) to the national civil rights movement.
	In LAPD's *Agents & Assets* project, participants and audiences made links between issues of drug reform policy and other U.S. foreign policy issues by consciously designing public events to include a broader global framework for dialogue.
	Over 90 percent of participants in the *Common Threads Project* who completed a survey said that multiple perspectives that came forward in dialogues added to their understanding of each other and the issues.
Increased, renewed awareness or attention to an issue	The *Understanding Neighbors* project in Anchorage, AK, brought renewed, though still limited, interest to issues related to homosexuality and the rights of same-sex couples following a period of contentious and controversial public discourse.
	The Andy Warhol Museum's *Without Sanctuary Project* provided an extended and potent opportunity for Pittsburgh area residents to consider and discuss issues of race, both in relation to a spate of racially motivated hate crimes experienced by the community, but also in broader terms. Its opening just after 9/11, along with substantial media coverage and letters to the editor, extended public discourse on issues of race, bigotry, violence, and complicity.
	Henry Art Gallery's *Gene(sis)* exhibition and project raised issues related to human genome research as an important topic of public conversation in Seattle. The project captured the interest of local residents and, through the exhibition and a wide range of public programs, it provided a civic "space" for further learning and dialogue about these issues.
Issues reframed to provide a new way of looking at them	The *Understanding Neighbors* project in Anchorage reframed issues around same-sex couples from focusing on policy change to focusing on values and understanding in the context of ongoing discussions related to nondiscrimination, acceptance, as well as hurtful behavior in families, workplaces, and churches.
	The Jewish Museum's *Mirroring Evil* exhibition in New York City reframed discourse on the Holocaust by focusing on the perpetrator rather than the victim, thereby reframing public dialogue to explore contemporary issues related to complacency and complicity toward evil in society.

4	EFFECTED SHIFTS IN THINKING AND ATTITUDES ABOUT AN ISSUE
Increased tolerance and respect for other points of view	The scope of interfaith dialogues enabled by Cornerstone Theater's five-year *Faith-Based Theater Cycle* in Los Angeles resulted in individual experiences of greater tolerance and respect within and across faiths. As a result of difficult dialogue about issues of homosexuality within Islam during the development of a Muslim play, one participant conveyed her later embarrassment at her own opposition to the proposed gay character. She noted that, in a subsequent dialogue with friends, she challenged friends' hurtful comments about gay Muslims.
Actual change or shift in attitude or position about an issue	Following Dell'Arte theater's dialogues and play *Wild Card,* Blue Lake, CA, residents who were originally most vociferous in their objections to the construction of a casino in the abutting Native American Rancheria reported a sense of acceptance, even an understanding of why it was important to the Rancheria.
Greater interaction and improved relations between segments of the community	In Lima, OH, the president of the local chapter of Alpha Kappa Alpha (AKA), a black sorority, asked the *Common Threads Project* for a copy of its "community of color" list, indicating it was better than the AKA list.
	Dell'Arte's *Dentalium Project* dialogues held to inform the development of the play *Wild Card* were the first time that many long-time residents of the entrenched, abutting communities of Blue Lake and the Blue Lake Rancheria, CA, had ever sat down and heard each other's stories. An opening was created to continue to connect.
A greater sense of hope and recognition of positive forces to help address issues	The Middle School Drug Prevention and School Safety Coordinator at a Flint, MI, middle school reported that, "This exercise has given our students a sense of pride and hope. We are celebrating our efforts to create a caring atmosphere at McKinley where hurting of any kind is unacceptable."
	The personal story told in the film *Imagining Robert* and related public dialogues through the Massachusetts Foundation for the Humanities offered new hope and a valued set of affirming possibilities for mentally ill people and their families beleaguered by problems in the mental health system.

5	INCREASED PARTICIPANTS' SENSE OF SELF-EFFICACY AND COLLECTIVE EFFICACY TO TAKE ACTION
Individuals taking action	As a result of participating in the *African in Maine* project, a 20-year-old Somali man connected with a legislative advocate to learn what he could do to increase the number of Somali police officers on the local force in Portland.
	Individuals within the Congolese community of Portland, ME, were inspired to organize alternative cultural events to those sponsored by the primary Congolese association, bolstered by their participation in the *African in Maine* project.
	A Somali youth in Portland initiated a public forum with the help of the Center for Cultural Exchange, offering a chance for Somali and non-Somali people to exchange views about a controversy in nearby Lewiston regarding the mayor's public proclamation to keep Somalis from settling in Lewiston.
Citizens stepping up to assume civic leadership roles	Two Blue Lake, CA, residents ran for City Council, specifically inspired by the charge within Dell'Arte's play *Wild Card* to get involved in the future of the community. One of them won.

Collective efforts to take action	At the *Common Threads* conference in Lima, OH, 16 action groups were formed for future work together around issues, such as breaking down racism, classism, and sexism; return of black entrepreneurship; and fostering ongoing dialogue among elected city and county officials.
	The *Common Threads* Community Development Action Team linked up with the Chamber of Commerce in Lima, OH, to develop a citizen's long-range community plan. The team is successfully soliciting participation from both city and county officials. A summit meeting was held for all elected officials in June 2004. Government officials have agreed to *consider* implementing the recommendations growing out of this planning.
	The partner organizations that steered Flint Youth Theatre's *...My Soul to Take* project in Michigan believe the project resulted in more focused efforts, more recognition of deserving efforts, and more interplay and dialogue between stakeholders.
	In the *African in Maine* project, collective efforts within each of three African refugee populations to determine and implement cultural programs helped to build stronger relations within divided African communities; develop self-confidence, identity, and a sense of achievement in their new home; and build social networks. The Sudanese Community Organization, for example, is now a functioning and recognized voice for the entire community.
Recognition of one's own role in and responsibility for community norms and values	According to artist-educators, students in Pittsburgh who participated in The Warhol Museum's *Without Sanctuary* exhibition and dialogues (discussing racial bigotry at home and in school) became much more aware of their roles to interrupt the cycle of violence at an early age.
	The Lima, OH, public schools engaged Sojourn Theatre Company to return to Lima in 2004 for teacher training and school residencies with new awareness of fostering a sense of civic responsibility in youth and an appreciation of the role of the arts.

6	ENHANCED QUALITY OF AND CAPACITY FOR CIVIC DIALOGUE
Opening communication between people who don't typically communicate in the civic realm	All Montevideo, MN, residents interviewed as part of the creative process for Children's Theatre Company's play *Montevideo Stories* (about rural issues and the farm crisis) said that as a direct result of the play, people on opposite sides of the issues can now look each other in the eye and talk.
Enhanced community capacity for civic dialogue and arts- or humanities-based civic dialogue	Community members trained through eight of the Animating Democracy projects in facilitating civic dialogue were prepared to apply skills to future efforts related to cultural activity or otherwise.
	The Slave Galleries Project in New York City bolstered the Lower East Side Community Preservation Project as an ongoing, organized, and recognized forum for developing community history initiatives that address shared neighborhood concerns and use historic sites as settings and symbols for civic dialogue.
	The *Common Threads* dialogue process continues to be used in school and community settings in Lima, OH.
	Alaska Common Ground, a humanities-based policy organization that was a partner in the *Understanding Neighbors* project in Anchorage, AK, is applying civic dialogue methodologies learned through the project to its statewide public policy discussions.

7	ENGAGED CIVIC LEADERS IN A MUTUALLY RESPONSIVE ENVIRONMENT WITH CITIZENS AND STAKEHOLDERS
Civic leaders experience increased trust and improved relations among themselves and from citizens	City and county leaders in Lima, OH, are now talking with each other on a monthly basis for the purpose of building better relations between them as a result of the Elected Officials Dialogue action team formed through the *Common Threads Project*.
	California's Blue Lake City government and the Blue Lake Rancheria government have a city council liaison who is encouraging regular dialogue between the two. This new city councilwoman ran and won her post on a platform about improved relations that was inspired by Dell'Arte theater's *Wild Card* play.
Development of new civic leaders	In Lima, OH, African-American individuals involved as Sector Leaders in the *Common Threads Project* have been invited to the Civic Center Board and recognized with an award by the Chamber of Commerce.
	Youth involved as dialogue facilitators and evaluators in Northern Lakes Center for the Arts' *Water Project* in Wisconsin gained skills in facilitation and respect of community members and a sense of self identity as civic participants and leaders.
Civic leaders informed about the issue at a new level	Some key religious leaders and retired politicians participated in the *Understanding Neighbors* dialogues in Anchorage, AK.
	Children's Theatre Company's *Land Bridge Project* in Montevideo, MN, attracted people to the play and dialogue who local people observed would not generally come, including city council members, the mayor of a nearby town, and the head of the local arts council.
Civic authorities recognizing voices of disenfranchised groups in a community	Because of the Esperanza Center's *Arte es Vida* efforts to save a historic building, concerned members of San Antonio's white and Chicano communities came to a shared understanding of the need for racial justice in historic preservation work. The Office of Historic Preservation is actively working with the Esperanza and other Chicano organizations to stop the demolition of other historic buildings. A city councilwoman, the Historic Preservation office, and several community groups are developing a community development plan that incorporates a more complex vision of the community based on people's history, culture, and values.
	The *African in Maine* project played a role in the emerging awareness among the city's government and business officials that racial and ethnic diversity is a prominent feature of life in Portland, and that they must figure out how to deal with it.
	A County Commissioner and a Land Use Committee member in Minneapolis brought information related to needs of disenfranchised residents affected by neighborhood development and a valuing of art in public process to their respective civic organizations based on their participation in Intermedia Arts' *People Places Connections* project.
	Local organizers in Detroit working with the Los Angeles Poverty Department on the *Agents & Assets* project noted that policy decision-makers who engaged in planning and attended events were "talking outside themselves" and connecting to those affected by drug policy in Detroit.

New angles, stories, and perspectives contributing to existing civic discourse on an issue	The timing of screenings and dialogues around the film *Imagining Robert* effectively contributed to (and benefited from) discourse—in Massachusetts and nationally—about the needs of the mentally ill and their family members, including insurance parity for the mentally ill, housing, treatment, and services.
Increased understanding of community readiness to engage with an issue	Out North's issue-mapping process (in which scores of individuals of different beliefs were interviewed) assessed the attitudes and readiness of the Anchorage, AK, community for structured dialogue around the issue of same-sex couples in the community.
Media coverage of arts-based civic dialogue projects contributing to public discourse about the issue	*The Lima News* in Ohio published 37 feature, editorial, and news articles over the 14 months of the *Common Threads* project, as well as monologues from the script, and they kept a photographic record of the project. Further, a *Lima News* editor became an advisor to the project, and two *Lima News* employees received dialogue facilitation training.
	The unprecedented media coverage and controversy surrounding The Jewish Museum's *Mirroring Evil* exhibition in New York City stimulated public discourse nationally (and internationally) on the question of who can speak for the Holocaust, the subject of victimhood, and to a lesser degree around the intended focus on complicity and complacency toward evil.
	Significant media coverage of the *African in Maine* project contributed to the goal of heightening Mainers' awareness of the presence of African communities, and exposure to the diversity within each of those communities. Media surrounding the Somali *Eid al Fitr* event—which was linked in the media's eye to the Lewiston controversies—was significant and played some part in shaping Portlanders' responses to the crisis.
	Letters to the editor of Pittsburgh newspapers regarding the impact of the *Without Sanctuary* exhibition and dialogues on people who participated evidenced the effect on individuals and contributed to broader public discourse about issues of race, bigotry, and the need to address this part of America's past.
New vision for the role of the arts in community partners' work and in discourse around issues relevant to their work	Hope Community, a human service and housing agency in Minneapolis that partnered with Intermedia Arts on its *People Places Connections* project, has engaged artists from the project to continue working with disenfranchised residents of the neighborhood around particular issues.
The arts perceived as a way to engage citizens and leaders in civic issues	A Hennepin County, MN, commissioner asked to use an art videotape created for Intermedia Arts' *People Places Connections* project to show to his fellow commissioners, stating that art has the potential to encourage commissioners to think creatively about the possibilities for development and land use issues and to take creative risks rather than act out of fear.
	As a result of their participation in the *Common Threads* project in Lima, OH, 96 percent of survey respondents indicated they had a better understanding of how the arts could be a catalyst for public conversation.
	As a result of Northern Lakes Center for the Arts' *Water Project* in Amery, WI, the center was invited by the county's water resources agent to host a series of meetings that resulted in the development of the Apple River Association. The center was also approached by the agency concerned with the entire local watershed to produce an environmental play after viewing the reaction to the production of *An Enemy of the People*.
A valuing of structured dialogue within community leadership and among citizens	The term "civic dialogue" has entered the vocabulary of Lima, OH's community leaders and is now used by public officials, NAACP leaders, economic development professionals, arts groups, and educators.

Following the success of *The Without Sanctuary Project*, The Andy Warhol Museum was invited by Amnesty International to develop an arts-based civic dialogue project in conjunction with A.I.'s national conference to be held in Pittsburgh. The Warhol mounted an exhibition of Warhol's *Electric Chair* paintings and prints as the basis for dialogues on the death penalty. In 2004, The Warhol mounted an exhibition related to the photos of prisoner abuse at Abu Ghraib in Iraq, with related dialogue opportunity.

Liz Lerman Dance Exchange, based on its participation in Henry Art Gallery's *Gene(sis)* exhibition on the human genome, is developing its own major project exploring issues of genomics and genetics.

Nearly 3,500 people in Flint, MI, were involved in classroom art projects, neighborhood safety initiatives, an anti-violence website, an improvisational theater performance, and more as a result of nine mini-grants given (out of 27 applications) in conjunction with Flint Youth Theatre's project addressing school violence.

In 2002, Northern Lakes Center for the Arts in Amery, WI, hosted *Racism in Rural Wisconsin,* employing many of the techniques learned and applied in its Animating Democracy project.

The Midtown Greenway Coalition invited artist Wendy Morris to create a performance for a series of business and community meetings about a Zoning Overly District for the Greenway in Minneapolis, as a result of Intermedia Arts' *People Places Connections* project.

MACLA's *Ties That Bind* exhibition in San José, CA, was presented at a sister alternative art center in Fresno, CA, which included a small-scale commission of new works by Fresno artists working with Central Valley-based Asian-Latino families. Dialogue components were part of the Fresno project.

Planning for Arts-based Civic Dialogue

ASK:	CONSIDER:	ESTABLISH:	DESIGN:
What do you want your arts-based civic dialogue to accomplish?	**What are reasonable and meaningful goals and outcomes of dialogue related to the civic issue?**	**Who should participate in the dialogue and how can you attract and engage them?**	**How do you create an environment that is safe and conducive for honest and open dialogue?**
· What difference do you hope to make as a result of creating dialogue? · How should you "name and frame" the civic issue(s) so that it will interest and be relevant to the publics you seek to engage?	· Increased visibility for or awareness of the issue · Deepened understanding of the complex dimensions of the issue · Increased tolerance and respect among people who hold different beliefs or values · Participants have increased sense of self-efficacy to take action on the issue · Civic leaders gain deeper understanding of citizen perspectives on the issue · Broadened participation in dialogue about the issue, including people who are concerned about the issue but don't typically become engaged	· What is the history of the issue in the community? · Who are the stakeholders? · What perspectives on the issue need to be represented in the dialogue groups? · Is the lead organization perceived as a credible convener of dialogue? · With which organizations do you need/want to partner in order to be effective? · What is necessary to gain their support and participation?	· When and how is art being employed as a stimulus or process for dialogue? How can dialogue activities be integrated with the artistic/cultural experiences? · Who can design/facilitate your dialogues using strategies compatible with the artistic expression, tone, culture, and community(ies) to be convened? · What settings, formats, and approaches to facilitation will best support dialogue? Time and place? Length and number of sessions? Size of dialogue groups? · How should groups be composed to ensure multiple perspectives and diversity (ethnic, racial, gender, class, or other relevant characteristics)? · What elements of this dialogue should be documented and how?

The Dialogue: How a Liz Lerman Dance Exchange Workshop Develops Artistically, Dialogically, and Civically

	ACTIVITY	ARTISTIC DEVELOPMENT	DIALOGIC DEVELOPMENT	COMMUNITY BUILDING OR CIVIC DEVELOPMENT
First Steps	· Leaders circulate and greet participants, learn names, and engage in one-on-one conversations.	· Promotes participant comfort and removes first barriers to artistic process.	· Establishes ease between leader and participant.	· Promotes basic community building value: know your neighbors. · Begins to break down certain expectations about hierarchy. · Promotes the value of each individual in the group.
	· Leaders collect and respect observations and opinions.	· Appreciates individual contributions to encourage later communication.	· Allows opinions to be voiced and heard without judgment being expressed. · Reveals multiple viewpoints.	· Establishes a community of multiple viewpoints.
Warm-up	· Participants introduce themselves (stand in a circle and state name, where from, and what brought them there, or variation thereof). · Participants are invited to take charge of their own bodies and what to share. They are given the option of *not* participating.	· Introduces gesture. · Places people in command of themselves.	· Establishes the expectation of a conversation. · Accords respect and expresses trust to each participant. · Ensures everyone gets a turn.	· Renders power, control, and choice to each participant. · Prompts each participant to take responsibility for own actions.

	ACTIVITY	ARTISTIC DEVELOPMENT	DIALOGIC DEVELOPMENT	COMMUNITY BUILDING OR CIVIC DEVELOPMENT
Core Program	· Blind Lead *(This exercise is often used as a warm-up.)*	· Uses skills for moving and introduces partnering that will be used later.	· Fosters one-to-one inter-action as partners interact while keeping awareness of group dynamic. · Expands listening skills beyond the sense of hearing. · Heightens multisensory awareness of fellow participants. · Gives opportunity to exchange perspectives and reflect on meaning.	· Establishes trust. · Levels differences in status as leader/follower roles are practiced and switched.
	· Topic- or commonality-focused question is posed in a story circle formation.	· Explores content, text, and stories for movement and symbol.	· Full group sharing and discussion takes place. · Values personal and "I" statements. · Reveals deeper personal viewpoints.	· Breaks participants out of insular experience. · Values the personal in the social context. ("The personal is political.")
	· Participants break out of the circle. · Participants circulate, having a series of one-on-one conversations with different partners.	· Introduces more movement possibilities. · Deepens collaborations.	· Engages with different partners on a one-to-one basis. · Recognizes a range of ideas.	· Emphasizes the value of individuals in the group. · Affords mutual learning.
	· Choreographic assign-ments—involving generating ideas, sharing, synthesizing, and show-ing. Process—usually moves between solo, pair, and small group work, ultimately with a showing made to the full gathering.	· Establishes ensemble building, content and skill development, editing, and performance values.	· Sharing, mutual teaching, and problem solving takes place. · Negotiation and manage-ment of agreements and disagreements made.	· Group becomes a community of purpose.
Reflection	· Observations of the experience are collected throughout the workshop and cumulatively at the end.	· Consolidates skills, content, and performance values.	· Offers opportunities to stop the course and reflect and observe as a group.	· Participants enjoy appreciation of varied and shared experiences. · Confirms group achievement.

Key Field Resources

Art in the Public Interest (API) is a nonprofit organization that supports the belief that the arts are an integral part of a healthy culture, and that community-based arts provide significant value both to communities and artists. API's **Community Arts Network (CAN)** promotes information exchange, research, and critical dialogue within the field of community-based arts, that is, art made as a voice and a force within a specific community of place, spirit, or tradition. The CAN project was created through a partnership between Art in the Public Interest and The Virginia Tech Department of Theatre Arts' Consortium for the Study of Theatre and Community. API manages the CAN website. www.communityarts.net

National Coalition for Dialogue & Deliberation (NCDD) was formed in 2002, after 60 leaders and 50 organizations collaborated to produce the first National Conference on Dialogue & Deliberation. The conference brought together practitioners and scholars from across the spectrum of dialogue and deliberation practice for the first time. NCDD's members are committed to continuing to foster collaboration and to building understanding and cohesion in the dialogue and deliberation community. NCDD's website is an expansive resource providing information about the full range of dialogue and deliberation practices, dialogue organizations across the country, issues and concerns in the dialogue field, and other special features. NCDD hosts a biennial conference. www.thataway.org

Glossary

arts-based civic dialogue: Dialogue in which the artistic process or presentation provides a key focus, catalyst, forum, or form for public dialogue on a civic issue. Opportunities for dialogue are embedded in or connected to the arts experience. Arts-based civic dialogue may draw upon any of the arts or humanities disciplines.

civil society: That sphere of voluntary associations and informal networks in which individuals and groups engage in activities of public consequence. It is distinguished from the public activities of government because it is voluntary, as well as from the private activities of markets because it seeks common ground and public good. It is often described as the "third sector." (Definition from the Civic Practices Network website, www.cpn.org)

civic: Of or relating to a citizen, a city, citizenship, or civil affairs; relating to or befitting citizens as individuals.

civic engagement: The many ways that people may get involved in their communities to consider and address civic issues, build social capital, and encourage civic participation. These include, but are not limited to joining committees or boards, volunteering, community organizing, participating in community planning or improvement efforts, and attending and participating in civic forums. Civic dialogue is one form of civic engagement.

civic dialogue: Dialogue about civic issues, policies, or decisions of consequence to people's lives, communities, and society as a whole. Civic dialogue is intentional and purposeful in relation to civic goals and concerns.

cross-talk: In structured dialogue, the opportunity for participants to respond to one another's comments, usually following interaction that promotes listening and provides equal time for all participants to speak and be heard without interruption or challenge.

culture: A set of practices and expressions (including language, behavior, ritual, values, art) shared by a group of people. It is distinguished from the biological basis of race and the national basis of ethnicity. Hip-hop culture, for example, crosses race and ethnicity but reflects a cohesive creative practice and expression.

cultural grounding: To be rooted in the values, traditions, and expressions of one's own culture. Considered fundamental to ensuring that people who are disenfranchised feel empowered to actively participate in the dominant political structure.

cultural hybridity: The production of new political identities resulting from the modern-day complexities of migration and exile, immigration and repatriation, intermarriage, and other catalysts of cultural fusion.

debate: An exchange in which the purpose is to win an argument by finding flaws in or critiquing the other party's position, making counterarguments, and defending one's own views against those of others. (Definition from Daniel Yankelovich, *The Magic of Dialogue*)

deliberation: An approach to decision-making in which individuals enter a conversation and may experience a change in their opinions and preferences as a result of critical thinking, the consideration of relevant factual information from multiple points of view. (Definition from the Deliberative Democracy Consortium, www.deliberative-democracy.net)

deliberative democracy: Deliberative democracy rests on the core notion of citizens and their representatives deliberating about public problems and solutions under conditions that are conducive to reasoned reflection and refined public judgment; a mutual willingness to understand the values, perspectives, and interests of others; and the possibility of reframing their interests and perspectives in light of a joint search for common interests and mutually acceptable solutions. (Definition from the Civic Practices Network, www.cpn.org)

dialogue: Two or more parties with differing viewpoints work toward common understanding in an open-ended, typically face-to-face format. Qualities of dialogue that distinguish it from debate or discussion: (1) Dialogue is inclusive of *multiple perspectives* rather than promoting a single point of view; (2) Dialogue encourages that *assumptions* be surfaced and participants suspend judgment in order to foster understanding and break down obstacles; (3) Dialogue seeks to create *equality* among participants, (4) Dialogue aims for a greater understanding of others' viewpoints through *empathy*. The word "dialogue" derives from two Greek words: *dia*, meaning "through" and *logos*, meaning "word" or "meaning." (Definition from Study Circles Resource Center and from Daniel Yankelovich, *The Magic of Dialogue.*)

historic sites of memory: Historic sites of memory are places where important historic events occurred or that commemorate historic events, figures, or ideas through the creation of a monument, museum, or other interpretive means. Such sites are considered important to sustain in the public conscience because they represent the triumph of democracy, social justice, or human rights, or because they represent their failure. The power of their stories can inspire and deepen dialogue on contemporary social and civic concerns. (Definition from the International Coalition of Historic Site Museums of Conscience, www.sitesofconscience.org)

intergroup dialogue: Dialogue between members of different identity groups.

intragroup dialogue: Dialogue between members within a single identity group.

multipartiality: Borrowed from the field of psychology to describe the role of the therapist in maintaining a metaview of the situation and being on everyone's side simultaneously. Multipartiality also relates to the role of the dialogue facilitator, who helps participants consider multiple points of view in a dialogue and seeks a solution that will benefit all parties.

nonverbal dialogue: Expression and communication that conveys meaning without words; may take the form of dance, movement, music, abstract images, gesture, and body language.

public discourse: Public discourse includes various and usually simultaneous levels of communication around a civic issue—private conversation, organized discussion forums, news reporting and editorials, and political debate. Public discourse may include dialogue.

safe space: An environment in which everyone feels comfortable to express themselves and participate fully, without fear of attack, ridicule, or denial of experience. (Definition from Arizona State University Intergroup Relations Center, www.asu.edu/provost/intergroup/)

social capital: Those stocks of social trust, norms, and networks that people can draw upon to solve common problems. Networks of civic engagement, such as neighborhood associations, sports clubs, and cooperatives are an essential form of social capital, and the denser these networks, the more likely that members of a community will cooperate for mutual benefit. (Definition from the Civic Practices Network, www.cpn.org)

story circles: Among the many approaches to the use of story, the most well-known and influential approach is Story Circles, as formalized by John O'Neal of Junebug Productions. The premise behind the process is that by allowing people to hear each other's viewpoints or experiences in the form of stories, they gain a much fuller understanding of alternative ideas and experiences without unnecessary confrontation, and without feeling that their own ideas are being threatened or rejected. Participants sit in a circle. The process moves around the circle clockwise allowing each person equal time to tell a story in response to the question offered by the convener or facilitator. There is then a period allowing each person to "sum up," i.e., offer something that they learned or thought about, and finally a period for cross-conversation to pursue issues that emerged and what they want to do about it.

Illustrations

COVER

top row (left to right)
*King Kamehameha I Statue
Conservation Project,*
Hawai'i Alliance for Arts
Education. (spine)

Moby Dick,
Perseverance Theatre.

Animating Democracy
Learning Exchange,
Minneapolis, March 2002.

Hair Parties Project,
Urban Bush Women.

The Great Wall of Los Angeles,
SPARC (Social and Public
Art Resource Center).

Project 2050,
New WORLD Theater.

Animating Democracy
Learning Exchange,
Minneapolis, March 2002.

Artist Marty Pottenger,
Abundance.

*Common Threads Theater
Project,* Sojourn Theatre.
Photo by Todd Campbell
and David Massey,
The Lima News, 2002.

bottom row (left to right)
Henry Art Gallery,
*Gene(sis): Contemporary Art
Explores Human Genomics.*
Photo by Eduardo Kac, GFP
Bunny, 2000. Courtesy of
Julia Friedman Gallery. (spine)

Arte es Vida, The Esperanza
Peace and Justice Center.

...My Soul to Take,
Flint Youth Theatre.

Mark Valdez, Cornerstone
Theater Company.

Animating Democracy
National Exchange on
Art & Civic Dialogue.
Photo by Tony Caldwell, 2003.

Nuevo California, San Diego
REPertory Theatre.

The Poetry Dialogues, City Lore.

Imagining Robert,
Massachusetts Foundation
for the Humanities.

Wild Card,
Dell'Arte International.
Photo by Carol Eckstein.

PART I

page 2 (left to right)
*You Can't Take It With You:
An American Muslim Remix,
Faith-Based Theater Cycle,*
Cornerstone Theater
Company, 2003.
Photo by Craig Schwartz.

*The Slave Galleries
Restoration Project,*
St. Augustine's Episcopal
Church, 2005.
Photo by Hector Peña.

African in Maine,
Center for Cultural Exchange.

Hallelujah/USA, 2003,
Liz Lerman Dance Exchange.
Photo by Stan Barouh.

page 8 (left to right)
Wild Card,
Dell'Arte International, 2002.
Photo by Carol Eckstein.

*Common Threads Theater
Project,* Council for the
Arts of Greater Lima.
Photo by Todd Campbell
and David Massey,
The Lima News, 2002.

Moby Dick,
Perseverance Theatre.

Animating Democracy
Learning Exchange,
Minneapolis, March, 2002.

*Order My Steps,
Faith-Based Theater Cycle,*
Cornerstone Theater
Company, 2003.
Photo by Craig Schwartz.

page 12
Composer Jin Hi Kim
with high school students.
Photo courtesy of American
Composers Orchestra.

page 15
go_HOME artists Danica Dakic
and Sandra Sterle.
Photo by Egbert Trogemann.

Contributors

Pam Korza co-directs Animating Democracy, a program of Americans for the Arts that fosters civic engagement through art and culture. In addition to co-writing *Civic Dialogue, Arts & Culture: Findings from Animating Democracy,* she is co-editor of *Critical Perspectives: Writings on Art & Civic Dialogue,* and *Case Studies from Animating Democracy.* She provided research for and co-wrote—with Barbara Schaffer Bacon and Cheryl Yuen—the launching study, *Animating Democracy: The Artistic Imagination as a Force in Civic Dialogue.* Pam worked with the Arts Extension Service at the University of Massachusetts at Amherst (AES) for 17 years. There she coordinated the National Public Art Policy Project in cooperation with the Visual Arts Program of the National Endowment for the Arts, which culminated in the book *Going Public: A Field Guide to Developments in Art in Public Places,* which she co-wrote and edited. She was co-editor and contributing writer to *Fundamentals of Local Arts Management,* also published by AES. She directed the Boston-based New England Film and Video Festival, a regional independent film festival.

Barbara Schaffer Bacon co-directs Animating Democracy, a program of Americans for the Arts that fosters civic engagement through art and culture. Barbara has worked as a consultant since 1990, prior to which she served as executive director of the Arts Extension Service at the University of Massachusetts at Amherst. Her work includes program design and evaluation for state and local arts agencies and private foundations nationally. Barbara has written, edited, and contributed to several publications including *Civic Dialogue, Arts & Culture: Findings from Animating Democracy*; *Case Studies from Animating Democracy*; *Animating Democracy: The Artistic Imagination as a Force for Civic Dialogue*; *Fundamentals of Local Arts Management*; and *The Cultural Planning Work Kit.* Barbara has served as a panelist and adviser for many state and national arts agencies. She is president of the Arts Extension Institute, Inc., a board member of the Fund for Women Artists, and an elected member of her local school committee.

Andrea Assaf is the artistic director of New WORLD Theater (NWT) at the University of Massachusetts, Amherst. She is a performer, director, writer, educator, and activist. Before joining New WORLD Theater, Andrea was the program associate for Animating Democracy. She has a masters degree in performance studies and a B.F.A. in acting, both from New York University. Her performance work ranges from spoken word to theater, from multidisciplinary solo work to collaborative ensemble productions. Her community arts experience includes: youth work with NWT's *Project 2050,* intergenerational work with Liz Lerman Dance Exchange, original collaborative performances within the Filipino/a-American community in New York City, and performance-based conservation education in Tanzania, East Africa. In 2004, Andrea was awarded a grant from Cultural Contact (United States–Mexico Foundation for Culture) to collaborate on a binational dance-theatre project, *Fronteras Desviadas/Deviant Borders.* She speaks Kiswahili and Spanish, and is a member of the Writers' Roundtable and Alternate ROOTS.

About Americans for the Arts and Animating Democracy

Americans for the Arts is the nation's leading nonprofit organization for advancing the arts in America. With more than 40 years of service, it is dedicated to representing and serving local communities and creating opportunities for every American to participate in and appreciate all forms of the arts.

To learn more about programs, membership, and how you can support Americans for the Arts, call 202.371.2830 or visit www.AmericansForTheArts.org.

Animating Democracy, a program of Americans for the Arts' Institute for Community Development and the Arts, fosters arts and cultural activity that encourages and enhances civic engagement and dialogue. Animating Democracy is a resource for linking the arts and humanities to civic engagement initiatives. Animating Democracy helps to build the capacity of artists and cultural organizations involved in a wide sphere of civic engagement work through programs and services, including:

- A website providing practical and theoretical resources related to the arts as a form and forum for civic engagement and dialogue;

- Referrals of artists and cultural institutions experienced in designing creative civic engagement and dialogue programs on a wide array of contemporary issues;

- Learning exchanges and professional development programs that offer opportunities to learn and share practices and innovative methods in arts-based civic dialogue/engagement work;

- Technical assistance and consultation for museums, historic sites, and community groups seeking to develop arts- and humanities-based civic engagement initiatives; and

- Publications featuring books, essays, and reports exploring arts- and humanities-based civic engagement.

For more information about Animating Democracy, call 202.371.2830 or visit www.AmericansForTheArts.org/AnimatingDemocracy.

Civic Dialogue, Arts & Culture: Findings from Animating Democracy is a publication of Animating Democracy, a program of Americans for the Arts, which seeks to foster civic engagement through arts and culture. Other Animating Democracy publications include:

ART & CIVIC ENGAGEMENT SERIES (2005)

Dialogue in Artistic Practice: Case Studies from Animating Democracy

Hair Parties Project, Urban Bush Women

Faith-Based Theater Cycle, Cornerstone Theater Company

An Aesthetic of Inquiry, an Ethos of Dialogue, Liz Lerman Dance Exchange

Cultural Perspectives in Civic Dialogue: Case Studies from Animating Democracy

King Kamehameha Statue Conservation Project, Hawai'i Alliance for Arts Education

African in Maine, Center for Cultural Exchange

Arte es Vida, The Esperanza Peace and Justice Center

Museums and Civic Dialogue: Case Studies from Animating Democracy

Gene(sis):Contemporary Art Explores Human Genomics, Henry Art Gallery

Mirroring Evil: Nazi Imagery/Recent Art, The Jewish Museum

The Without Sanctuary Project, The Andy Warhol Museum

History as Catalyst for Civic Dialogue: Case Studies from Animating Democracy

The Slave Galleries Restoration Project, St. Augustine's Church and the Lower East Side Tenement Museum

Traces of the Trade, Katrina Browne and the Rhode Island Council for the Humanities

The Without Sanctuary Project, The Andy Warhol Museum

Art, Dialogue, Action, Activism: Case Studies from Animating Democracy

Common Threads Theater Project, Arts Council of Greater Lima

Agents & Assets, Los Angeles Poverty Department

Arte es Vida, The Esperanza Peace and Justice Center

Understanding Neighbors, Out North Contemporary Art House

CRITICAL PERSPECTIVES: WRITINGS ON ART AND CIVIC DIALOGUE (2005)

ANIMATING DEMOCRACY: THE ARTISTIC IMAGINATION AS A FORCE IN CIVIC DIALOGUE (1999)

To order these publications, visit the Americans for the Arts online bookstore: www.AmericansForTheArts.org/bookstore.

Visit the Animating Democracy website for other case studies and writings on art and civic dialogue. www.AmericansForTheArts.org/AnimatingDemocracy.

Index